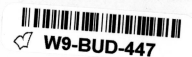
W9-BUD-447

Exhibition organized by
the Arts Council of Great Britain
with the support of the British-American Associates

SACRED CIRCLES

TWO THOUSAND YEARS OF
NORTH AMERICAN INDIAN ART

Catalogue by Ralph T. Coe

Hayward Gallery, London 7 October 1976–16 January 1977

ABBOT MEMORIAL LIBRARY
EMERSON COLLEGE

Arts Council of Great Britain

Exhibition designed by Barry Mazur
and Brian Griggs

Catalogue written by Ralph T. Coe
Edited by Irena Hoare
Catalogue designed by Roger Huggett, Sinc Ltd
Printed by Lund Humphries, London and Bradford

Exhibition Officer Catherine Lampert
Assisted by Caroline Richardson
Advisor in Great Britain Judith Nash

© Arts Council of Great Britain 1976
Soft cover ISBN 01 7287 0096 4
Hard cover ISBN 01 7287 0095 6

E
98
.A7
C54

Contents

Preface

The artistic achievements of the North American Indians are so considerable and yet so little known in this country that the present exhibition is long overdue. From every point of view it is an especially appropriate contribution to the American Bicentennial celebrations. The scale of the exhibition is such that we have been able to remedy the gap in our knowledge in the most ambitious manner. This achievement we owe to Ralph T. Coe whose intention in assembling the exhibition has been to establish the art of the North American Indian as one of the great artistic expressions of the world. Mr Coe, who is Assistant Director of the William Rockhill Nelson Gallery of Art and Atkins Museum of Fine Art, Kansas City, has acted as 'Curatorial Director'. It is to him that we owe our deep gratitude for his dedicated and intelligent shaping of the exhibition.

Catherine Lampert has been responsible in the Arts Council for all the organizational work of the exhibition including the planning and editing of this catalogue. In this she has been ably assisted by Caroline Richardson.

It all began when Mrs Robert T. Phinney, an American living in London, suggested to Mr Coe the possibility of an American Indian art exhibition in Great Britain. Mr Coe, who was working on an Indian show at the Nelson Gallery at the time, discussed the idea with Sir John Pope-Hennessey, then Chairman of the Art Panel of the Arts Council. In 1973 the Arts Council decided to present the exhibition within the framework of the Bicentennial celebrations. The exhibition has been co-sponsored by British–American Associates.

Ralph T. Coe began travelling in 1973 across the United States and Canada to examine and select Indian material from north of the Rio Grande to Alaska and Greenland. His travels, which continued through 1976, extended to Germany, Denmark and France as well as Great Britain where he was helped by Mrs Judith Nash. We have also had the valuable collaboration of Mrs Nash in assembling the catalogue and planning the installation and are grateful for her participation.

In the course of Mr Coe's research it became apparent that in some areas there was an abundance of magnificent material, much unpublished and unknown, and that the problem would be choosing between equally outstanding objects. We are only sorry not to have been able to represent every one of the fine collections of Indian art. On the other hand, given the age and fragility of the majority of the objects it is not surprising that only a handful of certain types of native American art survived at all. All of the owners we approached responded to our requests with amazing generosity and have in addition supplied the fullest documentation on their loans.

In 1974 a Committee of Honour was formed to underline the importance of the Anglo-American co-operation which was of course essential to the planning of such an event. We are greatly indebted to the two patrons of the exhibition, HRH The Duke of Edinburgh and Vice President Nelson A. Rockefeller. They, as well as the members of the Committee of Honour, have contributed personally to the planning of the exhibition and their advice and good will is greatly appreciated.

The staging of an exhibition, envisaged on such a scale, called for a new approach. An Anglo-American volunteer committee was formed to collaborate with the Arts Council. As a result of these volunteer efforts, half of the needed funds were raised from non-governmental sources. Special sub-committees for education, publicity and hospitality were formed under the leadership of Mrs Robert T. Phinney, Chairman; Mrs John D. Coffin; Mrs Jean A. Curran, and Mrs Robert V. Lindsay, Vice-Chairmen of the Women's Committee; and Mr Angus Littlejohn, Chairman of the Men's Advisory Committee. The members have worked steadily both in Great Britain and the United States to ensure the exhibition's success. We would like to express our deepest appreciation for the time they have so generously given in this effort.

Mrs Pat Van Pelt has made a most worthwhile contribution by organizing and training a group of volunteer guides who will be offering educational tours for school parties.

The Arts Council owes an enormous debt to Pan American World Airways. They came

forward in July 1975 with the offer of free transatlantic air freight, and thus made possible the borrowing of objects from widely dispersed collections. Within the United States some works have been transported by Braniff International Airways and Trans World Airlines and we are grateful for their assistance, and that of the Civil Aeronautics Board. The airlines have co-operated with our agents, W. R. Keating & Co. in seeing that the objects were handled with the utmost care.

Many other organizations and individuals have contributed to the funding of the exhibition and have helped in other ways. In addition to those names listed later on we would like to record our special appreciation for the assistance offered by: Mr W. Howard Adams; Mrs Howard A. Austin, Jr; Mr William Brandon; Dix (Charlmont Press) Ltd; The Drapers' Company; Mr Lionel Epstein; Mr Patrick Forbes of Moet & Chandon; The Horniman Museum; Mr Allen Hurlburt; Mrs Gladys Jannaud; The London Hilton; Morgan Guaranty Trust; Davis Polk and Wardwell; Mr Samuel W. Meek; Mr Jack B. O'Hara; Mrs Christian A. Herter, Jr.; Aquascutum, Ltd; Harvey Nichols; H. & M. Rayne, Ltd.; Selfridges, Ltd.; Simpson (Piccadilly) Ltd; Mrs Ivan K. Woodroffe.

The cultural offices of the United States Embassy and the Canadian High Commission have always been more than willing to answer our requests. From the outset we have had the support and advice of Mr Michael Pistor, Counsellor for Public Affairs, and Mr Charles R. Ritcheson, Cultural Attaché, at the American Embassy in London. In Washington the American Revolution Bicentennial Administration has been most sympathetic and their official endorsement and assistance with loan negotiations have been extremely useful. We are especially grateful for the help given by Mr John W. Warner and Mr William Blue.

Throughout the planning of the exhibition we have had the fullest co-operation from the British Museum and owe to their good will the loan of some of the rarest Indian objects. We would like to express our indebtedness to Sir John Pope-Hennessey, Mr Malcolm McLeod and the Trustees of the Museum. The guidance of Miss Elizabeth Carmichael, Mr Jonathan King and Mr Harold Gowers has been greatly appreciated at every stage, as has the practical help offered by the staff of the Museum of Mankind.

The principle of selection was to represent the traditional arts of the Native Americans north of the Rio Grande (except for Casas Grandes), and while concentrating on artistic values, to show modest objects that shed light on their culture as well as outstanding examples which are also here in abundance. In fact the exhibition extends beyond 2000 years, several works dating from 1500–1000 B.C. having been selected as a preamble, while the latest works were made by living artists within the last few years. Of special interest to Europeans will be the extensive archaeological representation, so little known or appreciated hitherto in this part of the world. It includes many unique and superbly important pieces which may never be seen here again, for which we are indeed indebted to the cooperation of the lending institutions. Mr Coe has included many categories of American Indian art which he feels are insufficiently known to the public, and has sometimes deliberately stressed these less familiar aspects. For example there are eight Mimbres painted pots from mediaeval New Mexico as against one pot by the celebrated living potter Maria of San Ildefonso, and a wealth of Athabascan material from western Canada to balance the American Plains representation.

The enormous problems of designing the installation of such a diverse assembly of objects in the space of the Hayward Gallery have been met by Mr Barry Mazur, assisted by Mr Brian Griggs. We are grateful for their efforts to create a context sympathetic to the Indian's sensibility and for the help of Peter Smith, Anna Plowden, Charlotte Townsend and Russell Brothers. Likewise the design and organization of a catalogue in which over 800 objects are illustrated and documented has presented awesome problems. Mr Ralph Coe's scholarship is the foundation of the catalogue. We would like to thank the designer Mr Roger Huggett and the editor Mrs Irena Hoare for their contributions and Mr Mick Gidley for his work on the Curtis photographs. In Kansas City, Mrs Dale Waller has assisted Mr Coe and Mrs Anne Tompkins and Professor Marilyn Stokstad have researched the bibliography.

The Arts Council is grateful for the help offered to Mr Coe by his many colleagues who went out of their way to make suggestions and facilitate loans. These include: Dr Helge Larsen, Copenhagen; Bishop Michon and Curé Robert Michel, Chartres Cathedral; Dr Axel Schulze-Thulin, Linden Museum; Mr H. J. Case, Ashmolean Museum, Oxford; Dr Edward

Rogers, Miss Peta Daniels, Dr Helmuth Fuchs, The Royal Ontario Museum; Mr Douglas Leonard, Museum of Man, Winnipeg; Mr Denis Alsford, National Museum of Man, Ottawa and Mr C. E. W. Graham and Miss Harriet Campbell of the McCord Museum, Montreal. In the United States numerous directors, curators and private collectors have collaborated in making the project a success. Among those to whom Mr Coe is especially grateful are: Dr Stephen Williams and Miss Fran Silverman of the Peabody Museum, Harvard University; Mr Peter Fetchko and Miss Lucy Bishop of the Peabody Museum of Salem, Mass.; Dr Stanley Freed, American Museum of Natural History; Miss Claudia Medoff, University Museum, Philadelphia; Dr William G. Fitzhugh, Dr William Sturtevant, Mr John C. Ewers and Mr John Rich, Smithsonian Institution; Dr Lewis Larson, Georgia State Department of Natural Resources; Mr William R. Maples and Miss Barbara Purdy, Florida State Museum; Miss Esther Bockhoff, Cleveland Museum of Natural History; Mr Donald Collier, Field Museum, Chicago; Mr Alexander Stoia and Mr Ben Stone, Philbrook Art Center, Tulsa; Mr Thomas Maythan and Mr Richard Conn, Denver Art Museum; Mrs Kendra Bowers, Taylor Museum, Colorado Springs; Dr Karl Dentzel, Museum of the Southwest, Los Angeles; Mr Jerry Brody, Maxwell Museum, Albuquerque; Mr David Hartley, Robinson Museum, Pierre, South Dakota; Mr Francis Newton, Portland Art Museum; Mr Thomas Seligman, M.H. de Young Museum, San Francisco; Mr Michael Kan, Brooklyn Museum; Mr Gregg Stock and Miss Susan McGreevy, Kansas City Museum. Private collectors who were generously supportive include Mr and Mrs Morton I. Sosland, Kansas City; Mr and Mrs John Hauberg, Seattle; Mr and Mrs Robert Campbell, Portland; Mr Hermann Vonbank, Munich; Mr Colin Taylor, Hastings; Mr Richard Pohrt, Flint, Michigan; Mr Proctor Stafford, Los Angeles; Mr Bill Holm, Seattle; a Montana private collector; Mr Anthony Berlant, Los Angeles; Mrs Katherine White, Los Angeles; Mr James Economos, New York; Mr Bob Ward, Santa Fé; Mr Robert Stolper, London; Mr Douglas Ewing, New York; Mr E. Michael Haskell, Santa Barbara; Mr Michael Johnson, Walsall; Mr William D. Wixom, Cleveland; Mr Rex Arrowsmith, Santa Fé; Mr Peter I. Hirsch, Santa Fé; Mr Coe was also advised by Father Maurice Van Ackeren, S.J. Kansas City and Father Donald Grabner, S.B. Conception Abbey, Missouri.

Robin Campbell *Director of Art*
Joanna Drew *Director of Exhibitions*

Lenders to the exhibition

Canada

McCord Museum, Montreal
National Museum of Man, National Museums of Canada, Ottawa
Dr Edward S. Rogers
Royal Ontario Museum
Manitoba Museum of Man and Nature
Hudson's Bay Company Historical Collection, Lower Fort Garry National Historic Park

Denmark

The National Museum of Denmark, Department of Ethnography

France

Trésor de la Cathédrale de Chartres

Germany

Stolper Galleries, Munich
Linden Museum, Stuttgart – Staate Museum für Völkerkunde
Mr Hermann Vonbank

United Kingdom

Peter Adler Collection
University of East Anglia (The Robert and Lisa Sainsbury Collection)
The Royal Scottish Museum
University Library, University of Exeter
Mr Sven Gahlin, London
Mr Michael G. Johnson, Walsall
The British Library Map Library
The Trustees of the British Museum
National Army Museum
Margaret, Duchess of Argyll
The Visitors of the Ashmolean Museum, Oxford
Mr Paul Stolper
C.F. Taylor Collection, Hastings

United States of America

Maxwell Museum of Anthropology, Albuquerque
Mr and Mrs Rex Arrowsmith
Mr David T. Beals III
Mr Anthony Berlant, Santa Monica, California
Mr Darrell L. Bolt
Ms Karen Bunting
Peabody Museum of Archaeology and Ethnology, Harvard University
Mr and Mrs Robert Campbell
Field Museum of Natural History, Chicago
Cincinnati Art Museum
Cincinnati Historical Society
The Cleveland Museum of Art, The Harold T. Clark Educational Extension Fund, Extension Exhibitions Department
The Cleveland Museum of Natural History
Dr and Mrs Oliver E. Cobb
Taylor Museum of the Colorado Springs Fine Arts Center
Conception Abbey (Benedictine), Missouri
The Denver Art Museum
The Detroit Institute of Arts, Purchase City Appropriation
Mr James Economos
University of Arkansas Museum
Dr and Mrs W. David Francisco
Georgia Department of Natural Resources
Guennol Collection (objects on loan to the Brooklyn Museum)
Florida State Museum
Mr E. Michael Haskell
Mr John H. Hauberg, Seattle
Mr and Mrs Peter I. Hirsch, Sante Fé
Jonathan and Philip Holstein Collection
Mr and Mrs James D. Ireland
Janss Foundation
Mr and Mrs Michael R. Johnson
Mr Donald D. Jones
Mrs LaRue Jones
Kansas City Museum of History and Science
Nelson Gallery of Art/Atkins Museum
Mr and Mrs George S. Lewis Jr.
University of California at Los Angeles Museum of Cultural History
Southwest Museum, Los Angeles
Mr and Mrs Robert H. Mann
Maryhill Museum of Fine Arts
Mr Fred Mitchell
Montana Private Collection
American Museum of Natural History
The Brooklyn Museum
The Museum of Primitive Art, New York
University of Notre Dame, Indiana
Joslyn Art Museum, Omaha, Nebraska
Mr and Mrs Leland Payton

University Museum, Philadelphia
Heard Museum, Phoenix
Robinson Museum – South Dakota Historical Society, Pierre
Chandler–Pohrt Collection, Great Lakes Indian Museum, Cross Village, Michigan
Oregon Historical Society
Portland Art Museum, Portland, Oregon
Mr and Mrs John A. Putnam
Mr and Mrs Julian W. Rymar
Saint Joseph Museum, Missouri
Washington University Gallery of Art, St Louis, Missouri
Peabody Museum of Salem
The Fine Arts Museums of San Francisco
Mr and Mrs Morton I. Sosland
Mr Proctor Stafford
Mr and Mrs Bruce M. Stevenson
Mr and Mrs Gregg F. Stock
Mr and Mrs Peter B. Thompson
Philbrook Art Center, Tulsa, Oklahoma
Mr Bob Ward, Santa Fé
National Museum of Natural History, Smithsonian Institution, Washington DC
Mr John White
Ulfert S. Wilke Collection
Mr and Mrs William D. Wixom
Several Private Collections

Patrons

Committee of Honour

H.R.H. The Duke of Edinburgh, KG, KT

The Hon. Nelson A. Rockefeller,
The Vice President of the United States

The Hon. Walter H. Annenberg
Her Excellency The Hon. Anne Armstrong
The Hon. David Bruce, CBE
The Rt. Hon. The Lord Caccia, GCMG,
The Rt. Hon. The Earl of Cromer, PC, GCMG, MBE
Sir Patrick Dean, GCMG
The Rt. Hon. The Lord Franks, GCMG, KCB, CBE
The Rt. Hon. John Freeman, PC, MBE
The Rt. Hon. The Lord Harlech, PC, KCMG
Sir Peter Hayman, KCMG, CVO, MBE
His Excellency Sir John Johnston, KCMG, KCVO
His Excellency The Hon. Paul Martin, PC, QC
Mr Bernard Ostry
Sir John Pope-Hennessy, CBE
His Excellency The Hon. Sir Peter Ramsbotham, KCMG
The Hon. Elliot L. Richardson
Dr S. Dillon Ripley
The Rt. Hon. The Lord Sherfield, GCB, GCMG
His Excellency Mr J. H. Warren
The Hon. John Hay Whitney, CBE

Anglo-American Volunteer Exhibition Committees

Women's Committee

Chairman
Mrs Robert T. Phinney
Vice-Chairmen
Mrs John D. Coffin
Mrs Jean A. Curran
Mrs Robert V. Lindsay

Mrs Mortimer Adler
The Countess of Airlie
Mrs Horace Andrews
Miss Juliet Aschan
Mrs Betty Assheton
Mrs Jason Bacon
Miss Nancy Balfour
Mrs George Barclay
Mrs John G. Beevor
Mrs Powell Cabot
The Lady Caccia
Lady Campbell
Mrs John P. Carroll
Mrs Ernestine M. Carter, OBE
Mrs Peter Cary
Mrs John Chadwick
Mrs Donald Claudy
Lady Coulson
Miss Fleur Cowles
Lady Crowe
Lady Dean
Mrs Roy Dickerson
Mrs David K. Dodd
Lady Dodds-Parker
Mrs Luis Domingues
Mrs Ellsworth Donnell
Mrs Angier Biddle Duke
Mrs John Elink-Schuurman
Mrs Lionel C. Epstein
Mrs Douglas Fairbanks
Mrs John R. Fell
Mrs David Fox
Mrs Lionel Fraser, OBE
Mrs Evan Galbraith
Mrs G. Giles
Mrs John Glover
The Lady Gore-Booth
Mrs Rupert Hambro
Mrs Craig Hammitt
Mrs Richard Hammerman
The Lady Harlech
Miss Inge Heckel
Mrs J. E. Hilburg
Mrs Murdoch Howland
Mrs Leanne Hull
Mrs Gladys Jannaud
Patricia, Countess Jellicoe
Mrs Peter Johnson
Mrs John J. Kennedy
Mrs Rosemary L. Klein
Mrs Dudley I. C. Knott
Mrs John W. Lapsley
The Countess of Lisburne
Mrs Joshua Logan
Mrs Richard Mahan
Mrs S. S. Marshal III
Mrs Henry McNulty
Mrs Beverley E. Miller
Mrs Roger Morrison

Mrs Thomas Mullins
Mrs Edward R. Murrow
Mrs William Nelson
Mrs Herman Nickel
Miss Helen O'Neill
Mrs John A. Pell
Mrs Michael Phelan
Mrs Elizabeth Cox Plum
Mrs Arnost Propper
Mrs C. Nicholas Potter
Mrs George Putnam
Mrs C. Peter Read
Mrs Paul Rice
Mrs Elliot L. Richardson
Mrs Charles R. Ritcheson
Mrs Rostislav Romanoff
Mrs Robert M. Rummell
Mrs Walter Shepard
The Lady Sherfield
Mrs J. Edward Sieff
Mrs Duncan Smith
Mrs Philip Spalding
Mrs A. Richard Stern
Mrs Dwight Stocker
Mrs John Street
Mrs Thomas Tolar
Mrs Peter Van Pelt
Mrs Albert Weismuller
Mrs Charles A. Winans

Men's Advisory Committee

Chairman
Mr Angus C. Littlejohn

Mr Jason Bacon
Mr Douglas Bogart
Mr Peter Cary
Mr John P. Carroll
Mr Michael Craig-Cooper
Mr Harry G. Cressman
Mr Frank Dawson
Mr Stuart W. Don
Mr Douglas Fairbanks, KBE, DSC
Mr George Ford
Mr Robert Fraser
Mr Allen Hurlburt
Mr W. B. Hirons
Mr Peter Johnson
Mr John Keffer
Mr Robert V. Lindsay
Mr Jonathan S. Linen
Mr Hugh Parker
Mr John A. Pell
Mr Alex Rhea
Mr James D. Stocker
The Hon. Thomas Stonor
Mr John Walker
Mr P. S. Winkworth

Exhibition Guides

Education Committee Co-Chairmen
Mrs Charles R. Ritcheson
Mrs John A. Pell
Director of Guide Programme
Mrs Peter Van Pelt

Mrs Horace Andrews
Mrs J. Taylor Bigbie
Mrs Jan Brumm
Mrs John P. Carroll
Mrs Peter H. Conze, Jr.
Mrs Roy Dickerson
Mrs David K. Dodd
Mrs T. F. Gaffney
Mrs G. Greenwald
Mrs George Humphrey
Mrs Muriel Julius
Mrs Thomas L. Keltner
Mrs John J. Kennedy
Mrs John Lapsley
Mrs Michael B. Phelan
Mrs Arnost Propper
Mrs Daniel A. Richards
Mrs Robert M. Rummell
Mrs Richard J. Shelton
Mrs Rawleigh Tremain, Jr.
Mrs A. J. Walton
Mrs Albert Weismuller
Mrs Jack E. Windham
Mrs J. Woodcock
Mrs William Youngclaus

The British-American Associates and the Arts Council of Great Britain gratefully acknowledge support from the following individuals and organizations

Benefactors

Mrs Jean A. Curran
Mr and Mrs Lionel Epstein
Mr and Mrs John R. Fell, Jr.
Mrs Parker B. Francis III
Mrs Sidney D. Gamble
Mrs Eugene McDermott
Mr Hubert T. Mandeville
Mr and Mrs Sam Meek
Miss Margaret S. Neal
Mrs John W. O'Boyle
Mr and Mrs Robert T. Phinney
Mr and Mrs Charles H. Price II
Mr and Mrs Constantine Sidamon-Eristoff
Sosland Family
Mr David Stickelber
Mr and Mrs Herman Sutherland
Mrs T. C. Weltmer
Mr and Mrs John B. Weltmer
The Hon. John Hay Whitney

Corporate Benefactors

M. L. Annenberg Foundation
Braniff International Airways
British Petroleum North America, Inc.
Carter Hawley Hale Stores, Inc.
Chase Manhattan International Foundation
Corning Glass Works Foundation
Courtaulds Ltd.
Davis Polk and Wardwell
The Dickinson Trust Ltd.
H. J. Heinz II Charitable and Family Trust
The London Hilton
International Harvester of Great Britain Ltd.
International Nickel Co.
Samuel H. Kress Foundation
Loyalhanna Foundation
Merrill Lynch Holdings Ltd.
Mobil Oil Co. Ltd.
Morgan Guaranty Trust Company of New York
Newsweek International, newsmagazine
Pan American World Airways
S. Pearson & Son Ltd.
Rockefeller Brothers Fund
Scientific American Magazine
Seattle First National Bank
Trans World Airlines Inc.

Donors

The Nancy Balfour Benevolent Trust
Mrs George H. Bunting
The Hon. & Mrs Angier Biddle Duke
Mrs C. J. Gamble
Mrs L. G. Harper
Mr John P. Humes
Mr and Mrs Robert V. Lindsay
Mr George T. Lowy
Mr Gerard Piel
Mr and Mrs Donald G. Siegel
Mrs A. Richard Stern

Corporate Donors

American Express Foundation
Bankers Trust Company
Chrysler (UK) Ltd.
Cleary, Gottlieb, Steen & Hamilton
Dart Industries Inc.
Doubleday and Company, Inc.
First National City Bank
Fried, Frank, Harris, Shriver & Jacobson
Kaiser Engineers Limited
The Kidder Peabody Foundation
Manufacturers Hanover Trust Co.
McDonnell Douglas Corp.
Mellon Bank NA
Northern Trust Company of Chicago
Republic National Bank of New York
The Bank of Tokyo Trust Co.
Union Commerce Bank
United California Bank
Vinson, Elkins, Searls, Connally & Smith
Winthrop, Stimson, Putnam & Roberts

Contributors

Mr and Mrs John P. Carroll, Jr.
Mr and Mrs Amon G. Carter, Jr.
Mrs Antoinette G. Denning
Mrs Humphrey Firman
Dr and Mrs W. David Francisco
Mr and Mrs Rupert Hambro
Mr and Mrs John H. Hoover
Mrs George C. Keiser
Mr and Mrs J. Roger Morrison
Mrs Edward R. Murrow
Dr and Mrs Carl Muschenheim
Mr and Mrs Elmer F. Pierson
Mr and Mrs John W. Starr
Mr and Mrs C. Humbert Tinsman
Mr Temple W. Tutwiler, II

Corporate Contributors

Bank of America
Beecham Group Ltd.
Caterpillar Tractor Co. Ltd.
Crocker National Bank
Dechert Price & Rhoads
Fidelity Bank
Fiduciary Trust Company of New York
First National Bank of Boston
First National Bank in Dallas
The Foreign and Colonial Investment Trust Co. Ltd.
Hercules Powder Company Ltd.
Kaiser Engineers
The Estée and Joseph Lauder Foundation, Inc.
Manufacturers Hanover Trust Company
Miriam Marks Charitable Trust
Marks & Spencer Ltd.
Morgan Grenfell & Co. Ltd.
Phillips Petroleum Company Europe-Africa
Redmayne Charitable Trust
Edward and Lois Sieff Charitable Trust
Trustees of the S. G. Warburg & Co. Ltd. Charitable Trust

Friends

Mrs Betty Assheton
Mr and Mrs Ronald Atkins
Mr and Mrs George C. Barclay, Jr.
Mrs Lucia V. B. Batten
David T. Beals III
Mrs David T. Beals
Mr and Mrs Michael Bennahum
Mr and Mrs John E. Beweese
Mr and Mrs Menefee Blackwell
Mr and Mrs William Coleman Branton
Mr and Mrs John Brinton
The Hon. W. Randolph and Mrs Burgess
Mr and Mrs Powell Cabot
Mr and Mrs G. Guyton Carkener
Mr and Mrs John D. Coffin
Mr and Mrs J. Oliver Cunningham
Mr and Mrs George C. Dillon
Mr and Mrs R. H. Downey, Jr.
Mrs C. C. Elbel
Mr and Mrs Robert G. Evans
Mrs John Fell
Miss Irene Fisher
Mr and Mrs George Ford
Mr Richard B. Gamble
Mr and Mrs Richard L. Gelb
Mr David Gibson
Mr and Mrs Frank W. Goodhue
Mr John S. Guest
Dr and Mrs John A. Hadden, Jr.
Mr Donald J. Hall
Miss Inge Heckel
Mr and Mrs C. A. Herter, Jr.
Mr W. B. Hirons
Mr Howard J. Hook, Jr.
Mr and Mrs David L. Hopkins, Jr.
Mr and Mrs Cliff C. Jones
Mr William T. Kemper
Mr and Mrs Dudley I. C. Knott
Mr Irwin L. Levy
Mr and Mrs Angus C. Littlejohn
Mr and Mrs William M. McDonald
Mr and Mrs Milton McGreevy
Mr Samuel Mack
Mr H. S. Melcher
Mr and Mrs Thomas Mullins
Dr and Mrs Franklin D. Murphy
Mrs William G. Nightingale
Miss Katherine Ordway
Mr and Mrs Walter H. Page
Mr and Mrs Jerry A. Pearson
Mr and Mrs John A. Pell
Mr and Mrs Robert W. Phelps
Mrs L. T. Preston
Mr and Mrs Arnost Propper
Mr G. W. Pusack
Mr and Mrs George Putnam
Mrs John B. Putnam
Mrs Nancy S. Reynolds
Mr and Mrs William Reynolds
Mr and Mrs Clifford E. Ricci
Col. and Mrs D. A. Richards
Mr and Mrs Charles R. Ritcheson
Mr and Mrs Rostislav Romanoff
Mr and Mrs E. S. Rosenthal
The Right Hon. Lord and Lady Sherfield

Mr and Mrs Philip Straus
Mr and Mrs Eugene Milton Strauss
Mr and Mrs Alfred E. Tarr
Mr Stuart W. Thayer
Mr and Mrs Solomon Byron Smith
Mr and Mrs Harold W. Sorenson
Mrs Kenneth A. Spencer
Mrs Augustine Jaquelin Todd
Mr and Mrs Burton Tremaine
Mr and Mrs James M. Walton
Mr David H. White
Mr and Mrs Frank H. Woods
Miss Lucia Woods

Corporate Friends

Baker Weeks & Co. Inc.
Brown Brothers Harriman & Co.
B.S.G. International Ltd.
Chemical Bank
Drexel Burnham & Co. Inc.
Ralph A. Fields Foundation
Firestone Tyre & Rubber Co. Ltd.
Edward W. Hazen Foundation, Inc.
Loeb, Rhoades & Co.
Merriman Foundation
Northwestern National Bank of Minneapolis
Wrigley and Edna Jean Offield Foundation
G. D. Searle & Co. Ltd.
Solomon Byron Smith Charitable Fund
Sotheby Park Bernet & Company
Spear and Hill
Stowe Hardware & Supply Company
Wilmer, Cutler & Pickering

Participants

Mr Hoyt Ammidon
Mr and Mrs Andrew Anderson-Bell
Mr and Mrs Horace Andrews, Jr.
Mrs Mahlon Apgar, IV
Mr and Mrs Donald Arthur
Miss Juliet Aschan
Mrs Howard A. Austin
Mrs Frank Babbott
Mr and Mrs H. N. Baetjer
Miss Katharine Baetjer
Mr and Mrs C. D. Barton
Dr and Mrs James E. Baxter
Mr and Mrs Robert Beaumont
Mr and Mrs Thomas Benet
Mr and Mrs George Bickler
Mr Richard S. C. Biddle
Dr and Mrs Charles T. Bingham
Mr and Mrs Peter Black
Mr and Mrs Watson K. Blair
Mr and Mrs Francis Blake, Jr.
Mr and Mrs Reginald Brack
Mr and Mrs Patrick R. Brady
Mr and Mrs John C. Bragg
Mr and Mrs Alan G. Bralower
Mr and Mrs Ralph Brandt
Mrs Jasper Brinton
Miss Pamela Brinton

Mr and Mrs Carlos Brown
Mr J. Carter Brown
Mrs Peter van Brunt
Mrs James Burgett
Mrs McGeorge Bundy
Mr and Mrs Frederick H. Bunting
Mr F. A. Bush
Mrs A. D. Butler
Mr and Mrs Reed P. Byers
Mr and Mrs Robert C. Cabot
Mr and Mrs Brooks Carey
Mr and Mrs David Carter
Mrs Ernestine M. Carter, OBE
Mr F. Martin Caylor
Mr and Mrs John Chadwick
Mrs Martin Chandler
Mr and Mrs Francis Christy
Mrs Francis T. Christy
Mr and Mrs Abram Claude
Mr and Mrs Abram Claude, Jr.
Mrs Dorothy M. Cogswell
Mr and Mrs Edgar J. Cook
Mr and Mrs Philip S. Cook
Mr Robert Corcoran
Mr G. Cradock-Watson
Sir Colin and Lady Bettina Crowe
Mrs Louis D. Cullings
Dr and Mrs J. A. Curran
Mr and Mrs Lewis L. Dail
Mr and Mrs Daniel P. Davison
Dr Richard G. Day
Sir Patrick and Lady Dean
Mr and Mrs Roy H. Dickerson
Mrs De Vere Dierks
Mr and Mrs David K. Dodd
Mrs Susan Donnell
Mr J. T. Dorrance, Jr.
Sir Val Duncan
Mr and Mrs Thomas Fails
Mr and Mrs Myron S. Falk, Jr.
Mr and Mrs J. S. Fangboner
Mr and Mrs Edgar C. Felton
Mr and Mrs Ted Findeiss
Mr and Mrs Carl Flaxman
Mr and Mrs W. H. Fobes, Jr.
Mr and Mrs Silas M. Ford III
Mr and Mrs David W. Fox
Mrs Lionel Fraser, OBE
Mr Reginald Fullerton, Jr.
Mr and Mrs Ronald Furse
Mr and Mrs A. P. Gagnebin
Mr and Mrs Evan Galbraith
Mrs Neil W. Gardiner
Mrs Aileen T. Geddes
Mrs Alan P. Giles
Mrs Samuel E. Giles
Mr Julian Wood Glass, Jr.
Mr and Mrs Charles Goodhart
Mr and Mrs George L. Gordon
Lord and Lady Gore-Booth
Mr and Mrs P. G. Goulandris
Mr and Mrs George M. Grace
Mr and Mrs W. T. J. Griffin
Mr and Mrs C. H. Grine
Mr and Mrs D. L. Griswold
Mr and Mrs Christian Halby
Mr and Mrs Richard Hammerman
Mr and Mrs William E. Harris

Mr and Mrs A. D. Hart
Mrs E. Harvie-Watt
Mr and Mrs Bolling W. Haxall
Mrs Ronald Hedley-Dent
Mr and Mrs Edwin H. Herzog
Mr and Mrs Walter Hirshon
Mrs Atherton W. Hobler
Mr and Mrs Charles Hollerith
Mr and Mrs Roger Horchow
Mrs Leanne B. Hull
Mr and Mrs George Humphrey II
Mr and Mrs R. L. Ireland III
Mr and Mrs Lewis Iselin, Jr.
Mrs Henry Ittleson
Dr and Mrs Ira J. Jackson
Mrs A. W. Jagger
Mr and Mrs Peter Jefferys
The Hon. Philip C. and Mrs Jessup
Mr and Mrs Crawford Johnson III
Mr and Mrs Laurence S. Johnson
Mr Herbert V. Jones, Jr.
Mr and Mrs Jerome Karter
Mr and Mrs John J. Kennedy
Mr Nicholas L. S. Kirkbride
Mr David Klee
Mrs Rosemary L. Klein
Mrs Leonard Charles Kline
Mr and Mrs A. C. Langworthy
Mr and Mrs John W. Lapsley
Mrs D. P. Larsen
Mrs Oliver Lebus
Mrs Robert E. Lee
Mr and Mrs William Leslie
Mr and Mrs Eugene Levin
Mrs Claire J. Lewis
Mr and Mrs Roger H. Lloyd
Mr and Mrs Mharshall Long
Mr and Mrs Lee Lyon
Mr William H. McCluskey
Mrs Eleanor T. McDonald
Mr and Mrs Thomas J. McGreevy
Miss Nancy McLarty
Mrs H. P. McLaughlin
Mr and Mrs Donald L. McMorris
Mr and Mrs Henry McNulty
Mrs H. A. McWhorter
Mr and Mrs Richard N. Mahan
Mr and Mrs Henry Maringer
Mr and Mrs C. C. Marks
Mrs Elton L. Marshall
Mr and Mrs William Matteson
Mr and Mrs Cord Meyer
Dr and Mrs William C. Mixson
Mr and Mrs Pierre Montalette
Mr and Mrs Edward A. Montgomery, Jr.
Mrs I. Sewell Morris
Mr and Mrs E. Paul Mortimer
Mr Sol Mostel
Mr and Mrs Clyde Nichols, Jr.
Mrs G. Olhaver
Mr and Mrs Edward L. Palmer
Mr Henry Parish
Mr and Mrs George Parker
Mr James H. Parker III
Mr Frederick B. Paton
The Hon. and Mrs Jefferson Patterson
Mrs Michelle E. Pearce

Senator Claiborne Pell
Mr and Mrs Karel Penninck
Dr and Mrs Michael B. Phelan
Mrs Webster Plass
Mr and Mrs Walter W. Pollock, Jr.
Mrs Warwick Potter
Mr Alan N. Press
Mr and Mrs Lewis T. Preston
Dr and Mrs Andreas R. Prindl
Mr El Richards
Mr Edwin R. Ridgway, OBE
Mr and Mrs Bewster Righter
Mrs Volney Righter
Mrs Walter N. Rothschild
Mr and Mrs Robert M. Rummell
Mr and Mrs F. F. Russell
Mrs Margaret Sloan St. Aubyn
Mrs Bert J. Sanditz
Mr and Mrs Hugh Sassoon
Mrs Arthur Schmidt
Mr and Mrs G. W. Schomaker
Mr and Mrs W. J. Schroeder
Mr and Mrs George H. M. Schuler
Mr Hermann E. Senkowsky, RIBA
Mr and Mrs Norman Shachoy
Mr George L. Shinn
Mrs Rosemary Smathers
Mr and Mrs Philip Spalding
Mr and Mrs C. Burr Spencer
Mr and Mrs C. Nicholas Spofford
Mr and Mrs John Spurdle
Mr and Mrs Arthur H. Stampleman
Mrs Elizabeth Stern
Mr and Mrs C. M. Stewart
Mr and Mrs James D. Stocker
Mr John L. Street, Jr.
Mr and Mrs Edward F. Taylor
Mrs Lionel Tebbutt
Mr and Mrs Peter S. Thacher
Mr Peter Thomas
Mr and Mrs John Burton Tigrett
Mrs J. W. F. Treadwell
Mr and Mrs Alexander B. Trowbridge
Mrs Nion Tucker
Mr and Mrs R. Hugh Uhlmann
Mr Philip G. Vance
Mr and Mrs Vance Van Dine
Mr and Mrs Donald W. Vollmer
Mrs Paul Ward
Mrs June Weldon
Mrs Albert Williams
Mr and Mrs Robert Williams
Mr David Wills
Mr and Mrs Leland E. Wilson
Mr and Mrs Charles A. Winans, Jr.
Mr and Mrs Frederick Winston
Mrs Isabel Bishop Wolfe
Mrs Patricia Wolfston
Mr and Mrs Richard A. Wood
Mr and Mrs Brewer C. Woods

Corporate Participants

John Addey Associates Ltd
Arco Oil Producing, Inc.

Detroit Bank & Trust Company
Goldman Sachs International Corporation
E. F. Hutton & Co.
Johnson Wax Euro Centre
David Woods Kemper Memorial Foundation
Knott Hotels Company of London Ltd.
Lloyds Bank International
Mead Ferguson
M. J. H. Nightingale & Co. Ltd.
Shields Model Roland Co.
Texas Gulf Export Corp
TRW Europe, Inc.

This list was compiled at the time of publication, July 1976

Sacred Circles: The Indianness of North American Indian Art

The New Awareness

The day when American Indian art could be dismissed as unartistic and provincial is over. It is beginning to receive world-wide attention, after centuries of neglect and much prejudice. The artistic evaluation of this art is still in its infancy, but we are just beginning to come to grips with some of its most important aspects.

Nostalgia has recently become a self-conscious ingredient in western culture, invading our songs, our poetry, our sense of values. During the past decade, our spiritually and physically cramped lives have led us to seek catharsis in works of art that express vast continuums of space and imaginative release. In response to this anthologies of American Indian poetry and speeches have appeared,[1] and belated praise has been accorded to the eloquence of Plains and Plateau Indian chiefs, who protested against the force that was moving the people off their land. White people have learned from these speeches what it is to love the land that they themselves used selfishly with no thought for what went before, and modern Americans are less sanctimonious about cross-cultural references these days, having learned something perhaps from the terrible events of this century. Consequently, while many know that 1976 marks the two-hundredth anniversary of the signing of the American Declaration of Independence, some at least will also remember that it commemorates the Battle of the Little Bighorn (June 25, 1876) when General Custer was defeated by the combined Sioux, Arapaho and Cheyenne forces. Nevertheless, although Americans may summer in Montana or Banff they can rarely distinguish sufficiently between the tribes of that area to tell Crow from Sioux beadwork, and few are aware that some of the world's most elegantly carved ancient bone figurines come from the Columbia River basin. Florida signifies noisy hotel-lined beaches to most people, but there was a time when its tranquil ponds were punctuated by bird effigy clan pole sculptures, and silence abounded. These facts have long been known to ethnologists and archaeologists but they have been part of a hidden America for the rest of us, and people have remained largely unaware of Indian artistic accomplishment despite the Pan-Indian movement. The aim of this exhibition is to show the main achievements of native American artists across many centuries, and also many more modest objects that will lend insight into the life and industry of a fascinating people. Thus two Woodland syrup paddles are exhibited as further context for the historic wampum belt from Toronto celebrating the treaty with William Penn. While no exhibition can be definitive, this one is at least encyclopaedic, affording broad bases for cross-cultural artistic comparisons, just at that moment when North American Indian art joins the mainstream of art history.

One of the clichés about American Indian art we hope to dispel is that 'It is alright as a beginning, then you go on to better things.' This view stemmed from most people's youthful enjoyment of 'Cowboys and Indians' and the association of Indians with scalps and raiding. The practice of human sacrifice has not tainted our study of Benin and Aztec art and should not be allowed to interfere with our study of Indian civilization. To see only what is scary in the sumptuous and glowering forms of Kwakiutl masks, while not perceiving what is remarkable and mystical in these same forms, is to avoid coming to grips with the symbolic presence of Indian art.

Americans and Canadians, having turned their eyes from Europe and Africa to look inward at their own continent, are finding that the art of the Indian world, for so long geographically co-existent with their own, is of universal quality when at its best. Perhaps we are still a little shocked at having to admit what fine sculptors, designers, and craftsmen native American artists were and are. It is one thing to accept Indian culture as anthropology and quite another to apply to it the standards of aesthetic appreciation reserved, let us say, for a Renaissance bronze or a Han tomb sculpture. Yet does not the unique Sioux wooden horse effigy (390), full of blood, thunder and springy abandon, bear comparison with the Kansu horse? That this art should at last be properly regarded for the sake of a better understanding among peoples has been the overriding purpose of this exhibition.

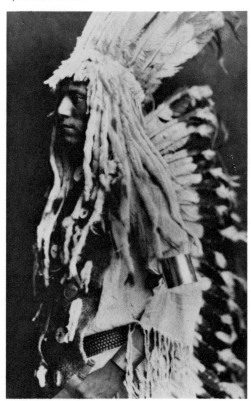

Old person – Piegan
by Edward Curtis

The Indian relic market of yesterday has become a sophisticated art market today. We admire collectors like J. O. Dyer at Fort Reno, Morley Reed Gotschall of Philadelphia, Grace Nicholson of Los Angeles, Harry Beasley of London, James Hopper of Dorset and William E. Clafflin of Boston who preserved many treasures which might otherwise have disappeared from the record. However these treasures have become high priced 'art objects' and one can no longer acquire for a few dollars a superb Ojibway love flute (466) from a curio dealer like Willis Tilton in Topeka, Kansas. Finds are still made, nevertheless, and fine 18th-century and early 19th-century quilled Woodland boxes still turn up in the north of England and Scotland, originally brought over by soldiers who served in Canada several generations ago. And in New Mexico last summer the most important painted bird effigy board ever found in the Southwest was discovered in a cave. In the last years all of these objects, once considered homespun and of only marginal local interest, have begun to be collected as avidly as any other art. While this is sad for the old-style Indian buff, it signifies the advancement of American Indian art to the status it deserves, expressing as it does the totality of a civilization, many faceted, complex and of lengthy duration.

Indianness

An appreciation of North American Indian art involves understanding the connection between overlapping concepts which cannot be rigidly defined. The Indian approach to nature and its relationship to man, to myth, to time and space, and finally to the idea of an unseen 'presence' are all necessary components of the study of the native Americans. This introduction is an attempt to define Indianness.

Much of the meaning of Indian art has been buried with the owners. The decorations on Plains shields were a personal protective vision efficacious for one person only. Secret society regalia had restricted applications difficult to communicate by means of form alone, while other quintessential aspects are not for us to learn and are held in trust as ritual secrets. On the Prairie Potawatomi reservation in Kansas, a scant two hours from Kansas City, there lives an elderly medicine man I know, who is probably even as I write pouring over his prescription sticks (162) and opening his herbal bundles, preserving knowledge handed down by his forebears. What he knows we cannot know. It is this lack of communication with outsiders that has allowed the native American to preserve his identity and to keep possession (as much as he can) of what he holds dear. He presides over the Mysteries. Rituals take place in the underground kivas of the Southwestern pueblos, where they cannot be exploited by commerce. Silence is encouraged and no questions are asked by observers at the winter animal dances at Cochiti and Santo Domingo. Restraint is the glue that holds ritual and societies together, and the deep azure and white fields of Indian beadwork design reflect this calm. Serenity and composure are often characteristic of even the most colourful artworks, such as a ribbon appliqué blanket from the Osage of Oklahoma which is, after all, primarily human shelter; the gay and beautiful appliqué of matched triangle motifs is confined to the edges (123). The vibrant pattern of an 'eye dazzler' the most colourful of Navajo wearing blankets (623) is half concealed by the wearer, rarely fully displayed. There is sobriety behind the soft laughter, and quietude even behind the antics of a kachina clown.

The underlying logic is different from ours and the technology is of another order, so that we hanker after the aesthetic form and content of native American art – the harmony – without knowing how to achieve it. Indian art treasures have been on view in the trays of the British Museum, at the Linden Museum in Stuttgart, Chartres Cathedral, the recesses of the Smithsonian Institution, and even in an abbey in Missouri, but until now they have been largely disregarded, our interest in nature not awakened enough to overcome our commercial spirits or our innate feeling of superiority. We were blind, the Indian on the other hand assimilated and used to good effect what we could teach him, using to the advantage of his art what he liked of our civilization, carrying on in the shadow of our dominant culture. He has long used European trade materials and adapted European fashions, often making of them something far removed from the original intention. Osage incorporation of an officer's dragoon coat into the wedding ceremony is an apt illustration in point (121) and the earliest known pouch to have been collected in the Massachusetts Bay Colony, not long after its founding, shows ingenious early use of trade materials, subtly suggesting a beaver, though every inch a pouch. It is the Indian artist, producing right

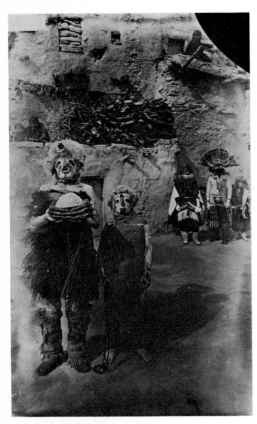

Hopi kachinas of the Powamu or 'Bean-planting' ceremony 1893
Smithsonian Institution

through the environmental changes wrought by the Industrial Revolution, who can now be seen to have had the last laugh, conveyed in cascades of beautiful quillwork patterns, sewn to the shoulders of a magnificently painted Cree frock-cut coat (109), or even in an American flag, bead-embroidered on a treaty carrying case. His genius altered wisely but never diminished.

American Indian art celebrates the continuity of a land mass and man's absorption of its features in a way that few European art forms do. A European handbag, although it may have a floral design, does not express the forest like an Indian pouch or shoulder bag does. Indian art expresses something quite different: as an amateur ornithologist I was once aghast at the ceremonial use of wrapped bird skins, lovingly decorated with coloured wool or beads, grasses, glass and rock, and even scalps in medicine bundles, but I feel very differently now. By subtly altering, decorating, formalising and packaging these materials the perception of the quality and role of plant or animal life as man's spiritual accompaniment is enhanced. Compare that to putting feathers in a lady's hat; one is meditative formalism, the other just decoration. Indian art evokes a living treasure: nature. Its aesthetic draws us close to the earth. The Indian use of natural fibres, tendons, quills, furry parts and hides is highly aesthetic. These materials are expertly manipulated, selected, tanned, softened, or even toughened. A falcon enfolded in brightly printed cloth becomes a source of mystic power (164). A bear claw necklace takes years to construct in a systematic, graded design (479); it is not at all the casual accumulation that might be supposed. The expression of the mythic power of an animal and the actual use of parts of that animal (i.e. bear fur, a turtle carapace) go hand in hand.

Painted house. Thunderbird lifting a whale. Alaska
Smithsonian Institution

The Indian artist refers continually to the springs from which his art first emerged, he never turns from that source. His art expresses for those who lack belief in myths something of the quality of myth. Clothing, for example, is full of exalted feeling. Dress seems inevitably to become regalia. Indian artists equate design and nature in a quite particular way, especially in those areas to which Indian awareness is almost exclusively addressed: to the land, mythology based on natural causes, and the spatiality of the continent itself. They address the bird and animal spirits that roamed as they did, often on equal terms, so that the depiction of a seal with progeny by a 19th-century Eskimo becomes so intimate as to be wholly disarming (220). By totally abstract means a Plains bow, arrow and case ensemble is invested with the glory of animal flight; dangled by the hand it seems about to run like an animal, it returns art to nature. In view of this oneness with his environment it is hardly surprising that the Indian finds the romantic European attitude to nature quite alien, witness this statement by Luther Standing Bear: 'We did not think of the great open plains, the beautiful rolling hills, and winding streams with tangled growth as "wild". Only to the white man was nature a "wilderness" and only to him was the land "infested" with "wild" animals and "savage" people. To us it was tame. Earth was bountiful and we were surrounded with the blessings of the Great Mystery. Not until the hairy man from the east came and with brutal frenzy heaped injustices upon us and the families that we loved was it "wild" for us. When the very animals of the forest began fleeing from his approach, then it was that for us the "Wild West" began'.[2] Luther Standing Bear describes a real harmony with the universe which is apparent in the art, and which meant that the Indian did not destroy, he propitiated. He did not disturb the natural order. We recognize his interaction now as a precious thing: the animal effigy pipes (494) become intercessors between man, animal, the four quarters of the earth and the cosmos. The expressive quilled and beaded patterns tell of the authority of sky and land, light and water, greenery, and man's sympathy with these phenomena.

The Indian lives within his land, not on it. Therefore his works occupy space in harmony with the land, and the scale is human, usually restricted to what can be held in a hand, put on a man or set on a saddle, although occasionally it might at most rival a tree in scale (necessarily so in the case of something like a totem pole). There are exceptions to this; the Chief Shakes screen and the carved sisiut (247) in this exhibition are examples of Northwest Coast gigantism (245), but on the whole the Indian felt no need to reach beyond what could easily be encompassed, feeling perhaps that the larger scale is better left to visions and dreams, better implied by nature than by man. A whole thunderstorm might be reduced by the artist to the surface of a small Pawnee drum, where a thunderbird symbol with lightening streaks projecting from enveloping wings scatters swallows into the ominous rush of the wind, like so many tossed leaves. A back ornament when embellished with

quilled thunderbird images is sufficient to suggest flight into the cosmos (117). On Midewiwin scrolls centres of prayer and ritual are represented by extremely small circles (160). A world of beavers, otters and muskrats can be compacted into a tiny Micmac pipe (165). It is marvellous the way slender porcupine quills can be manipulated through design and chevron-like changes in direction to sumptuously cover an entire chair back and bottom (105). Basket-makers, except when they made large storage vessels or the occasional hamper, tended to miniaturise when asked to demonstrate their skill. The Pomo Indians feathered tiny ones to balance on fingertips (595). Function and religious pantheism infuse these pieces not with physical illusion or perspective but ultimate simplicity: the plain force of a traditionally accepted idea, the distillation of mystic origins into design. A warrior with shield in mediaeval southwestern New Mexico is transferred into a modest programme of vivid black outlines in an ordinary white slipped clay pot with extraordinary, succinct, and pleasing effect (524). All these patterns form a paean, even in confined exhibition quarters and in proximities never intended, to the sun, the morning star, the cardinal directions, and the expanse of sky over land. We are connected to these vast regions by, for example, the rainbow or cloud terraces painted on a Southwestern pot, or the mesa and cloud terraces woven into a Navajo serape-style blanket. An unassuming peyote kit becomes a microcosm of prayer, song, and deep contemplation far beyond the confines of its box container (485). In Indian hands simplicity often suggests outward reach.

Many of the objects in this exhibition are visionary: men in Ohio looked upon the silvery translucence of the enigmatic mica serpent from the Turner Mound (10) two thousand years ago, as pipes were smoked and the spirits of the serpents, hawks, vultures and pumas (7) rose into the ether; a delicate and precious feathered and shell-decorated Pomo gift basket (593) once glinted in the sun in central California, witness to a birth or marriage before San Francisco was ever settled. Captain Cook's pathfinding voyage to the Northwest Coast in 1776–80 is brought alive by a mask left by natives on the deck of his ship at Nootka Sound (271); only quite recently a Mistassini Cree leaned his toboggan (154), decorated with a north wind symbol, against the north corner of his lodge, to placate that wind. The romance inherent in contemplating American Indian culture, however, should not blind us to unpleasant facts. Indian hands are bloodstained too; they knew hatred and had no mercy in raids or war. Women often handled the torturing of captives. The Mandan shirt from the Chandler–Pohrt collection has pipes drawn on its surfaces representing the owner's leadership in raids (pipes were symbols of leadership) and the figure designs were very probably his victims (408). Militarism was a total way of life to a Plainsman, and cannibalism may have been more rife in prehistoric and early contact times than is sometimes realized. The *Jesuit Relations* and other French chronicles contain comments on the practice that leave little to the imagination, although the writers may well have been misinformed or biased.[3] Despite this no one can deny the strength of Indian culture and art or his mystical sense of union with nature.

If the relationship of one thing to another in terms of exact proportional measurement is unclear in Indian art (except in recent years when purely artistic considerations have become paramount), the Indian traditional assertion of attunement with his creator and his environment – one interdependent upon the other – is met with at every turn. It is asserted by what, for lack of a more specific term, we may call 'presence'. It is a term not unlike the Indian word for power, 'medicine'. Here it becomes an artistic counterpart. The presence of Indian art is contained in its ability to project psychic intent or idea through design impact. That process replaces scale. Indians for example knew much about strongly optical design devices and symbolic equivalents without the settlers' teachings. We continue to be astounded by the looming presence of a grand Tlingit heraldic design that grows like a visual organism before our eyes. Even a randomly spaced parade of mounted warriors with flying lances across a muslin field (484) conveys tremendous energy and presence, despite the casual composition. The smallest design upon a bracelet, earring, or moccasin does not lack its specific impact. The miniature 'target' quilled on a pouch possesses the same dynamism as the larger one on a shirt (414).

Most American Indian tongues had no word for art as an independent concept. The Northwest Coast carver was absorbed by his adzing the way a woodsman is absorbed in felling a tree; the basket-maker turned to her twining as an extension of fibre gathering. This does not mean these actions were simple, the steps involved in canoe building were a

The warrior and his bride 1871
Smithsonian Institution

complicated extension of many processes. Nothing artificial interfered with the means and the ends, which is why the art seems so fresh in its impact today, admirable in its directness. One cannot separate native American clothing from either wearing, sewing, ceremony, or medicine power. 'Presence' involves not only the marks that strike us as symbolic, but also the arrangement of patterns into signs that demonstrate a high level of unconscious affinity with nature; for example the sparkling aspects of water, leaves, wild flowers and sky as distilled into the beadwork of a Great Lakes bandoleer bag (136). Tight and varied as the bag designs are, an even greater concentration of patterns projects from the endless coils of Californian basketry, from the swelling ornamentation of a Datsolalee basket (585), from the elliptical point-counter-point of the Mono lidded basket (590), or the archaic and strongly emphatic Tulare basket from a Copenhagen collection (583). With remarkable succinctness these surface patterns were deployed around the containers, looking outward from roundness like the sun.

Symbolizing the relationship between man, myth, and natural phenomena involved staging and pantomime. An extraordinary manifestation of this, a sort of symbiosis of that relationship, is seen in the transformation masks of the Northwest Coast (263). The human aspect subsumed the animal by the pulling of a string, as the inner mask was revealed. In the Indian universe it was often easy to slip from the human into the animal guise and then return, for humans to impersonate the buffalo or the deer, and to become closer to animal spirits by wearing their hides, or thrusting them forward as a decorative standard as in the Hupa deer dance of northern California. In line with the interdependence of design, fabrication and the need for drama are the sympathetic magical associations of charms and fetishes and shamans' dolls. Magic and the occult was not extraordinary but ordinary to many Indians. The shaman was there, and his art helped to make the visions and guardian spirits visible, dredging them up from beyond sight into consciousness for protective or expiatory purposes. Presence made art a fulcrum between what exists and what might be imagined to exist.

Shifting psychic associations led to corresponding interweavings of association and content in design, until in the process the exact meaning became lost. There was great importance attached to the expression of the relativity of phenomena and how each one acted upon the other. The buffalo – meat, fertility symbol, hunting symbol – could also relate to the

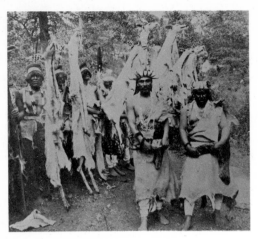

White deerskin dance, Hupa
Smithsonian Institution

sun. The embodiment of these supernatural associations – at the highest and most reverent point of Indian perception, and therefore very difficult for us to understand – is a class of objects of which the puma and Hupa deer skins are two examples. In a way the endowment of natural objects with metaphysical power is not unlike the transformation of 'found' objects when placed in a specific cultural context such as the art gallery.

The significance of the sacred circles

The sacred circles scattered throughout the exhibition can be studied from the point of view that with them, as with other motifs, symbol and emanation equal presence.
To the Indian soul the medicine wheel or the circle, the sun and stars alike, had varied simultaneous associations. Colour was direction, it was time of day, and it evoked a quarter of the earth. A newborn Isleta baby was offered to the four directions and to the fifth, above, middle, and below, as well.[4] For us the word presence, existing beyond form, used here, emits such multiple associations. That is the Indian way. Seen this way the objects, masks, pottery ceremonial gear, and implements become exponential. The circle often stood for unity in the Indian view, a symbol of tribal unity and a link with the universe. Let it here stand for the psychic awareness underlining the art – its life's blood at one point or another. Only by such acknowledgement are those designs, fabrications of skin and vegetal matter, and carvings no longer static but moving and alive, releasing healing powers once more, as do the miniature set of Eskimo carved figures right before our eyes (223).

The title used here – Sacred Circles – is admittedly a drastic compression of form into content. How can one unify the concepts behind the diverse cultures of a people that spoke six hundred and fifty dialects, with ecologies as varying as the tundra and the southern forests? Before one honours the influence of powerful animal spirits – the eagle and thunderbird, the underwater panther, the serpent, puma, otter, beaver, hawk and deer – the idea of the cosmos interposes, first in the form of the sacred disc, the sun or moon, and then as the four cardinal points (the sacred number four is important to many Indian rituals) which measure 360 degrees, or all of space.

Circles are important in Indian thought and art alike. Many of the objects exhibited here might be seen as coming within the scan of a psychic medicine wheel. In a recent book Hyemeyohsts Storm says 'In many ways this circle, the Medicine Wheel, can best be understood if you think of it as a mirror in which everything is reflected. "The Universe is the Mirror of the People", the old teachers tell us (the teachers being Cheyenne ancestors), "and each person is a mirror to every other person". Any ideal, person or object, can be a Medicine Wheel, a Mirror for Man. The tiniest flower can be such a Mirror, as can a wolf, a story, a touch, a religion, or a mountain top.'[5] According to Plains teaching such wheels were constructed from stones or pebbles which formed a crude wheel and spokes upon the ground. A huge circle of stones does exist today almost three thousand metres above sea level in the Bighorn Mountains of Wyoming. (Figure 1). Internal evidence suggests that it was perhaps built about 1760 and was used to sight the summer solstice.[6] Contemplating this fragile relic one senses the original orientation of Indians to the horizontal disc of earth which sloped to the horizon, and toward the vertical disc which dominated space by light. In that locale the concept of a sacred circle seems eminently plausible.

Circles were associated from an early time with 'medicine', the Indian concept of magic or supernatural power, both good and bad. There are sun circle rock carvings, a large number prehistoric, found in many areas, among them the Southwest, and one from near Albuquerque with a wind cross is illustrated here; it foreshadows the idea behind the great stone wheel in Wyoming (Figure 2). There is an Anasazi mediaeval clay pot in the exhibition which comes from a site near Snowflake, Arizona and has a star in circle design (Figure 3). It hints at how the concept might have been transmitted northwards. The four colours of the day on present-day Navajo sun house altars should be read cyclically although they are painted on a flat reed screen, as they have to do with rotation – again the four cardinal directions. The round kivas of the Southwest come to mind although sometimes they are square. Our catalogue continues with Crow medicine rings, hide-covered hoops taken into battle, and the round buffalo altars made of stones set on the ground like medicine wheels, with a buffalo skull at the centre. Plains medicine painted

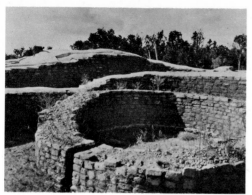

Mesa Verde kiva
British Museum

shields were indeed sacred circles, with sharp pointed symbols for sun, stars, and the four winds whirling forever upon the round hide cover (Figure 4). Such shields were made into the 20th century. In Mississippian times, shortly before the contact period begins, slate palettes were beautifully incised with sun circle designs. Sometimes a cross was substituted for the sun-wind symbol. A sun circle was prominently incised on the forehead of a clay trophy head pot from Arkansas, in the exhibition, with lines emanating from it in the four directions representing the wind (31). A very subtle version of this motif is the soft buckskin Cheyenne pipe bag (502b). It reveals a circle at the top when held outstretched, with four hanging flaps to symbolize the directions.

The round medicine lodges of the Arikara on the upper Missouri River were oriented strongly to the four cardinal points (Figure 5); the lodges were designed to imitate the universe. 'In the Arikaran concept of the universe each of the semi-cardinal quarters of the horizon is consecrated to one of the four elements, four guardians under God. Thus the southeast corner (of the lodge) is consecrated to the sunrise, the southwest corner to the thunder, which implies water, necessary element of all fire. The northwest quadrant is consecrated to the wind and movement of air, and the northeast is consecrated to night. In addition, each of the four quarters had a secondary significance, and in this second grouping of power or elements the southwest quarter is dedicated to the guardian spirit of the genius of the bison.'[7] The sundance lodges of the Plains Indians were similarly round, though more open to the weather (Figure 6). Even the flat leather cut-out images of buffalo, elk, and phallic warriors tied to the pole in the middle of the sundance lodge were multi-directional in function (463). And the origin of the quilled and beaded 'target' designs that appear so prominently on Indian buckskin shirts is clear (419), even though their impact was largely decorative. The wearer became the personification of the ancient sacred circle, which came from the spirits.

The Indian thought of measurement in terms of space, denoted by the sun's path, the rainbow, or his own position and the journey he must take. Writing in the 1870s, Colonel Richard I. Dodge, who observed more fairly than many an observer of Indians in his day, noticed: 'The Indians measure time solely by days, by sleeps, by moons, and by winters. There is no name for any subdivisions of time less than a day. When it is desired to indicate any shorter period, he points to the heavens, and measuring off a space, says "it was as long as it would take the sun to go from there to there." . . . There is no name for any day among the wild Indians, though those about agencies call Sunday "the day when the white man does not work." There is no subdivision of time according to our week.'[8] Indian time was continuity and measure did not interrupt it. The world view, was basically circular, not linear. Only the Dakota and Kiowa produced calenders; these records were spatially and pictographically related to events and were often conceived as a continuous spiral. Minutes and seconds have nothing to do with these counts. Both spirit and duration were spatial, which is another reason why Indian art has little sense of scale in the western understanding of the term – size but no scale. Indian art has reacted to change (and still does), but does not itself cause change, due to the different view of time. Innovation is not due to the conscious actions of an 'avant-garde' and radicalism is often on the side of tradition – Indianness.

Despite trade routes which covered many miles and the resultant cross-cultural influences of very dispersed tribes, cultural progress seems to have been very uneven. The art demonstrates that different time clocks co-existed. Take for example the slow permeation into the Louisiana area (Marksville focus) of the type of platform effigy pipe first made in Ohio many centuries before (30). This kind of thing complicates our notion of what really went on in the continent. 'Western European people have never learned to consider the nature of the world discerned from a spatial point of view. In seeking the religious reality behind American Indian tribal existence, Americans are in fact attempting to come to grips with the land that produced the Indian tribal cultures and their vision of community.'[9]

There is a tremendous sense of continuity in the numerous objects in this exhibition, in spite of changes in culture, brought on by European proximity, the introduction of new materials and even the alteration of technologies. It is partly because their scale is psychic, not material, so they relate to one another under the encompassing umbrella of the sacred circle. The raven of the Northwest Coast and the far away Great Lakes thunderbird both

wheel within that circle. That this circle still turns in the face of the Western take-over of Indian land – which they hold precious above all else – is an almost miraculous testimonial to the tenacity of the beliefs of the Indian. Only where that core of belief is preserved does American Indian art exist in a state of health today.

Notes
(for the full references see the bibliography)

1 Two recommended anthologies listed in the bibliography are: *Great Documents in American Indian History* edited by Wayne Moquin and Charles Van Doren and *The Sky Clears, Poetry of the American Indian* by A. Grove Day.

2 Chief Luther Standing Bear, *Land of the Spotted Eagle*, page xix.

3 George E. Hyde, page 83.

4 *Isleta Paintings, with Introduction and Commentary by Elsie Clews Parsons*, Esther S. Goldfrank, editor. Smithsonian Institution, Washington, D.C., 1962, number 5, page 22. These remarkable and sensitive watercolour drawings of Isleta life and customs were submitted anonymously to the Smithsonian Institution as a record of the pueblo's culture.

5 Hyemeyohsts Storm, page 5. This book, which makes a contemporary statement about Cheyenne religion through the interpretation of traditional symbols, has been protested to by Indians. Several Cheyenne wrote a condemnatory letter to the trade newspaper, *The Indian Trader*. It is stoutly defended by Vine Deloria, Jr. Its presentation of religious values is cyclical rather than chronological, like the medicine wheel it describes.

6 John A. Eddy, pages 1035–1043.

7 James Howard, 'The Arikara Buffalo Society Medicine Bundle', *Plains Anthropologist, Journal of the Plains Conference*, Vol. 19, No. 66, 1962, part I, page 245.

8 Colonel Richard Irving Dodge, pages 396–397.

9 Vine Deloria, Jr., page 76.

Figures

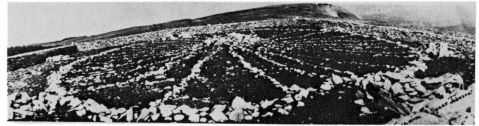

1 Medicine wheel, Medicine Mountain, Wyoming

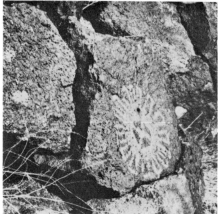

2 Sun symbol pictograph

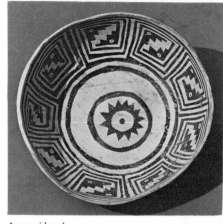

3 Anasazi bowl

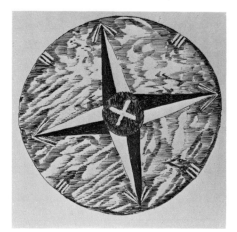

4 Plains hand drum

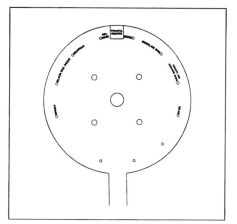

5 Arikara Medicine lodge

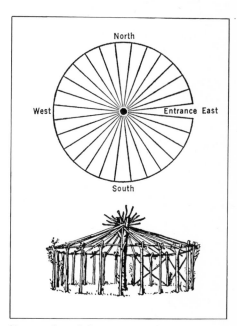

6 Sioux sundance lodge

Glossary

This glossary does not include Indian words which have entered everyday use and are generally understood, such as moccasin, teepee, tomahawk, papoose, etc. For a general discussion of the American Indian contribution to European vocabulary see *The Indian Heritage of America* by Alvin M. Josephy Jr. London, Jonathan Cape 1972 and Penguin 1975. The technical terms defined below have a particular meaning in Indian studies.

argillite	Sometimes referred to as 'slate carving'. It is mined on Queen Charlotte's Island, is soft when worked and hardens through exposure to air.
babiche	Caribou rawhide lines used for webbing snowshoes and toboggans.
bandoleer bag	A shoulder bag.
bayeta	A reddish Spanish trade cloth which was unravelled, redyed and woven into blankets.
bannerstones	Spear-thrower weights of highly abstract form in polished stone.
birdstones	Spear-thrower weights in the form of Woodlands birds.
blanket strip	A decorative woven strip usually sewn on to a robe or blanket.
burden strap	Also called 'prisoner ties', lines used for transporting heavy objects.
calumet	Highly prized ceremonial war pipe, usually carved stone bowl, with eagle feathers, beadwork, horsehair attached.
catlinite	Slate, mined at Pipestone, Minnesota, named after the famous painter of Indians, George Catlin, who first discovered the mineral. Its soft pliability made it ideal for carving pipes.
copper	Currency of the highest value, indication of tribal or individual wealth, often the supreme gift at potlatch ceremonies. Coppers were always made of that metal, incised and painted with totemic designs.
coup stick	Carried by a mounted warrior as his weapon, to touch an animal or enemy and return unharmed.
crupper	Decorative horse trapping which attached to the saddle and passed under the horse to keep the saddle in place.
frontlet	The central element in a shaman's dance headdress, worn on the forehead.
ghost dance	Religious dance considered a rite of invocation which brought the dancer into communication with the spirits of departed friends. Said to have been founded by a Paiute Messiah, Wovoka, in 1890. It spread quickly among the Sioux and was suppressed by the United States Army.
gorget	Rectangular or circular tablet, often of shell, with perforations for wearing around the neck.
headstall	Decorative piece attached to the horse's bridle.
Hocker design	A re-occurring design motif, often of a central figure with arms and legs outstretched, which is found in the art of early China, Polynesia, Melanesia, and in the Americas, especially in Peru and on the Northwest Coast. It is a major point of reference for belief in the trans-Pacific migration theory.
hogan	A ceremonial mens' house, usually of log construction.
kachina	A miniature representation, or doll, of one of the 350 supernatural beings who control the religious and social life of the pueblo, made for tribal ceremonies. In modern times, made for ceremonies and then given to tribal children, sometimes carved as tourist pieces.
kiva	A subterranian ceremonial lodge.
labret	Shell, bone or stone, etc., inserted through the lip as decoration, usually by women among the American Indians.
mesquite	A spiny, deep-rooted tree or shrub of the southwestern United States and Mexico, bearing bean-like pods rich in sugar.
parfleche	A storage bag, mostly of rectangular shape, used to hold either ceremonial gear, clothing or in some cases meat. Sometimes referred to as 'meat cases'.
pony beads	Also known as 'trade beads'. Pony beads were made of glass and were introduced by traders in the early 19th century. Originally white, black and sombre shades, but later a vast variety of colours. Glass and smaller 'seed' beads gradually replaced quillwork among the Indians for decoration.
potlatch	An important Northwest Coast tribal ceremony or festival, with dancing, feasting and gift exchanging rituals.

prehistoric	In terms of American Indian archaeology, refers to the period in Indian history which occurred before the written record, usually taken as before 1492. Also called pre-Columbian or pre-contact.
pueblo	One of the Indian villages of Arizona, New Mexico and adjacent regions built of stone or adobe in the form of communal houses.
quillwork	Ancient sewing technique, dating from the 14th century, which employed dyed porcupine quills or moosehair, or more rarely birdquills. The process of making the quills workable was painstaking; they were first sorted, washed, dyed, then softened, usually in the mouth, then flattened, again by mouth. The sewing was carried out primarily on the outside of the hide garment, and a variety of 'stitching' decorations developed.
quirt	A braided cord or whip.
ribbonwork	Cut-out designs in silk, applied to garments as decoration. Also referred to as 'silk appliqué' or 'ribbon appliqué'.
roach	The featherwork part of a ceremonial headdress, called a roach headdress. A 'roach spreader', usually made of antler, held the feather erect, sometimes through a socket. Roach spreaders were highly prized and delicately carved.
shaman	The spiritual leader of a tribe. In North American Indian society the shaman was the keeper of tribal lore and rituals, the evoker of visions, the arbitrator of social customs. In rare cases the shaman was also chief of the tribe. He had knowledge of rituals which were passed on to the next generation along with the ceremonial gear and clothing.
sisiutl	A mythical two-headed serpent. The motif occurs in ancient Chinese art as well as in Polynesia.
slave-killer	A weapon which may have had ceremonial usage in killing slaves at potlatch ceremonies.
soul-catcher	Used by a shaman in curing ceremonies. The soul of the patient was captured in the soul-catcher until it could be returned to the body.
spindle whorls	Used for spinning goat-wool and dog-hair for weaving blankets.
stroud	A coarse blanket or garment formerly used in trading with some North American Indians.
thunderbird	A mythological bird supposed to cause thunder and lightning.
umiak	Eskimo boat worked by women.
wampum	Made only of purple or white clamshell beads. Wampum served primarily as a symbol of friendship and goodwill among the Iroquois tribes and their allies. It was exchanged at ceremonies or at treaty-signing councils. It was also used as money for trade with the Dutch and English, but the famous belts were symbolic of the pledged word of a tribe and were extremely rare. Only a few examples have survived.

The glossary and time chart were compiled by Judith Nash.
The maps were designed by Judith Nash, Michael Johnson and Sinc Ltd.

Time Chart of North American Indian History

Region			Culture	Timeline
Northwest Coast		(?) 500-1750 AD	Northwest Coast Tribes	
Eskimo		(?) 450 BC-100 AD	Okvik	●●●●●●●●●●●●●●●●●●
		100 BC-250 AD	Old Bering Sea	●●●
		100-500 AD	Dorset	
		400-750 AD	Ipiutak	
	500-1050 AD	1050-1450 AD	Early Punuk/Punuk II	
		1200-1700 AD	Thule	
		1450-1900 AD	Inugsuk	
	(?) 1400-1976 AD		Aleut	
		1900-1976 AD	Contemporary Eskimo	
Woodlands	2000-400 BC	400 BC-100 AD	Early Archaic/Late Archaic	●●●●●●●●●●●●● ●●●●●●●●●●●
		750 BC-250 AD	Old Copper	●●●●●●●●●●●●●●●●
		100 BC-350 AD	Adena	●●●●
		500-800 AD	Marksville	
		350-1000 AD	Hopewell	
	Mound Cultures	1400-1700 AD	Temple Mound II	
		900-1400 AD	Temple Mound I	
		400-990 AD	Burial Mound II	
		100-400 AD	Burial Mound I	
	1000-1300 AD	1300-1750 AD	Early/Middle Mississippi	
		1300-1750 AD	Key Marco	
		1600-1900 AD	Historic	
		1850-1976 AD	Reservation Period	
Plains		1000-1650 AD	Semi-sedentary	
		1650-1870 AD	Expansion Period	
		1870-1975 AD	Reservation Period	
Southwest		2000-100 BC	Cochise	●●●●●●●●●●●●●●●●●●
	450 BC-450 AD	450-700 AD	Basketmaker I & II/III	●●●●●●●●●●
		100 BC-1700 AD	Hohokam	●●●
		800-1750 AD	Pueblo	
		700-1750 AD	Anasazi	
		1080-1450 AD	Mimbres	
		1050-1550 AD	Tularosa	
		1500-1800 AD	Casa Grande	
		1550-1650 AD	Four-mile Polychrome	
		1650-1750 AD	Sikyatki	
		1850-1976 AD	Papapo, Pima	
		1500-1900 AD	Chumash	
		1850-1976 AD	Reservation Period	

North American Indian Historic Tribal Locations

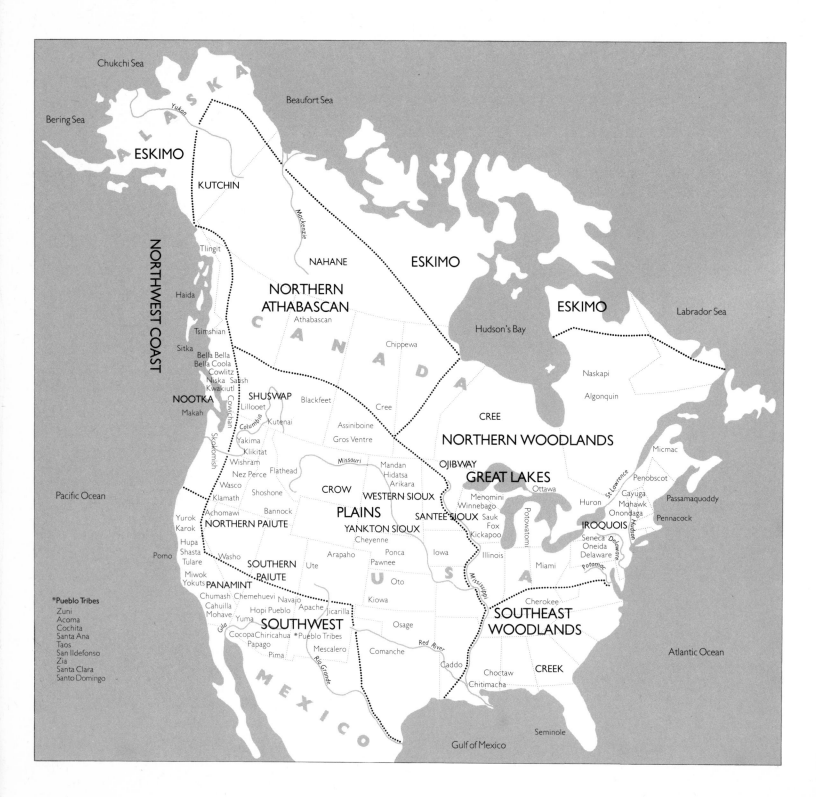

Chukchi Sea

Bering Sea

Beaufort Sea

ALASKA

Yukon

ESKIMO

KUTCHIN

NORTHWEST COAST

Tlingit

NAHANE

ESKIMO

Mackenzie

Haida

NORTHERN ATHABASCAN

Athabascan

CANADA

ESKIMO

Labrador Sea

Hudson's Bay

Tsimshian

Chippewa

Sitka

Bella Bella
Bella Coola
Cowlitz
Niska Salish
Kwakiutl

SHUSWAP

Blackfeet

Cree

NOOTKA

Lillooet

Makah

Columbia

Kutenai

Cowichan

Skokomish

Yakima

Klikitat

Wishram

Nez Perce

Flathead

Assiniboine

Gros Ventre

Missouri

Mandan
Hidatsa
Arikara

Naskapi

Algonquin

CREE

NORTHERN WOODLANDS

Micmac

OJIBWAY

GREAT LAKES

Ottawa

St. Lawrence

Penobscot

Huron

Cayuga
Mohawk
Onondaga

Passamaquoddy

Pennacock

Pacific Ocean

Wasco

Shoshone

CROW

WESTERN SIOUX

Menomini
Winnebago

Klamath

Bannock

PLAINS

SANTEE SIOUX

Sauk
Fox
Kickapoo

Potowatomi

IROQUOIS

Hudson

Achomawi

Yurok
Karok

NORTHERN PAIUTE

YANKTON SIOUX

Cheyenne

Iowa

Illinois

Seneca
Oneida
Delaware

Delaware

Hupa
Shasta
Tulare

Washo

Ute

Arapaho

Ponca
Pawnee

Miami

Potomac

Pomo

Miwok
Yokuts

SOUTHERN PAIUTE

PANAMINT

Oto

USA

Kiowa

*Pueblo Tribes
Zuni
Acoma
Cochita
Santa Ana
Taos
San Ildefonso
Zia
Santa Clara
Santo Domingo

Chumash

Chemehuevi

Cahuilla
Mohave

Hopi Pueblo

Navajo

Apache

Jicarilla

Cherokee

SOUTHEAST WOODLANDS

Yuma

Gila

SOUTHWEST

*Pueblo Tribes

Osage

Cocopa Chiricahua

Papago

Mescalero

Comanche

Red River

Atlantic Ocean

Pima

Rio Grande

Caddo

Choctaw
Chitimacha

CREEK

MEXICO

Seminole

Gulf of Mexico

North American Indian
Twentieth Century Tribal Locations

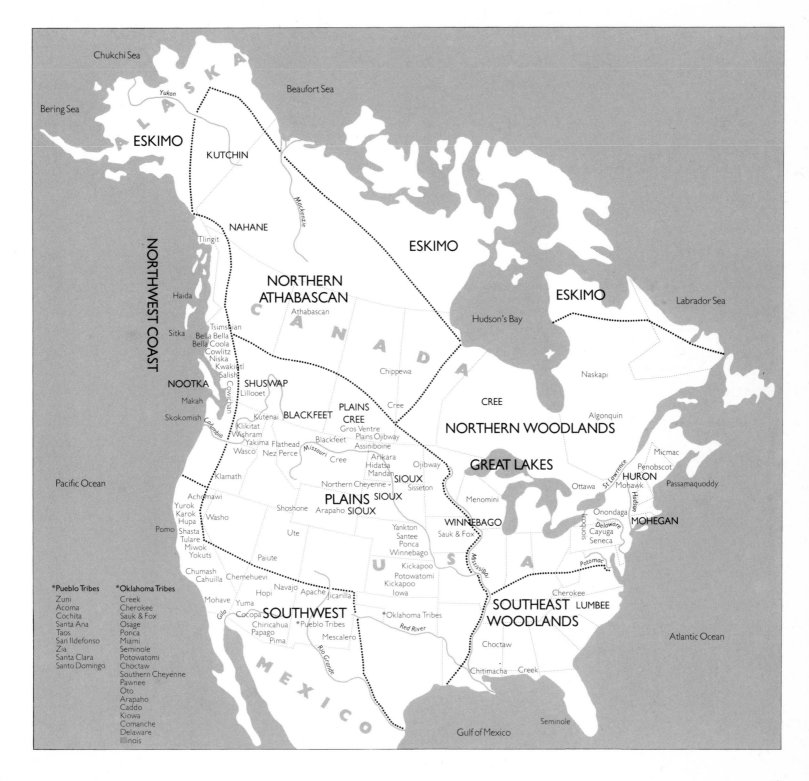

Early Archaeological Sites of the Southwest

Principal Tribes of the Northern Northwest Coast

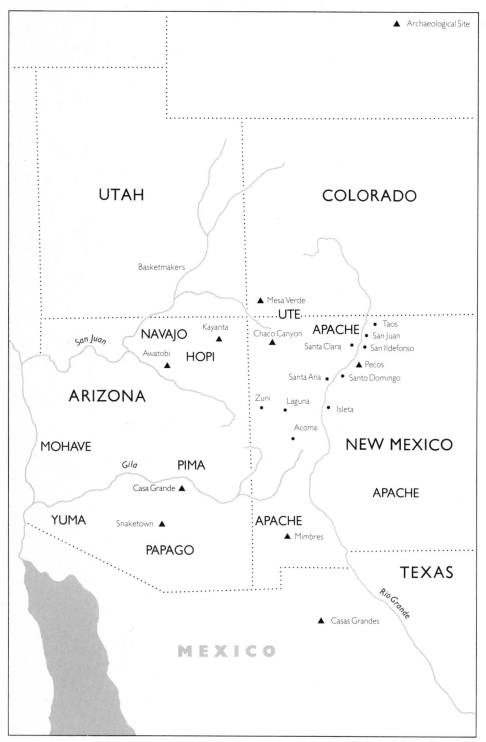

▲ Archaeological Site

UTAH

COLORADO

Basketmakers

▲ Mesa Verde

UTE

NAVAJO Kayanta ▲ Chaco Canyon ▲ APACHE • Taos
 • San Juan
San Juan Awatobi ▲ HOPI Santa Clara • • San Ildefonso

ARIZONA ▲ Pecos
 Santa Ana • • Santo Domingo

MOHAVE Zuni • Laguna • • Isleta

 Acoma • NEW MEXICO

Gila PIMA APACHE

Casa Grande ▲

YUMA Snaketown ▲ APACHE

PAPAGO ▲ Mimbres

 TEXAS

 Rio Grande

MEXICO ▲ Casas Grandes

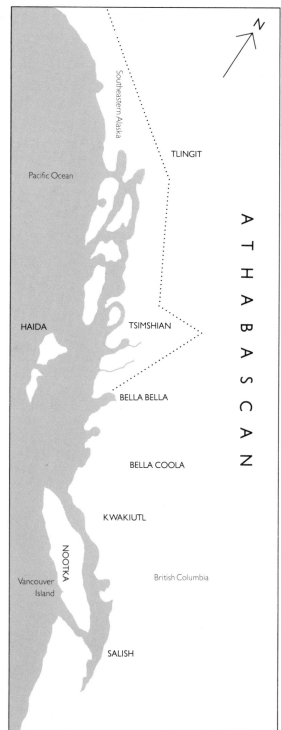

Southeastern Alaska

Pacific Ocean

TLINGIT

HAIDA TSIMSHIAN

ATHABASCAN

BELLA BELLA

BELLA COOLA

KWAKIUTL

NOOTKA British Columbia

Vancouver Island

SALISH

Bibliography

In the catalogue entries bibliographical references are indicated by the name of the author followed by the page or plate number. In the bibliography exhibition catalogues appear under the city in which the exhibition was held or when there is a single author under the author's name.

Adair, John.
 The Navajo and Pueblo Silversmiths. Norman, Okla., University of Oklahoma Press, 1944.
Adney, E. T. and Chapelle, H. I.
 The Bark Canoes and Skin Boats of North America. Washington, D.C., Smithsonian Institution, 1964.
Albuquerque, N.M.
 Maxwell Museum of Anthropology. *Seven Families in Pueblo Pottery*, Albuquerque, N.M., 1974.
Anderson, John A. and Hamilton, H. J., ed.
 The Sioux of the Rosebud; a History in Pictures. Norman, Okla., University of Oklahoma Press, 1971.
Barbeau, Marius.
 Totem Poles According to Crests and Topics. Ottawa, National Museum of Canada, Bulletin 119, Anthropological Series no. 30, 2 vols., 1930.
 Haida Carvers. Ottawa, National Museum of Canada, Bulletin 139, Anthropological Series no. 38, 1957.
Blessing, Fred K.
 'The Birch Bark Mide Scroll.' *The Minnesota Archaeologist 25*, no. 3 (July, 1963): 87–142.
Boas, Franz.
 'The Decorative Art of the Indians of the North Pacific Coast.' *American Museum of Natural History Bulletin* 9 (1897): 123–176.
 Primitive Art, Instituttet für Sammenlignende Kulturforskning, vol. XIII, series B. 1927. Reprint: New York, Dover Publications, 1955.
Bodmer, Carl.
 Atlas. Early Western Travels, vol. 25. Cleveland, A. H. Clark Co., 1906.
Bradfield, Wesley.
 Cameron Creek Village; a Site in the Mimbres Area in Grant County, New Mexico. Santa Fé, New Mexico: The School of American Research, 1929.
Braunholtz, H. J.
 Sir Hans Sloane and Ethnography. London, 1970.
Brown, James A., ed.
 Approaches to the Social Dimensions of Mortuary Practices. Memoirs of the Society for American Archaeology, no. 25; issued as *American Antiquity*, vol. 36, no. 3, part 2, July 1971.
Bullen, R. P.
 'Carved Owl Totem, De Land, Florida'. The Florida State Archaeologist, vol. VIII, no. 3, 1955.
Burland, C. A.
 Man and Art. London, Studio, 1959.
Camil, G.
 The Weymontachine Canoe. Ottawa, National Museums of Canada, Anthropological Series, no. 2, 1974.
Canadian Institute.
 Annual Report of the Canadian Institute Session 1886–1887; Being an Appendix to the Report of the Minister of Education, Ontario, 1887. Toronto, Ontario, Warwick & Sons, 1888.
Capps, Benjamin.
 The Indians. New York, Time-Life, 1973.
Carpenter, Edmund.
 Eskimo Realities. New York, Holt, Rinehart and Winston, 1973.
Catlin, George.
 The Manners, Customs and Condition of the North American Indians. 2 vols. London, G. Catlin, 1841. Reprinted in new edition by Dover Publications, New York, 1973.
Chang, Dwang-chih.
 The Archaeology of Ancient China. New Haven, Conn., Yale University Press, 1968.
Chief Luther Standing Bear.
 Land of the Spotted Eagle. Boston, Houghton Mifflin, 1933.
Coe, Ralph T.
 'The Imagination of Primitive Man.' *Nelson Gallery-Atkins Museum Bulletin*, vol. 4, no. 1, Kansas City, Mo., 1962.
Collins, John E.
 Nampeyo, Hopi Potter, Her Artistry and Her Legacy.
 Fullerton, California, Muckenthaler Cultural Center, 1974.
Colton, Harold S.
 Hopi Kachina Dolls, with a Key to their Identification. Albuquerque, N.M., University of New Mexico Press, 1949. (Revised edition 1959.)
Cook, Captain James A.
 A voyage to the Pacific Ocean, vol. 182. Vol. 3 by Captain James King. London, 1784.
Cosgrove, H. S. and Cosgrove, C. B.
 The Swerts Ruin: a Typical Mimbres Site in Southwestern New Mexico. Papers of the Peabody Museum, vol. 15, no. 1, Cambridge, Massachusetts, Peabody Museum of Archaeology and Ethnology, 1932.
Covarrubias, Miguel.
 The Eagle, the Jaguar and the Serpent. New York, Alfred A. Knopf, 1954.
Curtis, Edward.
 The North American Indian. 30 vols. Cambridge, Mass., Harvard University Press, 1903–1930. (Reprinted by Johnson Reprint, 1970.)
Cushing, Frank H.
 'Exploration of Ancient Key Dweller's Remains on the Gulf Coast of Florida.' *Proceedings of the American Philosophical Society* 25, no. 153 (December, 1896).
Dalton, O. M.
 'Notes on an ethnographical collection from the West Coast of North America (more especially California), Hawaii, and Tahiti, formed during the voyage of Captain Vancouver 1790–95.' *Internationales Archiv für Ethnographie*, 1897.
Day, A. Grove.
 The Sky Clears, Poetry of the American Indian. Lincoln, Neb., University of Nebraska Press, 1951.
Deloria, Vine Jr.
 God is Red. New York, Dell Publications Co. Inc., 1973.
Densmore, Frances.
 Teton Sioux Music. Washington, D.C., Smithsonian Institution Bulletin 61, 1918.
 Chippewa Customs. Washington, D.C., Smithsonian Institution Bulletin 86, 1929.
Dickason, Olive Patricia.
 Indian Arts in Canada. Ottawa, Information Canada, 1972.
Dixon, George.
 A voyage round the world. London, 1789.
Dockstader, Frederick J.
 Indian Art in America. Greenwich, Conn., New York Graphic Society, 1961.
Dodge, Colonel Richard Irving.
 Our Wild Indians: Thirty-three Years Personal Experience Among the Red Men of the Great West. New York, Archer House Inc., 1959.
Douglas, Frederic H. and D'Harnoncourt, Rene.
 Indian Art of the United States. New York, Museum of Modern Art, 1941.
Drucker, Philip and Heizer, Robert F.
 To Make My Name Good; a Re-examination of the Southern Kwakiutl Potlatch. Berkeley and Los Angeles, University of California Press, 1967.
Dunn, Dorothy.
 American Indian Painting of the Southwest and Plains Areas. Albuquerque, N.M., University of New Mexico Press, 1968.
Dyer, Mrs D. B.
 Fort Reno. New York, G. W. Dillinger, 1896.
Eddy, John A.
 'Astronomical Alignment of the Big Horn Medicine Wheel.' *Science*, (American Association for the Advancement of Science), vol. 184, no. 4141 (June 7 1974).
Emmons, George T. and Boas, Franz.
 The Chilkat Blanket. New York, 1907.
Evrard, Marcel, ed.
 Masterpieces of Indian and Eskimo Art from Canada. Paris, Société des Amis du Musée de l'Homme, 1969.

Ewers, John Canfield.
Plains Indians Painting : a Description of Aboriginal American Art. Stanford, Calif., Stanford University Press, 1939.
The Blackfeet, Raiders on the Northwestern Plains. Norman, Oklahoma, University of Oklahoma Press, 1958.

Fagg, William.
Eskimo Art in the British Museum. London, 1970.
The Tribal Image. London, 1970.

Fallon, Carol.
The Art of the Indian Basket in North America. Exhibition catalogue. Lawrence, Kansas, University of Kansas Art Museum, 1975.

Fawcett Thompson, J. R.
'Thayendanega the Mohawk and his several portraits.' *Connoisseur*, vol. 170, January 1969.

Feder, Norman.
'American Indian Art Before 1850.' *Denver Art Museum Quarterly*, Summer 1965.
Elk Antler Roach Spreaders. Material Culture Monographs, no. 1, Denver, Colo., Denver Art Museum, 1968.
American Indian Art. New York, Abrams, 1971.
Two Hundred Years of North American Indian Art. New York, Praeger Pubs., in association with the Whitney Museum of American Art, 1971.

Feder, Norman and Malin, Edward.
'Indian Art of the Northwest Coast.' *Denver Art Museum Quarterly*, Winter, 1962. (Revised and reprinted 1968).

Fewkes, Jesse W.
Hopi Katchinas Drawn by Native Artists. Glorieta, N.M., The Rio Grande Press Inc., 1969; a reprint of the Bureau of American Ethnology, Annual Report 21, 1903, pages 3–126.

Flint, Mich., Flint Institute of Arts.
Art of the Great Lakes Indians. Exhibition catalogue, 1973.

Frank, Larry and Harlow, Francis.
Historic Pottery of the Pueblo Indians 1600–1880. Boston, Mass., New York Graphic Society, 1974.

Fundaburk, Emma Lila and Foreman, Mary Douglass.
Sun Circles and Human Hands. Luverne, Alabama, Fundaburk Pubs., 1957.

Griffin, James B., ed.
Archaeology of the Eastern United States. Chicago, University of Chicago Press, 1952.

Gunther, Erna.
Art in the Life of the Northwest Coast Indians. Catalogue of the Rasmussen Collection in the Portland Art Museum, Portland, Oregon, 1966.
Indian Life on the Northwest Coast of North America ; as Seen by the Early Explorers and the Fur Traders During the Last Decades of the Eighteenth Century. Chicago and London, University of Chicago Press, 1972.

Hamilton, Henry W. *et al.*
'The Spiro Mound.' *The Missouri Archaeologist*, vol. 14, October 1952.

Harlow, Francis H.
Matte-paint Pottery of the Tewa, Keres and Zuni Pueblos. Santa Fé, N.M., Museum of New Mexico, 1973.

Hawthorn, Audrey.
Art of the Kwakiutl Indians ; and Other Northwest Coast Tribes. Vancouver, University of British Columbia Press and Seattle and London, University of Washington Press, 1967.

Holm, Bill.
Northwest Coast Indian Art ; An Analysis of Form. Seattle and London, University of Washington Press, 1965.

Hyde, George E.
Indians of the Woodlands, from Prehistoric Times to 1725. Norman, Okla., University of Oklahoma Press, 1962.

Inverarity, Robert.
Northwest Coast Indian Art. London, British Museum, Ethnological Department, 1924.
Art of the Northwest Coast Indians. Berkeley and Los Angeles, Calif., University of California Press, 1950. (Reprinted 1967.)

Kane, Paul.
Wanderings of an Artist among the Indians of North America. Toronto, Radisson Society of Canada, 1925.

Larson, Lewis H.
'Archaeological Implications of Social Stratification at the Etowah Site, Georgia.' *American Antiquity*, vol. 36, no. 3, July 1971.

Lismer, Marjorie.
Seneca Splint Basketry. Indian Handcraft Pamphlets, no. 4. Washington, D.C., U.S. Office of Indian Affairs, June 1941.

Lister, Robert H. and Lister, Florence C.
The Earl H. Morris Memorial Pottery Collection. Series in Anthropology, no. 16. Boulder, Colo., University of Colorado Press, September 1969.

London, British Museum.
Handbook to the Ethnographical Collections. London 1910.
Prehistoric, Ethnographical and Christy Collections. Part 1, vol. III. London, 1872.

Los Angeles, University of California at Los Angeles.
Masterpieces from the Sir Henry Wellcome Collection at U.C.L.A. Los Angeles, 1965.

Lowie, Robert H.
Indians of the Plains. The American Museum of Natural History, Anthropological Handbook, no. 1. New York, McGraw-Hill Book Co., Inc., 1954.

Lyford, Carrie A.
Quill and Beadwork of the Western Sioux. Washington, D.C., Department of the Interior, Bureau of Indian Affairs, 1940.
Ojibwa Crafts. Lawrence, Kansas, Haskell Institute, 1945.

Mails, Thomas E.
The Mystic Warriors of the Plains. Garden City, New York, Doubleday and Co., Inc., 1972.
Dog Soldiers, Bear Men and Buffalo Women ; A Study of the Societies and Cults of the Plains Indians. Englewood Cliffs, New Jersey, Prentice-Hall, Inc., 1973.
The People Called Apache. Englewood Cliffs, New Jersey, Prentice-Hall, Inc., 1974.

Marshall, I.
'The Beothuk Indians.' *Canadian Antiques Collector*, Vol. 10, no. 2, March–April 1975.

Martin, P. S., Quimby, G. I. and Collier, D.
Indians Before Columbus. Chicago, University of Chicago Press, 1947.

Mason, Otis Tufton.
Aboriginal American Basketry : Studies in a Textile Art Without Machinery. Glorieta, N.M., The Rio Grande Press, Inc., 1970, a reprint of the Annual Report of the Smithsonian Institution, 1902.
Indian Basketry. 2 vols. New York, Doubleday, 1904.

Matthews, John Joseph.
The Osages ; Children of the Middle Waters. Norman, Okla., University of Oklahoma Press, 1961.

Maximilian, Prince of Wied-Neuuied.
'Travels in the Interior of North America, 1832–1834.' *Early Western Travels, 1748–1846.* Parts 1, 2, 3 in vols. 22, 23, 24. Ed. by R. G. Thwaite. Cleveland, A. H. Clark Co., 1906.

Melgaard, Jørgen.
Eskimo Sculpture. New York, Clarkson N. Potter, 1960.

Mera, Harry P.
Pueblo Indian Embroidery. Memoirs of the Laboratory of Anthropology, vol. 4. Santa Fé, N.M., University of New Mexico Press, 1943. Reprinted by William Gannon, Sante Fé, N.M., 1975.

Miles, Charles.
Eskimo and Indian Artifacts of North America. New York, Bonanza Books, 1963.

Mindeleff, Victor. *A Study of Pueblo Architecture : Tusayan and Cibola.* Bureau of American Ethnology, Annual Report 8. Washington, D.C., Smithsonian Institution Press, 1891 (1893) ; pages 3–228.

Minneapolis, Minn., Walker Art Center. *American Indian Art : Form and Tradition.* Exhibition catalogue, 1972.

Mooney, J.
The Sacred Formulas of the Cherokees. Bureau of American Ethology, Annual Report 7. Washington, D.C., Smithsonian Institution Press, 1891 (1892), pages 301–397.
The Ghost-dance Religion and the Sioux Outbreak of 1890. Bureau of American Ethnology, Annual Report 14. Washington, D.C., Smithsonian Institution Press, 1896, pages 641–1110.

Moorehead, Warren K.
Prehistoric Implements. A Reference Book. A Description of the Ornaments, Utensils, and Implements of Pre-Columbian Man in America. Cincinnati, Ohio, The Robert Clarke Co., 1900.

Moquin, Wayne and Van Doren, Charles.
Great Documents in American Indian History. New York, Praeger Pubs., 1973.

Morgan, Lewis H.
The League of the Ho-Dé-No-Sau-Nee or Iroquois, 2 vols. New York, Burt Franklin, 1901 ; reprinted by Yale University Press, 1954.

New York, Museum of Primitive Art.
The Robert and Lisa Sainsbury Collection. Exhibition catalogue distributed by New York Graphic Society, 1963.

Niblack, Albert P.
The Coast Indians of Southern Alaska and Northern British Columbia. New York : Johnson Reprint Corp., 1970; a reprint of the 1888 United States National Museum Report, Washington, D.C.

Opler, Morris E.
'Myths and tales of the Jicarilla Apache Indians.' *Memoirs of the American Folklore Society*, vol. 31, New York, 1938.

Ottawa, National Museum of Man, National Museums of Canada and the Royal Scottish Museum, Edinburgh.
The Athapaskans : Strangers of the North. Exhibition catalogue, 1974.

Paul Wilhelm, Duke of Württemberg.
Travels in North America 1822–1824. Translated by W. Robert Nitske. Edited by Savoie Lottinville. Norman, Oklahoma, University of Oklahoma Press, 1973 ; a translation of *Erste Reisenachdem nördlichen Amerika in den Jahren 1822 bis 1824.*

Peso, Charles de.
Casas Grandes, a Fallen Trading Center of the Chan Chichimeca, 3 vols. Flagstaff, Arizona, Northland Press, 1974.

Ray, Dorothy J.
Artists of the Tundra and the Sea. Seattle, Washington, University of Seattle Press, 1961.
Eskimo Masks : Art and Ceremony. Seattle, Washington, University of Washington Press, 1967.

Read, C. H.
'An account of a collection of ethnological specimens formed during Vancouver's Voyage in the Pacific 1790–95.' *Journal of the Royal Anthropological Institute.* London, 1891.

Ritzenthaler, Robert E.
Iroquois False-Face Masks. Publications in Primitive Art 3. Milwaukee, Wisconsin : Milwaukee Public Museum, 1969.

Roe, Frank G.
The Indian and the Horse. Norman, Okla., University of Oklahoma Press, 1955.

Salmony, Alfred.
Antler and Tongue ; an Essay on Ancient Chinese Symbolism and its Implications. Ascona, Switzerland, Artibus Asiae, 1954.

Schoolcraft, Henry R.
History of the Indian Tribes of the United States : Their Present Condition and Prospects, and a Sketch of their Ancient Status. Historical American Indian Press, n.d. ; a reprint of the 1857 edition. Reprinted by J. B. Lippincott & Co., 1957.

Schulze-Thulin, Axel.
Indianische Malerei in Nordamerika, 1830–1970. Stuttgart, Linden Museum, 1973.

Schuster, Carl.
'A Survival of the Eurasiatic Animal Style in Modern Alaska Eskimo Art.' *Indian Tribes of North America, Proceedings of the 29th Congress of Americanists*, vol. 3. Chicago, n.d. ; pages 35–45.

Silverberg, Robert.
The Mound Builders. New York, Random House, 1970.

Skinner, Alanson.
Material Culture of the Menomini. Indian Notes and Monographs, no. 20. New York, Museum of the American Indian, Heye Foundation, 1921.
'Observations on the Ethnology of the Sauk Indians.' *Bulletin of the Public Museum of the City of Milwaukee* 5 (August 30 1923). 1–57 ; reprinted by Greenwood Press.

Speck, Frank G.
The Double-Curve Motif in Northeastern Algonkian Art.
Anthropological Series no. 1. Memoir no. 42. Ottawa,
National Museum of Canada, 1914.
Decorative Art of Indian Tribes of Connecticut.
Anthropological Series no. 10. Memoir no. 75.
Ottawa, National Museum of Canada, 1915.
Symbolism in Penobscot Art. Anthropological Papers of
the American Museum of Natural History, vol. 29, pt.
2, New York, The Trustees, 1927.
The Iroquois, a Study in Cultural Evolution. 2nd ed.
Bloomfield Hills, Michigan, Cranbrook Institute of
Science, 1955.
Speck, Frank G. and Orchard, William C.
The Penn Wampum Belts. Leaflet no. 4. New York,
Museum of the American Indian, Heye Foundation,
1925.
Squier, E. G. and Davis, E. H.
'Ancient Monuments of the Mississippi Valley.'
Smithsonian Contributions to Knowledge, no. 1, article 1.
Washington, D.C. Smithsonian Institution Press, 1848,
pages 1–306.
Stevens, Edward T.
*Flint Chips, a Guide to Pre-Historic Archaeology as Illustrated
by the Collection of the Blackmore Museum, Salisbury.*
London, Bell and Daldy, 1870.
Storm, Hyemeyohsts.
Seven Arrows. New York, Harper & Row, 1972.
Strong, Emory.
Stone Age on the Columbia River. Portland, Ore., Binfords
and Mort, 1959.
Terrell, John Upton.
The Plains Apache. New York, Thomas Crowell & Sons,
1975.
Trigger, Bruce G.
The Huron, Farmers of the North. New York, Holt,
Rinehart and Winston, 1969.
Vaillant, George C.
Indian Arts in North America. New York, Harper Bros., 1939.
Vienna, Museum für Völkerkunde.
Indianer Nordamerikas. Exhibition catalogue, 1968.
Wallace, Anthony F. C.
The Death and Rebirth of the Seneca. New York, Alfred A.
Knopf, 1973.
Wallis, Wilson D. and Wallis, Ruth S.
The Micmac Indians of Eastern Canada. Minneapolis,
Minnesota, University of Minnesota Press, 1955.
The Malechite Indians of New Brunswick. Anthropological
Series no. 40. Bulletin no. 148. Ottawa, National
Museum of Canada, 1957.
Washburn, Wilcomb E.
The Indian in America. New York, Harper & Row, 1975.
Washington, National Collection of the Fine Arts,
Renwick Gallery.
Boxes and Bowls. Exhibition catalogue, Smithsonian
Institution Press, 1974.
Washington, National Gallery of Art.
*The Far North; 2000 Years of American Eskimo and Indian
Art.* Exhibition catalogue, 1973.
Waters, Frank.
Masked Gods . . . Navaho and Pueblo Ceremonialism. 2nd
ed. Chicago, The Swallow Press, 1950.
Book of the Hopi. New York, The Viking Press, 1963.
Watson, Virginia Drew.
The Wulfing Plates. New series, no. 8. St Louis,
Washington University, 1950.
Webb, William S. and Baby, Raymond S.
The Adena Papers, No. 2. Columbus, Ohio, The Ohio
Historical Society, 1957.
Wildschut, William and Ewers, John C.
Crow Indian Beadwork; a Descriptive and Historical Study.
New York, Museum of the American Indian, Heye
Foundation, 1959.
Crow Indian Medicine Bundles. 2nd ed. Contributions,
no. 17. New York, Museum of the American Indian,
Heye Foundation, 1975.
Willey, Gordon.
An Introduction to American Archaeology, vol. 1. Englewood
Cliffs, N.J., Prentice-Hall, Inc., 1966.
Willoughby, Charles C.
*Antiquities of New England Indians, with Notes on the
Ancient Cultures of the Adjacent Territory.* Cambridge,
Massachusetts. The Peabody Museum of American
Archaeology and Ethnology, Harvard University,
1935.
Winnipeg, Manitoba, Winnipeg Art Gallery.
*Canvas, Quill, Brush and Hide: an Exploration of Manitoba
Indian Art.* Exhibition catalogue, 1975.
Wissler, Clark.
'Decorative Art of the Sioux Indians.' *American Museum
of Natural History Bulletin* 18 (1904), 231–278.
Wormington, H. M.
Ancient Man in North America. Denver, Colo. Colorado
Museum of Natural History, 1957.

Photographic Credits

The Arts Council would like to thank the lenders who have supplied photographs for this catalogue.
We have been asked to credit the following photographers.

Abrams Photo-Graphics, Phoenix
(for the Heard Museum)

Derek Balmer, Bristol
(for the American Museum in Britain)

Len Bouché, Santa Fé
(for Mr and Mrs Peter I. Hirsch and Mr and Mrs Rex Arrowsmith)

Hillel Burger
(for the Peabody Museum of Archaeology and Ethnology, Harvard University)

Duane Dailey, Columbia, Mo.
(for Leland and Crystal Payton)

Ursula Didoni
(for the Linden Museum, Stuttgart

Dudley, Hardin & Young Inc., Seattle, Wash.
(for Mr and Mrs Michael R. Johnson)

Susan B. Einstein
(for the University of California at Los Angeles Museum of Cultural History)

Bruce Frumker
(for the Cleveland Museum of Natural History)

William Galen, Portland, Oregon
(for Mr and Mrs Robert Campbell and Mr and Mrs Bruce M. Stevenson)

Hamilton Studio, Kansas City
(for Mr and Mrs Morton I. Sosland)

Heritage Studio, Redwood City
(for Karen Bunting)

David J. Kaminsky
(for the Georgia Department of Natural Resources)

Barbara and Justin Kerr, New York
(for the Jonathan and Philip Holstein Collection)

Lisa Little
(for the Museum of Primitive Art, New York)

Frank J. Thomas, Los Angeles
(for Anthony Berlant)

Nicholas Tucker, London
(for the Peter Adler collection)

John Webb, Cheam, Surrey
(for the Field Museum of Natural History, Chicago and the University
of East Anglia [Robert and Lisa Sainsbury Collection])

Colour Illustrations

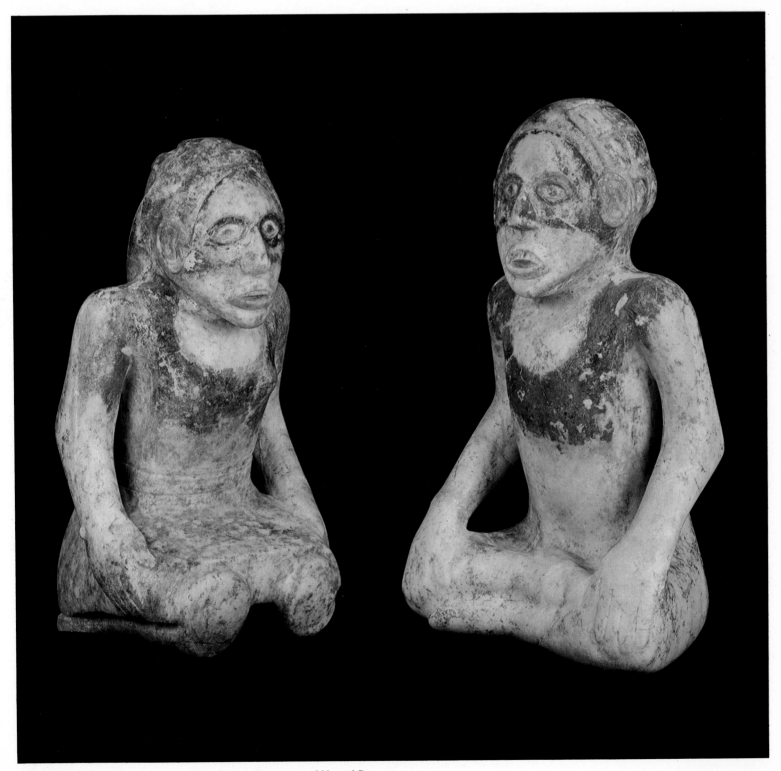

38 **Pair of figures,** Etowah *Lent by the Georgia Department of Natural Resources*

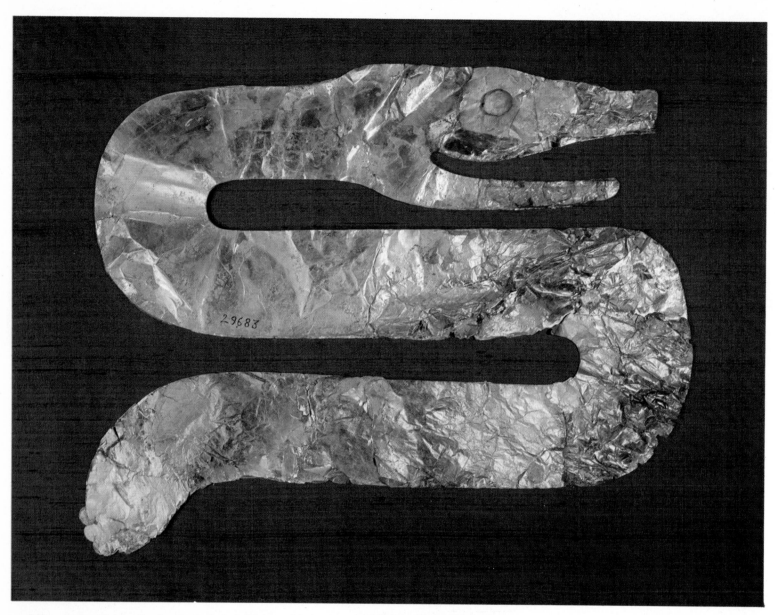

10 **Mica snake,** Hopewell *Lent by the Peabody Museum of Archaeology and Ethnology, Harvard University*

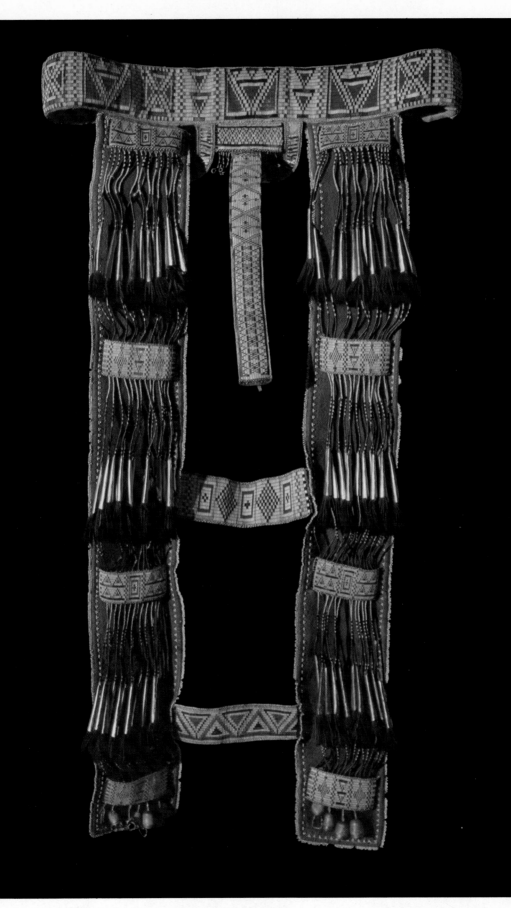

144 **Cradle front,** Cree *Lent by the Hudson's Bay Company Historical Collection*

115 **Octopus bag,** Cree *Lent by the Royal Scottish Museum*

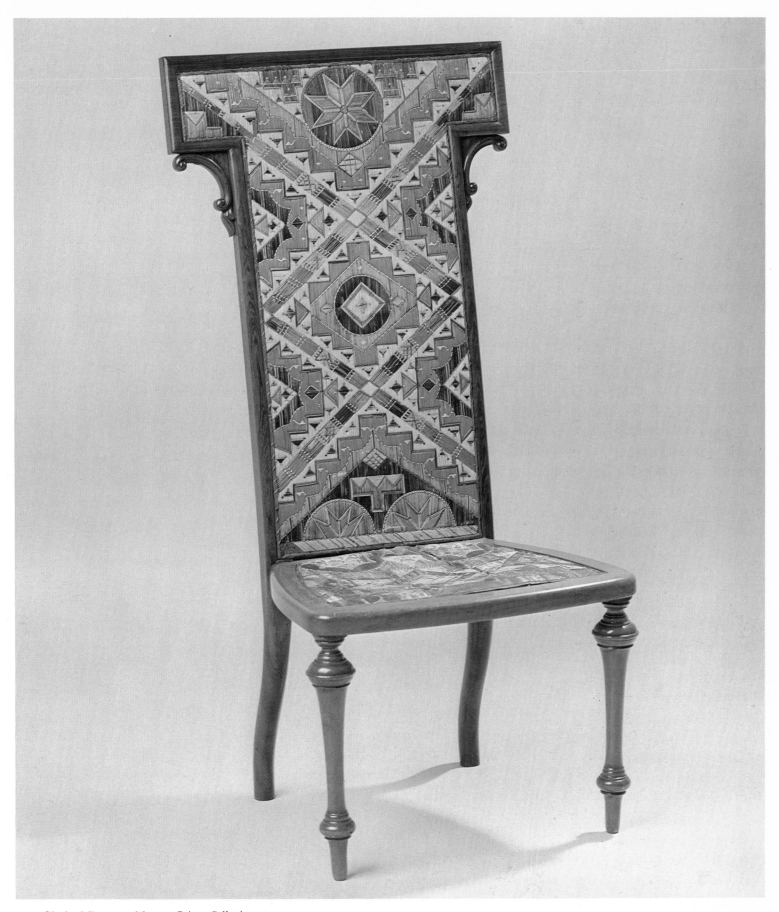

105 **Chair,** Micmac *Montana Private Collection*

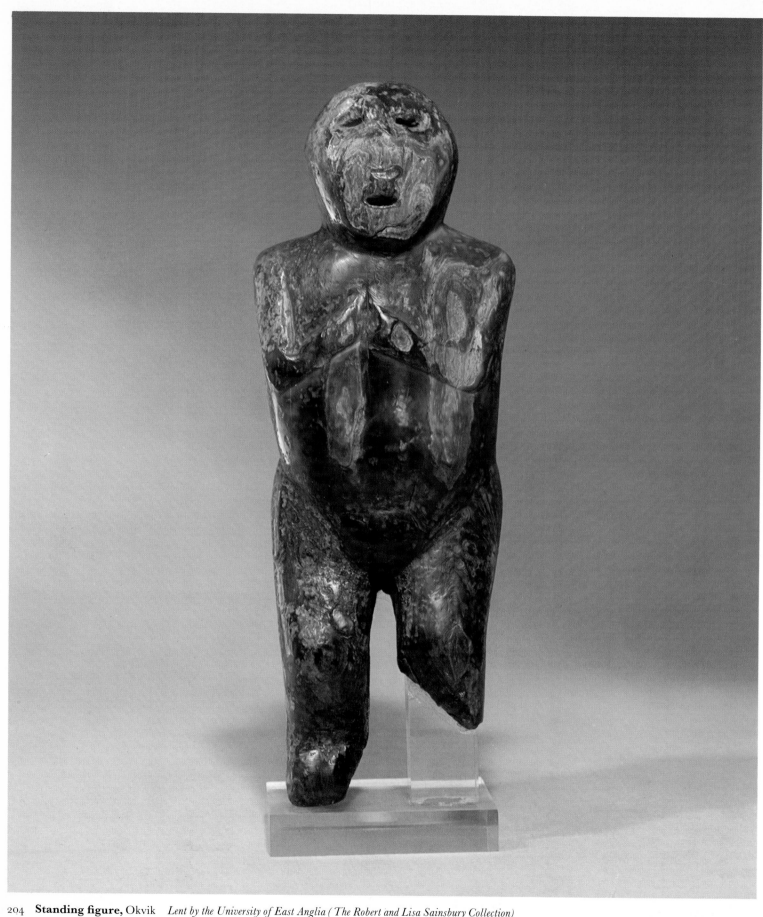

204 **Standing figure,** Okvik *Lent by the University of East Anglia (The Robert and Lisa Sainsbury Collection)*

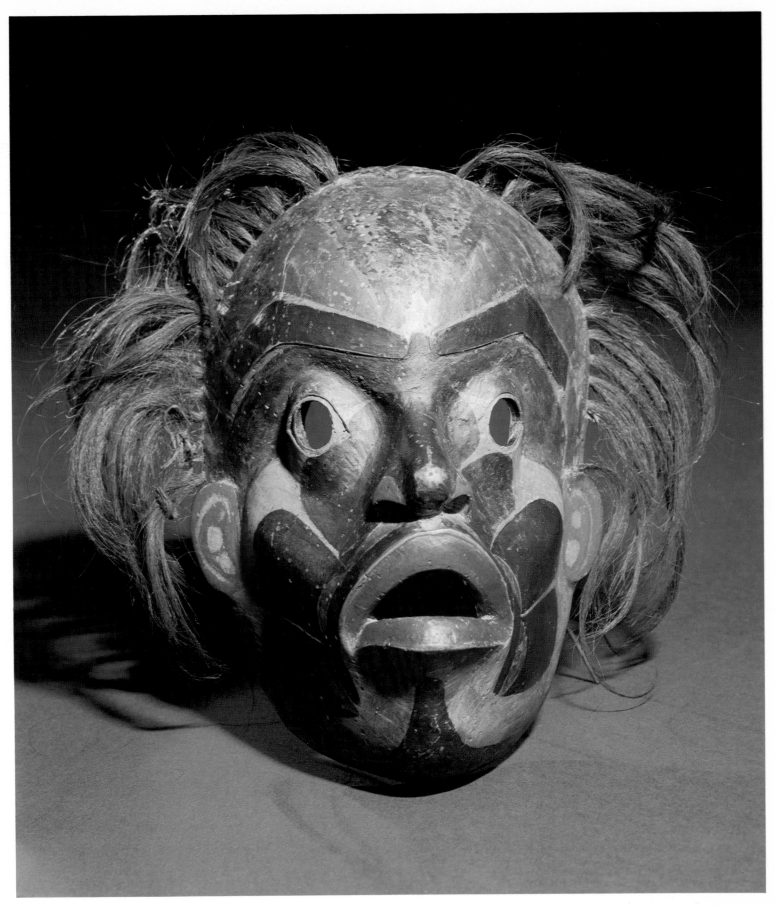

266 **Mask,** Bella Bella *Lent by the Trustees of the British Museum*

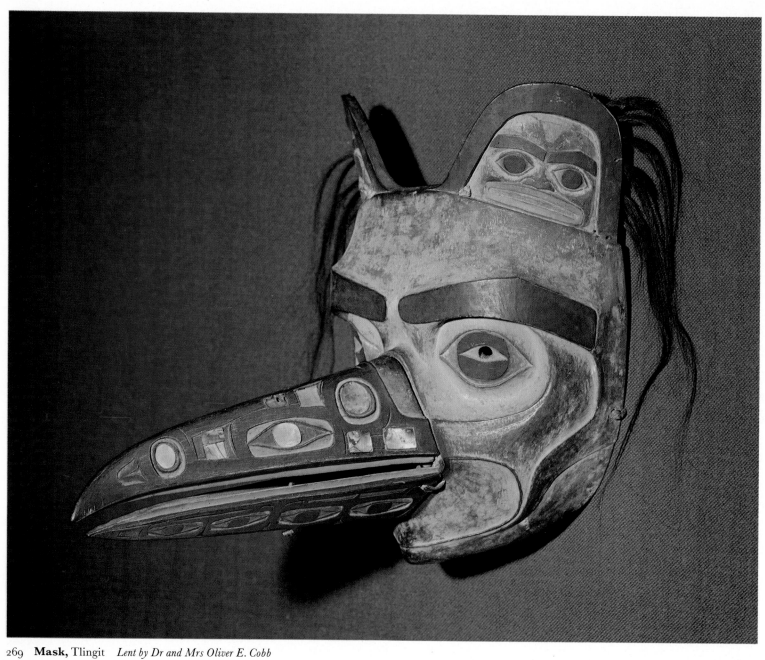

269　**Mask,** Tlingit　　*Lent by Dr and Mrs Oliver E. Cobb*

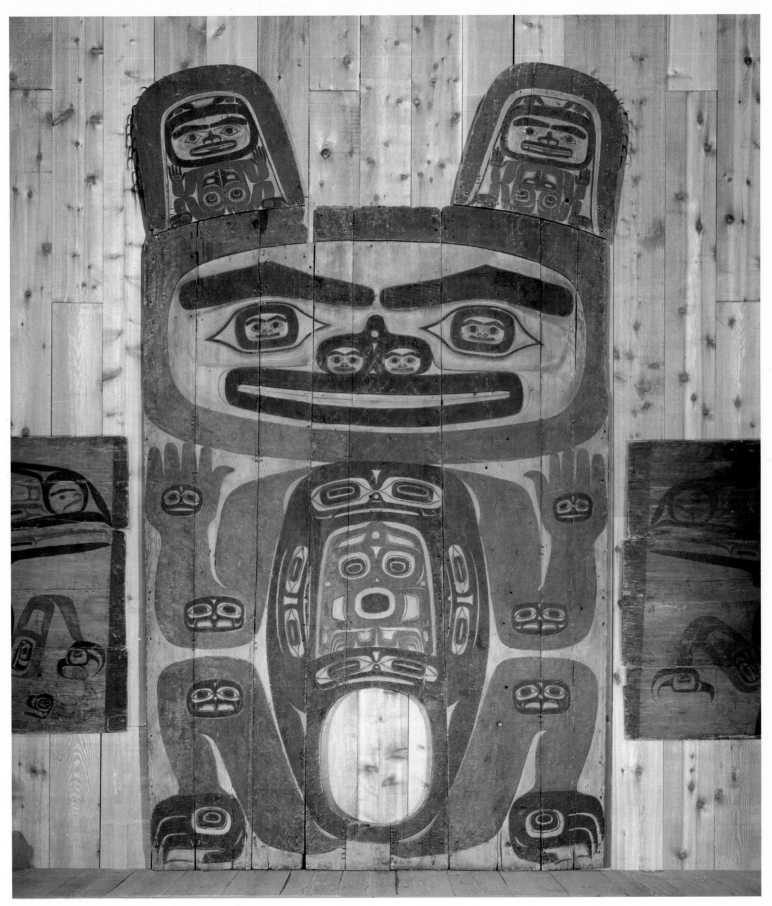

245 **Shakes screen,** Tlingit *Lent by the Denver Art Museum*

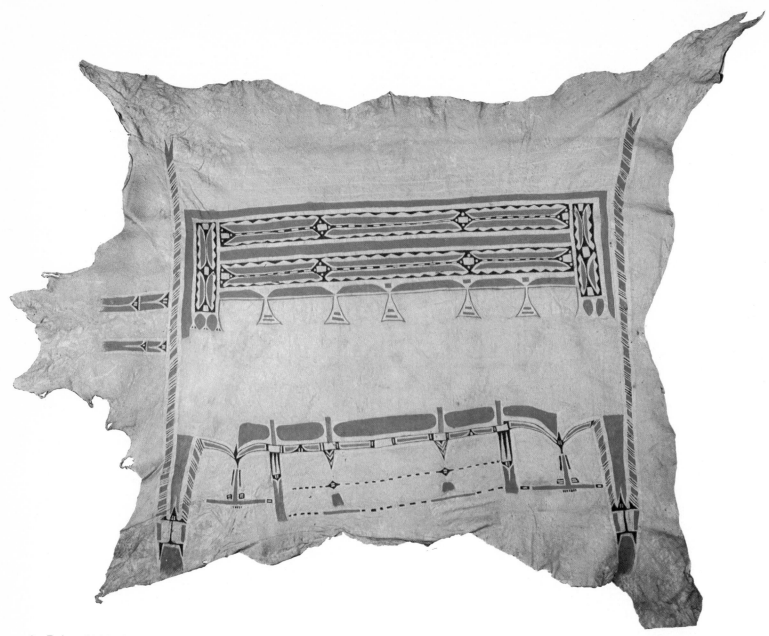

508 **Painted hide,** Sioux *Lent by the Linden Museum, Stuttgart*

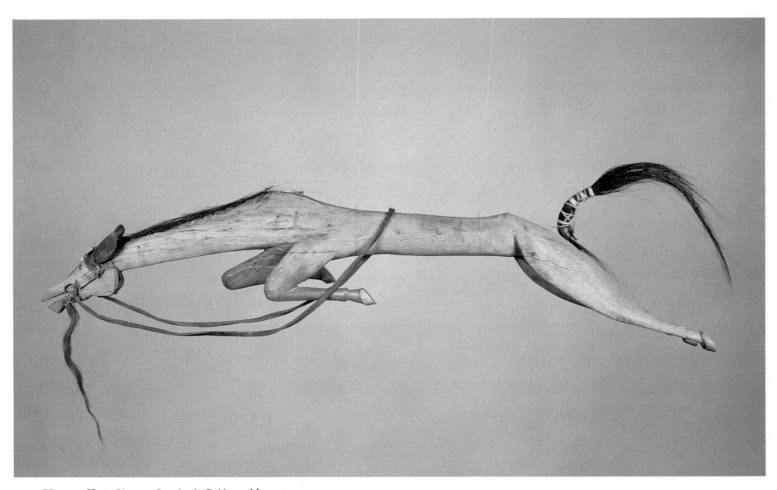

390 **Horse effigy,** Sioux *Lent by the Robinson Museum*

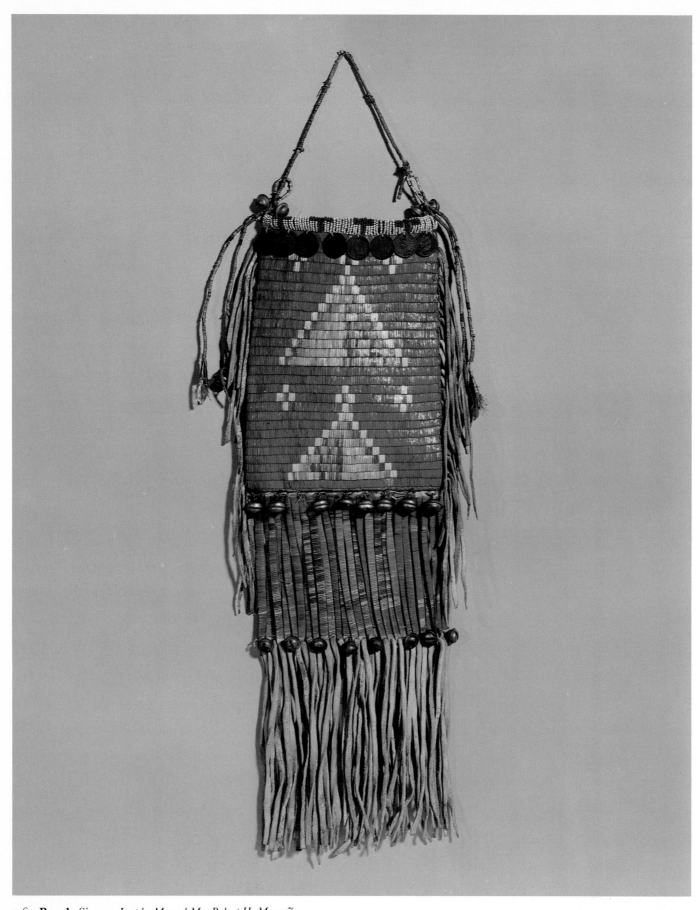

506 **Pouch,** Sioux *Lent by Mr and Mrs Robert H. Mann Jr*

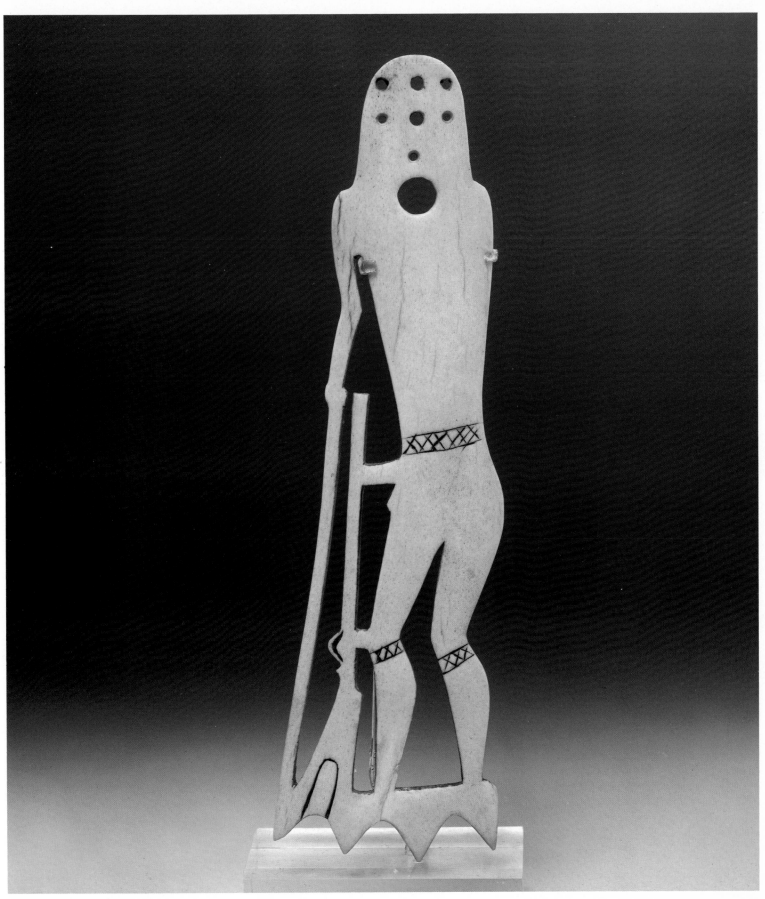

435 **Roach spreader,** Chippewa *Lent by Mr James Economos*

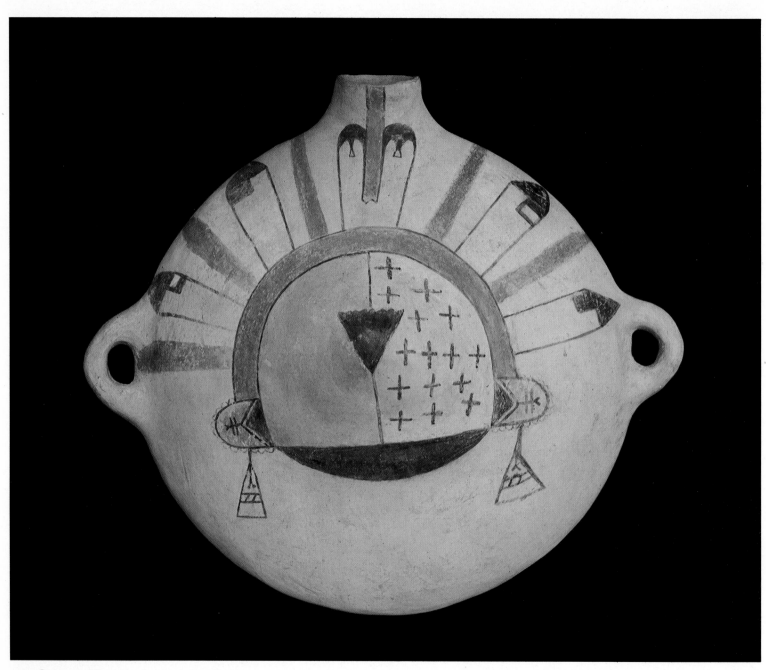

552 **Canteen,** Sikyatki *Lent by Anthony Berlant*

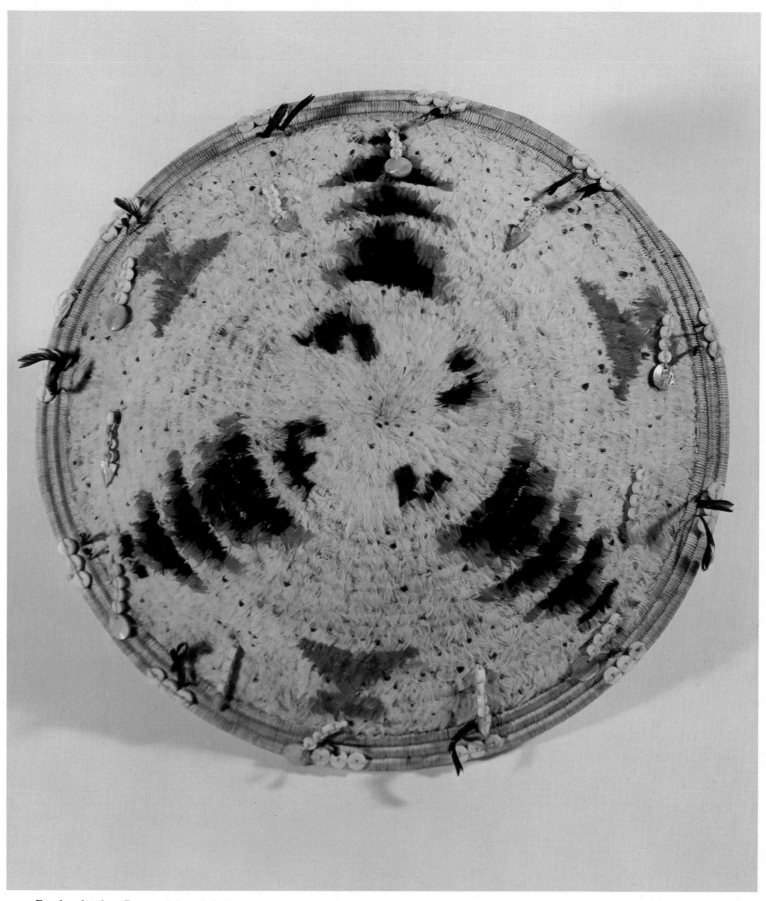

593 **Feather basket,** Pomo *Private Collection*

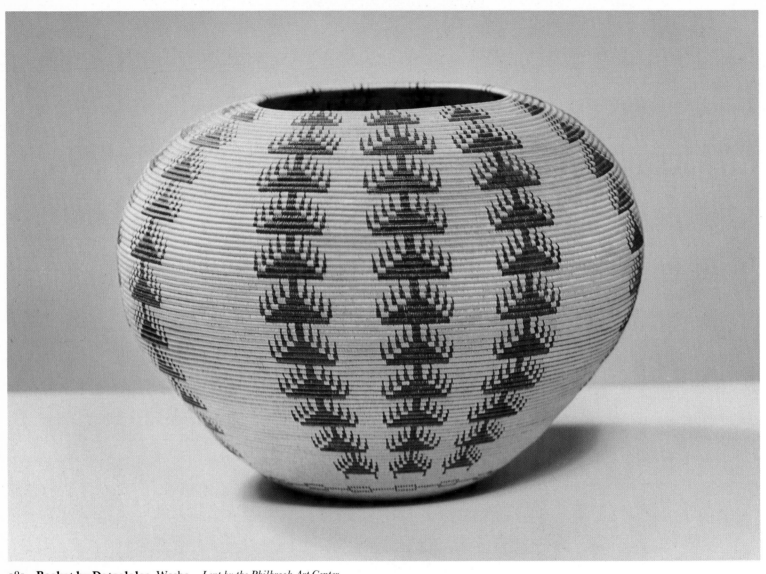

585 **Basket by Datsolalee,** Washo *Lent by the Philbrook Art Center*

Archaeology

Archaeological Earthworks and Effigy Pipes: The Serpent Cult

Archaeologists generally agree that the earliest Americans crossed into North America from Siberia about 25,000 years ago, at a time when ice conditions may have reduced further the short distance between Asia and North America by lowering the water level of the Bering Strait. These early people were hunters, and their spear points have been found imbedded in the bones of extinct mastodons. Their flint arrow-heads were often beautifully shaped by pressure flaking. Unfortunately the pattern of diffusion of the early hunters across North America is not clearly demonstrated by the archaeological finds, although a number of paths of diffusion have been deduced from the scanty evidence that is available. What is certain is that these people had Asiatic physical traits and also a regard for shamanism – a belief in the ability of certain persons to employ supernatural powers.

With the importation of maize from Mexico into the northeastern United States, about 1000 BC, it gradually became possible for the hunting people to develop a sedentary life. This was followed rather quickly by the development of animistic cults. Even then the population that could be supported was relatively small compared with the populations of the southern part of the continent. By the fifteenth century it is estimated that the population of North America was about 750–850,000, while there were 19–20 million people living elsewhere in the Americas.

The ancient art of eastern North America developed over a period of some fifteen hundred years, with direct antecedents extending back to the 3rd millennium BC. After the development of agriculture to supplement hunting new cultures arose that required effigy sculptures – pipes and other cult objects – for their ceremonies, and the preoccupation with these images was so distinctive as to confer a unique cultural identity. Across the centuries the carved images gradually increased in size, though their forms were generally compact and small. Effigy making was accompanied by the development of an equally distinctive earth architecture – defence works, effigy mounds and burial sites for the dead.

North American archaeology has suffered from negative attitudes that arose early in the eighteenth century. In the year 1700 a Jesuit priest, Jacques Gravier, spent the winter at an Illinois village now identified as Cahokia, near present-day St Louis, which is the site of the largest earthworks ever built by man – the Cahokia Mound. He never saw fit to note this monstrous mound in his journal, although it was over one hundred feet high and contained sixteen cubic acres of earth (more than any Egyptian pyramid). Similarly, although other travellers noticed barrows or small tumuli here and there across the eastern half of the United States, they excited little comment. Not until 1786 did General Rufus Putnam make a map of a prehistoric mound, at the town he founded, Marietta, Ohio. The original inhabitants of America were not generally considered capable of a real architecture, let alone sculpture or carvings. It should be said that little had yet been excavated in the way of mound-builder art, but if it had, it would have probably been dismissed as so many irrelevant images. Thomas Jefferson introduced the concept of stratigraphic archaeology to the world when he excavated one of the barrows in his native Virginia; he became interested in the problems of Indian origins and history, but scoffed at their historic remains: 'I know of no such thing existing as an Indian monument: for I would not honour with that name arrow points, stone hatchets (3), stone pipes (5), and half-shapen images.'[1] Like so many after him, Jefferson considered this study a branch of natural history – zoology, not archaeology.

In 1787 the Indians were ensured their own land in the Northwest Territory but in the aftermath of the American Revolution settlers poured into the Ohio valley. It was not until the settling of the Ohio country that people began to be interested in Indian mounds, during the closing years of the eighteenth century. The town of Circleville, Ohio was named after the earthworks which were being reoccupied; their shape determined a double ring of streets. By a primitive sort of tree ring dating the Reverend Manasseh Cutler was able to establish that the Marietta mounds were the work of Indians long since departed. In a book published in 1791 William Bartram tells how he was entertained by a Creek chief in Florida upon the top of a mound still in use. Like de Soto, who landed in Florida in 1538, and the early Spanish explorers, he found that the important

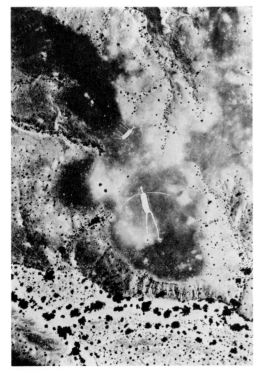

Indian pictographs, Blythe, California
Smithsonian Institution

buildings in Indian villages were placed upon artificially constructed platforms, that are generally known today as temple mounds.

A. E. Gallatin, Secretary of the United States Treasury under Jefferson and a noted student of Indian languages, thought that the mounds, particularly the Cahokia Mound, were the result of ancient Mexican influences, arguing that the cultural drift was from the south northward, not from the north southward. Another amateur of Indian studies, President William Henry Harrison, believed the opposite. The degree of Mexican influence upon North American archaeology is debated to this day. It seems logical now to view the development as a self-sufficient evolution from primitive paleo-Indian associations, with occasional, but crucial, Mezzo-American influences. But the art is definitely self-generated and not a sort of provincial sub-Mexican product.

In a spate of nineteenth-century novels related to the 'Gothic Romance', mound-builder towns were described as being ravaged by a giant mastodon (this explained neatly the well-publicized finding of mastodon bones) or destroyed by an earthquake à la Sodom and Gomorrah. Though he toyed for a while with a Celtic origin for the ancient Indians, receiving confusing advice from European scholars, Henry Rowe Schoolcraft in his classic *History of the Indian Tribes of the United States* (1857) attempted to put an end to such myths, stressing that it was not necessary to invoke higher cultures of a more elevated status, in order to accommodate the presence of the mounds. 'There is nothing in the magnitude and structure of our western mounds which a semi-hunter and semi-agricultural population, like that which may be ascribed to the ancestors of predecessors of the existing race, could not have executed.'[2] He also changed his mind about the Celtic association: 'Foreign archaeologists have attempted to give this inscription (a pictograph on the Taunton River in Massachusetts) an unmerited historical value, as a Scandinavian monument. Having visited the locality, and made it a study, with the aid of an Indian interpreter, I have no hesitation in pronouncing it an Algonquin pictographic record of an Indian battle.'[3] Schoolcraft hit upon an essential concept when he indicated that high technology was not an issue. It is by the Indian measure of things, no matter how impressed we may be, that the mounds are stupefying or vast. They are pure geometry, up to sixty feet high, arrived at through trial and error, in an unscientific environment. These are formal monuments of American archaeology but they are earthen, not marble or even stone clad. Earth was *the* material, stone being reserved for sacred pipes and sculptures. Earth was not temporary, as were the houses made of thatch. Berms, breastworks, pyramids, cones and effigies were permanent earth-sculptures. None of these forms were originally suggested by the surrounding hills. They were meant as opposites – markings.

The Etowah mounds of Georgia, which hid the famous pair of cult figures exhibited here (38) until they were excavated in 1962, is sited on flat land. They were landmarks, not buildings, like the Spiro Mound in Oklahoma and many earlier mound complexes in Ohio, West Virginia, Indiana, Illinois, Wisconsin, and eastern Iowa. They must have had the same effect on the ancients as a skyscraper built amidst fields and trees would have on a contemporary American.

The ancient Americans of the Adena, Hopewell and Mississippian periods were not stone masons; they carved stone as we would wood, and they could not alter rock into slabs. They worked without the mathematical logic required by such architecture, and they moulded hugely, as with clay. One does not have to have a craft society to make an earthen mound and surmount it with a thatched temple, but there must have been an assembly-line-like division of responsibility, and the builders must have had great imagination and perseverance. The celebrated effigy mound known as the Serpent Mound in Adams County, Ohio, is fourteen hundred feet long following the serpentine convolutions, and is surely one of the most succinct and graceful effigies in the world. To dare to build it (actually there are two such mounds in Ohio, but the Adams County one is the most spectacular) took a commitment of extraordinary power, which amounted to a psychic covenant with the serpent deity the mound represented.

The dampness of the climate has eroded all the organic materials so that very little of the archaeology has survived in its original state and nearly all of the textiles have disappeared. Because of their intrinsic interest, a number of objects from the late Archaic period are presented as a preamble to the exhibition (Archaic period 3000–1000 BC). Great Lakes 'Old Copper' implements are something of an anomaly; they are actually products of the

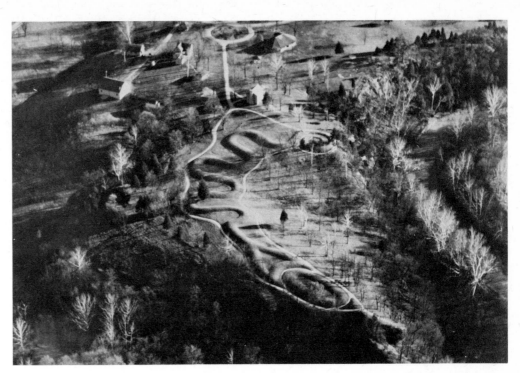

Great serpent mound, Adams County, Ohio
Smithsonian Institution

earliest metallurgy complex in the Americas, though the casting of metal was basically never subsequently learned in North America. That technique came to Mexico via the Andean area and the isthmus of Central America. The implements date from around 1000 BC and are practically identical to implements from northeast Asia. The copper was cold-hammered into tongs, spear points, chisels and knives; some of the copper spear heads are notably fat and socketed (2). The sockets and rivet holes would ordinarily point to a fairly old tradition, but no earlier metal finds have been made, let alone any with a more direct connection with Asia. Both bannerstones and birdstones are found in the north-eastern United States where all those exhibited here come from (1). As pre-mound objects their preservation is frequently due to the farmer's plough. Often there is a high degree of polish and the grain of the stone integrates well into the shape and design. Bannerstones introduce us to the Woodland abstract design tradition, which forms a counterpoint to the naturalistic designs (birdstones) of the subsequent prehistoric periods. They are dated 3000–1000 BC, although they probably belong to the end of that sequence. The birds sometimes have telescope eyes and appear to be nesting. These and the banner-stones, which are of many shapes, are classified as hunting charms and spear weights and may have emerged from the New England polished stone implement and plummet tradition, which was a stone counterpart to the Great Lakes copper culture. Widely distributed in Archaic North America were stone hand and grooved axes. The one exhibited here was found along the eastern border of Kansas (3). This object is beautifully balanced and so refined in colour that it can stand alone as an independent sculpture, not merely as an implement. Originally the groove held thongs which bound the axe to its handle.

In comparison with old world archaeology that of the new world developed late. The two most extraordinary efflorescences, the Hopewell and the Mississippian, date from around 200–300 AD and from about 1300–1500 AD, the latter coinciding with the European Renaissance. Yet an impression of very great age is conveyed by the new world archaeology. When the early hunters crossed from Siberia over twenty thousand years ago, they lost a sense of continuity with their previous culture which explains why their pre-historic art retains a primordial and stylized character, a quality of the beginning of art. This disorientation with regard to time persisted until 1500. In my opinion that is why even the very naturalistic animal effigy pipes of the Hopewell, for all their mastery of observation, remain remote and cold as works of art.

Ancient Indians have left us art of an astonishing power. One way to better understand it is to search for a tribe that lived within historical memory approximately as they did. A

Caddo village
Smithsonian Institution

Southern tribe would be indicated since the last great archaeological period, the Mississippian (1200–1600 AD), was a southeastern development. The Choctaw provide a partial bridge between modern and ancient cultures. They believed that their ancestors issued from a hole in a mound, Nanih Waya, Winston County, Mississippi. They also believed in the immortality of the soul, had a system of honoured officials, and reduced their dead to a basket of bones by the ceremonial picking off of the flesh after a mourning period. The flesh was burned and the bones buried: '. . . sometimes the earth was placed over it to form a mound and sometimes the bones of several villages were carried out and placed in one heap and covered with soil'.[4] Early drawings of John White and De Bey record this practice as early as 1600. Crossed bone designs, handsomely incised on pottery from Moundville, Alabama, and on shell gorgets may indicate the archaeological precedent, at least the regard for bones as treasure, that led to such mourning ceremonies. In earlier Hopewell times, to the North, the bones themselves were incised (11).

The Choctaws played a game called chunkey, common in the southeast, in which poles were hurled after a beautifully smoothed discoidal (a round stone) rolled along the ground. We know from a Mississippian pipe found in Oklahoma that this game was played in prehistoric times, when it may have had some specific significance. Choctaw ball players were gorgeously painted with designs, perhaps not unlike those on Mississippi Valley archaeological pottery (32), red swirls and swastikas, sublimated sun and serpent symbols. When the Spaniards first met Tuscaloosa, a great sixteenth-century Choctaw chief, he was wearing a mantle of feathers that went down to his feet, '. . . and in the storehouses about Cofitachequi were feather mantles (white, grey, vermilion, and yellow), made according to their custom, elegant, and suitable for winter'.[5] Swanton cites an old Creek woman, who lived east of the Choctaws, who could remember feather work: 'As recently as 1907 a Creek Indian remembered that an old woman – the same who recalled the use of textiles made of slippery elm bark – remembered that these were sometimes ornamented with the irridescent feathers of the turkey gobbler arranged in designs'.[6] The ancient vision of a priest attired in his feather cape on top of an earthen temple platform comes to mind.

Choctaw family life was clan oriented to the point where the father had no authority over his children. The towns were well fortified but spread out, with houses sometimes hardly within sight of one another. Southern tribes, especially the Choctaw and Cherokee, readily sent children off to boarding schools or founded seminaries of their own. In the early nineteenth century it must have been embarrassing for a federal official to be addressed by a Cherokee in a style more literate than his own. They were a relatively chaste people, and offered themselves for punishment according to a complex system of retribution, even astonishing Europeans by presenting themselves for execution dutifully at the appointed time and place. This was not mere acquiesence: 'When a Choctaw became angry at an opponent, he was likely to challenge him to a duel in which it was understood that both should die. When such a challenge had been given, it was impossible to refuse except at the penalty of everlasting degradation and disgrace'.[7]

The Southern tribes, even before the removal to Oklahoma, had already descended from the temple mounds. By consulting the costumed figures embossed on copper plates we can attempt to reconstruct the magnificence of their dress, textiles, winged cloaks, masks and sceptres (45). For all its boldness their art also had a subtlety where least expected, as in the feet and toes folded into the underside carving of a bird effigy pipe. One feels that the stone almost apologises for crushing the bird's feet. It is this type of oblique reference that prevents Mississippian period art from being heavy and dull. In historical times the sun religion was weakly structured in comparison with the socio-political sun hedonism along the Mississippi River, where the chief of the Natches was called 'Great Sun' and was carried about on a pillowed palanquin.

One of the earliest of the mound-builder cultures was that of the Adena, and in that culture design became separated from stone work: a raptorial bird motif, often of disjointed complexity, appears on sandstone and slate tablets, with grooves on the back perhaps to facilitate ceremonial blood-letting (6). Among the Adena effigies is the unusual male effigy pipe, identified by Raymond Baby as an acondroplastic dwarf, which is crucial to our knowledge of this archaeology. There was evidently a transition from rock shelter to village living, most of the Adena people dwelling in round houses with conical bark slab roofs and willow wicker sides. Ornaments were made of copper, mica and stone. One plausible explanation for the Adena images is that they developed from the stone plummet, and were

ultimately united to the pipe form. Smoking the pipe constituted an offering to the spirit of the animal represented.

The Adena culture overlapped that of the Hopewell people (Burial Mound II – Woodland Period); Hopewell is named after the mound group of that name excavated by Warren K. Moorehead in Ross County, Ohio, near the Adena Mound. The centre of the culture was in southern Ohio, but with other important centres in Indiana, Illinois and eastern Iowa, and with provincial settlements persisting into Kansas. Picture the present concept of America in reverse, for the epicentre of culture was in Ohio, and the two coasts were not major areas. Hopewell (100–500 AD) has given us some of the most engaging animal carvings known – those on the platform effigy pipes – together with magnificent cut-out symbols of mica, one of the most important of which is the Turner Mound serpent, which shows, in comparison with the earthen serpent mound, that mica was actually the harder material to shape, size notwithstanding. Hopewell forms, two or three dimensional, have a laboured constancy. The earth did not glitter like mica, nor did it have the hardness of the Ohio pipestone which was used to make brilliant effigy pipes. Whatever the medium, one is aware of the patiently complex effects of whetstones, grindstones, hand hammers, chisels, burning out and flint knives.

The founding of the Ohio State Archaeological Society in 1885 fostered professional excavations of the mounds. The Adena Mound was explored in 1901, the Harness Mound in 1906, and the Tremper Mound in 1915. H. C. Shetrone, who excavated Tremper Mound with William C. Mills, notes that it had been extended three times for burial, and that its length was two hundred feet, with a moat-like earthworks surround: 'In a smaller compartment which might be considered the principal vault, there was located a great communal depository, more than ten feet in length, in which were human ashes representing probably several hundred cremations. A third compartment, the shrine room, contained a remarkable collection of articles which plainly had been cherished personal possessions (offerings) of those whose remains reposed in the many depositories, or objects placed there by friends as offerings to their departed companions. These comprised a great number of stone tobacco pipes, some of plain design, but mostly made in the images of birds or animals native to the locality. In addition to the pipes there were many ornaments of stone, flint, mica, pearl and other materials, and displaying the same ingenious skill.'[9] Examination of this mound showed that in common with 'others of its kind, it had been in use by its builders for many years, and that, when for some reason or other it was abandoned, it was intentionally burnt to the ground and the great mound of earth heaped over its side, to serve as a lasting and impressive monument to those whose ashes it covered and protected.'[10] Only leaders could have been so honoured in this cult of the dead.

The most famous collection of Hopewell effigy pipes was assembled by Ephraim George Squier, a Chillicothe, Ohio newspaper man, with the help of Dr E. H. Davis between 1845 and 1847. The collecting was done in the course of an archaeological survey, *Ancient Monuments of the Mississippi Valley*, published by the newly founded Smithsonian Institution. The Squier material which is now in the British Museum is all from the Chillicothe area, and has, for the most part, a homogeneous character. The hawk tearing at a fish engraved in the pipe's platform base is an early example of action in Amerindian art (8g). A heavy-beaked crow or raven remains sluggishly awkward by comparison (8c). Naturalistic observation reaches its highest plane in such platform effigy pipes. The most important revelation for me in the Squier collection is the tiny deer image which is not a pipe at all but a maskette, and which ranks as major lapidary work (8k). There are also several large non-Hopewell pipes that were made south of the Ohio River and traded north (28), and two pipes with southeastern traits, a mountain sheep (30) and a Gulf Coast manatee (29) that Squier accepted as original Ohio material. These little sculptures have a meaning that far outstrips their size. One feels their importance. It has something to do with the salient presentation of each animal, quail, hawk, bear, panther, snake, beaver or squirrel. The most beautifully modelled Hopewell pipe in the exhibition (5) is not from the Squier group. It was included because the bird of prey was subtly placed across rather than parallel to the platform, a successful reversal of the normal Hopewell practice as shown by the Squier pipes. In comparison with this hawk pipe and similar ones from the Tremper Mound (Ohio State Museum), the Squier ones are dry and stiff. They lack the animation of the superb crouching puma pipe (7). Could the Squier material therefore date from later in the Hopewell sequence than is often supposed, during a 'post-classic' phase, say 500

Conch shell mask
Catalogue no. 37

55

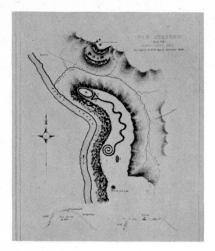

Plan of Great Serpent Mound. 1846
Smithsonian Institution

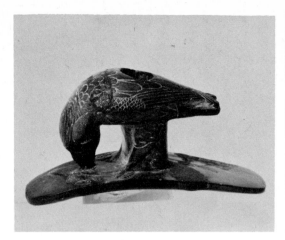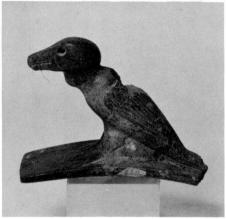

or 700 AD? It is a possibility, especially as the Marksville (Louisiana and adjoining states) Focus pipe (late Burial Mound II 900–1000 AD), with an effigy of a sea-cow or manatee, was found by Squier during his Ohio explorations. The Hopewell culture is now known to have affected Florida, and probably more evidence of Hopewellian activity in the Southeast will eventually be uncovered.

The Hopewell peoples also left fine pottery, textile fragments and miniature clay figurines of themselves. These have been unearthed in Ohio (15), Illinois and eastern Iowa. Though not modelled with the subtlety of the animal effigies, they have a certain refinement and delicacy. They hold infants on their backs, take atlatls in hand, kneel, squat or stand; they are the first genre people in Amerindian art. A number wear ear spools, which is a Mexican custom and in general these figurines recall Panuco (Tampico) II figurines (100–200 AD).[11] Copper was used for beads, ear spools, antler headdresses (one has survived at the Field Museum, Chicago), gorgets and copper cut-out ornaments used as costume appliqués. These appliqués with their curvilinear and crystal-like components look back to the devices applied on ancient Siberian textiles. They may very well reflect a time-dimmed association with Asiatic antler-horn motifs.[12] Great Lakes beadwork also uses similar patterns. It might be hard to believe in such a long design ancestry, if the comparisons were not so clear. Thus Hopewell influence has reached almost up into our own day, undergoing the typical patterns of dormancy, fluctuation and reappearance typical in other spheres of American Indian art.

About the time of the early Romanesque period in Europe the Hopewellian dynamic, however, had passed its prime. The Intrusive Mound culture took its place, with elbow pipes and unadorned platform pipes with keeled edges replacing the magnificent animalism. Why did the elaborate honouring of the dead with serpent-animal ceremonies evaporate? Like Egyptians the Hopewellians had provided the dead with genre figures of the living, but the need for this passed. The answer may lie in agriculture. As corn became more plentiful the system of worship may have seemed less necessary because it was not so crucial to have cultural exchanges with neighbouring centres, in case of local famine. The cults waned. Whatever the cause, the latent humanism of the Hopewellians lapsed and never returned.

When cultism rose again it affected the southern half of the United States, along that belt of ceremonial exchange that stretched from Spiro Mound in Oklahoma through to Moundville, Alabama and to Etowah, Georgia. The mounds now became temples, real ceremonial complexes, no longer quiet tombs for the dead. In general the art was on a larger scale; over a dozen pairs of large cult figures have been found in these southern sites, from Etowah to the Angel site on the north shore of the Ohio River. Mississippian art took on an eccentric and macabre quality. The pipe carvers depicted a crouching man (39), who sometimes hunches somewhat menacingly. One pipe of this period depicts a brutal beheading; a beautifully executed shell gorget from Oklahoma portrays a human kneeling with a severed head in one hand. Temple Mound II (1400–1700 AD) period mounds were surmounted with temples with a stockade displaying such severed heads, and trophy heads became expressive pottery in that part of Arkansas along the Mississippi River (33).

There was a rise of militancy in the art, with certain patterns incised so often they become

Effigy pipes

Far left
Hawk eating another bird, Ohio Hopewell
Left
Turkey Buzzard, Ohio Hopewell

Right
Snake, Ohio Hopewell
Far right
Wolf, Tennessee

Catalogue no. 8

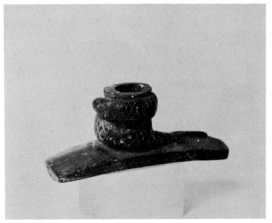
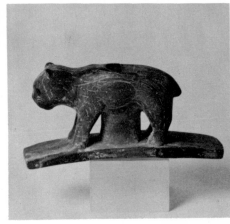

etched into the mind – serpents, hand-and-eye symbols, forked eye motifs, spiders, birds, sun circles, crosses, bi-lobed symbols. Before very long the serpent image was dissolved into a labyrinth of scale patterns interlocked with crosses and directional swirls. Shell gorgets, engraved conch shells and monolithic axes all bear these motifs in differing combinations. Included here is a shell mask with forked-eye design that found its way to Canada, by being traded up the Mississippi River valley. Along with the associations with death, conveyed by a certain lugubriousness in the designs and in the forms, the designs had some propaganda value, symbolically expressing the ideas of what archaeologists loosely call 'The Southern Cult'. The symbols were almost universally understood by the Indians of the time. Falcon-man dancers have survived on embossed copper plates, though their regalia, except for fragments, has not (45).

The more lyrical pottery of the Caddoan area of Arkansas and Louisiana, has poised and closely incised sworl patterns (31), and the so-called 'melon seed' jars with their ovoid elegance are unmatched anywhere else in Amerindian art (34). Only in Florida did the persistence of the cult relax somewhat. The spider became more decorative, and the deer was evidently worshipped as an animal of great beauty (17a). But it was all to fade with the coming of new settlers, which happened so fast that no one wrote down what the massive symbolism of the Southern cult was really about, and its iconography remains a puzzle to this day.

'What influences acted to bring all this about?' the sculptor Henry Moore recently asked on looking at a number of Mississippian objects destined for inclusion in this exhibition. It is always being suggested that such works resemble objects from pre-Columbian Mexico or the Caribbean, as if they could not be appreciated within their own context properly. Yet nothing in North America looks like any of the known artifacts from either area, though tantalising resemblances are there. Late archaeological discs or palettes look like Tajin or Aztec work; engraved shells and gorgets distinctly call to mind nearly contemporaneous Huaxtec shell engraving. These two examples indicate an influence coming up from the Gulf of Mexico's west coast and over into the southeastern area. Writing about an Alabama limestone palette with fine rattlesnake designs and feather-like markings, Lee Parsons observed: 'Once again both the double serpent and the plumed serpent concepts figure prominently in pre-Columbian Mexican art where these images are identified with the deity, Quetzalcoatl (the "feathered serpent").'[13] One can postulate a Mexican superimposition over the old Adena-Hopewell serpent, bearing in mind the fact that a Hopewell mica cut-out ornament exhibited here already features plumes above the head (9), and that the forked eye or tear motif is also older than Mississippian times (37). It is also rewarding to trace the migration of the slope-shouldered concave sided pot. Donald Lathrop has recently pointed out that the ancient trade between Ecuador and the Pacific coast of Mexico eventually implanted this pottery form into Mexico, where one sees it in Taltilco wares.[14] The story can be carried still further; the final home of this type of ware was in Arkansas, about 1400–1600 AD where the shape of the pots is actually accordion-sided. Caddoan dog effigy pots from Louisiana and Arkansas may well owe something to Mexican Colima predecessors, and there are a number of other concordances.

The rugged approach of this art, despite the small size of many of the objects that are left,

makes the works seem very important, and the images can be read directly as crucibles of power. Even an axe can be read that way, whether Archaic or Mississippian (35). In the final analysis these are not humble objects at all. They are potent works created by a dour people, obsessed with their cults, the memory of which is forever imprisoned in the silent archaeology they have bequeathed us.

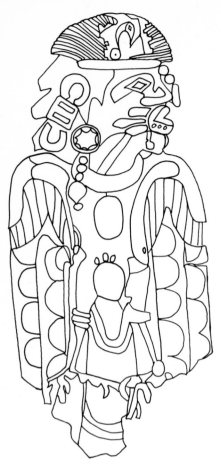

Drawing of Wulfing plate
Catalogue no. 45

Notes

1 Thomas Jefferson, *Notes on the State of Virginia*, Chapel Hill, University of North Carolina Press, 1955, p. 97 (First published in 1781)

2 Quoted from Robert Silverberg, *The Mound Builders*, New York, Ballantine Books, 1974, p. 51

3 Henry Rowe Schoolcraft, *History of the Indian Tribes of the United States*, Philadelphia, J. B. Lippincott & Co., 1957, pp. 113–114

4 Angie Debo, *The Rise and Fall of the Choctaw Republic*, Norman, Oklahoma, University Press, 1971, p. 6 (originally published 1934)

5 John R. Swanton, *The Indians of the Southeastern United States*, Washington, Smithsonian Institution, Bureau of American Ethnology, Bulletin 137, 1946, p. 455

6 Swanton, *op. cit.*, p. 455

7 Angie Debo, *op. cit.*, p. 23

8 Roy Hathcock, *Ancient Indian Pottery of the Mississippi River Valley*, Camden, Arkansas, Hurley Press, Inc., 1976, plate 263

9 Henry C. Shetrone, *The Indian in Ohio*, Ohio Archaeological and Historical Quarterly, Vol. 27, 1918, pp. 490–91

10 Shetrone, *op. cit.*, p. 492.

11 J. B. Griffin, R. E. Flanders, P. F. Titterington, *The Burial Complexes of the Knight and Norton Mounds in Illinois and Michigan*, Ann Arbor, Memoirs of the Museum of Anthropology, University of Michigan, No. 2, 1970, p. 70

12 Sergei I. Rudenko, *Frozen Tombs of Siberia, The Palyryk Burials of Iron Age Horsemen*, Berkley University of California Press, 1970, plates 77, 79, 80, 82, for illuminating Siberian parallels to Hopewell metal designs

13 L.A.P. (Lee A. Parsons) *Prehistoric American Indian Stonework*, The St Louis Art Museum Bulletin, September–October 1974, p. 74

14 See *Ancient Ecuador: Culture, Clay and Creativity* (text by Donald L. Lathrop, catalogue by Donald Collier and Helen Chandra), Chicago, Field Museum of Natural History, 1975, Ch. VI, and No. 604. For the Caddoan 'cousin' which ends this migration see Frederick J. Dockstader, *Indian Art in America*, Greenwich, Conn., New York Graphic Society, 1961, No. 31

1 **Birdstones and bannerstones**
Late Archaic or Early Woodland Period
3000–1000 BC

a **Slate birdstone**
Ontario, Middlesex County
34038

b **Slate birdstone**
No location
915.8.20

c **Slate bannerstone**
Ontario, Lambton County, Plympton
Township
180

d **Slate bannerstone**
Ontario, Middlesex County, Mosa
Township
37299

Lent by the Royal Ontario Museum

Bannerstones and birdstones are difficult to
date – they seem to have been made over a
long period of time in the Archaic period
(3000–1000 BC). In order to avoid the
controversies that have arisen over
widespread faking of such objects, these
have been selected from the archaeological
holdings of a Canadian museum, where
documentation can be trusted. They range
in size from 4 cm to 10 cm in length.

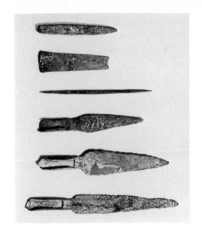

2 **Six 'old copper' culture objects**

a **Spearhead of copper**
Princeton, Green Lake County
Wisconsin
68038 20 cm long

b **Spearhead of copper**
Greenville, Ontagomie County
Wisconsin
168166 15.5 cm long

c **Spearhead of copper**
Camp McCoy, Wisconsin
205269 18 cm long

d **Copper chisel**
Ontagomie County, Wisconsin
52296 10.5 cm long

e **Copper celt**
Princeton, Green Lake County,
Wisconsin
68123 9.5 cm long

f **Copper punch**
No information
68200 15 cm long

Lent by the Field Museum of Natural
History

The old copper culture of
Minnesota–Wisconsin is something of an
enigma as some of its artifacts – socketed
spear points (*a–c*) and punches with pointed
stems (*f*) among them – are very similar to
ancient Asiatic iron tools. Perhaps the
tradition of Asiatic forged bronze and iron
tools was translated into hammered copper
in the New World in the Great Lakes area
where nugget copper was plentiful. One can
postulate a related stage, the ivory
implements of Dorset Eskimo, found at
Cape Dorset, Hudson Straight, but their
culture dates later (*c* 100 BC) than old
copper (*c* 1500–1000 BC). Similar tools were
made of stone during the late Archaic period
in New England. The use of metalurgy in
Minnesota and Wisconsin antedated
metalurgy in Mexico by 1000 years and is
the oldest known in the New World.

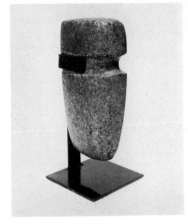

3 **Axe** Late Archaic, *c* 1000 BC
Missouri–Kansas border
Granite 20 cm long, 8.8 cm deep
Lent by Donald D. Jones

Found near Stanley, Kansas, in 1963, this
grooved axe may date as late as the late
Archaic. Axes of this general type are to be
found in many parts of the United States
and Canada and are ascribed by
archaeologists to the Archaic period. Few
are as beautifully formed as this or in such
attractive stone. Missouri axes are
associated with the Nebo Hill horizon after
the site excavated by J.M. Shippee. 'Nebo
Hill points resemble those of the Guilford
Complex which is believed to be more than
6000 years old. Grooved axes are found on
Nebo Hill sites. Since these are surface
finds, however, there is no proof that they
are the same age as the points.' (H.M.
Wormington, pages 146–147.)

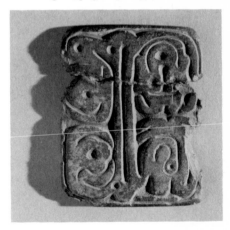

4 **The Waverly Tablet** *c* 100 AD
Ohio, Adena
Shale 8.6 cm long, 7 cm wide (maximum)
Lent by the Cincinnati Art Museum

The Waverly Tablet is not among the
twelve known Adena Tablets listed by
Webb and Baby (page 83 ff), but it should
be added to their Group III. It shows the
highly stylized features of a reptilian bird
common to the majority of these tablets.

While the uses of Adena Tablets are not known, 'Evidence is accumulating that Adena had already developed a fairly complex ceremonial burial association, which pointed to some kind of cult of the dead. . . . Such a burial cult required for its maintenance, growth and development the participation of its adherents at public ceremonies on "feast days" and other special occasions. On such occasions it might well be that a considerable portion of a village displayed by dress or ornamentation their adherence to the concepts of the cult. This might have been done with images of the deities or with other religious motifs. It is believed that Adena tablets were engraved and used to meet this end.' They may also, on the unengraved side, have been used to sharpen awls for ceremonial blood letting. Found by its first owner, Robert Clarke, at a mound in Waverly, Ohio. Lent to the Cincinnati Museum since 1890 and given to the museum by Clarke's heir, Mrs William Galt in 1939.

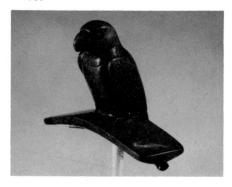

5 **Effigy pipe** 300 BC–1 AD
Naples, Illinois
Indurated clay-stone 11 cm long, 8.5 cm high, 3 cm wide
On loan to the Brooklyn Museum from the Guennol Collection L49.3.1

This platform pipe in the form of an eagle or hawk is one of the masterpieces of Hopewell culture. The hollow eyes are filled with metal and the incised feathers and tail are exceptionally graceful.

It was found in about 1832 by Daniel Burns, John W. Winsor and others when digging a grave on the large mound which lies on a bluff above the Illinois River. It was found inside a stone bowl along with another bird pipe, a frog pipe and a copper gouge.

Writing in 1882 John G. Henderson said: 'Of this pipe Dr Charles Rau says: "It is certainly the finest mound pipe thus far known. . . . Not having been exposed to the action of fire like the Ohio pipes, it has suffered no damage whatever, and is as perfect as on the day when it was made."' (see John G. Henderson, 'Aboriginal Remains near Naples, Illinois', *Annual Report of the Smithsonian Institution for the Year 1882*, pages 686–721.)

Formerly owned by Mrs E.C. Bickerdike and Mr Byron W. Knoblock.

6 **Stone tablet** Pre 700 AD
Ohio, Adena
Stone 11 cm high, 8 cm wide
Lent by the Cincinnati Historical Society

This Adena tablet was excavated from a now destroyed mound, located in present day Cincinnati at Fifth and Mound Streets, in 1841. 'The principal grave, however, from which the mound was commenced, was found nearly on a level with the original surface and contained a much decayed skeleton, of which a portion of the skull is still in the possession of Mr Jest, who was the owner of the ground on which the mound stood. Under the skull was found the stone known as the Cincinnati Tablet, with two polished, pointed bones about 18 cm long, charcoal and ashes.' F.J. Heer, *The Mound Builders of Cincinnati*, Ohio Archaeological and Historical Publications, 1909, volume 18.

Squier speculated that the design of the tablet 'resembles the stalk and flowers of a plant than anything else in nature'. Today we consider that parts of a raptorial bird are represented. The three grooves may be for ceremonial blood letting. Wells and Baby classify this tablet in their group III.

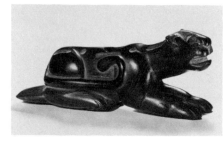

7 **Effigy pipe** c 200–400 AD
Indiana, Posey County, Hopewell
Steatite 16 cm long, 6 cm high, 4 cm wide
On loan to the Brooklyn Museum from the Guennol Collection L49.5

This crouching puma with curling tail has the bowl at the centre top and the mouth piece on the animal's back. The eyes and animal spots were once inlaid. Although it does not have the typical Hopewell platform shape, neither does it fit into the style of Southern death cult material.

Discovered by Henry Mann in 1916 as a surface find east of Mount Vernon, Indiana. At the time the right front leg was missing, but it was found on the site in 1938. The Mann site includes pottery with Woodland, Hopewell and Marksville affinity, together with stamped wares from the southeast (Mississippi Period).

Formerly owned by Joseph Geringer, Claude U. Stone, Byron W. Knoblock and then A. Bradley Martin.

8 **Fourteen effigy pipes** 100 BC–600 AD
Ohio, Hopewell culture, Woodland period from Mound 8, Mound City
Slate or limestone
Lent by the Trustees of the British Museum

a **Kingfisher**, Ohio pipe in the form of a bird
9.5 cm long, 4.5 cm high, 4 cm wide
S 241

b **Crow**, Ohio pipe in the form of a bird's head
10.7 cm long, 5 cm high, 4 cm wide
S 242

c **Crow**, Ohio pipe in the form of a squatting bird
9 cm long, 5.5 cm high, 3.25 cm wide
S243

d **Turkey buzzard**, Ohio pipe
7.5 cm long, 6 cm high, 3.5 cm wide
S 246

e **Hawk**, unfinished Ohio pipe in the form of a bird
7.5 cm long, 5.5 cm high, 3.25 cm wide
S 248

f **Hawk**, fragmentary Ohio pipe in the form of a bird of prey
5 cm long, 5 cm high, 3.75 cm wide
S 249

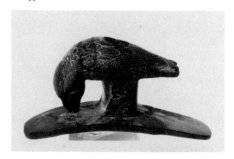

g **Hawk**, Ohio pipe in the form of a hawk eating another bird
10.5 cm long, 4.5 cm high, 4.2 cm wide
S 257

h **Weasel**, Ohio pipe in the form of a small rodent
6.5 cm long, 3.5 cm high, 3.5 cm wide
S 258

i **Snake**, Ohio pipe found enveloped in a sheet of mica and copper
8.5 cm long, 4 cm high, 3 cm wide
S 282

j **Carnivorous animal**, Ohio pipe from Ross County
31 cm long, 5.5 cm high, 7.5 cm wide
S 331

k **Deer's head**, black stone
10.5 cm long, 2.25 cm high, 2.5 cm wide
S 324

l **Feline animal**, Ohio pipe, southern focus, post Classic Hopewell
7 cm long, 5.5 cm high, 3.75 cm wide
S 272

m **Tufted cherry bird**, Ohio pipe
9 cm long, 5.75 cm high, 3.75 cm wide
S 5227

n **Wolf**, Ohio pipe from Ross County in the form of a feline animal
Chlorite
9.5 cm long, 4.5 cm high, 2.75 cm wide
S 276

This group of Hopewell animal and bird effigy pipes of platform type was collected by Ephraim George Squier, a newspaper editor from Chillicothe, Ohio, and Dr E.H. Davis, between 1845 and 1847, during the course of a survey of ancient Ohio mounds. Squier's report, the first of the Smithsonian Institution's *Contributions to Knowledge* series, is one of the landmarks of archaeological history. Since many of the sites he described have been destroyed (the process continues today), the report ('Ancient Monuments of the Mississippi Valley', New York, 1840) is invaluable for its drawings and elevations of the lost sites. Squier was posted by President Taylor to Central America in 1849. Before leaving he tried unsuccessfully to sell his collection. It was eventually purchased by William Blackmore, London, in 1864. He was willing to donate the pipes to an American institution, 'but some museums (including the Smithsonian) were not interested in having them, and others did not have the space to display them properly' (Robert Silverberg, page 63). The Hopewell pipe-makers excelled at capturing the essence (pose, demeanour, typical gesture) of the animal portrayed in a highly sympathetic way.

A guide was published to the collection, E.T. Stevens, *Flint Chips, a Guide to Pre-Historic Archaeology as Illustrated by the Collection of the Blackmore Museum, Salisbury*, London, Bell and Daldy, 1870.

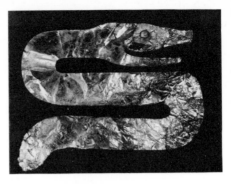

10 **Snake** *c* 200–500 AD
Ohio, Hopewell
Mica 26 cm high, 33 cm wide
Lent by the Peabody Museum of
Archaeology and Ethnology, Harvard
University 29683

The Turner Mound in Hamilton County, Ohio, yielded this stylized mica silhouette ornament of a serpent (found in mound IV), along with a number of delicately modelled clay figurines (see number 15) and some pattern-incised bones (number 11). With others of its class it has been called a clothing ornament, although there is no means of attachment and the material is extremely friable. The mica comes from mines in Virginia and North Carolina, and must have been a much sought after trade item with its silvery, magical translucence. H.C. Shetrone excavated a mica hand symbol from the Hopewell Mound in 1902 which is now in the Ohio State Museum, and another hand, together with a headless figure effigy, is at the Field Museum. This art in mica is uniquely Hopewellian and is among the most mysterious of ancient indigenous cultural manifestations. What did these objects signify? This serpent might be a product of the same concept (a serpent cult) that made possible the gigantic serpent earthwork mound in Adams County, Ohio. The hand silhouette might be an early manifestation of the hand and eye symbolism, found in Mississippian times, which carried on into Plains Indian 19th-century painting.

11 **Bone** *c* 200–400 AD
Ohio, Hopewell
Human bone 14 cm long
Lent by the Peabody Museum of
Archaeology and Ethnology, Harvard
University A456

From the Turner group of mounds, Hamilton County, Ohio. Collected by F.W. Putnam, curator of the Peabody Museum, and C.L. Metz in 1889, found in altar I, trench I.

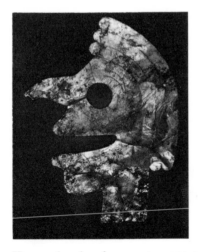

9 **Human head and serpent** *c* 200–500 AD
Ohio, Hopewell
Mica
a 30 cm high, 25 cm wide;
b 21 cm long, 3 cm wide
Lent by the Peabody Museum of
Archaeology and Ethnology, Harvard
University 30002, 30003

These are more realistic than most Hopewell mica ornaments, in that details are incised. From mound III of the Turner Mound group the largest of six mounds on the site; it was twelve feet high, containing one altar on which this head image was found, an ashpit under the mound and a refuse pile.

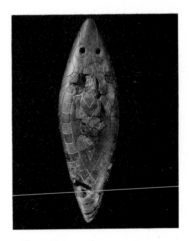

12 **Effigy dish** *c* 100–200 AD
Ohio, Hopewell
Stone 27 cm high, 9 cm wide
Lent by the Peabody Museum of
Archaeology and Ethnology, Harvard
University 29684

This horned toad or lizard-like 'monster' is one of the most wildly unorthodox Hopewell images. Like the mica serpent (number 9) and male figurine (15), it was found in mound IV of the Turner Mound group and, like them, was an altar offering. Its hatched designs relate to bone incising. The Turner Mound was excavated by F. W. Putnam and Dr C. L. Metz, Madisonville, Ohio, in May–December 1882.

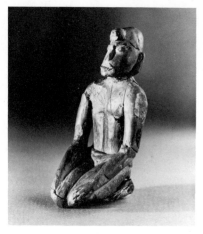

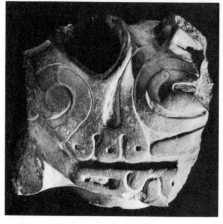

13 Copper plate
Ohio, Liberty Works, Hopewell
Copper 13 cm high, 14 cm wide
Lent by the Peabody Museum of
Archaeology and Ethnology, Harvard
University 35053

This plate represents an eagle. Note the
punch work delineation of eye and crest
area. It was found in Mound 3, Liberty
Works, on an ash bed surrounded by
human bones, in 1884. The mound was on
the land of Edwin Harness.

15 Kneeling figure 200–600 AD
Ohio, Hopewell
Clay 7.5 cm high, 3.5 cm wide
Lent by the Peabody Museum of
Archaeology and Ethnology, Harvard
University 29687

A number of these figurines in low-fired
terracotta came from the Turner Mound,
and have aided in reconstructing the
appearance of the Hopewell people. This is
sculpturally one of the finest of the group.
Another similar Turner Mound group of
figures is in the Milwaukee Public
Museums. The most realistic group of all,
including a maternity figurine, a figure
holding an atlatl (spear thrower), and a
mother carrying a baby on her back comes
from the Knight Mound in Calhoun
County, Illinois (Elaine Bluhm Herald,
'Middle Woodland Indian Life', The
Palimpset, State Historical Society of Iowa,
Iowa City, December 1970, figure 5). These
are the earliest North American genre
representations.

16 Harness head
Ohio, Liberty Works
Stone 4.5 cm high, 3.5 cm wide
Lent by the Peabody Museum of
Archaeology and Ethnology, Harvard
University 35002

A portion (feline or human) of a carved
pipe. It was found in a large mound within
the Great Circle, near the west corner of the
square of earth works in Liberty Township,
Ohio, in 1884.

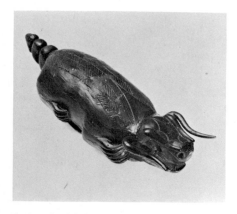

14 Animal with horns 100–200 AD
Ohio, Hopewell Turner Mound IV
Stone 26 cm long, 7 cm wide
Lent by the Peabody Museum of
Archaeology and Ethnology, Harvard
University 82–35–10/29685

This remarkable animal-reptile effigy is
perhaps the most complete and expressive
example of middle-period Hopewell
cultism. The tail has a rattle, on
the bovine-like head there are horns and the
small feet are pressed close to the body. The
hollowed-out form indicates use as a
container although the ritual function is
unknown. Collected in 1882 by F. W.
Putnam and Dr C. L. Metz, Madisonville,
Ohio.

17 **Four objects from Key Marco**
800–1400 AD
Florida, Key Marco

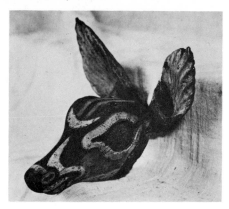

a **Deer mask**
Wood, paint
8.5 cm high, 8 cm wide, 16 cm deep
40707

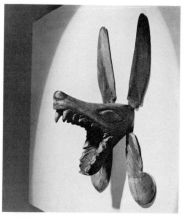

b **Wolf mask**
Wood, paint
30 cm high, 18 cm wide, 15.3 cm deep
40700

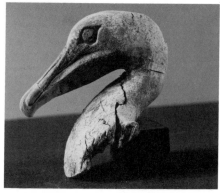

c **Pelican**
Wood, paint
11 cm high, 6 cm wide, 6.8 cm deep
40708

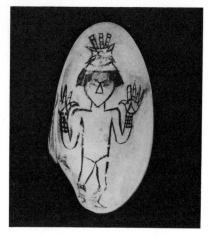

d **Valve shell**
Shell, paint
9.5 cm high, 9.8 cm wide, 1 cm deep
40796

Lent by the University Museum, Philadelphia

These important pre-contact works were found on Frank Hamilton Cushing's explorations of the Key Marco shell mounds in 1895 (see F. H. Cushing, 'Explorations of Ancient Key Dwellers' Remains on the Gulf Coast of Florida', *Proceedings of the American Philosophical Society*, Vol. XXV, 1897, no 153, pages 329–432). 'We found two of the figureheads – those of the wolf and the deer – thus carefully wrapped in bark matting, but we could neither preserve this wrapping, nor the stripe of palmetto leaves or flags that formed an inner swathing around them. . . . Near the northernmost shell beach . . . was found, carefully bundled up . . . the remarkable figurehead of a wolf with the jaws distended, separate ears, and conventional, flat, scroll-shaped shoulder or leg pieces, designed for attachment thereto with cordage. . . . In another portion of the court the rather diminutive but exquisitely carved head, breast, and shoulders (with separate parts representing the outspread wings, near by) of a pelican was found, and in connection with this, a full-sized human mask of wood, . . .'.

Unfortunately many of the Key Marco finds, including the pelican's wings, shrunk beyond repair in the drying process. The carvings are extremely sensitive; note the fluting of the deer's ears (carved antlers and tortoise-shell eyes were once attached). The deer may relate to the ancient Ohio tradition. Among the other objects which were found was a painted shell 'representing a man, nearly nude, with outstretched hands, masked and wearing a headdress consisting of a frontlet with four radiating lines – presumably symbols of the four quarters . . .'.

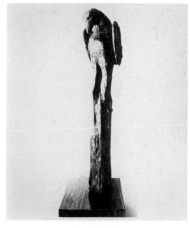

18 **Eagle pole** 500–800 AD
Florida, Hopewellian
Wood 1.57 m high (eagle 61 cm)
Lent by the Florida State Museum

Two animal effigy poles have been rescued so far from the Florida swamps and waterways; this eagle and a better preserved owl, 12 feet high, dredged from the Saint Johns River in 1955 (see R. P. Bullen, 'Carved Owl Totem de Land, Florida,' *The Florida State Archaeologist* volume VIII, no. 3, September 1955). The eagle was found in 1926 in Fish Eating Creek, west of Lake Okeechobee. The head is a conjectural reconstruction by the Florida State Museum. Carved from southern yellow pine, the burnt surface has been cleaned. Perhaps originally incised, as in the case of the owl where incision patterns were quite well preserved. This pole was found by Melton Norton 100 feet east of a large Indian mound called Fort Center, Glades County. While the pole has traditionally been attributed to the Calusa, *c* 1600 AD, such a late date is now highly doubtful in view of the discovery by W.H. Sears of a convincing number of Hopewell-like traits at Fort Center (see W.H. Sears, 'Food Production and Village Life in Prehistoric Southeastern United States', *Archaeology*, vol. 24, no. 4, October 1971, pages 322–329). He identified several wooden images (otter, buzzard, hawk, waterbird) that were once tenoned to poles and set upon a charnel platform in a pond. The eagle would have been used in this way as a clan or cult symbol. The nature of the corn planting and earthworks at this Hopewellian site suggest a connection between the northeastern and southeastern cultures with a later dating for the Florida focus. The animal-bird cult images at Fort Center can be seen as the earliest known examples of a tradition that extended to Key Marco; the concept of palisaded images on earth platforms may stand behind the much later Temple Mound II (1400 AD) mounds which had skulls attached to poles.

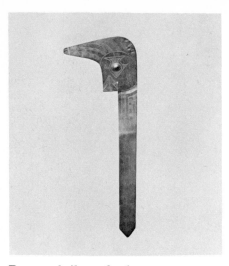

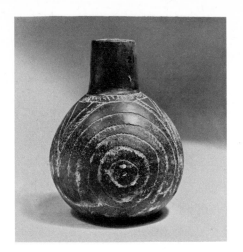

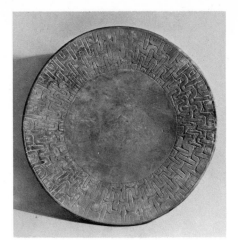

22 Plate *c* 1500–1700 AD
Louisiana, Mississippian period
Clay 7.3 cm high, 41.4 cm diameter
Lent by the Field Museum of Natural
History 207931

This plate was pounded on a mould, with resultant variations in thickness. The four-inch outer rim features U-shaped (serpent) continuous motifs. The incised serpents coil around oblong centres. Half serpents are incised around inner and outer rim borders. 'L'eau noir' incised, Plaquemine culture. Found on the Medora site, west Baton Rouge parish.

19 Engraved silver of unknown use
c 1600 AD
Florida, Punta Rassa
Silver 23.5 cm high, 8.7 cm wide
Lent by the University Museum,
Philadelphia

Excavated at the mouth of the Caloosahatchee River near Sanibel Island on the west coast of Florida. A similar gold ornament was found in central Florida (see John W. Griffin, 'Historic Artifacts and the Buzzard Cult', *Florida Historical Quarterly*, April 1946, pages 296–301) and two similar ornaments were found in Brevard County, one of copper and the other of silver. All date from pre-contact times and have designs which may indicate a spider cult.

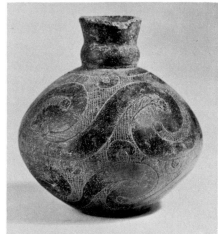

21 Two bottles 1200–1600 AD
Arkansas, Mississippian period
Clay
a 15 cm high, 11 cm diameter
b 13.5 cm high, 13 cm diameter
Lent by the Field Museum of Natural
History 21969, 50251

Two different solutions to the late Mississippian Caddoan clay bottle. *a* is straight necked with three concentric roundels of seven circles each. It is pebble-polished with the 'white' incising actually the colour of the non-polished clay. *b* has two levels of running rinceau with dots and hooks with cross-hatched filler that bring out the eliptoid shape of the bottle. The swollen neck ring echoes the point of maximum diameter. From Caddo Indian burying ground, Arkansas River, Arkansas.

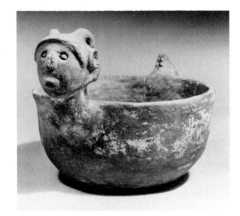

20 Effigy bowl 1200–1600 AD
Arkansas, Mississippian period
Clay 14.5 cm high, 24 cm wide
Lent by the Field Museum of Natural
History 50693

The horned human has a Southern Cult topknot of the type found on stone cult images (see number 40). This pot appears to be so low-fired that it was 'warmed' rather than fired in the recent meaning of the word and stirred out of the ashes with ash patina. Found in Saint Frances County, east central Arkansas.

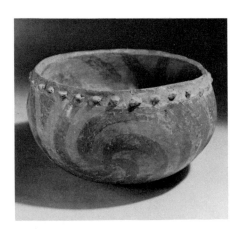

23 Bowl 1200–1600 AD
Arkansas, Mississippian period
Clay, paint 11.5 cm high, 20 cm diameter
Lent by the Field Museum of Natural
History 50259

A Caddoan pot, red on buff. It is decorated with a variation on the swastika design, one of the earliest of Indian motifs and often encountered in Arkansas archaeological painted ware. Note the tension between the outside and inside designs.

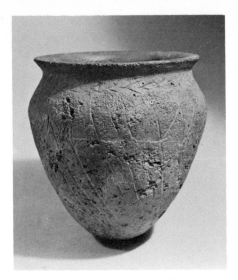

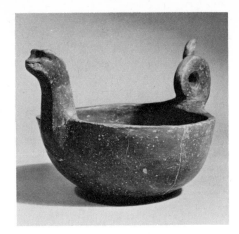

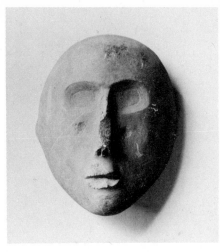

24 **Pointed bottom pot (restored)**
New Jersey, Woodland period
Clay 14 cm high, 11.5 cm diameter
Lent by the Field Museum of Natural
History 204522

This pot represents a widespread pottery
type made throughout the Woodland
periods in eastern North America with basic
similarities both in shape and decoration to
Siberian bronze age pottery. (See C.C.
Willoughby, *Antiquities of the New England
Indians*, Cambridge, 1935). It is from an
undesignated location in New Jersey.
Comparable work is found from Maine to
Virginia. For a similar profile in a Chinese
neolithic ceramic from Shansi see Thomas
Dexel, *Die Formen Chinesischer Keramik*,
figure 1, number 6. Kwang-chih Chang (in
The Archaeology of Ancient China, New Haven,
Yale University Press. 1968, figure 44, page
135) illustrates a pot with flared rim (Miao-
ti-kou II culture) that clearly illustrates the
distant Oriental connection of Woodland
pottery.

25 **Effigy pot**
Arkansas, Mississippian period
Clay 13.5 cm high, 21 cm diameter
Lent by the Field Museum of Natural
History 50812

Found in Cross County, Arkansas. The
monster head and coiled tail pass through
the body of the pot in a mucilaginous way.
This serpent bowl appears in George
Valliant's pioneer book, *Indian Arts of North
America*, plate 29. Another monster pot with
coiled tail from the Walls site, De Soto
County, Mississippi, is illustrated in James
B. Griffin, *Archaeology of the Eastern United
States*, figure 127f.

27 **Mask** *c* 1200–1600 AD
Ohio (?), Mississippian Period
Yellow ferruginous sandstone
21.5 cm high, 17 cm wide
Lent by the Cincinnati Art
Museum 1938.5124

The yellow sandstone of this mask is now
grey with grime. It probably represents an
ancestral figure, deposited as a burial
offering. When the exact place of origin is
unknown, masks of this type are usually
attributed to Tennessee, because in the
Temple Mound II period western
Tennessee produced some of the most
ambitious stone sculpture in the eastern
United States (see Gordon Willey, page
300). Other masks of this type have been
found in Georgia, Kentucky and southern
Ohio; the Ohio examples may have
reached there through trade. The mask
may have been part of the Cleneay gift of
1887, but was not officially part of the
Museum's collection until 1938. Another
Ohio stone head, impassive in feature, but
more sculptural, was found in the Heinisch
Mound (see F. Dockstader, plate 19).

26 **Pottery vessel** *c* 1200–1600 AD
Missouri, Mississippian Period
Clay 8.8 cm high, 26 cm long
Lent by the Nelson Gallery of Art/Atkins
Museum (Nelson Fund) 32–73/17

This yellow clay vessel in the shape of a
conch shell was a substitute for the
expensive shell itself. The detailing is very
accurate but in form the vessel is wider and
less curved than a true conch. Found in
Pemiscot County in extreme southeast
Missouri.

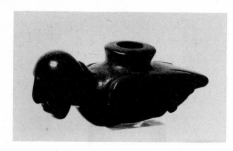

28 Bird/human head effigy pipe
500 AD or later
Ohio
Green stone
8.5 cm long, 4 cm high, 3 cm wide
Lent by the Trustees of the British Museum
S 315

While this pipe was found in Ohio by
Squier and Davis, it is not a platform pipe
of the Ohio, Indiana, Hopewell type. The
bird-man recalls the human/bird
ceremonial copper plaques of the
Mississippian Period, 850–1500 AD. For
similar pipes see Raymond C. Vietzen, *The
Ancient Ohioans and their Neighbours*, privately
printed, 1945, figs. 96–97.

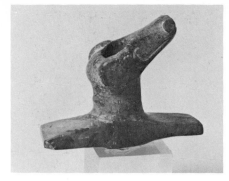

30 Ohio pipe, 'sheep, deer or elk'
900–1100 AD
Gulf of Mexico coast, Marksville culture
Slate or limestone
8 cm long, 6.5 cm high, 3 cm deep
Lent by the Trustees of the British
Museum S 261

This pipe may represent a mountain sheep.
Although found in Ohio by Squier and
Davis it must have be made to the south,
like the 'sea cow'.

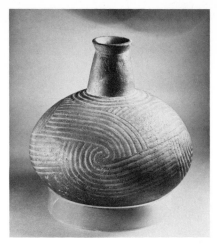

32 Pot *c* 1200–1600 AD
Arkansas, Mississippian Period
Clay 18 cm diameter, 23 cm high
Private Collection

29 Effigy pipe, 'sea cow' 900–1100 AD
Louisiana, Marksville culture
Clay 9 cm long, 5 cm high, 3.75 cm wide
Lent by the Trustees of the British
Museum S 264

Though considered by its collector E.J.
Squier to this day to be an Ohio Hopewell
pipe, this effigy would seem to have been
made by the Marksville people of Louisiana
and the Gulf Coast–lower Mississippi valley
area, who flourished 900–1100 AD (see P.S.
Martin, G.I. Quimby and D. Collier, pages
406–409, figure 99). They made some clay
effigy platform pipes resembling the
Hopewell type, but of a less refined and
heavier style. That pipes of Marksville type
were found in the Ohio area gives rise to
speculation about late
Hopewell–Marksville trade. As early as
1870, Stevens, the author of *Flint Chips*, also
speculated about this pipe (page 429). 'This
animal (sea cow) is found in tropical
regions. Seven sculpted figures of the
Lamantian have been obtained from the
mounds, of which three are nearly perfect –
yet these figures represent animals not met
with on the spot (Ohio), but found a
thousand miles distant upon the shores of
Florida.'

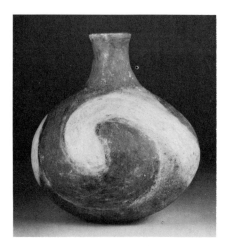

31 Pot 1200–1600 AD
Arkansas, Mississippian period
Clay, paint 22 cm high, 18 cm wide
Lent by the University of Arkansas
Museum

A superior example. The four spiral motifs
do not usually cross one another on pots of
this type; perhaps a wind symbol. From
Camden Bottoms, Yell County, in west
central Arkansas.

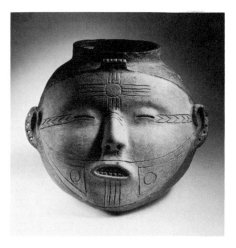

33 Head pot 1200–1600 AD
Arkansas, Mississippian period
Clay, paint 13.8 cm high, 18 cm diameter
Lent by the University of Arkansas Museum

These head pots occur in northeastern
Arkansas by the Mississippi River. They are
among the most brutal and astonishing
images in pre-Columbian North American
Indian art. A sun-wind symbol, typical of
the Southern Death Cult is incised on the
forehead. Hanging ornaments from the
forehead flange and pierced ears would
have added to the realism. The eyes are
closed, and the mouth drawn open in death.
Found at Bradley site, Crittenden County.
Real trophy heads played a part in the
ceremonies of the Temple Mound Period in
Tennessee, across the river. A Summer
County, Tennessee, round shell gorget
shows a dancer holding such a head by the
hair (see E. and M. Foreman, plate 46,
upper left).

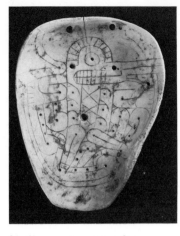

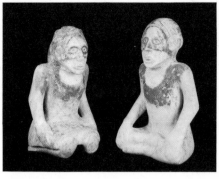

34 Melon-shaped jar *c* 1200–1600 AD
Arkansas, Mississippian period
Clay 27 cm high
Private Collection

The shape of this jar is unique to Arkansas.
It possibly held seeds, but use has not been
determined. It is distinguished by the
incised decorations at the top, which
emphasize the melon shape, and define the
tiny orifice. Note the subtle fire cloud
shadings and mottling on the pot's dark buff
body. From Clark County, south central
Arkansas.

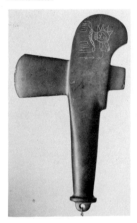

35 Axe *c* 1400–1600 AD
Georgia, Mississippian Period
Stone
33 cm high, 20 cm wide (across blade)
Private Collection

Made for ceremonial usage, this
Southeastern blade is probably a stone
reproduction of a functional axe. Holes
have been pierced in one end.
Sandpolishing was used to burnish the
surface. Only one axe from each site in the
Southeast was engraved like this one, using
stone tools only, with a bird of reptilian
form. From its beak a 'speech symbol'
descends and on the opposite side are
carved two hand and eye symbols, typical of
the Southern Cult. From the Etowah
Mounds, Bartow County, Georgia.
Labelled, 'Found in the fall of 9/19/1884';
owned originally by the collector Hubbs of
St Louis, Missouri.

36 Shell gorget 1200–1600 AD
Tennessee, Mississippian Period
Shell 17 cm long
Lent by the Peabody Museum of
Archaeology and Ethnology, Harvard
University 20124

This gorget has complicated figure designs
representing a kneeling, winged man. It
was collected by Dr Charles Pickering in
1843–1844 from a mound on the north bank
of the Hiwassee River in Meigs County,
Tennessee; it was found in association with
a human skeleton.

Mississippian shell work reached a high
level of sophistication, quite probably
influenced by the Huaxtex shell engraving
of northern Mexico. It can also be seen as a
continuaticn of the Hopewellian bone
incising tradition, grown more pictorial and
less hieratic in style.

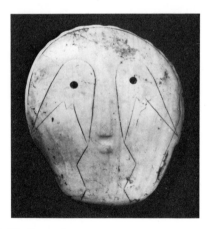

37 Shell mask 1200–1700 AD
Mississippi Valley, Mississippian Period
Shell
Lent by the Royal Ontario
Museum 915.11.1

This type of shell mask was widely traded
throughout the Mississippi Valley area;
many examples come from Tennessee. This
one was found at Calf Mound, Darlingford,
and is associated with the Southern Death
Cult, which originated in the southeastern
United States and is characterized by the
tear-eye design.

38 Pair of figures *c* 1400–1500 AD
Georgia, Etowah
Marble, paint 61 cm high (both)
Lent by the Georgia Department of Natural
Resources

These male and female figures were
excavated in 1962 by Lewis H. Larson at
Etowah, Georgia, one of the most
important southeastern mound complexes.
'Burial 15 was a log tomb built in a pit that
had been dug at the base of the ramp on the
eastern side of the mound. The tomb was
just over 9 feet long and was 4.5 feet wide.
The pit was 3.5 feet deep. Vertical posts set
in a trench formed the walls of the tomb,
while poles laid across the width of the pit
opening created the roof. Included in the
tomb were parts of the dismembered bodies
of four individuals. In addition to the
scattered skeletal material were two large
stone human effigies, stone and clay pipe
bowls, shell beads, copper covered wooden
ear discs, antler projectile points, and
fragments of sheet copper (hair ornaments).
The floor of the tomb presented a picture of
complete disarray. The stone effigies were
broken, as a consequence of dropping one
upon the other as they were placed in the
tomb. The other objects and parts of bodies
were scattered over the floor of the tomb
without any obvious design.' (L.H. Larson,
page 65.) Unfortunately no information
about the function of these impressive
sculptures is contained in their method of
burial. Were they special cult figures, or
generalized portraits of ancestors? None
have southern cult motifs on them, yet all
date from this time. This pair represent a
sculptural type which had a fairly wide
distribution in the southeastern United
States. About a dozen such seated figures
are known from later pre-Columbian times.

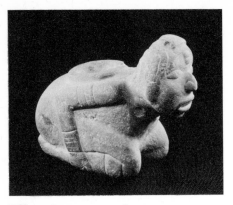

39 Effigy pipe *c* 1400–1600 AD
Mississippi, Mississippian Period
Stone 11.3 cm high, 15 cm long
Private Collection

A Mississippi Valley variant of the
'crouching man' pipe found in Tennessee
and Alabama. The stem was attached to the
hole at the back. This pipe shows a close
stylistic affinity to another pipe in this
exhibition (see number 40). It probably
comes from the area of Emerald Site near
Natchez, Mississippi, according to Dr
Stephen Williams.

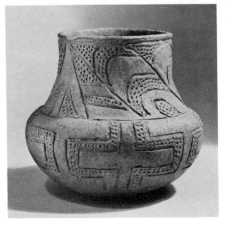

41 Vase 1200–1600 AD
Southeastern United States, Mississippian
period
Clay 14 cm high, 15.6 cm diameter
Lent by the Field Museum of Natural
History 59997

The origin of this buff ware vase is not
known. Note the vigour of its cross and
frond-like design. Probably a Churupa
piece.

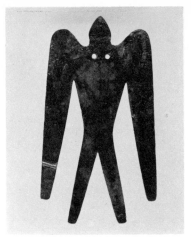

43 Ornament
New Hampshire, Algonquin
Copper 15 cm long, 13 cm wide
Lent by the Peabody Museum of
Archaeology and Ethnology, Harvard
University 1536

Little is known of this bird ornament except
that it was found at Amoskeag Falls,
Manchester, New Hampshire, 'fifteen feet
below the surface'. It could have been
fashioned from a piece of early contact
trade copper. It was sold by 'Mr Goodale to
Mr G.G. Lowell' in 1867 and given to the
museum by A. Lawrence Lowell in 1933.

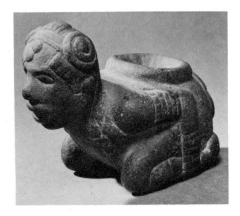

40 Effigy pipe *c* 1200–1600 AD
Mississippi, Natchez, Emerald site,
Temple Mound I(?)
Stone 12.2 cm high, 17 cm long, 8.5 cm
wide
Lent by the Brooklyn Museum. Frank S.
Benson and Henry L. Batterman
Funds 37.3802

In style and pose this pipe closely resembles
number 39. In Henry Rowe Schoolcraft's
History of the Indian Tribes of the United States,
Philadelphia, J. B. Lippincott & Co., 1857,
plate 8, the Brooklyn pipe is illustrated by a
Seth Eastman drawing as a New York State
antiquity which it definitely is not, even if
found there. It is of Mississippian period
origin, probably from the Emerald site,
Natchez.

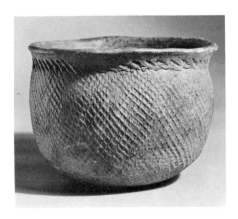

42 Bowl *c* 1600–1800 AD
North Carolina, Cherokee
Clay 11 cm high, 16 cm diameter
Lent by the Field Museum of Natural
History 15514

Found in Swain County, North Carolina.
The body texture is made from the
impression of matting, with stick marks
below the outer rim.

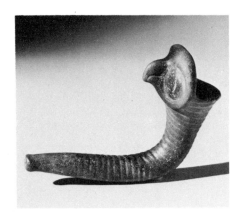

44 Pipe 1300–1400 AD
Woodlands, Ontario, Iroquois
Clay
Lent by the Royal Ontario Museum
25555

This early post-Hopewell elbow pipe
contains forms which survived into the
Historic period.

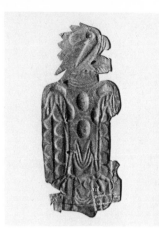

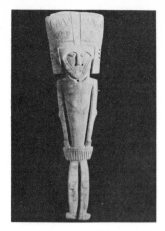

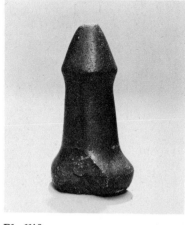

45 **Four of the 'Wulfing Plates'**
 c 1200–1400 AD
 Arkansas, Mississippian period
 Copper
 a 30.5 cm high
 WU 3679
 b 33.5 cm high
 WU 3681
 c 25.1 cm high
 WU 3680
 d 31.7 cm high
 WU 3685
 Lent by the Washington University Gallery
 of Art, St Louis, Missouri

Eight of these copper plaques were found in
October, 1906, in Dunklin County in
southeast Missouri and were subsequently
owned by Max J. Wulfing, of Saint Louis.
No skeletal remains or other artifacts
accompanied the find, which accords with
other stray plaques occasionally found from
Oklahoma to Georgia. A farmer's plough
severed their lower edges. Their copper was
cold hammered and shows evidence of
repairing (riveting) and prolonged use.
Several of the plates are composed of double
sheets or added segments. They depict a
winged bird-being in ceremonial costume. *a*
is the most human and stylistically
elaborate with ear spools and facial
characteristics. *b*, *c*, and *d* have the forked
eye motif which originates in early Ohio
archaeology and quite possibly derives from
a duck hawk or peals falcon (similar to a
European peregrine falcon). These plaques
relate to the Spiro Mound (Oklahoma)
sphere of cultural influence. See
designations used by V. D. Watson, in
Washington University Studies, new series,
number 8, 1950, *The Wulfing Plates*.

46 **Figure**
 Oregon, Columbia River
 Bone 26 cm high, 8 cm wide
 Lent by Mr Fred Mitchell

This male figure of uncertain ceremonial
use, was found near the mouth of the
Umatilla River, near its juncture with the
Columbia River. Its age cannot be
determined, except that it certainly dates
from before the advent of Lewis and Clark,
around 1800. Note the sun circles on the
headdress, and the triangle designs that are
related to teepee border moon and star
designs (see number 440).

48 **Phalliform stone** 1000–500 BC
 Northwest Coast
 Stone 18 cm high, 9.5 cm wide
 Lent by the National Museum of Man,
 National Museums of Canada,
 Ottawa VII–6–451

A number of phallic hand hammers and
pestles have been found in lower British
Columbia. Their presence is foreign to
present Salish residents who can recall
nothing of their use. Collected *c* 1900.

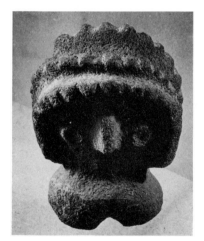

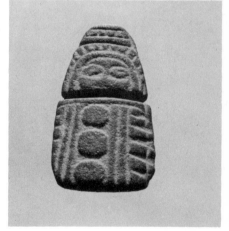

47 **Effigy stone** Prehistoric
 Washington, Columbia River
 Stone
 22 cm high, 17 cm wide, 13 cm deep
 Lent by Mr and Mrs Bruce M. Stevenson

Traces of yellow and red paint remain on
this Janus-headed sculpture which may
have been attached to a staff.

49 **Amulet**
 Washington, Columbia River, Miller
 Island
 Stone 3 cm high, 1.5 cm wide
 Lent by the Maryhill Museum of Fine Arts
 (Mr and Mrs Robert Campbell)

Miller Island is located upstream from the
Dalles Dam on the Columbia River. The
main midden of the island has been eroded
by the rise of the water. This tiny amulet is
of unknown use, but probably from a
burial.

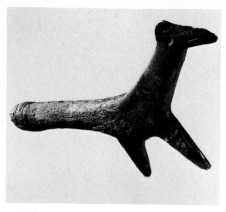

50 **Club**
Washington, Columbia River
Antler 17 cm high, 34 cm long, 4 cm wide
Lent by the Maryhill Museum of Fine Arts
(gift of Mr and Mrs Robert Campbell)

Clubs like this are called 'Slave Killers' in
the literature, although there is no reason to
suppose that this translates a native term.
This one, made from antler bone, was
excavated at Wishram, Washington in 1971
by James Leachman. Archaeological date
uncertain.

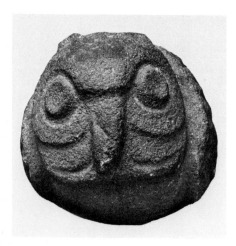

51 **Owl**
Oregon, Columbia River, Historic
period (?)
Stone 52 cm high
Lent by the Oregon Historical Society

This cult owl of volcanic rock is from
Sauvie's Island, well known for its stone
images, situated north of Portland, Oregon,
where the remains of fifteen ancient Indian
villages can be found, although the land is
now heavily farmed. Archaeological
remains found on the island are measured
in the hundreds of years, according to
Emory Strong, since the area is geologically
young.

Woodlands and Athabasca

Woodland Art in the Historic Period

The North American Woodlands extend from Labrador across northwestern Canada into Alaska, and from the Great Lakes south to Oklahoma, Louisiana and Florida; the whole of the eastern part of Canada and the United States is included. Many Woodland Indians of the Historic period were dwelling in areas with an old archaeological tradition, and some were descendants of the former inhabitants.

The Woodland area was a vast undulating tapestry of lakes, rivers, mountains, lowlands and forests. Coniferous forests were at the northern rim; gradually these gave way to stands of birch, then the elm-oak-hickory forests. Southern pines, mountain ash and dogwood trees dominated the Atlantic littoral. Gradually the landscape turned into the bayous, mangrove swamps and shell beaches of the southern United States. Twelve hundred miles west of the Atlantic the forests thinned out, as the rolling landscape flattened out across the prairies to meet the high Plains. Even today, in a diminished form, this huge area possesses the muted wooded ecology of the days before the European settlers, when the Indians knew the feeling of being solitary, yet close to nature. Below the still surface, however, there was animation, like the microscopic activity beneath the surface of a pond. Otters swam in the pools of the north and purple gallinules bobbed in the waterways of the south. Beavers built dams across the streams from New England to Kansas. Moose, elk and caribou also roamed. Birds called out over the valleys and filled the flyways at migration time. Still water (lakes) and white water (rapid moving streams) provided relief in the wooded landscape. The rhythm of the changing weather brought seasonal variations of colour: yellow green in the spring, dark green in the summer, russet in the autumn, and white in the winter. Further colour was provided by the bright berries and wildflowers, like the colours in a piece of Woodlands beadwork.

According to the Indians, supernatural beings lurked in the forests – spirits who lived in the flowers and animals, in the birds, the sky and the stars. These represented the major life forces. Woodland Indians recount the adventures and exploits of giants and dwarfs and, most notably, of Wenebojo, the trickster. These apparitions could make themselves larger or smaller, or come to life again from the dead. Many of the myths concern the interlocking of human beings with animals through transformation. This was not a matter of heraldry or crest assertion as on the Northwest Coast, but true totemism (when a natural object, almost always an animal, is assumed to be the emblem of an individual or clan because of a special relationship between the animal and the person or group); the term is derived from the Ojibway Indians. Totemism is expressed in this statement by a Winnebago medicine man, as reported by Paul Radin: 'I came from above and I am holy. This is my second life on earth. . . . At one time I became transformed into a fish. At another time I became a buffalo. From my buffalo existence I was permitted to go to my higher spirit-home, from which I had originally come.'[1]

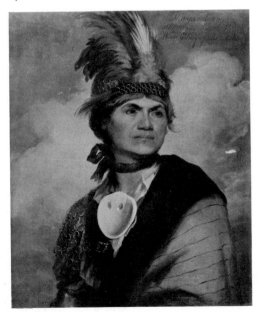

Chief Joseph
by Gilbert Stuart

The otter and muskrat became emblems of the first degree of 'lodge' of the Ojibway Grand Medicine Lodge ritual society, and medicine bags were made from their pelts. Offerings of tobacco from these pouches served to protect initiates during the ritual and to reinforce their prayers at the prescribed ritual centres along the path through the lodges. These bags, either of native fibres (140a) or yarn (140b), contain their message in their understated patterns. Not even in the most floriated period (ca. 1890–1910) did the regard for under-statement totally disappear, although it is seen at its most pristine in pre-1860 work.

While the animals became clan symbols, '. . . in the beginning, when the clans began to form, the bird clans came upon the earth first and alit upon an oak tree at Red Banks; and when they alit upon the oak tree they became human as we are now'[2], a host of supernatural beings remained outside this control. Chief among these was Windigo, a giant ice monster who stalked the woods in winter awaiting his chance to eat people. Another very powerful being was the underwater panther who had several guises in the Great Lakes area. Among the Menomini he was a horned water serpent (horns always indicate the supernatural state), and a beautiful eighteenth-century Michigan pouch shows an underwater panther wallowing like a large cat (132); he is also often seen guarding the portals of the lodges incised on the birchbark medicine scrolls of the Grand Medicine Lodge (160). The 'great lynx', as the panther was known, was terrifying because of his habit of

Palmetto house, Louisiana
Smithsonian Institution

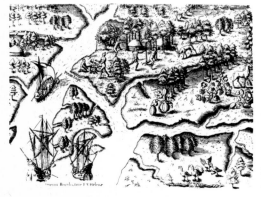

The French reach Port Royal, Florida 1562
De Bry engraving based upon a Le Moyne
drawing
Smithsonian Institution

dragging people from the shore into his underwater home. He could tip over canoes, and had the power to move as freely on land as water. Because of these features, and due to his cunning, he was greatly sought for his curative powers and was in a sense the progenitor of the medicine man. 'In whatever form, luckily, the water monster was terrified of thunder, the noise made by the Thunderers or thunderbirds when they were protecting the Indian.'[3] The stunning back ornament with the quilled thunderbird design from a Georgian Bay, Ottawa tribe, lent by the British Museum (117), conferred on the wearer success in war while protecting him from the revenge of the mythical panther. In addition the shell at the top carried with it a sacred life force, and shells (migis) were owned by Midé patrons.

War was a venerated activity among the Woodland Indians. The Iroquois penetrated as far as central Missouri on raiding parties, before returning to their New York State homes. Each clan came to possess a war bundle, and among the Winnebago of Wisconsin (and later Nebraska) the Winter Feast or War Bundle Feast was also a thanksgiving ceremony incorporating the original myth and songs associated with the contents of the bundle. War clubs had richly polished surfaces, and came to be venerated for the accomplishments of their owners (79). While the maritime tribes were fairly peaceful, the Iroquois were blood-thirsty and not above cannibalism. The Kickapoo Indians who moved from Wisconsin during the seventeenth century to villages on the Wabash and Illinois Rivers, developed a thoroughly justified taste for revenge which they levelled in turn at the French, the British and the Americans. Even today there is a recalcitrant Kickapoo band in northern Mexico, avoiding any change in their customs (they are perhaps the best preserved Woodland tribal culture in existence) who, as true haters of acculturation, are generally hostile to any form of outside interference.

Most Algonquin people, however, found hunting, trapping, fishing and garden patch farming sufficient challenge, and good sport as well. Even the warlike Iroquois, with their spartan desire for great responsibility and rigorous self-sufficiency, maintained an elaborate pastoral calendar of nature-based thanksgiving ceremonies – the mid-winter ceremony, thanks-to-the-maple, the corn planting festival, the strawberry festival, the green corn ceremony and the harvest festival. 'The theme of this basic ritual sequence was thankfulness and hope: thankfulness to the spirit beings for past benefits to the community and hope that they would continue to provide them.'[4] Europeans saw the Woodlands as an area to clear and bring to life with their settlements, but to the Indian the forests were already brimming with spirit life. These strange spirit beings are incised on the medicine scrolls like detached faces, or scratched along the edges of Prairie prayer sticks (which contained prescriptions and songs). The Woodland people were so fully displaced from their lands – when not exterminated outright as most of the New England and coastal Virginia tribes were – that it is too easy to forget the richness of the lives they led in scattered freedom amidst the dells, prairies and semi-tundra of their huge domain. Powhatan's habit owned by the Ashmolean Museum, is evidence of the power of pre-contact Algonquin design. There is an archaic power and singleness of purpose contained in the drawing of the man and two deer which was lost during the Historic period (52).

The 'noble savage' (to use the term the first explorers applied to the Native Americans) who inhabited these lands were sometimes diplomats adept at playing British, French and American politicians off against one another. They were often able to secure an advantageous position in the fur trade. For pelts they secured kettles, cloth, sewing needles, thread and beads for their art. No European knife was able to replace the all-purpose crooked-knife, the carving knife of the Woodlands, sometimes beautifully embellished, once even with a figure-head like carving of a woman (95). Their downfall occurred in the period after the French and Indian war (1754–59) which was the culmination of the struggle between the French and English for possession of North America. Epidemics and whisky took their toll. (In a recent book Wilcomb E. Washburn advanced the theory that genetic peculiarities may well explain the tragedy of Indian lack of resistance to alcohol, which may have been as notable a factor in their decline as firearms or land cessation.[5]) In 1787 Indians were ensured land in the Northwest Territory, but in the wake of the Revolution settlers poured into these lands along the Ohio River and demanded army protection from the Indians.

Similarly the cotton and tobacco farmers from the south began moving west in search of fertile land. In May 1830 at the urging of President Andrew Jackson, Congress passed the Removal Bill which gave the President power to exchange land west of the Mississippi

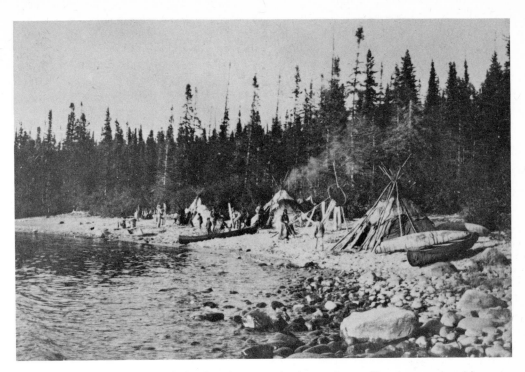

Montagnais camp on Grand Lake, Labrador
Smithsonian Institution

River for land promised to the Indians by treaty in the southeast. Despite protests this policy prevailed and the Choctaws were the first tribe to emigrate, in 1831. The successful and aristocratic Cherokee plantation owners from North Carolina were forced to move to Oklahoma, following the Trail of Tears (1838). Here they settled and were followed by other tribes, including the displaced Miami (122) and a Senaca band. Together with the native Osage, Kiowa and Southern Cheyenne they make up what is now the most cosmopolitan 'Indian' state in the American Union.

Many of the New England tribes first encountered by the colonists were quickly vanquished, though the Pennacock were still living near Indian Hill, Massachussetts, in the 1660s and 70s. King Philip's War led to the clearing of southern New England (1675) but the Mohegan survived in small numbers to modern times, and still make their splint baskets with potato-stamped printed decorations (70). The contemporary Maine Indians occasionally make fine beadwork, and the Iroquois of New York State still conduct their False Face curing rituals, in the long house, with masks and turtle carapace rattles. 'It is amazing that these societies still survive in western New York (and at the Five Nations Reserve at Brantford, Ontario), even in the heart of the industrial age, though "False Face" dancers now use automobiles to go to the aid of the sick', noted Covarrubias during the 1950s.[6]

The Woodland artist loved the association of game hunting, fishing, sky, trees and water. Occasionally his interpretation of nature reveals an offhand and delightful sense of humour. This can be seen in the gluttonous form of a wooden feast bowl (147), the slyness of a panther sitting on a song board (159), the charm of a shaman's dolls or in the figures on Paul Kane's pipe assembled like a college of tricksters (169). The leaf and flower patterns that hem dresses and burst over shoulder bags have little or no detail – that would be superfluous. The outlines and the colour contain all the meaning. There is a special type of vision at work in Woodland art, and the poetic associations of the designs are wide. Multi-pointed designs suggest endless snowflakes or stars (116), a few wild flowers connotes a thicket. Woodland clothing is empathic to nature, and all the clothing has about it an ethereal quality, so that moccasins become soft sculptures made for padding along leafy trails which, when embroidered, transform into the flowers they occasionally crush. Light structures were often preferred, like the birchbark casings out of which canoes and wigwam covers were formed. This sense of lightness exists in the best known indigenous Woodland technique, porcupine quillwork. It was in wide use by the time of the first European contacts with the Indians; it is supposed to have been in use at least 150 or 200 years before Columbus. The quills, after preparation, can be wrapped, netted, sewn, chained, spliced or

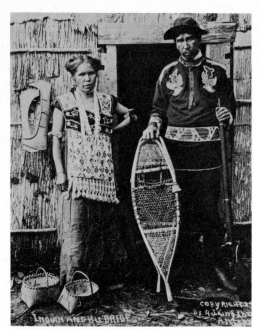

Menomini Indian and his bride with
snowshoes and birchbark baskets
Smithsonian Institution

plaited. The result is smoother than any type of basket plaiting (from which it may derive) and adds colour to any surface to which it is attached. The most controlled work was done by the Cree before 1850 (114), though the unknown inventor of the technique may have been an eastern Algonquin. The oldest recorded piece of quillwork (toe patches) was found on a pair of moccasins at Promontory Point in Utah, perhaps deposited there by an Athabascan at the time of the southward migration (both the Navajo and Apache are Athabascan-speaking peoples who migrated from northwestern Canada to the southwest sometime between 1000–1500 AD).

The Micmac Indians of Nova Scotia excelled at the decoration of birchbark boxes. Their style of quilling was open and elegant though not as precise as Cree work. The eighteenth-century chair in the exhibition shows that Europeans did commission work, in fact much quillwork was done for early Europeans during peaceful times. Many soldiers serving in North America brought back Indian objects and from time to time early quill and moosehair embroidered boxes are found in England and Scotland. Until about 1870 Micmac quills were dyed naturally; then commercial dyes were used, giving a more garish effect. The Micmac were unique in the wide variety of circles, diamonds, points, scrolls, squared circles, concentric motifs, and colour changes within portions of designs that they used as well as in the way they outlined designs to expand the optical effect.

Working with birchbark is another speciality of the region, and also illustrates the Woodland artist's desire for harmony. The bark, when peeled, has a soft pliability, and it is fawn in colour, almost like forest camouflage, while the inner layer is pink. It was the inner layer that was scraped to reveal patterns and silhouettes on the sides of containers (100). 'Ojibway lore' says Nhenehbush (a supernatural trickster of very human appearance) 'marked the birch as his tree, figuring the bark with its characteristic graceful pattern that reminds Thunders to observe respect'.[7] Birchbark is not only attractive but waterproof and fire resistant as well. It can be stitched, rolled, bent or engraved, and pictures can be drawn on it or containers, boxes, moose calls, or roof mats made from it. Birchbark's fleshy surface made it sympathetic to the soft incised lines that meander across the pictorial Ojibway Midewiwin scrolls (160). In these pictures one thing constantly seems to become another, an example of the interchangeability of Indian imagery. The little figures are lightly set down as they sing, join hands, converse, seem to comment upon or intensely watch the priests' medicine ceremony. Another related form is the folded birchbark print, which unfolds to reveal a pattern in mirror symmetry: 'Pieces or remnants of the young bark's fine inner layers have been used for sheerly decorative purposes, the women biting patterns (floral ones in the 1930s) into them, and letting them swing freely in the air for light to pick its way through.'[8]

Beadwork both preserved and extended the old patterns: the double-curve, the scroll, the geometric suite. Trade beads greatly influenced the Indian's colour sense; if before 1700 the taste was for autumnal colours (preserved in later moccasins, quilled and embroidered decoration, and even in 19th-century Athabascan tumplines (188)), with brown, russet, cream and blue predominating, the late eighteenth-century and especially nineteenth-century beadwork had colours more like spring flowers and berries. Tubular beads, wampum, fashioned painstakingly from clam shells, were in use along the east coast before the coming of the trader. They were used spectacularly on the symbolic treaty presentation belts of the Iroquoian tribes and form the basis of the old geometric pattern tradition. Some show the cross patterns of late prehistoric southeastern pottery (53). Others show old cut-out or folded pattern symmetry. They convey, in the restraint of their design and in the simple opposition of cream and purple beads, a stoic seriousness of purpose. When the Huron and Abenaki sent votive belts to the Cathedral of Chartres to attest their allegiance to the Virgin Mary in 1678 and 1699 they had to be told by the ecclesiastical authorities which Latin inscriptions should be put on the belts, but the artistic concept was purely Indian. By the later part of the seventeenth century the nuns at Lorette, near present day Quebec, had instructed Huron women in the art of chain stitching and embroidery, and like beads, fine cotton embroidery floss became a naturalized Indian material. The Woodland Indian always aimed to acquire prestige or dignity through costume, but the greater variety of cloth, beads and silk ribbons introduced by the traders gave Woodland Indian society something new: conscious high fashion. Hems could not be left alone but had to be beaded or embroidered, and the Glengarry-style cap (75) is an adaptation of the British soldiers' uniform by the Iroquois. This fashion consciousness reached the Cree

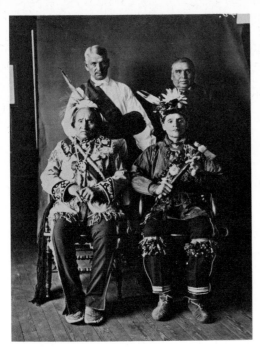

Studio photograph in Washington of four
Iroquois 1901
Smithsonian Institution

tailors in the eighteenth century (106). In the Great Lakes area ribbon appliqué, copied from the French, was introduced after 1750; it made for a strange amalgam of French stylishness and Woodland simplicity of taste. Shoulder strap bags, developed from military pouches, were carried as prestige objects, as many as twelve (but usually one or two) being worn at one time. They were sported at meetings and on ceremonial occasions (135), and in many cases the pockets were blind, as they were not used for any practical purpose. (These items of show should not be confused with the sober patterns on medicine bundle mat covers or medicine bags.) As far away as the Slave Lake area and the Mackenzie River the peoples of northwestern Canada made restrained versions of these prestige items (186). Long after the Cree quillwork complex had expired quilled belts and tumps from north Athabasca still retained the old tight geometric quilled patterns (188). The Oklahoma Osage are the southernmost practitioners of the appliqué technique. Their hour-glass and form patterns are classic examples of the style (123), and garments appliquéd in this way are much sought after. The women who do the work are very respected and do not sell to outsiders willingly.

One of the enigmas of Woodland art is its relationship to earlier phases of art in the same area. While the medicine bag seems to have been operative in Hopewell times, so much has been lost that the connections are very unclear. There is a line that extends from the British Museum's Hopewell stone deer maskette (8k) to the wooden deer mask from Key Marco (17a), and through to modern Cherokee deer masks. The wicker-like patterns in Cherokee baskets, Chitimacha baskets and Great Lakes mats surely descend from the same ancient geometric textile and fibre complex. The peculiar running scroll belts of the Chocktaw and Cherokee (60) retain the scroll design of Mississippian pottery, also from the southeast (31). In Hamilton's book on the Spiro Mound (Le Flore County, Oklahoma) there is a picture of a round flat-sided pottery bowl with an unravelling scroll motif that is even closer to the belts than the comparison afforded by this exhibition.[9] Some of the most insistently abstract designs in all Amerindian art decorate late nineteenth-century and twentieth-century Florida Seminole skirts and dresses (65), and these bright patchwork patterns may be in part a throwback to the old pre-historic feather work, which survived after the Spanish presence. These are tenuous links, we can only hope that others may yet come to light.

Much of what remains of seventeenth- and early eighteenth-century eastern Indian wood sculpture is preserved for posterity in Europe. In one case superb clubs by the same master have been preserved in both Denmark and Sweden. Several prime examples are on view here, which demonstrate to some degree the ancient penchant for the miniature effigy. In the pipe bowl from Copenhagen the bear literally grabs the bowl, and exposes his teeth in a snarling but playful grimace (69b), which no proper Hopewell bear would do, and his tail is allowed to extend unnaturally, for the sake of sculptural unity. 'The Iroquois have recognized the humorous as well as the formidable traits of the bear. They imitate his uncouth, relaxed waddle, his grumpy growl, and his playfulness, especially when young. '. . . The Iroquois pair up and kick like dancing bears. But also they make a communion of offering when they "strip the bushes" and partake of nuts and berry juice. . . . The rite addresses the Sacred Spirit, who brings on and can cure illnesses.'[10] The fundamental duality in the creative mind of the Woodland Indian is very clearly demonstrated in the spirit of communion and the spirit of playfulness which are both present in this pipe bowl.

Floral motifs may have been grafted onto an earlier, less realistic, naturalistic tradition. There is a small hook-like scroll that has the well-known double-curve eastern Woodland motif which somewhat resembles rows of fiddle-head ferns, and the ball-headed war club essentially retains this profile. There is an organic quality to the double-curve itself, less prominent among the Naskapi and Montaignais, but clearly evident in the graceful meanders and curves on Micmac and Penobscot hoods (86). Frank G. Speck noted a slight tendency to connect these designs to medicinal plants, to a sort of submerged floralism; so haphazard that '. . . what the origin and history of the double-curve design may have been it seems unsafe to say.'[11] In the same article he stated that the double-curve '. . . could represent the bonds uniting the different members of the chief's family, the sub-divisions of the tribe, or the officers of the council. This symbolism has, however, been almost totally forgotten except by a few of the older people.'[12]

The Algonquin double-curve has remained an enigma – detached, suspended in space, without precedent. A Penobscot collar (85) in the exhibition points to its origin. It

Right
Penobscot collar
University Museum, Philadelphia

Far right
Ritual vessel 12th century Shang dynasty
Nelson Gallery of Art/Atkins Museum

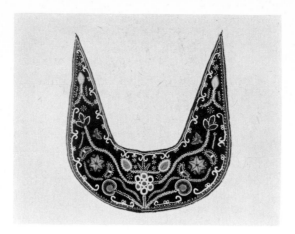

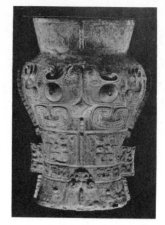

was made late enough in the nineteenth century to have floral and insect patterns entangled with the curves, but even the mixed motifs are deployed with an astonishing oriental bi-lateralism. Its over-all design relates clearly to the ubiquitous T'ao-t'ieh masks on Shang and Chou bronze ritual vessels. A Shang bronze is illustrated for comparative purposes. The Shang cheek lines, eyebrow lines and eyes will be found preserved in the Penobscot textile, pointing to an ancient common design source. The double-curve has flattened in the textile, as if it had resurfaced from the depths, but the design ancestry appears sure. Even during the second millennium BC in China this motif, representing the ears and horns of a tiger, disintegrated into surface patterns. Given the Asiatic origin of the American Indian, this survival is not as amazing as it might appear. From such evidence it can be postulated that the Algonquin motif has antecedents in common with the abstract depictions of tigers' ears and horns in the ancient Orient, and that sometimes even traces of the mask configuration have been preserved as well.[13]

For most Europeans and Americans forest Indians are those in James Fennimore Cooper's novels, or in public murals like those decorating the Minneapolis railway station. The only good Indian is an idealized one. That the Ojibway even still exist, or that the Penobscot still make beadwork cuffs does not often occur to the modern mind. 'The purpose to fill up Oklahoma with settlers will never sleep, and ought never to sleep, until it is accomplished', wrote an admirer of manifest destiny in the late nineteenth century, '. . . we know that an empty house, though swept and furnished, cannot be guarded against demonaic possession.'[14] To this day a Great Lakes school child is apt to be shown a picture of a porcupine to represent quillwork, not an Indian piece of quillwork, and it was not until 1973 that the first major exhibition of Great Lakes Indian Art was held in Flint, Michigan. But then, the Indian is familiar with a spiritual world which is, and probably always will be, very far away from ours.

Notes

1 Paul Radin, *The Winnebago Tribe*, Johnson Reprint Corporation, New York, 1970, page 270 (originally published in 1923 in the Smithsonian Thirty-Seventh Annual Report).

2 Paul Radin, page 242.

3 Robert E. Ritzenthaler and Pat Ritzenthaler, *The Woodland Indians of the Western Great Lakes*, Garden City, The Natural History Press (American Museum Science Books), 1970, page 139.

4 Anthony F. C. Wallace, *The Death and Rebirth of the Seneca*, New York, Alfred A. Knopf, 1973, page 51.

5 Wilcomb E. Washburn, *The Indian in America*, page 110.

6 Miguel Covarrubias, page 282.

7 Ruth Landes, *Ojibwa Religion and the Midewiwin*, Madison, The University of Wisconsin Press, 1968, pages 223–224.

8 Ruth Landes, page 224.

9 Henry W. Hamilton, plate 32, A.

10 Gertrude P. Kurath, '*Iroquois Music and Dance: Ceremonial Arts of Two Seneca Longhouses*', Washington, Smithsonian Institution, Bureau of American Ethnology, Bulletin 187, 1967, pages 66–67.

11 Frank G. Speck, '*The Double-Curve Motive in Northeastern Algonquin Art*', Canada Department of Mines, Geological Survey, Memoir 42, No. 1, Anthropological Series, Ottawa, Government Printing Bureau, 1914, p. 2.

12 Frank G. Speck, page 4.

13 The reader is referred to Speck, p. 1 XII, b. and Pl. XV for pouches that contain submerged mask-like elements. These can be also read upside down, as can the Penobscot collar in the University Museum, Philadelphia, another oriental feature.

14 Charles C. C. Painter, '*The Proposed Removal of Indians to Oklahoma*', Philadelphia, Indian Rights Association, 1887 (pamphlet).

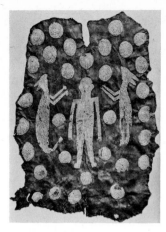

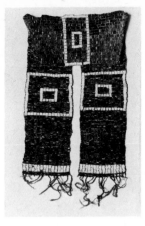

52 Powhatan's mantle
Woodlands, Algonquin
Deerhide, sinew 2.13 m long
Lent by the Visitors of the Ashmolean
Museum, Oxford

Powhatan, the great Werowance (Chief) of
the Algonquin tribes living in Tidewater
Virginia, united more than twenty-five
groups (ranging from 75 to 1000 people)
under his leadership shortly before the
founding of the Jamestown colony in 1607.
He was despotic; in his village on the north
bank of the York River he had absolute
power of life and death. His daughter,
Pocahontas, was the first Indian to be
brought to England by the English
following her marriage to John Rolfe. She
died of smallpox in 1617 on board ship in
the Thames estuary while about to return to
Virginia and was supposedly buried in
Gravesend.

This is the earliest piece of Historic period
American Indian art for which there is
documentation. Figures of a man and two
deer are formed from Marginella shells.
The use of these shells predates the
introduction of wampum beads from the
Northern Indians or trade beads from
Europe. Originally part of the Tradescent
Collection, it was mentioned in their
inventory in 1656. This family owned land
in Virginia.

53 Wampum belt 17th century
Eastern Woodlands, Iroquois
Shell beads 1.09 m long
Lent by the Trustees of the British
Museum 1949.Am.22.119

A wampum belt served as a gift, also as a
binding symbol of an agreement among the
Northeastern tribes, and they were of the
highest importance as documentary
evidence of such pacts. Here the ground
consists of cylindrical, purple beads offset
by three double rectangles of white beads.
This was probably collected by Sir John
Werden, 1640–1716, who was secretary to
James Stuart, Duke of York. Oldman
Collection.

55 Wampum belt *c* 1700 AD
Pennsylvania, Delaware
Beads
Lent by the Royal Ontario Museum
(Gift of Independent Order of Foresters)
HD 6364

Several wampum treaty belts can be
associated with William Penn's founding of
Pennsylvania. 'So long as Pennsylvania's
policy was suffused by the spirit of the
Society of Friends and controlled by the
hand of the proprietor, Indian (Delaware)
white relations existed on a plan of equality
and mutual respect.' (See W. Washburn,
page 84.)
The belt exhibited here, with figures of
equal size, is traditionally associated with
this treaty. It has a history of Indian
ownership, from the Delaware to the
Iroquois, to the Royal Ontario Museum.
Two from the white side which were in the
Penn family collection are now at the
Museum of the American Indian. Unlike
the other Penn belts the Toronto example
does not have a white bodyground, though
this is not necessarily the identifying
characteristic that Frank G. Speck and
William C. Harris Orchard thought it was.

54 Two wampum votive belts *c* 1678 AD
Saint Lawrence Valley, Abenaki (Naskapi)
and Huron
Shell, porcupine quill
a 1.22 m long, 10 cm wide;
b 1.83 m long, 18 cm wide
Lent by the Trésor de la Cathédrale de
Chartres

Although the inscriptions are in Church
Latin the technique is native. The Abenaki
belt reads 'Matri Virgini Abnaquaeidd'
and the smaller Huron belt 'Virgini
Pariturae Votum Huronum'. As wampun

belts are a form of graphic art, their style
easily absorbed Latin script. The lettering
of the Huron belt is so refined that small
beads are inserted to form serifs; the quill
bindings are an added refinement. Since the
Huron were reduced from their former
glory at Huronia to a small band at Lorette,
Quebec, the nuns there probably
superintended the making of the belts. *a* was
sent to Chartres Cathedral in 1678 as a
votive to the Virgin. The larger belt, regal
with its valuable purple quahaug shell bead
field, was deposited at Chartres in 1699 by
the Jesuits.

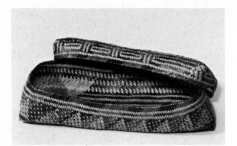

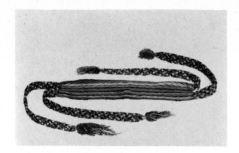

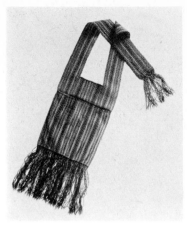

56 **Basket** 18th century
Southeast, Carolinas
Cane 54 cm long, 21 cm wide, 11 cm high
Lent by the Trustees of the British
Museum SL 1218

'A large Carolina Basket made by the
Indians of Splitt Canes some parts of them
being dyed red by the fruit of *Solanum
Magnum Virginianum Racemosum Rubrum* and
black. They will keep anything in them
from being wetted by rain, from Coll.
Nicholson, Governor of South Carolina
whence he brought them' (Sloane's own
description). This is one of the earliest
Southeastern split cane baskets for which
there is documentation.

58 **Part of the costume of Muskogie Chief
Francis** Early 19th century

a **Belt**
Woodlands, Southeastern
Wool 2.36 m long, 18 cm wide
Lent by the Trustees of the British
Museum 7479c

Broad belt of interwoven worsted,
patterned with zig-zag stripes, black, blue,
yellow and red; the ends plaited into two
tails. Presented by Sir Walter C. Trevelyan,
Bart., March 30 1871, to the Christy
Collection.

59 **Bandoleer pouch** 19th century
South Carolina, Creek
Cotton, beads, yarn
1.31 m long (including strap) 26.5 cm wide
Lent by the Smithsonian Institution
315,090

The Creek confederation used this type of
bag from early to mid 19th century. Given
by Col. John Van Rensselaer (Hoff), July 7
1920.

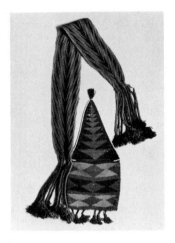

b **Bag**
Wool, beads 69 cm long, 21.5 cm wide
Lent by the Trustees of the British
Museum 7479e

Square finger-woven bag of blue worsted
with black and red patterns. The flap is
edged with white beads.

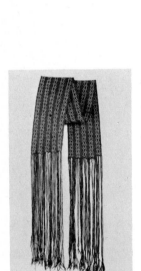

57 **Belt** 19th century
Woodlands, Southeastern
Wool 3.06 m long, 20.3 cm wide
Lent by the Trustees of the British
Museum 1942.Am.5.1

Muskogee woollen woven belt decorated
with small white beads and long fringes.
Presented by Lionel Ridout.

60 **Belt** Early 19th century
North Carolina, Cherokee
Cloth, beads
Lent by the Brooklyn Museum 50.67.24

The scroll design with its lazy-stitch is an
indigenous south Woodlands motif also
used by the Choctaw.

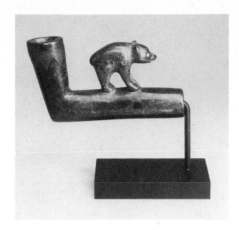

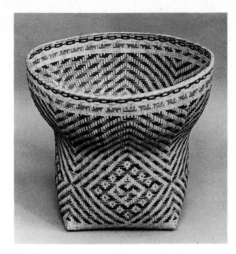

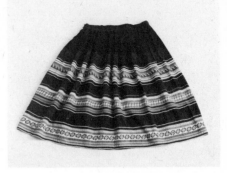

61 **Effigy pipe** Early 19th century
North Carolina, Cherokee
Pipestone, lead 7 cm high, 11 cm long
Private Collection

The modest effigy pipes of the Cherokee
were at the end of a long tradition of
Woodlands carving. This one, representing
a bear, was made before the Cherokee
were removed to Oklahoma in 1838.

63 **Basket**
Oklahoma, Cherokee
Wood, oak splints
48.5 cm high, 73.5 cm diameter
Lent by the Philbrook Art Center

This is an exceptional example of North
American plaiting technique (equal warp
and weft). A beautiful equilibrium has been
maintained between the cream and red zig-
zag patterns. The round mouth and bowl-
like shoulders transforming into a square
trunk and base are special characteristics of
Cherokee work. The profile fits closely
against the upper shoulder of the wearer
while resting squarely upon the back. See
C. Fallon, plate 6, for a photograph of a
woman with a similar basket on her back.

64 **Woman's patchwork skirt** 20th
century
Florida, Seminole
Cotton 72 cm long
Private Collection

The technique used by the Seminole is
adapted from European patchwork quilting
of the 19th century, but the piecing together
of hundreds of strips of cotton in many
colours in this way is now 'traditional' in
the tribe. Collected on the Seminole
Reservation, Big Cypress, Florida in 1937.

65 **Man's dress** 1949 AD
Florida, Seminole
Cotton, rayon 1.65 m long
Lent by the Denver Art Museum
RSe–6 & 7.

This patchwork dress shows the colourful
and florid patchwork decoration apparently
invented by the Seminoles early in this
century. The sewing machine contributed
to the versatility of the design, with its
indefinable Creole quality. Seminole
women wore skirts and blouses, and men
wore dresses like this.

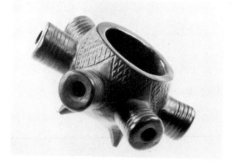

62 **Pipe bowl** 19th century
South Carolina, Catabwa
Earthenware 11 cm diameter, 6.5 cm high
Lent by the Smithsonian Institution
361,932

This multi-stemmed bowl is of a type made
for sale, and is unused. Given by the Victor
J. Evans estate, March 26 1931.

81

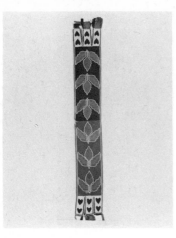

66 Bandoleer Mid 19th century
Woodlands, Delaware
Bead 71 cm long
Lent by the Brooklyn Museum 72.104

Bandoleer of the type used as baby carrier
straps.

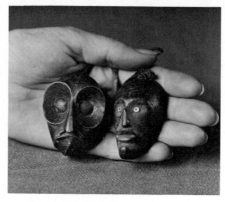

68 Pair of maskettes 18th century
Pennsylvania, Delaware
Wood
a 5.4 cm high, 4 cm wide, 3.5 cm deep
NA 3881
b 6.3 cm high, 3.6 cm wide, 2.9 cm
deep NA 3882
Lent by the University Museum,
Philadelphia

These delicately carved maskettes were
attached to larger masks together with a
tiny bundle of tobacco seed to give power to
the mask.

69 Three early Historic period sculptures
Pennsylvania, Delaware (?)
Wood

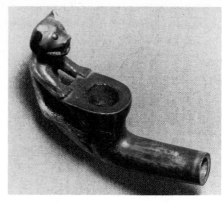

b **Pipe bowl**
24.5 cm long
E Dc 16

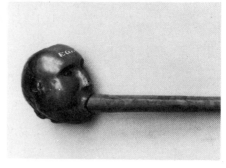

c **Pipe bowl and stem**
46 cm long
EGc 4

Lent by the National Museum of Denmark,
Department of Ethnography

These are among the earliest documented
wood sculptures from the east coast of the
United States. The place of origin is not
certain though the general type is
Iroquoian. The bear pipe bowl was
deposited in 1654, the human-faced bowl
and stem in 1710 and the club in 1737. All
of them show Woodlands sculpture in its
austere unrelieved state, without European
influence. The tradition of subsequent
Woodland wood sculpture stems from these
compact forms.

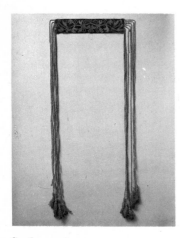

67 Sash 19th century
Florida, Seminole
Tradecloth, beads 3.18 m over-all length,
panel 50 cm long, 10 cm high
Montana Private Collection

According to William Sturtevant this sash
and its accompanying knife are the earliest
Seminole artifacts for which there is
documentation. Collected at the same time
as a knife and sheath in the Museum of the
American Indian; on the sheath is a tag
which reads: 'A relic of the Florida war of
1835–1843. Given to me when a boy by my
father, Thomas Hart, who received it from
Lieut. John H. Hill of the second dragoons
United States army. – Lieut. John H. Hill
from Gouchataminchas. Nuctilage
Hammock, March 10, 1840'.

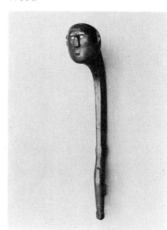

a **Club**
63.5 cm long
GB 8

70 Basket 19th century
Connecticut, Mohegan
Wood 12 cm high, 33 cm square
Lent by the Nelson Gallery of Art/Atkins
Museum (Nelson Fund) 31–125/120

An exceptional East Coast ash berry basket,
evenly plaited, with flower decoration which
was stamped on with cut potatoes. For a
Seneca plaited covered basket with similar
potato stamping see M. Lismer, plate XV,
page 33. It has been suggested that the
plaiting technique was introduced by
Swedish settlers in the Delaware valley (see
The World of the American Indian,
Washington DC, National Geographic
Society, 1974), but this leaves out of
account the probable spread northward
of cane split techniques long used by the
Choctaw, Cherokee and Chitimacha. Frank
G. Speck thought that the lower Mississippi
region was the area from which splint
basketry spread northward. However no
pre-19th-century New England baskets of
this type are known and none are
mentioned in the early literature.

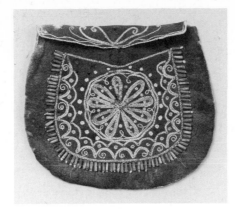

71 Bag Late 18th century
New York State or Canada, Iroquois
Leather, quills, metal, deer hair
15 cm high, 18.5 cm wide
Lent by the Denver Art Museum VIro–2

The taste of 18th-century Woodland tribes
was for dark leather bags, pouches and
moccasins (dyed from black walnut husks as
here, or other nuts), decorated with light-
hued porcupine quill embroidery. Metal
ornaments with dyed deer hair tassels
complete the ensemble. The treatment of
the rosette is more refined than similar work
on later bags.

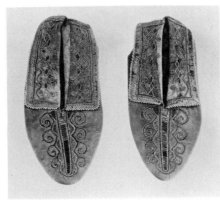

72 Moccasins *c* 1870 AD
Woodlands, Iroquois
Hide, moose bristle, quill, beads
24 cm long, 10 cm wide
Lent by the University Museum,
Philadelphia NA 7644

Note the elaborate use of moose bristle,
quill and beads typical of the late
nineteenth century.

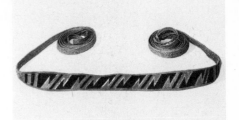

73a Burden strap 18th century
Northeast, Iroquois
Hemp, quill 4.96 m long, 4 cm wide
Lent by the Trustees of the British
Museum SL 573

'A cord made of hemp and porcupine quills
died from the Iroquois by the Indian Kings
given me by Mr Middleton for tying their
prisoners.' Sloane's description. This is
probably incorrect. 'Burden straps' were
used by Indian women to carry loads on
their back – the strap was wound around
their foreheads and the load suspended on
their backs.

73b Burden strap 18th century
Northeast, Iroquois
Hemp, quill 5.04 m long, 5 cm wide
Lent by the Trustees of the British
Museum SL 574

See previous entry. 'The same of a courser
sort without the quills', Sloane's
description.

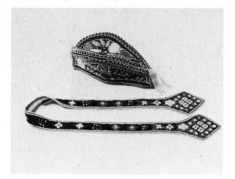

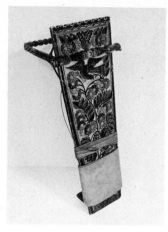

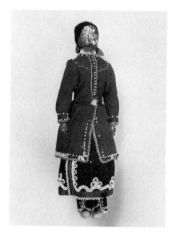

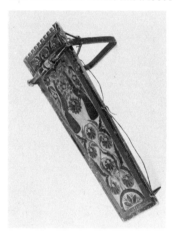

74 **Two sashes**
Woodlands, Iroquois
a Wool, beads 1.32 m long, 15.2 cm
wide 20159
b Wool 3.86 m long (with fringe), 22.8 cm
wide NA 5309
Lent by the University Museum,
Philadelphia

Early Woodlands and Great Lakes sashes
feature bead patterns that are deeply
embedded.

75 **Glengarry bonnet and beaded
sash** Mid 19th century
Woodlands, Iroquois
Black velvet, beadwork, ribbon
Bonnet 30 cm long; sash 1.12 m long
Lent by the C.F. Taylor Collection,
Hastings

Both pieces are decorated with typical
Iroquois floral beadwork. Two shades of
one colour was a distinguishing feature of
beadwork of this period. Caps like this one
were common from 1840 to 1870 and were a
direct adaptation of Scottish Highland
headgear. The sash was a badge of honour
worn by distinguished warriors or
sometimes by soldiers who served in
Canada.

76 **Two dolls** 19th century
New York or Ontario, Iroquois
Cornhusk, beads, cotton, wool
a 26 cm high;
b 28 cm high
Lent by the Denver Art Museum TIro–3,
TIro–4

a was collected in the field and was formerly
in the A.E. Douglass Collection. *b* was
collected about 1865 in the field; it was
formerly in the Ralph Linton Collection.

77*a* **Cradleboard** 19th century
New York, Mohawk
Wood, paint, cloth
76 cm high, 27 cm wide
Lent by the Saint Joseph
Museum 143/3580

Common to the St Regis Iroquois tribes
who also live in Canada. The flower, leaf
and bird motifs, carved in relief so that each
petal is differentiated, recall Quebec folk
designs, which are the source. Clan
animals are often carved at the bottom.
The front of the cradle has a foot rest.

77*b* **Cradleboard**
New York and Canada, Iroquois
Wood, paint 32 cm high, 31 cm wide, 74
cm long
Lent by the Smithsonian Institution
18,806

Iroquois Mohawk type baby carriers were
heavily ornamented with flower and animal
designs, evidently obtained from the French
Canadian folk artists and used in turn by
others of the Six Nations. In the McCord
Museum there is a tapestry panel of French
Canadian origin with similar bird designs.

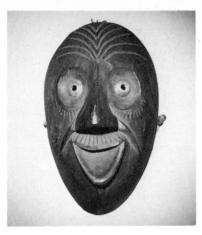

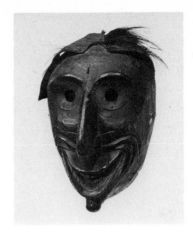

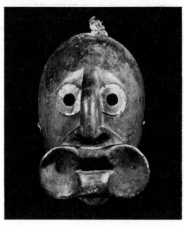

78 **Mask**
Woodlands, Iroquois, Cayuga
Wood, copper 28 cm high, 16 cm wide
Lent by the Peabody Museum of
Salem E27945

A False Face Society mask, fluted on the
upper lips and cheeks. For further details
see Robert Ritzenthaler, *Iroquois False Face
Masks*, Milwaukee Public Museum, 1969,
page 30.

80 **Mask**
Great Lakes, Iroquois, Seneca
Wood, tin, horsehide
24 cm high, 15.5 cm wide
Lent by the University of California at Los
Angeles Museum of Cultural History, Gift
of the Wellcome Trust X65-4039

Masks like this one were used by members
of the Hadigonsa shano, a club of masked
dancers charged with curing sickness, who
still operate today. Traditionally red
painted masks were carved from the living
tree in the morning, and black ones were
made in the afternoon.

82 **False face mask** *c* 1820 AD
Northeastern Woodlands, Iroquois
Wood 28 cm high, 17 cm wide
Private Collection

This mask was worn in 'curing' ceremonies.
False face masks were carved from living
trees, those really used in the ceremony
were supposed to possess animal spirits. The
masks were fed regularly and were carefully
wrapped and placed face down when
stored. They are among the most virile and
spectacular works of art created by the
Iroquois.

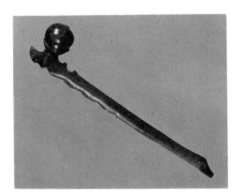

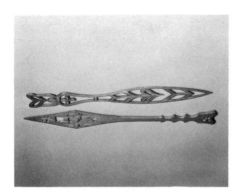

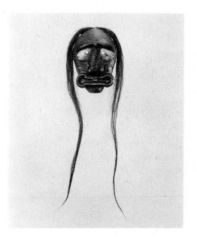

79 **Club** *c* 1800 AD
New York State, Iroquois
Wood 1.06 m long, 15 cm wide
Lent by Mr and Mrs Peter B. Thompson

This highly polished ball club with small
protuberance is probably Iroquois.

81 **Pair of paddles** *c* 1900 AD
New York State or Northeastern United
States, Iroquois (?)
Wood
a 44.5 cm long, 7 cm wide;
b 48.5 cm long, 7.5 cm wide
Montana Private Collection

Open work, carved paddles, used in
skimming and stirring maple sap in sugar
making. The Iroquois traditionally used
sugar as a seasoning since their food was
unsalted.

83 **Mask** *c* 1930 AD
New York State, Iroquois, Cayuga
Wood, paint, horse hair, metal
25.5 cm high, 17 cm wide, 12 cm deep
Lent by the University Museum,
Philadelphia 70-9-190

This is a late example of a False Face society
curing rite mask.

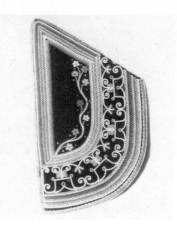

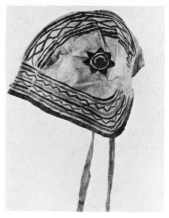

84 **Brooch** 1800 AD or earlier
Maine, Penobscot
Silver 15 cm high, 15 cm wide
Lent by the University Museum,
Philadelphia 53–1–22

This brooch, one of the finest examples of
New England silver work, has delicate sea
curves and scroll designs.

86 **Hood** *c* 1860 AD
Maine, Penobscot(?)
Cloth, beads 41 cm high, 24 cm wide
Lent by Michael G. Johnson, Walsall

This woman's hood, worn on special
occasions, has striking multi-marginal
bands of solid beadwork. Both the
aboriginal north Atlantic coast double-C
curve and the European-derived floral
patterns are used here in split stitched
beadwork. Frank G. Speck asserts that
rounded lower leading edges in such hoods
is a Penobscot (Maine) characteristic. See
F.G. Speck, 'Symbolism in Penobscot Art'.
*Anthropological Papers of the American Museum
of Natural History*, XXIX.

88 **Child's cap** 19th century
Woodlands, Penobscot
Buckskin, paint 14.4 cm high, 24.5 cm
wide, 14 cm deep
Lent by the University Museum
Philadelphia 30-3-8

This child's cap is decorated with designs
similar to those on Naskapi-Montaignais
coats. The wooded land in which the
Montaignais lived abounded in moose,
while the lichen and grass-covered land of
the Labrador Naskapi made them
dependent upon caribou.

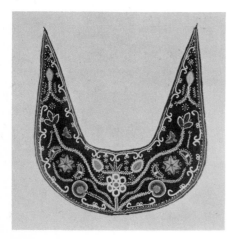

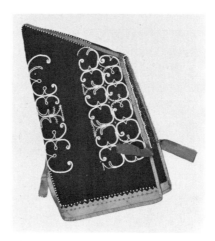

85 **Collar** Late 19th century
Woodlands, Penobscot
Beads, felt 53.3 cm high, 53.3 cm wide
Lent by the University Museum,
Philadelphia

This piece is an example of how colourful
the scroll and flower motif became during
the late 19th century.

87 **Woman's hood** *c* 1860 AD
Woodlands, Micmac
Cloth 41 cm high, 21 cm wide
Lent by the Royal Scottish
Museum 1924.871

Note the variation in the scroll ovals.

89 **Medal pouch** Late 19th century
Nova Scotia, Micmac
Cloth, beads 15.9 cm high, 14.4 cm wide
Lent by the McCord Museum, Montreal
M10

This pouch unites Victorian taste with the
ancient double curve motif.

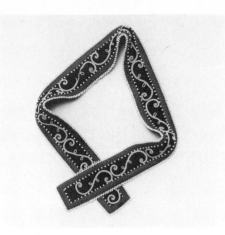

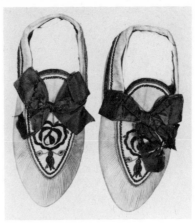

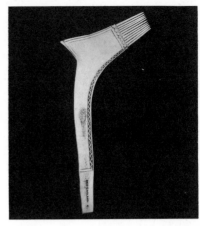

90 **Belt**
Maine, Penobscot
Flannel, glass beads, ribbon
34 cm long, 5.4 cm wide
Lent by the Peabody Museum of
Salem 9821

The C-curve is more elongated and
decorative than in earlier examples.
Received by the museum in 1907.

92 **Woman's moccasins** *c* 1890 AD
Eastern Woodlands, Montagnais or
Naskapi
Buckskin, ribbonwork, silkwork
25 cm long
Lent by C.F. Taylor Collection, Hastings

Collected by the Callander Missionaries,
from the area of Makkovik, Labrador.

94 **Comb** 18th century
Woodlands
Moosehorn 38 cm long, 17 cm wide
Lent by the Trustees of the British
Museum SL 758

'A comb made of moose horn; from the East
parts of New England, used among the
native Indians.' Sloane's description.
Sloane Collection.

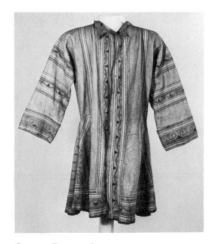

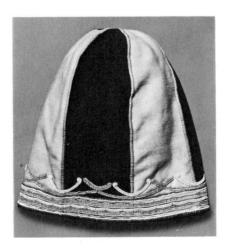

91 **Coat** Date unknown
Woodlands, Naskapi
Caribou skin 99 cm long, 1.58 m wide
Lent by the Trustees of the British
Museum 1963.Am.5.1

The designs on this hunter's summer coat
were stamped and applied with wooden
tools. The original shape comes from the
18th-century European frockcoat but such
coats were made by the Naskapi until the
early 20th century. They were thought to
bring the hunter good luck for one year,
after which a new coat had to be made.
Previously owned by Miss M.G. Niven.

93 **Toque** 20th century
Quebec or Labrador, Montagnais or
Naskapi
Cloth, beads 26.5 cm high, 27.2 cm long
Lent by the Royal Ontario
Museum 960.161.43

The inland Quebec Montagnais Indians,
who partly bordered the Micmac, used caps
like this, as did their northern neighbours,
the Labrador Naskapi, who tended to
attach the cap to their coats Eskimo-
fashion. The flattened double curve
motif points to maritime contact.

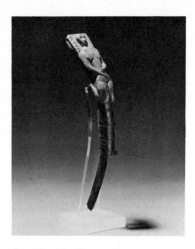

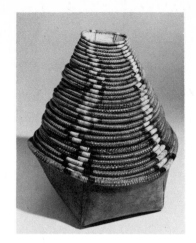

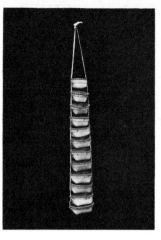

95 **Crooked knife** *c* 1850 AD
Maine, Pasamaquoddy or Penobscot
Wood, steel 29.5 cm long
Lent by the Jonathan and Philip Holstein
Collection

Depiction of a nude female in eastern
Woodlands art is most unusual. It might
have been suggested by a ship's figurehead.
Made from a file blade. Originally
probably had a steel wire wrapping.
Collected by Jonathan Holstein from a
Pennsylvania Dutch folk art collection and
obtained previously from a Pennsylvania
Dutch farm family who had used it as a
cabbage knife. How it got there from Maine
is not known.

97 **Baskets** Early 18th century
Woodlands, Cree (?)
Birchbark, quill 31 cm high (total)
30 cm long, 11.5 cm wide
Lent by the Trustees of the British
Museum SL 2065

'A nest of Olagans or thirty baskets made
with birch bark and adorned with
porcupines' quills given me by Captain
Middleton who brought them from Hudson
Bay' (Sloane's description). On the side of
the largest basket is inscribed 'For Miss
Nellie Midleton'. These baskets are
evidence of a nesting type which was made
into this century (see number 155). Sloane
Collection.

99 **Nest of baskets** *c* 1910–1920 AD
Canada, Northeastern Woodlands
Birchbark, moose hide
61 cm high (total)
Lent by the Cleveland Museum of Natural
History 7491

These oval-shaped baskets are perhaps
calendar baskets and possibly northern
Cree. See number 97.

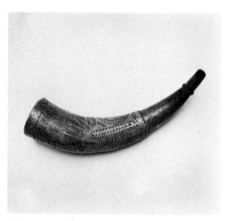

96 **Powder horn** 1725 AD
Woodlands, Penobscot
Horn, wood 35 cm long
Lent by the Peabody Museum of
Salem E50294

Engraved on this horn are patterns relating
to the designs on crooked knives,
representations of a European building with
a belfry and a drawing of an Indian lodge.

98 **Bark basket** 18th century
Massachusetts, tribe unknown
Elm bark, roots
Lent by John White

This rare basket shows the double-C
ornamentation of the eastern Woodlands,
unadulterated by any European influence.

100 **Basket** 19th century
Quebec, Montaignais
Birchbark, spruce root
24 cm high, 26 cm wide, 42 deep
Lent by the Peabody Museum of
Salem E31705

The fine stitching and elaborate design
derives from pre-contact Hopewellian
copper cut-out ornaments. Birchbark
templates were used to outline the designs
with a knife, which were then peeled away
to reveal the contrasting colour of the inner
bark.

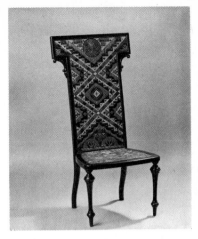

101 **Oval box** Mid 19th century
Northeastern Woodlands, Micmac
Birchbark, quill, grass
20 cm high, 32 cm wide
Lent by the Trustees of the British
Museum 2644

On the side of the box are white porcupine
quills in chevron, diamond, cross and bar
patterns; on the lid a red, white, blue and
brown quill design. The Micmac
specialized in the working of dyed
porcupine quills in geometric designs on
birchbark bases. Early examples, such as
this one, were dyed with soft vegetable
colours. In recent times the Micmac have
used aniline dyes. Christy Collection.

103 **Box** 19th century
Nova Scotia, Micmac
Quills, bark
7.5 cm high, 10.5 cm diameter
Private Collection

This round container uses on its lid native-
dyed quills in a quiet chevron-like design. It
is early 19th century in date as the Micmac
began to quill such boxes soon after the
Europeans came to dominate the
Maritimes. The bark side stripes recall
those on the lone surviving Beothuk
(Labrador) round box. This Micmac box
may date similarly. Later on Micmac
quillwork was more brilliant in colour with
elaborate patterns. A prototype birch bark
box is illustrated in W. and R. Wallis, *The
Micmac Indians of Eastern Canada*, page 73,
figure 16B.

105 **Chair** *c* 1780 AD
Nova Scotia, Micmac
Wood, quills
1.06 m high, 45.5 cm wide, 43 cm deep
Montana Private Collection

Micmac chairs with porcupine quill seats
and backs were made through Victorian
times. The style of the eastern Canadian
provincial frame into which the quillwork
patterns are set suggests a date of about
1780 for the seat and back. The quillwork is
in a very good state of preservation. One of
the finest examples of Canadian Maritime
quill design extant.

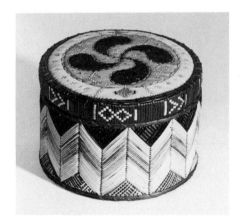

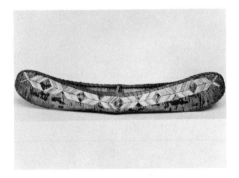

102 **Box**
Nova Scotia, Micmac
Birchbark, wood, porcupine quills
10 cm high, 14.6 cm diameter
Lent by the McCord Museum,
Montreal M113

The swastika-like design on the lid is most
unusual. It seems to be related to the
northern Algonquin north wind symbol.

104 **Canoe model** Early 20th century
Woodlands, Micmac
Birchbark, quill 56 cm long
Lent by the Trustees of the British
Museum 1921.10–14.110?

Birchbark canoe model decorated with
quillwork. 'Coloured quills in northern
lights patterns were used in some models or
toy canoes, but not in any surviving
example of full-sized (Micmac) canoe. It is
quite possible, however, that such quillwork
was once used in Micmac canoe
decoration.' (E.T. Adney and H.I.
Chapelle, page 68.)

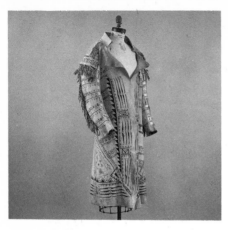

106 **Coat** 18th century
Ontario, Cree
Buckskin, quills, paint
1.20 m high, 66 cm wide (at shoulders, not
including sleeves)
Montana Private Collection

An elegant example of a Canadian
Cree buckskin long coat. The oblong
painted design recalls those on geometric
Plains box-and-border type hide paintings,
while the dyed porcupine quill epaulet
panels and tassels lend the dignity necessary
for important ceremonies. The high collar,
pinched waist and long sleeves are modelled
after an officer's coat of the period of
George III; the mauve, red and dark blue
colour harmony and the luxurious fringe,
let alone the pristine geometry of the
quillwork, are pure Indian. Collected in
1789.

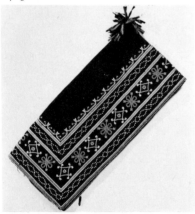

107 **Hood** Early 19th century
Quebec, Cree
Cloth, silk, beads 53 cm high, 24 cm wide
Lent by the Royal Ontario
Museum (Gift of C. G. Gladman)
912.23.2

This tassled hood from the Swampy
(Woodland) Cree of James Bay is a variant
upon the maritime type woman's hood,
here found far away from its original
context. The beadwork patterns are less
fluid and have the less prominent double C-
curves of the coast; they are more like the
emblematic designs of inland Algonquin
birchbark boxes.

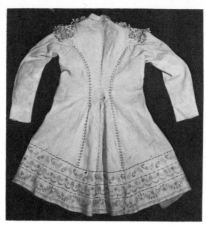

108 **Coat** Before 1821 AD
Ontario, Cree
Unsmoked moose hide, paint, porcupine
quillwork 1.13 m long
Lent by the Hudson's Bay Company
Historical Collection, Lower Fort Garry
National Historic Park

A full-fashioned coat with regular floral
bone stamping along the hem. The
unsmoked moose hide makes a fresh effect.
Such coats were made until about 1850.

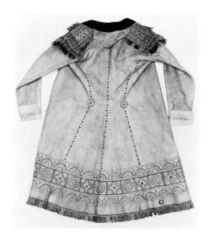

109 **Coat** Before 1850 AD
Algonquin, Cree, Metis type
Mooseskin
1.17 m long, 51 cm across shoulders
Lent by the Royal Scottish
Museum UC 273

The strongly geometric painted designs
along the lower edge of the coat are
northern Algonquin in derivation and
hence lack any floral reference. The designs
were impressed with a bone or antler. Part
of the University of Edinburgh Museum
Collection before 1850.

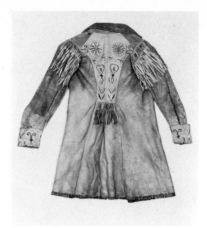

110 **Coat with caribou insert** 19th century
Algonquin
Mooseskin, caribou
1.09 m long, 51 cm across shoulders
Lent by the Royal Scottish Museum 357.8

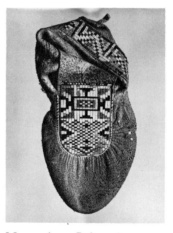

111 **Moccasins** Before 1850 AD
Manitoba, Cree
Moose hide, porcupine quills
26.5 cm long
Lent by the University Museum,
Philadelphia NA 5216

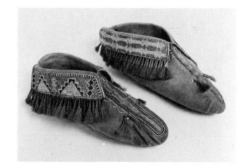

112 **Moccasins** Early 19th century
Woodlands, Cree
Hide, quill 26.5 cm long
Lent by the Trustees of the British Museum

These moccasins are decorated in red,
white, blue and black quillwork.

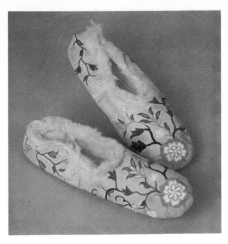

113 Moccasins *c* 1860 AD
Ontario–Quebec, Huron or Cree
Deerskin, silk thread, fur
Montana Private Collection

The delicate silk floral embroidery bears a hint of C-curve style, flowing to the rosettes at the tips. A similar pair without fur trim is in the Chandler–Pohrt Collection.

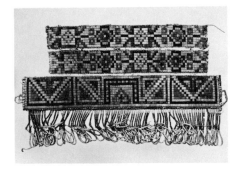

114

a **Decorative band** 1830 AD or earlier
Manitoba, Cree
Quills, moose hide
22.8 cm high, 3.2 cm wide
38354

b **Band epaulet for a coat**
Quills, moose hide
28 cm high, 9.7 cm wide
38356

Lent by the University Museum, Philadelphia

These specimens of Cree quill decoration were collected by George Catlin on his trip to the Upper Missouri in 1832. Since Catlin did not venture into Canada, these pieces would have seemed exotic to him and well worth collecting, even though he never saw a complete Cree outfit.

115 Set of costume articles
Mid 19th century
Manitoba, Cree

a **Gun Case**
Buckskin, quill, beadwork
1.53 m long, 25 cm wide
L.304.127

b **Octopus bag**
Smoked caribou skin, beadwork
54 cm long, 26 cm wide
L.304.128

c **Belt**
Caribou skin with loom woven porcupine quills 92 cm long, 8 cm wide
L.304.130

d **Quilled garters**
Caribou skin, cotton, quill
35 cm long, 4 cm wide
L.304.131 & A

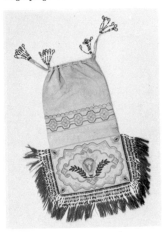

e **Huron bag with top pulls**
Skin, beadwork 39 cm long, 31 cm wide
L.304.129

Lent by the Royal Scottish Museum

All these objects were collected by Dr John Rae (1813–1893), the Arctic explorer. They were discovered in 1854 after the fateful Franklin expedition. Up until 1856 most of Rae's work was in the Arctic and he does not appear to have visited the Red River area until 1864.

It would be hard to find more graceful floral motifs than those of the octopus bag and garters. The embroidery was probably convent inspired but has been integrated into both masculine (gun cover) and feminine (octopus bag) decorative articles.

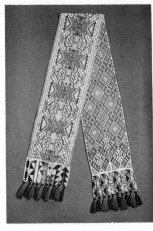

116 Sash 19th century
Great Lakes, possibly Potawatomi
Beads, wool 1.30 m long
Lent by the Trustees of the British Museum 1944.Am.2.204

A band covered with grass beads and fringed in red and green wool. It is usual for the two halves to be decorated with different patterns. From the Blackmore Museum, Salisbury. Beasley Collection.

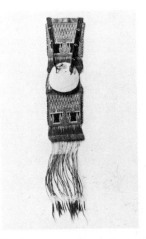

117 Back ornament 19th century
Great Lakes, Ottawa
Cloth, quill, metal 1.20 m long
Lent by the Trustees of the British Museum +6992

Hide straps covered in metal are suspended from a shell worn on the chest, attached to this is quillwork on which appears the 'thunderbird' motif. There is a similar back ornament in the National Museum of Man, Ottawa (see *Indianer Nordamerikas 1760–1860*, no. 20, Offenbach, Deutsches Schuhmuseum, 1868). See also the *Canadian Institute, Fourth Annual Report*, page 23, where David Boyle pictures a single quill panel showing one thunderbird in the same format 'procured from Ek-wah-satch who resides at Baptiste Lake. He informed me that it had belonged to his grandfather who resided near Georgian Bay.'

Presented to the Christy Collection, October 25 1893 by A.W. Franks.

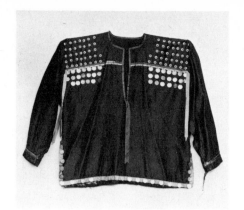

118 **Moccasins** *c* 1800 AD
Wisconsin, Kickapoo
Deerskin, velvet, ribbon, beads
19.5 cm long, 6.5 cm wide, 7.5 cm deep
Montana Private Collection

Kickapoo ethnology is extremely rare. This tribe lived along the Wabash and Illinois rivers and greatly aided the British during the war of 1812.

120 **Blouse** *c* 1920 AD
Oklahoma, Delaware
Cotton, ribbon 50 cm high, 123 cm wide cuff to cuff
Lent by the Denver Art Museum JD-1

On this woman's blouse are arranged 199 native-made German silver brooches. 228 Canadian nickels are attached to the yoke and body.

122 **Moccasins** *c* 1890 AD
Oklahoma, Miami
Deerskin, silk ribbon, beads
25 cm long, 7 cm wide, 9 cm high
Montana Private Collection

The work of the Miami, who were originally located near Toledo, Ohio, retained a Woodland character.

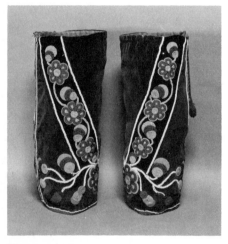

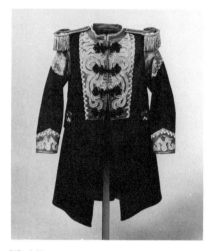

119 **Man's costume** *c* 1890 AD
Wisconsin, Ojibway
Velvet, cloth, beads, ribbon
breechclout 41 cm high, 85 cm wide;
leggings 38.5 cm high, 16.5 cm wide (each)
bandoleer bag 1.22 m high, 35.5 cm wide
Lent by Mr and Mrs James D. Ireland

Originally this man's costume was accompanied by an undecorated buckskin jerkin. The floral patterns, including the flowers-in-a-pot design panel on the bag front show the strongly representational bent of much Ojibway apparel beadwork after 1880. Beadwork against rich black or brown velvet became especially fashionable until recently. Collected by Maude Wilmot in or near Superior, Wisconsin, about 1911.

121 **Wedding coat** 20th century
Oklahoma, Osage
Commercial dress coat with added native German silver brooches, beadwork and silk ribbon appliqués 1.09 m high, 53.5 cm wide
Lent by the Denver Art Museum AOs–28

About the middle of the last century an Osage chief was given a dress uniform coat by an army officer. When his daughter married she wore the coat, conforming with the Plains custom of allowing children to parade their fathers' war honours. From then until about 30 years ago coats like this one were still worn at weddings.

123 **Blanket** *c* 1920–1930 AD
Oklahoma, Osage
Trade blanket, ribbon
1.52 m high, 1.84 m wide
Lent by Leland and Crystal Payton

Among the now widely dispersed Great Lakes tribes, the Osage have best maintained their respect for traditions, including the making of fine ribbon appliqué blankets. Several women of the tribe still do ribbon appliqué work for their fellow tribesmen. The stiff geometry of the double fork design is typically Osage.

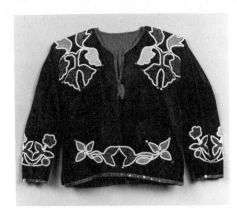

124 Blouse *c* 1900 AD
Wisconsin, Potawatomi
Velvet, beads, calico
55 cm high, 1.45 m wide (cuff to cuff)
Lent by the Denver Art Museum BPw-5

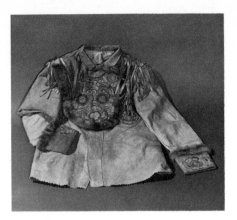

126 Coat 1912 AD
Manitoba, Ojibway
Moose skin, cotton thread, muskrat fur
Lent by the Manitoba Museum of
Man H4.11.12

This European-style coat shows that as late
as 1912, the date it was made by Mrs
William Berens of the Berens River
reservation for the Reverend Jones,
embroidery panels were still made to rival
Huron 18th-century work, or Cree work of
the early 19th century. The front panels,
cuffs, pocket and back yoke flower patterns
are more crowded than the prototype, and
the coat does not show the frock tailoring of
number 106.

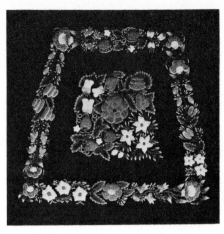

128 Embroidered panel *c* 1800 AD
Canada, Quebec, Huron (?)
Moose hair embroidery, felt
55 cm high, 57.5 cm wide
Lent by the Jonathan and Philip Holstein
Collection

Pieces like this are usually attributed to the
Huron. They were used as table or seat
covers, made for trade. This one is a seat
cover, unused.

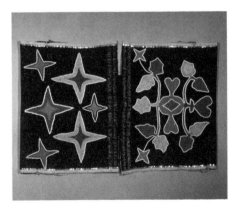

125 Breechclout *c* 1875–1880 AD
Nebraska–Wisconsin, Winnebago (?)
Cloth, ribbon, calico, beads, sequins
53 cm high, 1.60 m long
Montana Private Collection

Star and floral beaded patterns on a trade
cloth background.

127 Shawl *c* 1880–1890 AD
Nebraska, Winnebago
Broadcloth, silk ribbons
1.25 m high, 1.67 m wide
Lent by the Denver Art Museum AWin–1

Formerly in the Albert G. Heath collection.

129 Shawl *c* 1800 AD
Michigan (?), Potawatomi
Cloth, ribbon 1.27 m high, 1.38 m wide
Lent by the Denver Art Museum APw-1

This magnificent silk ribbon appliqué work
was made from an early stroud cloth rather
than a commercial blanket. Formerly in the
Albert G. Heath Collection.

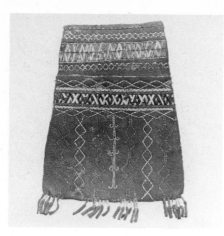

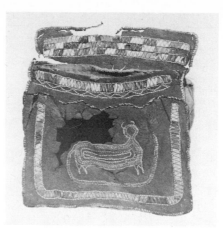

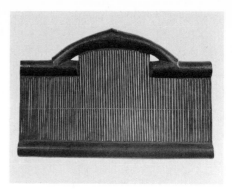

134 **Heddle** 19th century
Iowa, Sauk and Fox
Wood 21 cm high, 32 cm wide
Lent by the Chandler–Pohrt Collection

This object was used in the making of a type of woven bead work. Note the refined carving of the reed or comb. The undecorated handle (some have animal effigies) is useful for raising and lowering the heddle quickly. Collected at Tama, Iowa, in about 1860.

130 **Bag** 1750–1800 AD
Michigan, Ojibway
Buckskin, quills 18 cm long, 12 cm wide
Lent by the Chandler–Pohrt Collection

This bag is one of the most distinguished textiles from the upper Michigan peninsula. It is overlain with a diamond quilled pattern and has a refined Great Lakes variant of the Eastern Woodlands double curve motif down the centre. The quilled diamond outline patterns in the lower part herald the beaded border motifs of 19th-century Ojibway beaded bags. Collected by Milford G. Chandler.

132 **Bag** c 1780 AD
Michigan, Ottawa
Buckskin, quills 15 cm long, 13.8 cm wide
Lent by the Chandler–Pohrt Collection

There are three types of quillwork in this bag. The underwater panther design symbolizes one of the myths of the origin of the Great Lakes tribes. The zig-zag quilled line above the panther represents water. The deer hair fringe is lost. A pouch with two panthers paired, also collected at Cross Village, Michigan, is at the Cranbrook Institute of Science (see Frederick J. Dockstader, where it is misdated). It is virtually identical, in technique, design patterns and dyed black buckskin field, with the one displayed here.

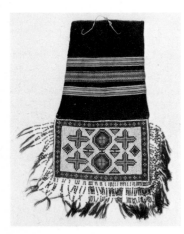

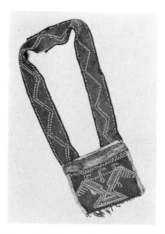

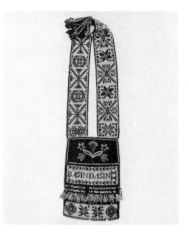

131 **Finger woven bag** Before 1850 AD
Ontario, Ojibway
Cloth, beads 41 cm long, 28 cm wide
Lent by the Royal Scottish
Museum UC 308

A beautiful example with a very succinct bead frame; the diamond chain pattern in the upper part is more refined than the same Ojibway patterns of the 18th century.

133 **Bag with three-headed bird**
19th century
Great Lakes, Ottawa or Ojibway
Wool, beads, lined with cotton
59 cm high, 19 cm wide
Lent by the Royal Scottish
Museum 1894.269

This beaded bag has an unusual interpretation of the thunderbird motif with three heads.

135 **Shoulder bag**
Michigan, Ojibway
Beads, cloth, ribbon 84 cm high
Lent by the Chandler–Pohrt Collection

The wide range of geometric designs on the surfaces of this bandoleer bag make it a master-work of its kind. Such bags were called friendship bags in Canada. This example is from the upper Michigan peninsula where the finest and tightest hand-loomed beadwork was done. Another bag by the same craftsman, matching this one, is in the Fort Wayne Military Museum and is illustrated in Flint, Michigan, *The Art of the Great Lakes Indians*, number 207.

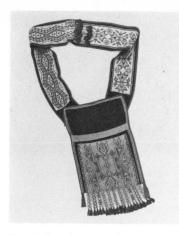

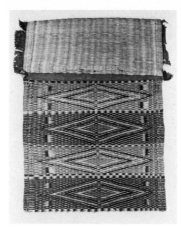

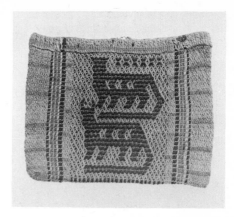

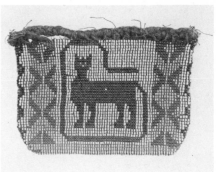

136 **Bandoleer bag** 19th century
Great Lakes, Chippewa
Beads 97 cm high, 24 cm wide
Lent by the Royal Scottish
Museum 1961.509

This strongly coloured bag is less
illusionistic than the floral designs popular
in the late 19th century.

138 **Bag** c 1825–1830 AD
Wisconsin, Fox
Matting fibre 78 cm high, 55 cm wide
(when opened)
Lent by the Linden Museum 36154

Woven fibre mats were used by the Great
Lakes tribes and taken into the Prairies
following tribal migration. When Prince
Maximilian collected this Fox matting, the
Fox still lived to the east of his route, but he
could have collected it along the middle
reaches of the Missouri as the Fox were
among the tribes attending the important
Mandan 'trade fairs'. They moved to Iowa
the year of his trip, 1832. The geometric
weaving of mats may underlie patterns of
later quill and bead work, as they are pre-
floral in nature and pure in design.

140 **Two bags** 19th century

a Michigan, Ottawa
Nettle fibre 16 cm high, 22.5 cm wide

b Iowa, Sauk and Fox
Beads 9.5 cm high, 12.5 cm wide
Lent by the Chandler–Pohrt Collection

Both of these bags represent underwater
panthers, a being made of natural nettle
fibre and b of trade beads. They represent
earlier and later phases of the same concept.
a has a thunderbird on the reverse; one of
the panthers has horns (the male) and the
other has none. b has a spider web design on
the reverse. Both are illustrated in *Art of the
Great Lakes Indians*, page 197, and both were
obtained by Richard Pohrt, from Angela
Kawecoma, Goodhart, Michigan, who
collected them in Tama, Iowa.

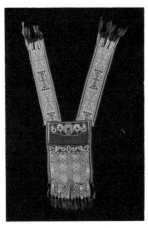

137 **Bandoleer bag** c 1890 AD
Great Lakes, Potawatomi
Wool, muslin 1.15 m long, 31 cm wide
Lent by the Cleveland Museum of Natural
History 5339

The extension of the vertical geometric
design into the lower tabs is extraordinarily
deft. The offset shoulder straps probably
indicate Winnebago or Potawatomi origin.

139 **Mat** c 1890–1900 AD
Iowa, Fox
Rushes 1.75 m long, 96 cm wide
Lent by the Smithsonian
Institution 279,712

From the Mesquakie Fox at Tama, Iowa.
The colours are well preserved. See also the
Sauk matted bag collected by Prince
Maximilian Zü Wied Neuwied about 1830.
Given by Dr Truman Michelson,
September 10 1913.

141 **Blanket bag** *c* 1900 AD
Minnesota, Ojibway
Cotton 53 cm long, 51 cm wide
Lent by the Smithsonian Institution
278,108

This bag, ornamented by a frieze of
thunderbirds, was collected by Frances
Densmore, an ethnographer and an
important writer on Ojibway music and
customs. She presented it to the
Smithsonian on June 9 1913.

142 **Bag** *c* 1950 AD
Iowa, Fox
Wool, yarn 33 cm high, 41 cm long
Lent by the Denver Art Museum RSF–9

A fairly recent interpretation of the
traditional Great Lakes woven bag; the
warps are native cordage, and the wefts of
commercial yarn. The motifs are
thunderbird and deer. Made by Mrs
William Leaf of Tama, Iowa.

143 **Cradle binder** *c* 1860 AD
Ontario, Ottawa
Wool cloth, silk ribbon
1.36 m long, 18 cm wide
Lent by the Denver Art Museum AOt–1

Decorated bands were used to bind a
swaddled baby to the wooden cradle board.
The outermost portion of the binding was
decorated.

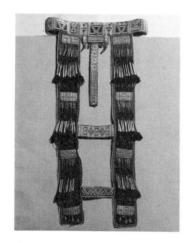

144 **Cradle front** Early 19th century
Manitoba, Cree (Red River?)
Wood, buckskin, quill, beads, felt, silk
metal cones, wool, thimbles 71.5 cm high
Lent by the Hudson's Bay Company
Historical Collection, Lower Fort Garry
National Historic Park 3169

This spectacular cradle front lacks its
backboard. Acquired by the Hudson's Bay
Company Collection in 1823. There are 15
quill panels with nine different designs; the
loom work in natural dyes is extremely fine.

145 **Sleeping robe** 1968 AD
Saskatchewan, Cree
Rabbit skins 2.03 m high, 1.52 m wide
Lent by the Manitoba Museum of Man
H4.12.197

This finger-woven robe with its soft open-
work weave is an example of a traditional
craft among the northern Cree which they
continue to practice today. In normal use
these robes lasted about two years. Made by
Noah Custer, Gromite Lake,
Saskatchewan, in 1968, whose family
donated it to the Manitoba Museum of
Man.

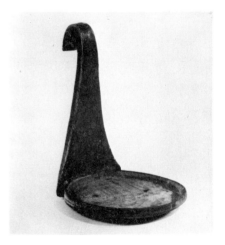

146 **Grease ladle** 20th century
Quebec, Cree
Wood, paint
10 cm long (handle), 6 cm diameter (bowl)
Lent by the Royal Ontario
Museum 965.117.31

This compact ladle is carved from a single
piece of wood. The slight railing around the
dipper expresses an uncommon degree of
finish.

b

a

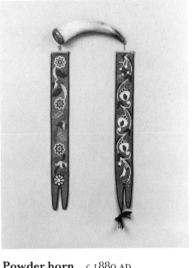

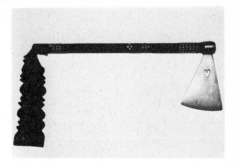

147 Ladles and bowl *c* 1760 AD
Great Lakes and Woodlands
Wood
a Oneida type 20.5 cm high, 61 cm
diameter
b Great Lakes type 20 cm high, 12 cm wide
c 27 cm high, 14.4 cm wide
Private Collections

a shows rim wear. These bowls were used
with gambling dice. *b* has an owl effigy on
the handle and is made of maple burl. *c*
exhibits concentric use of tree ring pattern.
Used at feasts and sometimes hung over the
rims of large burl bowls.

149 Powder horn *c* 1880 AD
Ontario, Cree
Cow horn, wood, mirror, cloth, beads
71 cm high, 28 cm wide
Lent by the Denver Art Museum BMst-1

Made by the Mistassini Cree of eastern
Canada. Note the mirror and plug. The
shoulder strap is of strouding with calico
lining and bead embroidery. Formerly
Allen Tupper True Collection.

151 Tomahawk Before 1860 AD
Missouri, Osage
Iron, wood, brass, cloth
20.5 cm high, 54 cm long
Lent by Hermann Vonbank 64/14

The iron blade of this war hatchet is
decorated with a punched-out heart design
and inlaid brass half moon and five-pointed
star; around the half moon are nine small
and two larger embossed stars. The Osage
believed their tribe originated in the stars.
The wood shaft is decorated with trade
tacks, with a scalloped and pointed-edged
dark blue cloth runner attached to the grip.
This beautifully balances the blade. In this
cloth at the bottom are four brass bells.

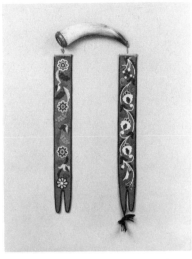

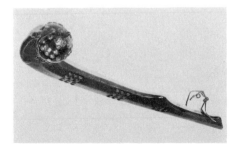

148 Club *c* 1800–1850 AD
Great Lakes, tribe unknown
Wood, tacks 59 cm long, 18 cm wide
Lent by Mr and Mrs Rex Arrowsmith

A richly patinated ball-headed club with an
otter clinging to the rim, decorated with
trade tacks and wood spikes inserted in the
ball.

150 Crooked knife *c* 1870 AD
Minnesota, Ojibway
Wood, metal 33 cm long
Lent by James Économos

Made from an old file blade, representing a
stylized horse, with a figure on it wearing a
peace medal.

152 Crooked knife *c* 1850 AD
Iowa, Sauk and Fox
Wood, steel 27.5 cm long
Lent by the Chandler–Pohrt Collection

The blade of this crooked knife is home-
forged from an old file. Great Lakes area
tribes frequently designed handles in the
shape of a horse's head. Eastern crooked
knives had scroll designs on their handles.

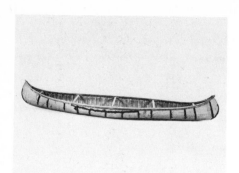

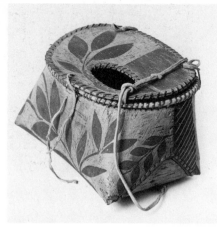

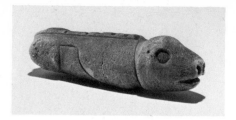

153 **Canoe** 20th century
Ontario, Algonquin
Birch bark, wood, pitch 3.66 m long
Lent by the Royal Ontario Museum 962
212

This hunting canoe was collected by Dr
Edward Rogers in the Ottawa River Valley,
north of Halburton in 1954. It is correctly
made with spruce gum sealing. Indian bark
canoes are economical and graceful in
design, and do not disturb the habitat.
Canadian maritime canoes have half
curved prows, and those from the Western
Great Lakes have recurved bows and sterns.
Ottawa valley canoes fit between these
extremes. One-man hunting canoes were
especially portable and easy to manipulate.
Maritime ocean canoes reached 25 feet
in length, and for the fur trade runs some were
built, under European direction, over 35 feet
long. The canoe exhibited is close to figures
106 to 110 in E.T. Adney and H.I.
Chapelle. For the intricate knowledge
necessary to build a similar canoe see G.
Camil, 'The Weymontachine Canoe', 1974.

155 **Creel** *c* 1910 AD
Manitoba, Cree (?)
Bark, buckskin 18 cm high, 31 cm long, 19
cm wide
Lent by the Heard Museum
NA NE Mis B.12

An adaptation of the birch bark containers
made traditionally in the upper Great
Lakes area, probably for a sportsman's use.
Negative leaf patterns made by scraping the
outer bark layer.

157 **Fetish** Early 20th century
Minnesota, Ojibway
Stone 22 cm long, 5.5 cm diameter
Lent by the American Museum of Natural
History 50.1/7392

This phallic/animal fetish image was used
in the Midewiwin medicine rites of the
Ojibway. Collected in 1913.

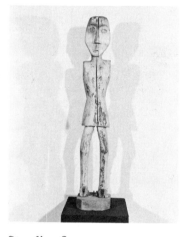

158 **Standing figure**
Ojibway, Michigan
Wood (later paint) 89.5 cm high
Lent by the Chandler–Pohrt Collection

Probably a magic figure used in Wabeno
sorcery.

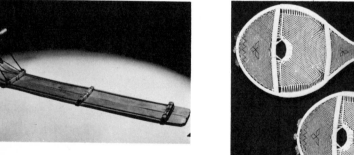

154 **Toboggan** 1953 AD
Ontario, Cree
Wood, paint 78.5 cm long
Lent by Dr Edward Rogers

This toboggan model, commissioned in
1953 by the ethnologist Dr Edward Rogers
of the Royal Ontario Museum, is
embellished with a red north wind design.
Toboggans were traditionally leaned
against the northwest corner of a house to
placate the north wind. They displaced
very little snow, despite the weight they
carried as they skimmed over the surface.
Today toboggans are rarely made.

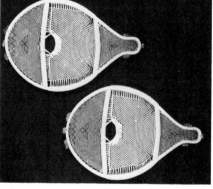

156 **Snowshoes** 20th century
Quebec, Cree
Wood, babiche, cord
82 cm long, 52 cm wide
Lent by the Royal Ontario
Museum 971.2.1

These white birch snowshoes with the
beaver tail shape are in the typical eastern
Canadian style. The design is made by
pulling the babiche when it is wet and
letting it dry taut and hard.

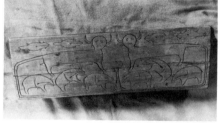

159 **Two Mide boards** *c* 1860–1880 AD
Minnesota, Ojibway
Wood
a 12 cm high, 38 cm long;
b 14 cm high, 33.5 cm long
Lent by Mr and Mrs Rex Arrowsmith

Used in the rites of the Midewiwin Society.
a is a pair of male underwater panthers
surrounded by six bears with heart lines for
hunting medicine and four beavers. *b*
consists of seven fish, two beavers, six otters
and an underwater panther with brass tack
eyes.

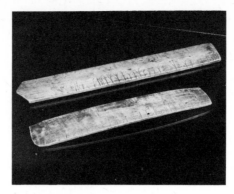

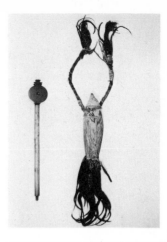

160 Two Midewiwin scrolls 1860–1870 AD
Minnesota, Ojibway
Birchbark, wood
a 1.76 m long, 36 cm wide
b 1.38 m long, 34 cm wide
Lent by Bob Ward, Santa Fé

The Mide scrolls were made for three main reasons: to instruct novices, to record the ritual and as master scrolls for discussion and interpretation by Mide priests. These are master scrolls. The engraved line through the centres represents the path travelled by a candidate through the lodges of the society. A candidate would be about fifty years old before he reached the third degree, although old scrolls exist with as many as eight lodges depicted.

The circle represents the world, guarded by four spirits representing the four directions. Mide priests stand along the outer paths which show the temptations and obstacles on the way. Two underwater panthers can be seen; they represent grave danger to those who ignore Mide teachings and guard the high degrees. An actual circle of prayer can be seen along the centre path.
Collection of Monroe P. Killy, previously Fred K. Blessing.

162 Two prescription sticks
c 1850–1875 AD
Kansas, Prairie Potawatomi
Wood
a 45.5 cm long, 6 cm wide
b 37.5 cm long, 6 cm wide
Lent by Mr and Mrs Gregg F. Stock

These sticks were used by Potawatomi medicine men as aids in brewing herb medicines. Each of the ruler-like images along the edges represents a certain plant, and the markings tell which plants to use to mix a particular remedy. The dots or striped pole-like design on these sticks indicate an interval between prescriptions. Pieces of cloth with leaves and bark stitched on them were used in the same way. From the Prairie Potawatomi reservation at Holton, Kansas, but found in Kansas City, Missouri in 1969.

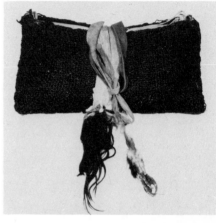

164 Medicine bundle Before 1840 AD
Oklahoma, Osage
Buffalo hair cord, scalps, buckskin, various materials including wood and catlinite
29 cm high, 58 cm long
Lent by Hermann Vonbank 72/112

The outer pouch is of braided, twisted buffalo hair cord, with a buckskin liner. A leather strap 2.66 m long is wrapped around the pouch several times and knotted, with a dark-haired human scalp, an eagle's claw and a patch of skin in the middle. The following items are contained in the bundle. a Falcon skin stuffed with human hair, head sewn in leather, throat painted red, rest of body green and blue, collar made of stag tail hair; there is a bundle of scalp pieces attached to the lower end of the bird, and there is a carrying band of wool, sinew and leather, with scalp pieces 95 cms long; the bird is protected by a leather cover. b Pipe of red catlinite with ash stem 40 cms long, with a morsel of tobacco in a leather case; round pipe platform is typical Missouri River Osage form. c Leather bandoleer for carrying bundle, 70 cms long. d Round leather cord, four-ply braiding over grass pith.

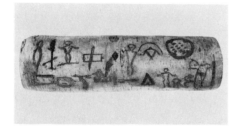

161 Scroll c 1885 AD (?)
Northeastern Plains, Ojibway
Birchbark 35 cm long, 10 cm wide
Lent by the Trustees of the British Museum 1949.Am.22.170

The incised zoomorphic drawings on this scroll had precise ritual meanings understood by persons initiated into the Midewiwin society. It was intended for private use. Collected in Minnesota: formerly the property of Chief Bad Boy. Formerly in St Augustine's College, Canterbury. Oldman Collection.

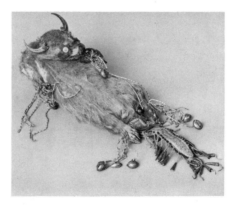

163 Medicine bag c 1800 AD
Minnesota or Canada, Ojibway (?)
Badger skin, quills, ribbon, beads, bells, eagle claws 65 cm high, 12 cm wide
Montana Private Collection

For medicine making the otter has been brought back to spiritual life by eagle claw 'horn' adornments. The otter and badger were protective animals to the Midewiwin and helped initiates through the entrances (degrees) of the Mide lodges. Their help was sought by Mide priests who made them herbal offerings from the bags.

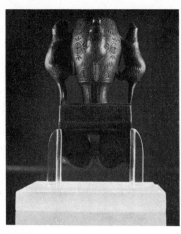

165 **Pipe bowl** *c* 1750 AD
Nova Scotia, Micmac
Soapstone
9.5 cm high, 6.5 cm wide, 5 cm deep
Montana Private Collection

An elaborate early pipe bowl, of a type
common to many tribes of the eastern half
of the United States and Canada. Its
silhouette is enhanced by finely carved
images of a beaver, a turtle, a muskrat and
an otter. The animal symbols suggest where
the Great Lakes tribes may originally have
derived their Midewiwin animal protection
designs. (See number 159.)

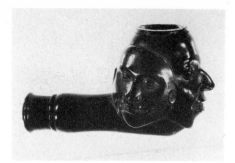

167 **Pipe bowl** Before 1850 AD
Great Lakes, Ojibway
Stone 11.5 cm long
Lent by the Trustees of the British
Museum St 723

This pipe belongs to the same category of
carving as number 168. Note the moulded
stem and exquisitely stylized faces. Christy
Collection.

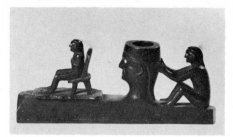

169 **Pipe** Early 19th century
Ontario, Ojibway
Steatite
Lent by the Royal Ontario
Museum (Gift of Frank Eames,
Toronto) 38457

Collected by the artist Paul Kane at
Manitoulin Island, Lake Superior, and
commented upon in *Wanderings of an Artist
Among The Indians of North America*,
published 1859 (Radisson Society of
Canada edition, 1925, pages 9–10). '. . . a
pipe carved by Awbonwaishkum out of
dark coloured stone, his only tools being an
old knife and broken file. I leave it to
antiquarians to explain how the bowl of this
pipe happens to bear so striking a
resemblance to the head of an Egyptian
sphynx. Questioned Awbonwaishkum as to
whether he knew of any tradition connected
with the design, but the only explanation he
could offer was that his forefathers had
made similar pipes with the same shaped
head for the bowl, and that therefore the
same model had always existed among the
Indians.' This style of pipe carving existed
long enough in the Lake Superior
neighbourhood to influence the more
narrative pipe bowl carving executed by the
Great Lakes tribes when they migrated to
the Plains or traded with the Plains people.
Several pipes of this type are known from
this locale. (See number 493.)

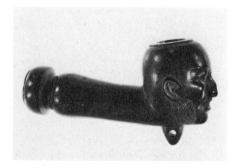

166 **Pipe** 19th century
Great Lakes, Chippewa
Catlinite 11.5 cm long
Lent by the Trustees of the British
Museum D.C.39

Carved in the form of a human head, with
aquiline nose and whiskers. Under the
throat is a projection with hole for attaching
ornaments. Collected from Pembina, Red
River, Minnesota by Mr A. Boyd,
December 1868. Bragge Collection.

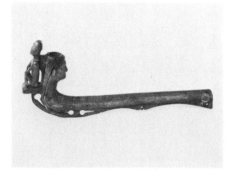

168 **Pipe** Early 19th century
Great Lakes, Ojibway
Ashwood 37 cm long
Lent by the Trustees of the British
Museum D.C.44

Tobacco pipe bought at sale at Brookfield
Hall, Hathesey, March 1868. Bragge
Collection.

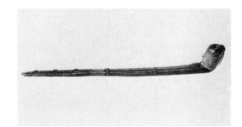

170 **Pipe** Early 19th century
Great Lakes, Chippewa
Ashwood, lead, brass nails 51 cm long
Lent by the Trustees of the British
Museum D.C.80

Tobacco pipe with flat stem carved from
one piece. Stem perforated and ornamented
with brass nails. Bowl lined with lead. The
pipe stem was often considered a bridge into
the heavens and was pointed upward in
prayer. Such pipes were smoked in rituals to
mark ceremonies and solemnize agreements
and are similar to pipes made on the Plains.
Given by Benn Pilman of Cincinnati, 1870.
Bragge Collection.

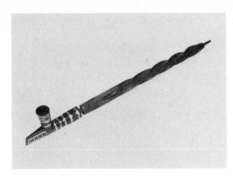

171 **Pipe** *c* 1870 AD
Minnesota, Ojibway
Catlinite, pewter, wood 71 cm long
Lent by E. Michael Haskell

The swirling configuration of the stem is
typical of Ojibway work. The convolutions
begin with a bird head form.

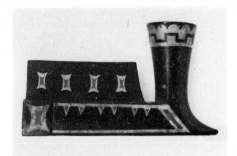

173 **Pipe** *c* 1870 AD
Great Lakes, Ojibway
Stone, lead, catlinite 15.4 cm long
Lent by the Trustees of the British
Museum D.C.88

Tobacco pipe in dark stone inlaid with
lead; the centres of the triangles, circles and
squares are fitted with catlinite. Great
Lakes prow-form type with outstanding
metal design. Collected from Pembina,
Minnesota. Bragge Collection.

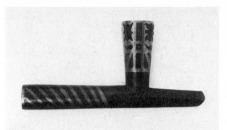

175 **Pipe bowl** 19th century
Minnesota, Ojibway
Red catlinite, lead inlay 18.5 cm long
Lent by the Trustees of the British
Museum 7722

Presented to the Christy Collection by the
Reverend W.D. Parish on January 24 1872,
this pipe was obtained from an Ojibway
camp in Minnesota in 1862.

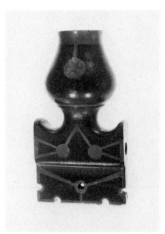

172 **Pipe bowl** Mid 19th century
Great Lakes, Ojibway
Catlinite, lead inlay
11 cm high, 5.5 cm wide
Lent by the Trustees of the British
Museum D.C.1

The bowl shape is close to the stem shape of
number 166. This pipe bowl was in the
Bragge Collection and before that the
Bernhard Smith Collection.

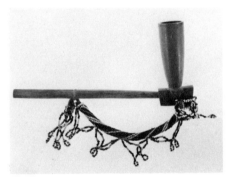

174 **Pipe** Early 20th century
Northern Woodlands, Naskapi
Shale, wood, beads
8.3 cm high, 3.5 cm wide, 18 cm long
Lent by the Trustees of the British
Museum 1921.10-4.192

Tobacco pipe with wooden stem and
coloured beadwork strap. The Naskapi and
Montagnais made similar pipes with
narrow cone-shaped bowls and trinket-like
adornments.

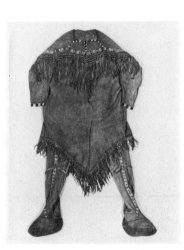

176 **Leggings with moccasins** Before 1900
Yukon Territory, Tinneh
Caribou hide, quills 1.01 m long
Lent by the McCord Museum M5055.1

The Tinneh learned from their Eskimo
neighbours to join leggings and moccasins
into one unit, for warmth and weather
protection. The porcupine quillwork is
exceptionally fine.

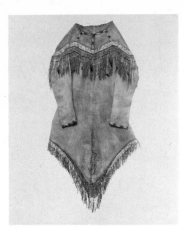

177 **Shirt** *c* 1900–1908 AD
British Columbia, Loucheux
Hide, porcupine quills, beads,
dentalium 1.32 m high, 61 cm wide
Lent by the University Museum,
Philadelphia NA 7739a

The Loucheux or Kutchin lived in the
Yukon territory between the Eskimo and
the Tlingit. Their dress was influenced by
the Eskimo, especially the long V-shaped
shirt tails and full trousers. They added
quilled or beaded edgings whereas the
Eskimo inserted bands of coloured skins.
The dentalium shell was traded inland from
the Oregon coast.

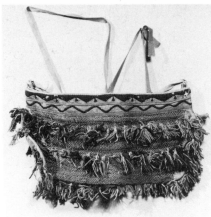

179 **Bag**
Northwest Territories, Athabascan
(tribe uncertain)
Net, moose hide, cloth, beads
23.5 cm high, 49.5 cm long
Lent by the Royal Ontario
Museum (Gift of the Toronto Diocesan
Anglican Church Women)
971.166.215

The Dogrib often made this type of utility
bag.

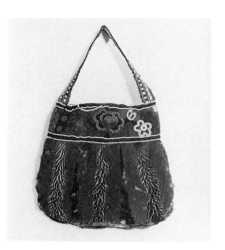

181 **Pouch**
Athabascan, Mackenzie River, Chipewayan
Hide, porcupine quills
15.6 cm long, 26.3 cm wide
Lent by the McCord Museum,
Montreal 1515

Chipewayan beadwork is essentially a
simplified version of Cree work to the south.
The geometry is more concise and
primitive.

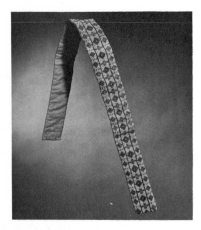

178 **Two belts**
Yukon territory, Kutchin
Buckskin, quillwork, beads

a 79 cm long, 5 cm wide
H4.38.4

b 76.5 cm long, 5 cm wide
H4.38.17

Lent by the Manitoba Museum of Man and
Nature

These belts in loom woven quillwork
represent a far northern holdover of the
type of quillwork made by the Cree until
about 1860.

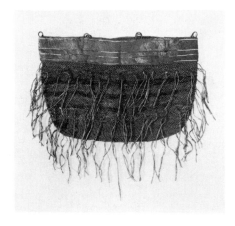

180 **Game bag**
Athabascan, Great Bear Lake Area, Dogrib
Quillwork
28.9 cm long, 42.4 cm wide
Lent by the McCord Museum, Montreal
M10421

This open mesh bag has been ornamented
with two rows of paired thongs, in contrast
with the horizontal accents across the top.

182 **Bag** Late 19th or early 20th century
Yukon or Northwest Territories, Nahani or
Slave
Skin, beads 23.5 cm high, 49.5 cm wide
Lent by the Royal Ontario
Museum 955.177.24

An Athabascan loonskin with deerskin top
with floral motifs. Derived from Woodlands
contact.

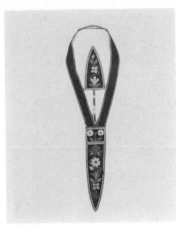

183 **Knife case** *c* 1800–1900 AD
British Columbia, Athabascan, Tlingit
Cloth, beads
smaller sheath 18 cm long;
longer sheath 35.5 cm long
Lent by Mr and Mrs Morton I. Sosland

The black field and floral designs of this
piece suggest it originated in Athabascan
territory adjoining British Columbia. The
double sheaths are evidence that it was
probably made to hold a Tlingit double-
bladed knife.

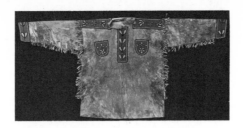

185 **Shirt and leggings with moccasins**
Before 1900 AD
British Columbia, Athabascan, Tsimshian
Caribou skin, beads
85.5 cm high, 68.5 cm wide
Lent by the Cleveland Museum of Natural
History 3381

The beaded panels and caribou skin of this
shirt from Metlakatla, a community
founded in 1887 by Tsimshian followers of
the missionary William Duncan, indicate
inland origin. Probably first traded to the
Tlingit, then to the Tsimshian colony at
Annette, Alaska.

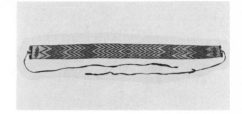

187 **Belt**
Yukon Territory, Tinneh
Leather with porcupine quill-work
2.25 m long
Lent by the McCord Museum, Montreal
M5067

Bow loomed porcupine quillwork was
made in a wide area of northwestern
Canada, though the strips tend to be
thinner and the designs more tensely
organized than among the Cree to the
South. This belt is sinew sewn.

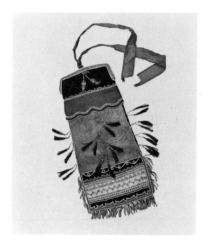

184 **Pouch**
Athabascan, Slave Lake area
Beadwork, quills 41 cm high, 21 cm wide
Lent by the Royal Scottish
Museum 1928.269

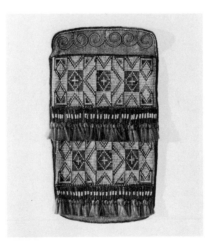

186 **Pouch**
Yukon territory, Tinneh
Leather, porcupine quills
14.1 cm high, 25.2 cm wide
Lent by the McCord Museum, Montreal
M5053

The double curve motif at the top of this
pouch survived far into the Canadian
Northwest.

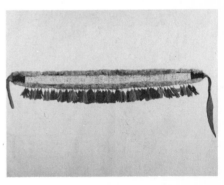

188 **Band** 19th century
Slave Lake area, Loucheux
Quill, beaver fur, wool 1.09 m long
Lent by the Hudson's Bay Company
Historical Collection, Lower Fort Garry
National Historic Park 5252–335–63

A particularly early tumpline with muted
quill patterns and well-preserved fur
borders and wool tassels.

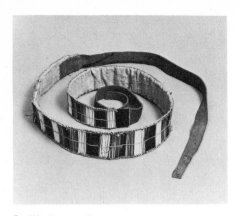

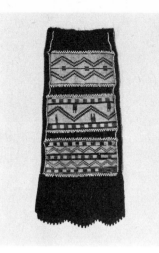

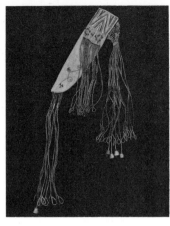

189 Quilled tumpline
Athabascan, Kutchin
Canvas, dyed bird quills, leather, velvet,
beads 97 cm long, 5.8 cm wide
Lent by the National Museum of Man,
National Museums of Canada,
Ottawa VI–1–72

The garish colours of the aniline dyes
suggest that this tumpline is later than
number 188.

191 Wall pocket
Great Lakes, Mackenzie River
Cloth, porcupine quill
35 cm high, 14.7 cm wide
Lent by the McCord Museum,
Montreal M5140

These applied strips are borrowed from the
patterns used in tumplines.

193 Knife sheath Pre 1823 AD
Athabascan, Red River
Buckskin, quill, thimble 38 cm long
Lent by the Hudson's Bay Company
Historical Collection, Lower Fort Garry
National Historic Park 4362,47–7

The quill-wrapped tassels seem to flow
naturally from the chevron-like quill band
at the top of the case. Collected by Mr
William Kempt in 1823.

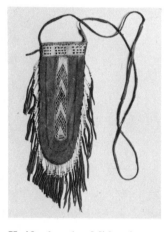

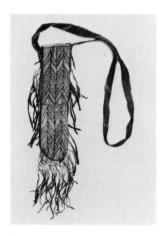

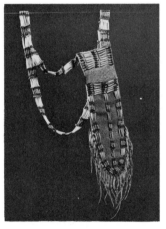

190 Knife sheath Mid 19th century
Athabascan, Tanaina
Bucksin, quill 37 cm long
Lent by the Trustees of the British
Museum 4939

This sheath is decorated with a 'T' shaped
pattern of quillwork; red, yellow and white
in chevrons and lines. This piece may have
been traded north to the Eskimo, but is
certainly of Athabascan origin. Purchased
by the Christy Collection on July 25 1868
from Frederick Whymper who collected it
from 'Kosequin River Indians'.

192 Buckskin sheath 18th century
Northwest Coast, Athabascan, Tanaina
Buckskin, quills 33 cm long
Lent by the Trustees of the British
Museum Van 99

This is one of the earliest examples of inland
quillwork. The chevron designs are simpler
than the ones from the MacKenzie River
area (see number 191) to the east. Collected
by Hewitt on Vancouver's voyage, 1792,
presented to the British Museum by Franks,
1891. See C.H. Read, 'An account of a
collection of ethnographical specimens
formed during Vancouver's voyage in the
Pacific Ocean, 1790–1795', *Journal of the
Royal Anthropological Institute*, 1891. See also
O.M. Dalton, 'Notes on an ethnographical
collection from the west coast of North
America (more especially California),
Hawaii and Tahiti, formed during the
voyage of Captain Vancouver, 1790–95',
Internationales Archiv für Ethnographie, 1897.

194 Knife sheath
Northwest Territories, Athabascan,
Kutchin (?)
Caribou skin, shells, beads
11 cm long, 7.5 cm wide
Lent by the Manitoba Museum of
Man H4.33.4

Iron volute knives were carried in cases like
this one (see number 195). There is no
information on this knife sheath, but it
could be as old as the similar sheath which
is part of a man's summer costume collected
by R.B. Ross in 1862 and in the Royal
Scottish Museum (see Ottawa, *The
Athapaskans: Strangers of the North*, number
177, page 130). Illustrated in O.P. Dickson,
opposite page 24.

195 Knife
Athabascan, tribe unknown
Steel, fibre, twine 68 cm high
Lent by the Smithsonian Institution 2,024

Steel knives with double volute handles
were made by Northern Athabascan tribes
in the Alaskan interior and Canada
(Koyukon–Kutchin). This is an extremely
large example, so much so that it has lost
the more customary hand dagger
proportions in favour of sweeping
pendulous forms which go from both
handles to the blade tip. Collected near the
Arctic coast by Bernard R. Ross and
accessioned December 28 1866.

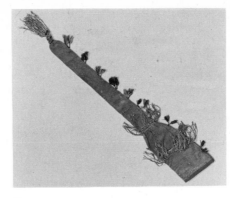

197 Gun case
British Columbia, Peel River, Loucheux,
Hide, porcupine quill, wool, beads
1.20 m long
Lent by the McCord Museum,
Montreal 1130

199 Blanket *c* 1912 AD
British Columbia, Athabascan
Red wool cloth, purple felt, lynx fur
92.5 cm high, 68 cm wide
Lent by the National Museum of Man,
National Museums of Canada,
Ottawa VJ J 47

Notice how the pointed edges of the cloth
borders echo the shapes of the fur ears that
compose the field. The staccato effect is
highly unusual.

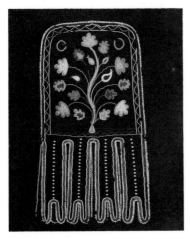

196 Octopus bag
British Columbia, Thaltan
Cloth, beads 41 cm high
Private Collection

This bag is from the Thaltan of interior
British Columbia, a tribe that often traded
with the Northwest Coast Indians;
photographs exist showing Northwest Coast
dignitaries wearing these prestige items.
Here the floral motifs of the eastern
Algonquin finally reach the far west of
Canada.

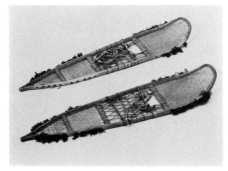

198 Child's snowshoes Pre 1895–1901 AD
Athabascan
Maple, babiche, wool
83 cm long, 17 cm wide
Lent by the National Museum of Man,
National Museums of Canada,
Ottawa VI–o–108

In contrast to the eastern Canadian type
(number 156), Athabascan snowshoes are
long and narrow.

Ivory Madonnas, Bear Cults, and Shamans' Visions: Eskimo Art and Archaeology

The inhabitants of the Far North of America, sparsely settled across the rim of Alaska, northern Canada, Labrador and Greenland, felt that the whole expanse of their cold world was teeming with spirit presences, hovering just out of sight. In Greenland, for example, there was the Tupilak, an amalgam of various animal bones; his glance was lethal, his powers destructive. In carved wood he becomes a horribly distorted monster with human features, although sculpturally not without a certain charm. This visionary animal was part of the world of fantasy that lurked just beyond the Eskimo visual range, a world which could be contacted through the medium of a shaman.

The Eskimo–Aleut peoples made their adjustment to their extreme environment so very long ago that at first glance their culture seems never to have changed. This is not the case, of course, for over the centuries they have developed many diverse skills to an extremely high degree; they made paper-thin clothing from animal skins, they developed the very exacting hunting techniques necessary in their difficult terrain, they invented a system of transportation – using sleds overland and kayaks and umiaks on water – which was superbly adapted to the lands they inhabited. The area was discovered by Europeans in the 17th century and curiosity about Eskimos was spread by such expeditions as Captain Cook's voyage to the Aleutian Islands. Although there was exploration by the Hudson's Bay Company nearby, trade with the Russians was the only regular contact until the growth of the whaling industry in the 19th century when objects began to be made for Western taste and were exchanged for tools and beads.

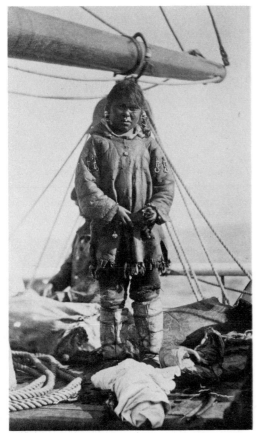

Girl Eskimo 1888
Smithsonian Institution

Much has been written about the Eskimo ability to specialize within his icy environment, the art in particular being cited as the product of limitations in materials: 'Dearth of materials set limits to the achievement of that fullness and complexity which is so characteristic of the Northwest Coast style to the south, but ingenuity on the part of the artist compensated for what the region lacked in material resources.'[1] Actually the materials were rich, but different, including ice for architecture and great piles of driftwood. The small size of most Eskimo art is usually attributed to the scarcity of materials and to some extent this is true, but the nature of belief, and function within the social environment, seem to have been the most important elements in the development of Eskimo art. Dorothy Jean Ray has pointed out that not all Eskimo objects are small, and that large feast dishes and masks were left in the winter villages while small objects accompanied the hunters to camps.[2]

While the most nomadic Eskimo living in central northern Canada made relatively few objects, the dwellers at Angmassalik in eastern Greenland created many figurines, some masks and superbly fashioned and decorated utilitarian objects from late mediaeval times through to the end of the nineteenth century. If the preference for working in walrus and bone ivory, driftwood, seal gut, bristles, puffin skins, feathers and fox furs, and later with trade materials such as Russian blue trade beads, was dictated by availability, the way these materials were worked was purely artistic. From prehistoric times to the modern period there has been too much refinement, and too much choice (even within the conventions) to dismiss the art as the product of material shortages. The Eskimos carve chiefly for reasons that lie within their character as a people, and not because of technical limitations. Only by approaching closer to the Eskimo himself can one enter into an understanding of his art, in which all is not as simple as it might seem.

Any regard the Eskimo might have felt for the past was continually swept away by icy drifts and swirling snow, which covered the barrows and burial cairns, and by the darkness which prevailed for months at a stretch. Summer was announced by the seals basking in the sun on the moving ice floes, winter by relentless cold with young seals in air pockets beneath the snow and ice, a sort of inverted igloo.[3] Education was severely practical. An Eskimo, particularly before the advent of the rifle, could not live for long if he failed to notice subtle changes in the weather or the slightest alteration in the ice, so he learned to

concentrate and pay attention to minute detail, qualities which were also brought to bear on the fragile surfaces of the ivory he carved. Young Eskimos studied subjects like the reactions of a seal to a hunter's shadow at a blow hole or how to avoid polar bears when they are hungry and apt to attack. A seal hunter's equipage is as finely calculated as a doctor's set of medical instruments. A single misjudgement with those instruments could be fatal; a false step on thin ice or a sled moving too slowly invited disaster.

The typical Eskimo lived within an extremely precarious ecological balance. As Birket-Smith said, the Eskimo existed '. . . at the edge of not only the inhabited, but also of the habitable world.'[4] His dexterity in day to day living was carried over into his carving. Hunting sea-animals was a wild, slippery affair with similar tensions to those attendant upon a troupe of high-wire performers or high altitude construction workers in our society. Despite an assumed nonchalance nothing could be taken for granted. Built-in long assimilated caution was the watchword for survival; 'In their predictions of ice conditions and the possibility of ice break-away, the Eskimos are exceedingly careful. They will not take the least risk of drifting away on the ice and being unable to cross an open crack to return to land. To the Eskimos nothing justifies taking a chance.'[5] Nonetheless, the elements of chance and risk always existed in this land where animals were better adapted by nature than man to live on the ice or in the water. No wonder that life focused upon the immediate present with gusto and relish. Fatalism and resignation awaited soon enough. So expendable was life that the old and infirm were sometimes abandoned on drifting ice, so that the healthy could survive unencumbered. The environment did not encourage government so much as custom. 'Tribes' were really experiments in group living perpetuated by success.

The concept of soul was the only thing that was somehow stable and permanent – an ice floe, a polar bear, a piece of driftwood, a whale, or a rock, everything animate or inanimate, had a soul or *inua*. Any mask with an inner face or carved with a fragmentary part of another face – an additional mouth or partial nose for example – represented not an individual animal but the collective *inua* of the whole species: a reincarnative force. Hence the round of festivals and dances in honour of the animals and spirits. The plural of *inua* is *inuit*, meaning people, which is the name by which Eskimos referred to themselves as a group; this implies that the Eskimo concept of a soul investing all things was man-centered, it signified his control over nature and especially over the animals upon which his life depended. That is why the masks are humanoid even when depicting animals, and why man-animal combinations were so easily and freely conceived in the sculpture. It is the hovering presence of these souls, as well as the protective shamanistic visions in which they occur, that so vividly animated the western Eskimo mask complex.

Along with caution and a high regard for skill went a heavy commitment to a world of spirits and spirit helpers controlled by the shaman, who demonstrated his skills before his audience with sleight of hand, props, even 'trips' beneath the ice or to the moon from which he returned dry as a bone and fit as a fiddle. Magic to the Eskimo was a potent creative force, part of the fecundity of life, the mother of artistic invention. Its proper use staved off danger or harm: 'It is the custom on the coming of strangers, for all the women who have borne children, to set up a circle round the sledge with its teams; undesirable spirit entities are then "bound" within the magic circle and can do no harm.'[6] Within the spatial world of the present which stretches to the moon, infested with supernatural entities which were often dangerous, souls and spirits were supplicated as a healing manifestation.

Festivals were held honouring dead animals (the inviting-in ceremony) or propitiating animals yet to be hunted (the bladder festival). Social dancing was done outside in the summer. The more complex ceremonies lasted for days and included dances, the wearing of masks, and the use of purifying smoke. In general these festivities constituted a sort of insurance programme to ensure hunting success through reincarnation, and provided the rich stimulation of close at hand supernatural adventure during the lonely winter.

The hard hunter's life produced a certain cynicism toward what was already concluded; thanking the spirits was not overdone: 'It is more characteristic of the Eskimos to elicit good fortune from the spirits ahead of time, and to pray for supernatural aid in advance. As soon as they have been favoured by good fortune they are apt to forget their gratitude.'[7] An easy-come-easy-go attitude made the struggle for survival a more palatable occupation, clothing the inner concerns with the softness of laughter. It was quite possible to address

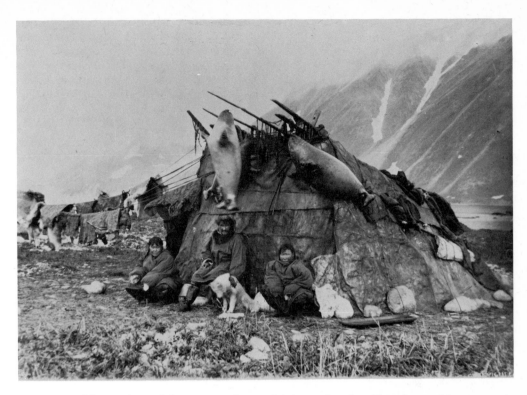

Plover Bay, Siberia 1899
Smithsonian Institution

supernatural forces through humour, at least using it as a handmaiden. In art this was applied judiciously and with taste, but it became less fettered in historic times. Then masks became monstrously jocular (216) or smiled benignly (222). Humour was a cathartic agent, but in North America only the Eskimo and the Woodlands Indians capitalised on this. Plains Indian art contains no humour, and the dour grandeur of Northwest Coast carving – remote, impassive, Olympian – is very far from these Eskimo leers. Festivity bursts; jokes are cracked. A now discontinued mask poked fun at inland Alaskan Indians such as the Anvik (217), upon whom the Eskimos proper looked down, and social usages of the most intimate type involved humour.

Holding an Eskimo child's rattle (236) or figurine in the hand one feels remarkably close to the person who made it, held in the grip of that peculiar Eskimo communicative charm. The objects express more than intimacy, however; the essence of the culture with its closed-in environment and desperate need for signs of continuation is also contained in them. The presentation is modest, but the presence is uncanny. The ivory seems to stand for the interchangeability of the animal or human, his soul, and the recipient, just as the Eskimo himself thought of wood as a symbol of strength: 'To the Eskimo the dwarf willow is a symbol of strength and suppleness against the overwhelming Arctic background, where survival depends upon a man's ability to contend with the forces of nature, while at the same time yielding to them and conforming with them.'[8]

The dwarf willow band arching delicately over the forehead of the face mask (222) and the polar bear ivory carving live in the eternal present. The precision and balance of both echo the life. Something of the white or amber clarity of Eskimo climes is implied by the finish and patina of ivory; an ancient toggle is loaded with the translucence of past ages. There is a compatibility to these objects that tells of a long ago acquired ease with the media.

We have a surprising amount of chronological information about the Arctic, given the vastness of the area and the relatively limited amount of archaeological investigation. There is in effect a step ladder of cultures from 1700 BC (Umak Island in the Aleutians) to the present. This can be seen from stratigraphic site tests, and from beach ridge datings (tracing cultural variations across beach ridges built up in parallel succession) and from carbon datings, made possible by the freezing of hearth remains. Since half of the Eskimo population dwelt in Alaska, and did so from earliest times, it is clear that cultural development there exceeded for the most part that which occurred elsewhere: due probably to better ecological conditions, and more abundant sea-mammals and game.

The earliest identifiable culture in the Bering Sea area is Okvik, with sites located on the Chukchi Peninsula at East Cape, Siberia, on St Lawrence Island, and Punuk Islets, and on the Diomede Islands. Whales were not hunted then, but the sea-mammal hunting economy was already highly specialized, and caribou and polar bear remains have also been found. The people of the area are considered true Eskimos who spoke Eskimo (not Paleo-Eskimos speaking Eskaleut), and their culture had much in common with that of today.

The so-called Okvik 'Madonna' figures are extraordinary and inexplicable objects in walrus ivory, of which over fifty have been found to date. Nothing in earlier Eskimo archaeology prepares us for these striking and forceful figurines, of which some are male, and many others show breasts. The famous 'Okvik Madonna' holds an animal (or possibly an infant). To me she appears to be the protectress of a sea mammal. Do we confront here personifications of the vagina dentata myth of Siberia and America, or are these figurines evidence of the sea goddess Sedna who lived beneath the sea in a house built out of stone and whale ribs?[9] This deity had her fingers severed one by one as she clung to her father's boat; one version has the first joints transformed into salmon, the second into seals, the third into walruses, and the metacarpals into whales. Though this myth has long been most powerfully observed outside the western Eskimo area, it is well known almost everywhere in the far north and could have originated in the Bering area, in association with a female sea cult requiring these figures. It is possible that the male figures might represent Sedna's father or one of her husbands. These figurines are from later Okvik times and overlap Old Bering Sea I (about 1–100 AD).

There are strong material correspondences which link Okvik and Old Bering Sea together, though whether the design repertory changed due to Siberian influences (there are OBS sites on East Cape, Siberia) or because of a parentage common to both is disputed. Old Bering Sea Periods II and III date from 100–300 and 300–500 AD approximately. OBS II designs handle late Okvik-OBS I motifs (spurred lines, detached lines, ellipses, dotted and broken lines, and circles) in a quite different manner. Much more emphasis is placed on the curved lines and circles, which become organic and strangely sub-human or squid-like. Curved lines and circles become separated into panels, often symmetrically balanced (205). The rather rare animal sculptures, usually polar bears, have eye-like designs which may represent joint marks, and which according to Carl Schuster, may indicate a relationship with the Scythian-Siberio animal style.[10]

Old Bering Sea III was a partially regressive phase, returning to the simplified and spikier designs of Period I, yet the curvilinear orientation was retained and strengthened by the setting of the circular or eye motifs and raised or bosse-like elements which gave them a singular visual prominence. The strongly compelling half-mammalian half-curvilinear Old Bering Sea engraved designs on ivory are ambivalent in content and remain a mystery. Do they represent mythical in-dwellers of the sea, hunting fetishism, a scheme for the articulation of animal parts or a synthesis of all these? If figural elements are present they are so heavily sublimated as to be undistinguishable from the sea-like rhythms of the designs as they break and roll across the ivory like waves on a Bering Sea beach.

The Punuk style which flourished between 600–900 AD, has been generally viewed as the outgrowth of the two traditions just discussed, with a possible admixture of influences from Birnik (northwest Alaska). The circle designs were no longer concentric but nucleated. There were fewer lines and spurs but when present these were more prominent, as was the field. There was a rather stiff concern with symmetry, and angularity ruled sharply over Old Bering Sea curves. Actually this simplicity and linear quality (201) has deep roots in Okvik I and previous manifestations in northwest Alaska (Choris, Battle Rock, Norton). It opposes the curvilinear tradition in ancient Alaska rather like the opposing curved and geometric components of Art Nouveau do in our own times. And, again like today, the geometric aspect increasingly grew to dominate (if one goes to Dorset and Thule).

A number of objects from an archetypal Ipiutak site at Point Hope, which was excavated during World War II by Dr Helge Larsen with Dr Froelich Rainey, are now in the National Museum of Denmark. Dr Larsen has postulated the presence of a bear cult among the Ipiutak, because of two rake-like objects of walrus ivory representing the head of a bear between its forepaws. 'As I have said, it looks like a comb and I believe it was used as a comb, namely for a bear skin in connection with certain rites . . . Considering the condition the skin must be in after the killing, smeared with blood and dirt, it is easily understood

that a thorough cleansing was necessary before the skin was adorned and put in the place of honour.'[11] Ipiutak style was a melting pot of previous cultures, given a more distinct rhythmic accent as in the open-work spiral objects (206), or greater independence as in the free-standing bear images and masks (206). It should be remembered that these ivories are in worn condition; however, a small number of Ipiutak ivories have survived in a non-eroded state and they are breathtaking with their precise surfaces.

The succeeding Dorset style was marked by a toughening of form, by an absence of curving lines and a scarcity of excellent examples. Thule culture became a pan-Eskimo style; one wave of the culture moved from west to east, reaching Greenland, and another wave moved backwards toward the Alaskan epicentre. Thule work has been described as flat and lacking originality; recent finds on St Lawrence Island, one of the richest archaeological repositories in the world with Okvik, Old Bering Sea, Punuk, Ipiutuk and Thule objects, makes it clear that the Thule contribution has to be studied more closely. The recently excavated hermaphrodite of walrus ivory (208), a sort of Eskimo kore-kouroi, is almost worthy of a pre-Golden Age Greece. It is infused with a latent humanistic content, hitherto lacking in the north, that goes beyond hunting and fishing skills and the animalistic myths. Two other very important Thule works should be cited here, though neither is exhibited, for they are the connecting links to the Historical period. The first, an engraved narrative scene, looking like one perhaps by a modern novice, appears on a Western Thule ivory bodkin,[12] while an Eastern Thule engraved ivory bow drill, with hunting scenes all along its narrow length, looks very much like a simplified version of a nineteenth-century bow drill.[13] If these objects had not been isolated in their true context by archaeology they might have passed for minor modern works.

After the purchase of the Alaskan territory from Russia by the United States in 1867, ivory carving continued unabated, especially common were snow knives, the ubiquitous bow drills with their elaborate accounts of whaling and walrus hunting expeditions engraved upon their surfaces, and pipes illustrating graphic village scenes including even drying racks and nearby patiently waiting seals, along with visionary fantasies. Reality and fantasy mix in these scenes so that the border between what is real and what is imagined is crossed with consummate ease. The splint-like ivory forms echo the whale bone cavities and walrus skeletons. The intimate carvings of animals and humans (some used as toys, others by shamans) convey the feeling that the Eskimo artist, in making them, has withdrawn into his own interior world, small in scale, taking the outdoors in with him.

Wooden forms, Aleut hats for example (240), were handled as if they were entirely of ivory, while the narrow head band across the top of a face mask (222) was bent as if it were an ivory splint. In modern western Eskimo wooden masks made for the trade, particularly those from Nunivak Island, the forms are there, and something of the skill remains too, but the sense of living invention is sadly absent. The spectacular surrealism has departed in proportion to the decline of the powers of the Angakok, the medicine man, so that masks which were executed not so very long ago seem as if they existed in another world. Perhaps the most extraordinary expression of Eskimo adaptive resourcefulness can be seen in their clothing. It was magnificently tailored by the women, sometimes with apron-like pads and among the Caribou Eskimos with beautifully beaded collars. It was often a membrane, which used the presence of air between skins and lining to maintain a comfortable temperature.

Drawing of mask dance
Smithsonian Institution

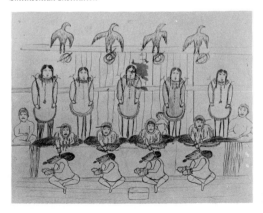

Aleut masks have been found in caves of uncertain date but old enough to form a substratum to the 19th century forms. Several have thick eyebrows and one has an eye form close to that of Northwest Coast masks; such stylistic similarities confirm that there is a relationship, not yet defined, between these early southern Eskimo masks and masks from the Coast even though the Aleut character is forcefully unique. Along the Alaskan coast to the north lies a rich field of inquiry into masks and their meaning. What constitutes a personal vision and what makes a mask type, the shaman's directions or the carver's style? While the shamans were responsible for almost all the ideas expressed by the masks, it is hard to believe that all of them were master carvers. In some regions the shaman appointed carvers to carry out the concepts. Reporting from the Kuskokwim area, Himmelheber found that the shamans had neither the patience nor the ability to carve their own masks,[14] while Ray states that this was not true in the northern area '. . . where the shaman usually carved his own mask. If the northern or Bering Sea shaman did not make the entire mask, he often carved only the spirit face, leaving the rest to another man'.[15]

General lines of stylistic development can be followed. The Pacific Eskimo masks are strongly simplified within a square or sharply triangular frame, close to those obtained on Kodiak island. The Nushagak River area and Good News Bay to the north add painted eye bands, chevrons, eyes with pupils, with the later masks being more massive and ferocious. It is in the Kuskokwim River area that the inua-type (or mask within a mask) is particularly found (220); a face on the stomach or back of the animal depicts the soul element. In the Yukon River area a flat nose ridge separates the eyes, and the nose becomes a triangle with the forehead plane, with the nostril line pointing to the centre or septum. There is often a pronounced smile, and a heart-shaped broad face upon a backboard decorated with feathers; delicate small face masks multiply with pear shaped formats, jack-o-lantern mouths, and feather appendages. The St Michael region was a trade centre facing both north and south where styles converged. Many kinds of masks were made here, including finger masks, and those with broad mouths, and narrow animal faces with protuberances such as a row of wooden bubbles projecting from the mouth like a string of miniature pagoda roofs. One of the prominent St Michael carvers was the 'seal-box' master, bringing up once more the matter of individual creativity. His masks often have a realistic lower part depicting a seal and an upper box-shaped inua, the meeting of the corners of the 'box' forming the nose. A pair of masks by this carver are exhibited here (219).[16] King Island masks usually have a white human face with black hair or eyebrows and a red mouth, influenced by the Kuskokwim-Yukon complex. The northern style around Point Hope is characterized by the rougher character of the carving, greater simplicity, pig-like nostrils, and a lack of appendages. There are certainly more Eskimo carvers now than in the 19th century although the work is done predominantly for commercial reasons.

Notes

1 Erwin O. Christensen, *Primitive Art*, New York, Thomas Y. Crowell, 1955, page 68.

2 Dorothy Jean Ray, 'Eskimo Sculpture', Minneapolis, Walker Art Center, *American Indian Art: Form and Tradition*, page 94.

3 For a drawing of such a seal hole see Diamond Jenness, *The People of the Twilight*, Chicago, University of Chicago Press, 1959, (first printed 1928), page 100.

4 Kaj Birket-Smith, *The Eskimo*, London, Methuen, 1959, page 26.

5 Richard K. Nelson, *Hunters of the Northern Ice*, Chicago, University of Chicago Press, 1969, page 35.

6 Edward Moffat Weyer, Jr., *The Eskimo*, Hamden, Conn., Archon Books, 1962, page 162 (quoting Rasmussen).

7 Edward Moffat Weyer, page 301.

8 Jorgen Meldgaard, *Eskimo Sculpture*, New York, Clarkson N. Potter, 1960, page 7.

9 Edward Moffat Weyer, page 349.

10 Carl Schuster, 'A Survival of the Eurasiatic Animal Style in Modern Alaska Eskimo Art', *Indian Tribes of North America, Proceedings of the 29th Congress of Americanists*, Chicago, Vol 3, pages 35–45.

11 Helge Larsen, 'Some Examples of the Bear Cult Among the Eskimo and other Northern People', Copenhagen, *Folk*, Vols. 11–12, 1969/70, page 34.

12 J. Louis Giddings, *Ancient Men of the Arctic*, New York, Alfred A. Knopf, 1967, Fig. 24, page 91 (from Cape Krusenstern).

13 Marcel Evrard, editor, *Masterpieces of Indian and Eskimo Art from Canada*, Paris, Musée de L'Homme, 1969, plate 21.

14 Hans Himmelheber, *Eskimo Kunstler*, Stuttgart, Strecker and Schroder, 1938, page 76.

15 Dorothy Jean Ray, *Eskimo Masks, Art and Ceremony*, Seattle and London, University of Washington Press, 1967, page 50.

16 For other masks by this carver see Dorothy Jean Ray, *Eskimo Masks, Art and Ceremony*, page 21 and plate 36, top left.

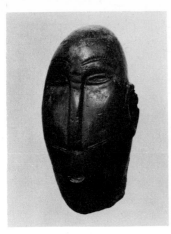

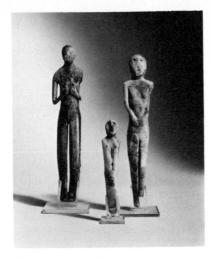

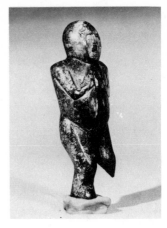

200 Head 500 AD
Eskimo, Okvik (Old Bering Sea)
Ivory 8.6 cm high, 4 cm wide
Lent by the National Museum of Denmark,
Department of Ethnography P-36.910

A number of Okvik heads have been found
which appear to have been severed from
the original carving. It is not known
whether this was deliberate.

202 Three shaman figurines
300 BC–100 AD(?)
Northwest Coast, St Michael, Norton
Sound, Okvik(?) Old Bering Sea
Ivory
a 6.9 cm high
b 12.5 cm high
c 11.2 cm high
Lent by the University of East Anglia (The
Robert and Lisa Sainsbury Collection)

All three of these elongated and highly
simplified figurines were excavated
together. Carved as votive pieces of
unknown use, they are incised and may
have been carved by the same person.

204 Standing figure *c* 100 BC–100 AD
Alaska, Okvik
Ivory 16.5 cm high
Lent by the University of East Anglia (The
Robert and Lisa Sainsbury Collection)

The head of this figure of a woman, who
appears to be pregnant, is not very ovoid,
and the trunk is realistically squat; the
mouth seems about to yell or exclaim. It is
notably more naturalistic than other known
Okvik-style figurines, yet it does not fit into
any later phase of Alaskan archaeology.
(See the famous Okvik 'madonna' in the
University of Alaska Collection or the figure,
discovered on Saint Lawrence Island in
1972, in the Alaska State Museum. Both
illustrated in *The Far North*, pages 8, 9.)
H.B. Collins has written about the
possibility of Okvik female figures being
'bear mothers', and this figure with its
musky animalism advances his view. (See
Dansk Etnografisk Tidsskraft, 11–12,
Copenhagen, 1969, pages 125–132.)

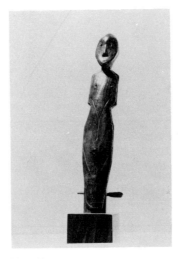

201 Scraper 100 BC–500 AD
Eskimo, Okvik (Old Bering Sea)
Ivory 10.9 cm high, 3 cm wide
Lent by the Danish National Museum,
Department of Ethnography P36.908

203 Handle
Alaska, Eskimo
Ivory 13 cm high, 2.5 cm wide
Lent by the Museum of Primitive Art,
New York 57.86

A walrus ivory dowell holds the figure in
place. It is a variation of the Okvik
'Madonna' fertility figure.

205 Harpoon socket (fragmentary)
Alaska, Old Bering Sea
Walrus ivory 4.5 cm high, 11.5 cm long
Lent by the Saint Joseph Museum 143/5417

The incised designs with secondary lines
and concentric eye-like circles are a
development of the earlier Okvik style, but
lack the curvaceous articulation of designs
of the Old Bering Sea III period. From the
Harry L. George Collection. Site unknown
(from Saint Lawrence Island to Kotzebue
area).

206 **Ipiutak objects** 300–600 AD
Alaska, Eskimo
Walrus ivory, caribou antler, wood

a Mask P-4109
3.8 cm high, 2 cm wide

b Harpoon socket, Deering site P-8197
7 cm high, 1.7 cm wide
c Swivel-like object P-4834
21 cm high, 3 cm wide
d Mask P-4410/1
4 cm high, 2.8 cm wide

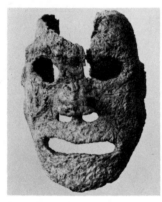

e Mask, eroded P-4688
5.3 cm high, 3.7 cm wide
f Carving with rodent-like head P-4800
12 cm high, 3 cm wide
g Throwing board with seal end, Deering
site P-7425
13 cm high, 2.5 cm wide
h Chain with 11 links P-4546
40 cm long
i Carving with loon head P-4827
22 cm high, 2.7 cm wide
Lent by the National Museum of Denmark,
Department of Ethnography.

These diverse specimens of Ipiutak carving
are from the artifacts unearthed and
classified by Froelich Rainey and Helge
Larsen at Point Hope, Alaska. The style of
Ipiutak artists was more varied than that of
the preceding Okvik and Old Bering Sea
periods, and set traditions which have
continued up to the present. The twisted
toothy face on the harpoon socket is similar
to the monstrous faces of Tupilak carvings
of modern times, while the box-like forms of
the humanoid maskette influenced the
complex masks of the 19th century. The
rodent-like carving is an accurate study of
the animal's skull.

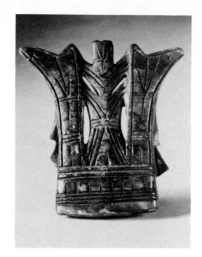

207 **Harpoon socket** c 900 AD
Alaska, Punuk
Walrus tusk 6 cm high
Lent by Mr and Mrs Julian W. Rymar

This piece is very similar to one excavated
by Otto Geist at Kukulik, Saint Lawrence
Island, and is probably from Saint
Lawrence Island, though information is
lacking. (See *The Far North*, page 20.) This
is a translation into turreted form of the
earlier ovoid-shaped Old Bering Sea
'winged objects'. The centre 'splat' may
retain the facial image sometimes seen in
such Old Bering Sea III harpoon tailpieces.

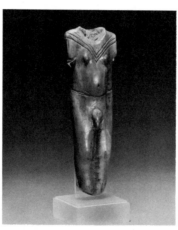

208 **Figure** c 12th century AD
Alaska, Eskimo, Thule
Ivory 18.5 cm high
Lent by the Jonathan and Philip Holstein
Collection
Walrus ivory hermaphrodite figure, never
before published or exhibited. Excavated
three years ago on Saint Lawrence Island.
It is early Thule, and forces a revision of
ideas on Thule, which has often been
considered a stereotyped culture, the main
importance of which was to transmit early
Eskimo style eastward across the rim of the
continent, paving the way for Historic
period developments. This elegant
sculpture makes it clear that Thule could
produce independent masterpieces.

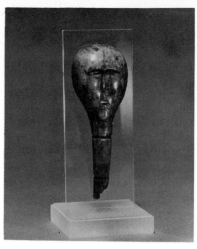

209 **Head** c 12th century AD
Alaska, Eskimo, Thule
Ivory 14.6 cm high
Lent by the Jonathan and Philip Holstein
Collection

Use unknown, perhaps a staff head or a
shaman's doll's head. Also found on Saint
Lawrence Island, northwest Alaska, and
also early Thule.

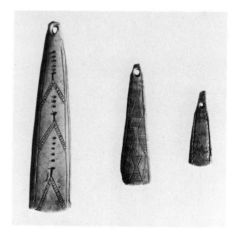

210 **Three engraved pendants** c 1200 AD
Newfoundland, Beothuk
Ivory
Lent by the McCord Museum, Montreal
1141

The extinct Beothuks of Newfoundland
used pendants like these for several
purposes: 'They were found wrapped in
bundles or sewn onto the fringe of a
garment and, in one instance, made into a
necklace. . . . Approximately 360 of these
pendants are known, most of which are in
the Newfoundland Museum.' (I. Marshall,
page 15.) While these Indians were of
Algonquin stock, the pendants, with their
linear geometric markings, seem related to
late Thule eastern Eskimo art.

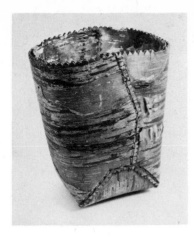

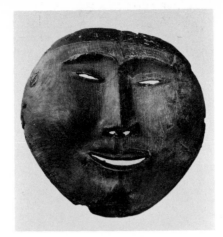

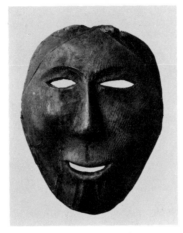

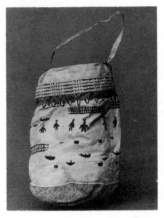

211 Birchbark dish Early 19th century
Newfoundland, Beothuk
Birchbark
17 cm high, 15 cm long, 13 cm wide
Lent by the Trustees of the British
Museum 6976

This Beothuk dish was probably excavated
from the tomb of Mary March at Red
Indian Lake, Newfoundland, by W.E.
Cormack in 1827. Presented by the Royal
Institution to the Christy Collection,
November 24 1870. The Beothuk were
annihilated by the European invasion.
in the early 19th century.

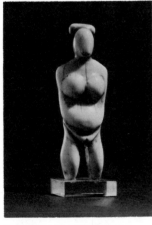

212 Standing female figure 19th century
Greenland, Angmassalik(?)
Ivory 10 cm high
Lent by the University of East Anglia (The
Robert and Lisa Sainsbury Collection)

Formerly owned by J. Worsae, Director of
the Royal Danish Museum in the mid 19th
century, who collected contemporary ivory
carvings in Greenland and on the
Northwest Coast.

213 Two masks c 1840 AD
Alaska, Eskimo
Wood

a 20.5 cm high, 15 cm wide
P-6384

b 20 cm high, 15 cm wide
P-6379

Lent by the National Museum of Denmark,
Department of Ethnography

These masks are from a group uncovered
from a grave at Point Hope in 1939 by Dr
Helge Larsen. More elaborate Eskimo
masks came later in the development of the
complex, and were made further to the
south. b has tattoo marks on the chin.

214 Eight Angmassalik objects
Greenland, Angmassalik
Lent by the National Museum of Denmark,
Department of Ethnography

a **Two human figures** 19th century
Wood 9 cm high (both)
L6554, 6560

b **Tupilak** 19th century
Wood 10 cm high
L19140

c **Sealskin bag**
Sealskin 16 cm high, 9 cm wide
Lc 1319-1

d **Eye shade** 1890–1900 AD
Wood, ivory 7 cm high, 15 cm wide,
13 cm deep
L.5050

e **Throwing board** 1890–1900 AD
Wood, ivory 45 cm high, 8 cm wide
5408

f **Box** 1890–1900 AD
Wood, ivory 11 cm high, 25 cm wide,
10 cm deep
L.5200

g **Visor** 1890–1900 AD
Wood, ivory 15 cm high, 10 cm wide
L.d.71-1

The village of Angmassalik is isolated on the
east coast of Greenland. A Danish party
reached the impoverished inhabitants in
1884 and found an art that rivalled that of
the Alaskan Eskimos. The visor was
collected during this first trip. The two
small figures were found by C. G. Amdrup
in 1899 during his excavations in the ruins
of a large house (Melsaard). These objects
show strong Dorset influence. The wooden
objects are made of driftwood and walrus
ivory. The use of small ivory carvings in
relief as a decoration on utensils gives a rich
almost rococo effect. There are fifty-three
ivory figurines on the harpoon throwing
board and sixty-one on the box.

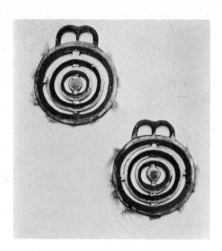

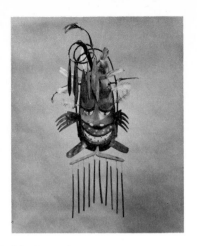

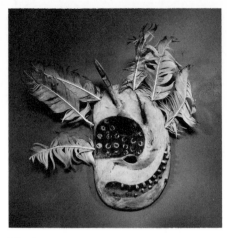

215 **Pair of finger masks** Pre 1884 AD
Alaska, Eskimo
Wood, hair
14 cm high, 11.5 cm wide each
Peabody Museum of Salem E3535

Sometimes pairs of finger animated masks
had faces and were decorated with a feather
crest. Used by women when dancing.

216 **Mask** *c* 1875–1900 AD
Alaska, Eskimo
Wood, paint, feathers, string
1.15 m high, 54 cm wide, 44 cm deep
Lent by the Museum of Primitive Art, New
York 61.39

This mask, with its black, red and ochre
colours, its willow band pendants, complex
twine lashings and feather details,
demonstrates the complexity of Eskimo
carving from the central area of western
Alaska. It shares many characteristics of
shamen spirit masks from the lower
Kuskokwim area south of the Yukon,
particularly in the addition of suspended
parts.

218 **Mask** *c* 1900 AD
Alaska, Eskimo
Wood, feathers
33 cm high, 30 cm wide, 8.5 cm deep
Lent by the University Museum,
Philadelphia NA 10348

This extremely distorted face mask is
characteristic of masks found on the lower
Yukon River. The distribution may be
wider, for this example was collected at
Hooper Bay on the Bering Sea.

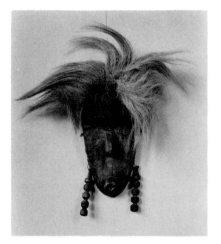

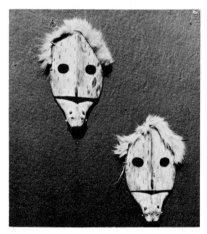

217 **Eskimoid mask** *c* 1900 AD
Alaska, Ingllik
Wood, moosehair, paint
56 cm high, 42 cm wide, 12.7 cm deep
Lent by the University Museum,
Philadelphia NA 5831

This cyclopean mask was collected from an
interior Alaskan tribe whose members live
along the Anvik river, under Eskimo
influence. The interior Athabascans
adopted the Eskimo bi-lateral family
descent and their masks are often hard to
distinguish from genuine Eskimo ones,
although they do tend to be more crude.

219 **Pair of masks**
Alaska, Eskimo
Wood 26.5 cm high, 13.5 cm wide, 8 cm
deep
Lent by the Saint Joseph Museum,
Missouri

From St. Michael. For another mask by the
same Seal Box master see Dorothy J. Ray,
Eskimo Masks: Art and Ceremony, plate 21.

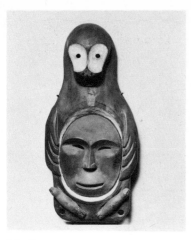

220 Mask
Alaska, Eskimo
Wood 48.5 cm high, 21 cm wide
Private Collection

A seal is presented basking in the water, as seen from above. The inua or 'soul' is contained in the face mask – a very clear example of the concept of the human spirit which always lives on, returning to the home of the animals to propitiate the species. Collected by Bishop Farrhaut of Mackenzie about 1880–90 on the lower Kuskuokim.

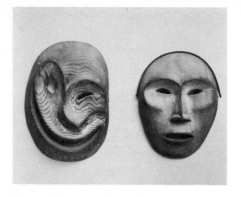

222 Two Eskimo masks
Alaska, Eskimo
Wood 20 cm high; 17 cm high
Private Collection

These masks are notable for their artistic use of wood; the grain has been incorporated into the contours of the distorted mask, while the other is paper thin and topped by a thin bentwood line.

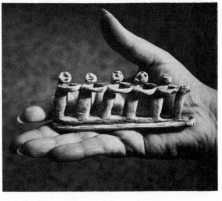

224 Carving of five figures 19th century
Alaska, Eskimo
Ivory 4.7 cm high, 11.3 cm wide
Lent by the Joslyn Art Museum 1959.484

Note that one of the little figures is turning back his head to break the monotony of composition. Collected between 1866 and 1881 by B. F. Reynolds, ship's engineer.

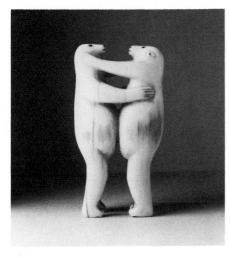

221 Two bears wrestling Late 19th century
Northwest Coast, Western Eskimo
Ivory, metal inlay 8 cm high
Private Collection.

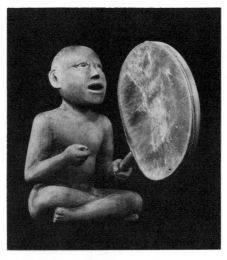

223 Four figure sculptures 19th century
Alaska, Eskimo
Wood, hair, intestines
a 20.8 cm high;
b 12 cm high, 13.2 cm long;
c 12 cm high, 14.5 cm long;
d 12 cm high
Lent by the Cleveland Museum of Natural History 4605, 4606, 4607, 4608

These figures describe a shaman's sick-curing ceremony. *a* is the naked shaman with eyes closed in a trance; *b* is the seated sick girl passively awaiting her cure; *c* and *d* are drummers intently singing. One still holds his intestine drum. In the 19th century Alaskan Eskimos made many models and figures in groups depicted as being engaged in activities important to the tribe. These are among the finest sculptures of this type. Collected in 1891–1893 by Dr H.N. Kierulff in Unakleet Village, Norton Sound.

225 Miniature tools 20th century
Alaska, Eskimo
Walrus ivory

a **Knife**
 12.5 cm long

b **Saw**
 11 cm long

c **Hammer**
 13 cm long

d **Mallet**
 15 cm long

Lent by the Nelson Gallery of Art/Atkins Museum (Gift of Mrs Margery Byram) 74-25/1-4

This set of tools was made for presentation to the school superintendant at Nome, Alaska, in the first decade of this century. They are a charming Eskimo commentary on the white man's technology, made by carvers who could be taught nothing technically.

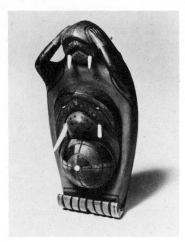

226 Box
Alaska, Eskimo
Wood 21 cm high, 8 cm wide
Lent by the Fine Arts Museums of San Francisco 26662

This box with walrus design has much of the charm, though less of the fantasy, associated with similar Eskimo masks.

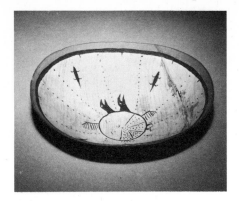

228 Set of Eskimo dishes 19th century
Alaska, Eskimo
Wood
a E13.075 16.7 cm diameter
b E13.076 5.5 cm high, 14.2 cm long, 13.2 cm wide
c E13.077 4.3 cm high, 15 cm long, 14.3 cm wide
Lent by the Peabody Museum of Salem

Painted inside these dishes are the owners' signs and symbols, which were also applied to animal bladders at the time of the bladder festival.

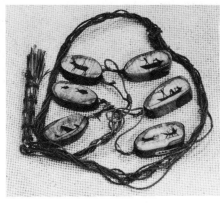

230 Throwing stones
Alaska, Eskimo
Stone with six braided lines and feather quill binding
Length of longest stone: 4.5 cm
Lent by the Joslyn Art Museum (gift of Dr and Mrs A.F. Jonas) 1951/494

These engraved stones, used for killing birds, show deer, fish, walruses and hunters in umiaks and sled. The engraving is in the northern style, with a special feeling for the translucent, snowy qualities of the polished stone.

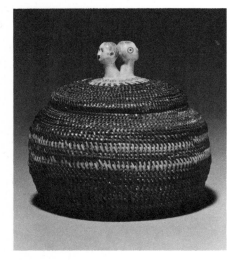

227 Basket 19th century
Alaska, Eskimo
Whale baleen, ivory 10.2 cm high, 12 cm diameter
Lent by the Jonathan and Philip Holstein Collection

The incorporation of whale baleen in Eskimo art dates back to Archaic times; it was used for canoe bailers and as sinew. Baleen baskets do not survive from earlier than the 19th century, but this was probably an indigenous art, not suggested by whites. The earlier type has human head lid decoration, and the later animal, though the two opposing heads, male and female, are most unusual. The female wears a labret; the male is tattooed. In form baleen baskets resemble Alaskan coiled baskets (see number 229). Collected by a missionary in the 1880s or 1890s.

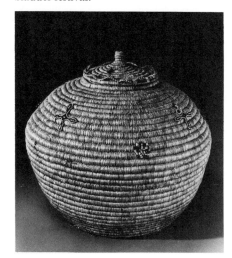

229 Covered basket c 1890 AD
Alaska, Eskimo
Straw, wool 39 cm high, 43 cm wide
Lent by the Peabody Museum of Archaeology and Ethnology, Harvard University 98412

This coiled basket with wool attachments is of exceptional quality and of a type produced by the western Alaskan Eskimos from between the lower Yukon and Kuskokwim River. Otis T. Mason calls attention to 'the delightful effects produced by simply managing the natural colours of the straw with which the sewing is done'. (Otis Tufton Mason, *Indian Basketry*, volume ii, pages 311–312.)

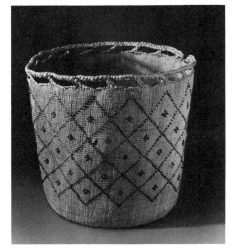

231 Two baskets 19th century
Alaska, Aleut
Grass, worsted
a 19 cm high, 13 cm diameter
Lent by the Nelson Gallery of Art/Atkins Museum (Nelson Fund) 33–1290
b 27 cm high, 30 cm diameter
Lent by the Peabody Museum of Archaeology and Ethnology, Harvard University 61915

The Aleut may not have made these baskets until the last century, perhaps influenced by the Tlingits.

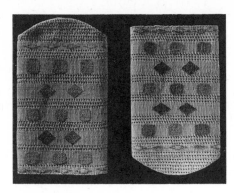

232 Card Case
Alaska, Eskimo
Straw 11.5 cm high, 6.5 cm wide
Lent by the Peabody Museum of
Archaeology and Ethnology, Harvard
University 87581

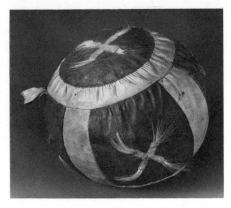

235 Ball Late 19th century
Siberia, Eskimo
Seal skin 20 cm diameter
Lent by the Peabody Museum of
Archaeology and Ethnology, Harvard
University 76076

Used in a girl's game. Museum records state
a collecting point from 'East Point Siberia
on the Diomedes'. Gift of Dr G.P. Howe,
received in 1910.

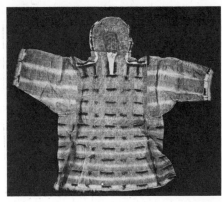

238 Parka
Alaska, Eskimo
Gut 1.23 m long, 1.38 m wide
Lent by the Smithsonian Institution
280181

This parka made from sewn strips of gut
comes from St Lawrence Island. The edge
trim is of polar bear fur and the trim along
the seams is from a brown bear. Fifty-seven
groups of crested Auklet topknots and
mandible parts are decoratively arranged
along the transparent gut seams. Although
this parka is wholly traditional in concept it
is sewn with thread rather than sinew. It
was collected by Dr R. D. Moore and
accessioned on October 10 1913.

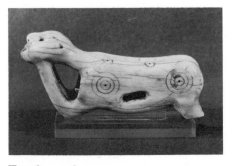

233 Toggle 19th century
Alaska, Eskimo
Ivory 12 cm long
Lent by the University of East Anglia (The
Robert and Lisa Sainsbury Collection)

In the form of a man with hands to chin and
legs broken.

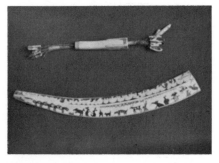

236 Toy rattle
Alaska, Eskimo
Walrus ivory 27.5 cm long
Private Collection

This toy rattle is equipped with miniature
ivory reproductions of the accoutrements of
real life: fish pounders, clubs and a kayak.
It was collected on the Bering Straits 1922.
From the Beasley collection.

237 Snow knife 20th century
Alaska, Eskimo
Ivory 34 cm long
Lent by the Nelson Gallery of Art/Atkins
Museum (Nelson Fund) 31–125/23

The engraving depicts a monster with
several stomachs, which is devouring
human parts.

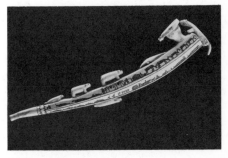

239 Pipe 18th century
Alaska, Eskimo
Ivory 31 cm long
Lent by the Nelson Gallery of Art/Atkins
Museum (Nelson Fund) 31–125/15

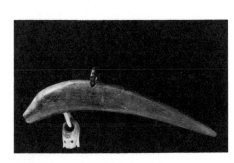

234 Fishing toggle or lure 19th century
Northwest Coast, Western Eskimo
Wood, ivory, hide 27 cm long
Private Collection

The lure, appropriately enough, takes the
form of a fish. Formerly Beasley Collection.

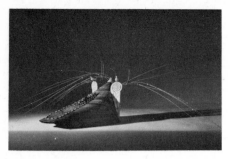

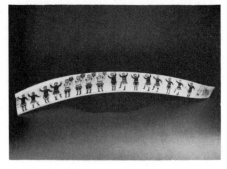

240 **Cap** 18th century
Northwest Coast, Aleutian
Wood, ivory, bristle, glass beads
40 cm long
Lent by the Trustees of the British
Museum N.W.C.2240

These hats were meant to attract the
animals and were worn only by men
renowned for hunting sea otters. The glass
trade beads show Russian influence. United
States Services Museum.

242 **Frieze of dancers** 19th century
Alaska, Eskimo
Ivory mammoth tusk
7 cm high, 61 cm wide
Lent by Mr and Mrs Julian W. Rymar

This frieze of twelve girls dancing out of
doors, is a lively representation of Eskimo
dancing. It shows a lodge on the right with
a European-style stove pipe. Four males
hold tambourines. The engraved and
carbon black on ivory technique is that of
north Alaskan 19th century pipes, snow
knives, bow drills, bag handles, and game
boards, but has a unique rhythmic quality.
Published incomplete in Charles Miles's
Eskimo and Indian Artifacts, number 4.15,
page 114.

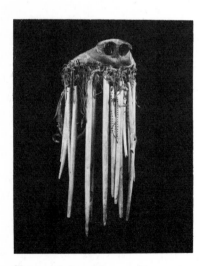

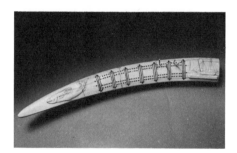

243 **Eskimo gaming board** 19th century
Alaska, Eskimo
Ivory 30 cm long
Lent by the University Museum,
Philadelphia

As with snow knives, pipes, tools, etc., this
gaming board would have been carved by
an individual for his personal use. The
game itself was modelled on a European
sailors' game, but the tradition of gaming
and the making of intricate boards is an
ancient one. On loan to the American
Museum in Britain, Bath.

241 **Shaman's headdress** Date unknown
Northwest Coast, Aleutian
Hide, wood, ivory 36 cm high
Private Collection

The crown of the headdress simulates a
bear's nostrils and upper jaw. Suspended
below by thongs are ivory teeth-shaped
pendants, some incised with a circular
design, and one with the form of an animal.
The headdress would have been worn with
the pendants hanging over the face. Similar
headdresses have been found on the
Siberian Peninsula. Three are in the
Leningrad Museum.

The Grandeur of Northwest Coast Sculpture

Some of the world's finest sculpture originated on the Northwest Coast of North America, that twelve hundred mile stretch of coastline studded with islands and inlets that extends from Puget Sound to beyond Yukatat Bay, after which the Alaskan Peninsula projects seaward. Only at one point, along the Nass and Skeena Rivers in Tsimshian territory, does the Northwest Coast sphere of cultural influence penetrate inland as much as two hundred miles. Otherwise Northwest Coast style is a maritime phenomenon, manifested where forests and rivers go down to the sea.

Between the sound and the bay, out beyond Vancouver Island, the Queen Charlotte Islands and the Alaskan panhandle, the Japan Current flows in a southerly direction, warming the land and encouraging the growth of tall timber, edible berries and fish. The Northwest Coast is a rich land with abundant river salmon, candlefish, and halibut runs, with gigantic stands of western red cedar, yellow cedar and spruce, to say nothing of hemlock, alder and maple. Ecologically speaking there are similarities with Norway, but the Northwest Coast is more balmy and fog ridden. Snow is confined to interior mountainous reaches or to ice fields. Lichen and moss flourish, often luxuriously, on the forest floor. Waterways extend their fingers inland for miles and upon these inland strands there were excellent sites for Indian winter villages used for the ceremonial season, when fishing grounds, established by right, were abandoned for the interval between salmon and halibut runs. If any group of tribes were led by superabundant nature to develop a leisure class, with time to exclude mundane affairs and concentrate upon social position and the attendant mythology and ceremonialism, the Northwest Coast tribes, particularly the northern ones – Kwakiutl, Bella Coola, Haida, Tsimshian and Tlingit – are this exceptional group.

So assured was their basic livelihood that thought could be given to developing a system of social prestige, including clan privileges that had to be validated for each generation. This was achieved through the potlatch, a feast accompanied by the giving away of presents during which claims to heraldic crests were publicly asserted. Totem poles displaying clan and personal animal-human symbols were erected in recognition of these claims. Some of the poles were placed against the centre of the peaked roof on the wooden houses, with entrances carved into them. On the inside house posts the same emblems were carved. The winter and summer ceremonies differed but were both conducted by speakers or stage managers who inherited their duties.

European contact was established in the 18th century by explorers such as Captain James Cook, George Vancouver and the Russians who founded Fort Sitka in 1802. Among the goods they traded were iron tools which allowed a greater ease of carving and meant that the poles became taller and the animal emblems more complex. It was not unusual for a white ship's captain to trade furs along the coast, sell them in northern China and trade the Chinese pigskin trunks for more skins before returning to Boston or London. As late as 1968 an antique Peking trunk filled with ceremonial masks, feast dishes and a Chilkat blanket survived in a Tlingit home.

This type of Asiatic trade may explain the similarity between the Northwest Coast art and some Oriental motifs and concepts, like the double-headed snake, the heraldic animal poses, bilateral designs. There is a type of feast dish found only among the Gilyak of Siberia and the Alaskan Tlingit. However it is surprising that no direct evidence has been uncovered to account for this generic similarity. Perhaps the common root lies in cultural traits such as shamanism which survived on the Northwest Coast. Northwest Coast art has a deeply conservative basis and its archaism is part of its appeal, even to its makers who felt that it was a confirmation of their own mythological origins.

To visit a Northwest Coast forest is to find the silent and expectant atmosphere which led the Indian inhabitants to evolve a rich and spectacular animistic mythology, embodied by the animal crests, masks, frontlets, feast dishes, shamans' equipment, dance and performance paraphernalia, speakers' staffs, 'totem' poles, rattles, storage boxes, and

Chief Shakes' house, Alaska
Smithsonian Institution

houseposts, which were superbly carved and embellished with rare sculptural eloquence. Though the Northwest carver's combination of images often led to an excess of decoration in that any and all categories of objects, even a trade gun (340) or a ceremonial bow (335) were reformed or treated as sculpture, his innate feeling for the substance of his material ensured he never violated the natural properties of wood. In his hands the forests came alive.

In a tall forest preserve which is one of the most beautiful in North America and is situated on North (Graham) Island in the Queen Charlotte Islands, the offshore home of the Haida, there is a unique, majestically tall, golden spruce, a mutant among trees. Every time that exceptionally lovely tree comes to my mind, so do a plethora of imagistic Northwest Coast carvings. Here, by the Yakoun River, giant logs were floated north to Masset Inlet and across to Old Masset to be made into the magnificent long and sturdy canoes of the Haida which were sometimes up to seventy-five feet in length, sculpturally decorated with animal crest symbols and painted with elegant bi-lateral designs which met at the prow. Such a forest is full of the atmosphere that produced the spectacular mythological tales; to go to Masset today reminds one of the sad disappearance of what was central to these myths, convinced belief. In 1968 I was invited to share some salmon in the house of blind octogenarian Chief Mathews (Weah) of the Haida, who pointed to a depression in the ground where his father's totem pole (today at Oxford University) once stood: 'It is customary for the nephews of a Chief to keep him supplied with halibut, but do you think this is done anymore for me. Not one piece! They want to go to the movies!'

The traditional artists of the Northwest Coast depended on their own formula for supernatural recall, based on a highly regularised symbolic design vocabulary made up from the recreation of animal parts – eyes, ears, paws, knee joints, tails, fins, nostrils – and body paint motifs. Each of these existed as a means of psychic recall. This regard for the all-pervading animal past should, I think, be stressed. The invention of one's own past, especially for purposes of asserting social distinction through lineage identification, is an undeniably sophisticated act. The Northwest Coast Indian, who was not primitive, created a past, and a style to go with it, that was quite extraordinary. While Plains Indian propaganda designs existed only in the present – in the owner's own personal vision, for example – the Northwest Coast heraldic animals represented a part of history. To the people of the Northwest Coast the assertion of historic lineage, if only in sculpture, was status, and this is at the source of the stunning and remote sense of animistic power that suffuses every inch of Northwest Coast art, even at its most abstract. A ladle will take on the

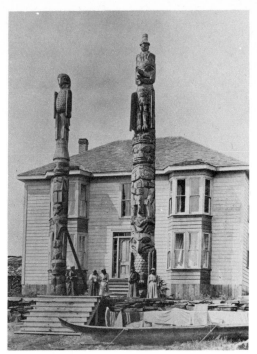

Totems at Wrangell, Alaska
Smithsonian Institution

form of a raven *in toto*, the body being the dispenser; similarly a clan hat becomes a heron – it is only secondarily a hat. It is really a crest manifestation for all to see and recognize (324), lest there be any doubt about assertions and claims of privilege. A Tsoonoqua mask of the Alert Bay Kwakiutl was worn once more before selling, just held up to the face for a moment, to assert ownership one more time. All these objects validated rights claimed by families 'from the beginning'. Masks affirm the time when man was closer to the animals; a time when he learned from them his basic skills and privileges, expressed by songs and dances, and entered freely into supernatural relationships with them, lords who lived under the sea or in the forest, dispensing myths to be reiterated at winter festival time. Supernatural children were even supposed to have been produced by such encounters.

Animal, bird and fish motifs point back to origins, to the past, as if an invisible but powerful shield intervened between man (present, alive) and nature-inspired myths (past, hovering between life and death). Through dance and the ceremonial season and by the joining of societies like the Kwakiutl Hamatsa (Cannibal) Society (258), or by the display of animal crest frontlets at a potlatch (292), one could look backwards comfortably to forces which were out of touch with the topical and the everyday. 'The stories contain a large number of fantastic episodes, describing events which took place long, long ago, when man and supernatural beings were in closer contact than at present. The people of today (among the Bella Coola) do not expect to have similar experiences now, but according to their point of view there is no reason why the incidents of the stories could not have happened in the distant past.'[1] It would not do to underestimate the archaic character of the themes of Northwest Coast art, for a large part of the psychological strength of the carvings and designs derives from a conviction that all these events did indeed take place in the past. To understand the animal presences you have to believe in them. Witnessing the masks used in the dance and the dramatic performances lent credance to the myths, like a glimpse of light, if only for a few moments.

This art gains its ferocious mystic power – a power all the more magnificent for its sculptural restraint and superb good taste – by exploring the gap that exists between nature as we can see it and the mythological past as it can only be envisioned, and by conjuring up forces of nature that cannot be seen. All the beings passing in review here – raven, hawk, eagle, crane, heron, killer whale, dogfish, bear, beaver, sea otter, and hair seal, not to neglect the animal-bird-fish composites or imaginative reincarnations that represent a still more complex synthesis – are compelling because in their creator's view they really do occupy space in a world next to ours, under the sea, beneath a river or in a magic forest.

It was by the exercise of a unique and sympathetic genius that the Northwest Coast carver, when he worked in mountain goat horn or metal as well as when he worked in wood, could establish precise – if highly obtuse and sometimes abstract – symbolic equivalents. His was a true plastic language, and with eyes, eyebrows, limbs, ears, he reconstituted animals before our eyes with a greater purity of line, form and pattern than they could possess in life.

In the 1890s the great ethnologist Franz Boas isolated and dwelt upon the Northwest Coast obsession with symbolism.[2] Although he classified the way each animal was represented, he did not link them with the carver's intuitive feeling for the organic ebb and flow of sculptured surfaces. A Northwest Coast mask or pole is an exuberant essay on organic formal development of a theme. Such unity of form and content has been beautifully expressed through a term formulated by a modern carver, Bill Holm. His term 'formline' covers primary, secondary and tertiary linear systems. By dwelling on what he calls the formline the observer will be able to appreciate the unity of symbol and form, design and surface, that was such a special part of the sculptor's control – to the point where at times, viewed independently, his work seems the product of some secret intervention, as if brought into being by the very forest demons it aims to represent.

So important is cohesion in Northwest Coast work that the difficult question arises of whether the designs or the feeling for sculpture came first. The fact is that the artist thinks like a sculptor, even when a Chilkat blanket with its raised embroidery is being woven, or when a plank is being adzed in order to paint it with heraldic devices (334). Mountain goat horn was boiled so that it could be shaped and carved into ladles. Wood was steam bent and elaborately smoothed to form smooth-edged boxes and chests. Even the smallest secular objects, awl cases and powder horns, had crest symbols, reminding the owner of his

affiliation. The sense was for articulating the environment, which inevitably led to the use of three-dimensional forms, and the fourth dimension, inhabited by the mythological and heraldic crests, was the logical follow up.

Particularly on the southern part of the coast in Salish territory there was an old tradition of geometric weaving patterns, the twined dog wool 'nobility' blankets being a good example (350), which relate to Thompson and Fraser River basketry patterns (373), and also to northern Tlingit basket imbricated design. According to Gene Weltfish, these designs are remnants of a tradition which was alive long before the advent of iron tools and the development of the fur trade.[3] But the sculptural urge is perhaps equally old, witness the ancient stone sculptures found all along the Coast, from lower British Columbia and Quatsino Sound north to Hazelton, Skidegate, Kitkatla and Sitka. Though the greatest concentration is in lower British Columbia, many of the northern examples have recognizable Northwest Coast design characteristics (51). Wilson Duff has assigned to them such romantically distant datings as twenty to thirty centuries ago.[4] Do these stones hint at wood equivalents? Despite the great efflorescence of wood carving in the 19th century, there is evidence that Northwest Coast carving was ancient by the time Cook, Dixon, Mackenzie, Malaspina and Vancouver made their landfalls in the 18th century. The Haida grease dish collected in 1789 (377), if offered on the market today without documentation, would readily be accepted as much later in date, say 1878, while the head images of wood left by the Indians on the deck of Captain Cook's ship (271) suggest a mature carving tradition on Vancouver Island (272). It is unfortunate that these early discoverers did not know how to make systematic collections from other areas. One wonders how many very old Haida, Tlingit or Tsimshian carvings are mistakenly taken for later work. While a number of pre-1800 masks and frontlets at Leningrad and Madrid have an archaic look, other sculptures from these early collections could be dated much later. The answer to the problem involves careful scrutiny, perhaps in the area of the morphology of motifs, putting artistic above ethnological considerations.

In the meantime we may keep in mind Philip Drucker's hypothesis that '. . . the first occupants of the rugged rockbound coasts to the north, must, in all likelihood, have arrived with a sizeable inventory of culture traits adapted to coast life: adequate canoe navigations, with all the appurtenances, knowledge and skills for navigating those rough waters; tools and techniques for marine fishing and hunting alike, if they were to survive. In other words, the sea-hunting early culture recently identified in the lower Fraser region may have been the basic pattern for the entire coast.'[5]

We do not know when this primitive culture began to take on the characteristics that took the Northwest Coast elaborate carving and design complex to its high level of reflectivity. Time was needed to develop such a sophisticated backward look, and stabilize its motifs. Allowing for similarities between Eskimo archaeology and early Northwest Coast design characteristics, and for the processes of acclimatisation to the environment and the development of heraldry beyond the simpler concept of the guardian spirits, Northwest Coast culture, as it was known at the beginnings of the last century, must have developed in essence by Mississippian times, if not earlier.

The art of the Salish tribes of Washington and southern British Columbia was a mixture of styles. For example the 'topnot' or ladder-like basketry design (373) was also found in northern California while their elaborate vision quest, as seen in the piercing guardian figure of a shark, may tell us something of what the beginnings of Northwest Coast sculpture was like. Salishan shamanism included the construction of symbolic canoes with figures inside. Baskets were characteristically hamper-like (388), although this example, which was made by the Athabascan tribe, the Chilkoot, is unusual in its realistic detail (note the hunter's gun).

Along the lower Columbia River the Salish tribes were the inheritors of the ivory and stone tradition that flourished there in prehistoric times. The ribbed figures carved on wood and horn Wishram bowls in the nineteenth century (389) demonstrate this continuity. Another Salish speciality was the weaving of geometrically patterned dogwool blankets. Although it died out about 1870, the practice has recently revived, using sheep wool, and the designs are still subject to family ownership (350).

The most southern group of masks that connect with area ritual are the wolf masks used in the Klukwalle. Perhaps the finest Nootka wolf mask is the one lent by the Denver Art

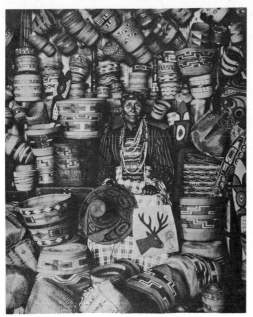

Yakutat baskets
Smithsonian Institution

Museum (249); its curving profile, bent wood superstructure and eye design are simple in comparison with Kwakiutl masks with their long animal profiles, but beautifully in keeping with the relatively uncomplicated dramatics of Southern wolf ritual. Accompanying the wolf masks was a 'Wild Man' of unusually large stature who wore an over-sized face mask often painted brown. Exhibited here is one of these masks (270), with uncharacteristically elaborate painting, the colour of which does not mar the abstract severity of Nootkan carving on the west shore of Vancouver Island.

'Colourful as is the Klukwalle, many masked and dramatic, as we move north into the country of the Kwakiutl, those past masters of ceremony, the wolf dwarfs in importance and the ritual pattern becomes enlarged and complex, almost too tangled to unravel; and everywhere the shadow of the cannibal arises, grim and dominant.'[6] Sculptural style becomes more complex in Kwakiutl territory, both on north-eastern Vancouver Island and the mainland, to the point where more southerly masks seem simple in comparison. The wolf becomes the Hamatsa or cannibal ritual with its three monster masks (256) with baroque nostrils and flaring crooked beaks, reaching a length of six feet. So complex is the mythology that masks with a hybrid man-animal character were introduced to dramatize the Tsetseka, the supernatural season (winter). 'Everything during this season was different from the rest of the year – names were changed, and there were penalties for those who forgot the new ones; songs were changed, and the ways of singing them were changed. Everything directed attention to the special nature of the Tsetseka season. At this time a new social order came into force. Clan, rank, and Bakoos (summer) names were replaced by a system according to which individuals were related to the spirits. Those of high secular rank had claim to the highest ranking spirit dances, but each person had to be formally initiated into the society his inheritance entitled him to join.'[7]

Kwakiutl style may be termed expressionist; distortion of feature and monstrous additions, such as sucker-like protuberances (257) or horns or unnaturally deep eye sockets, gave the masks and feast dishes a truly alarming aspect. The eye design, a clan emblem in the South, now becomes a dramatic painted or carved elipsis with staring concentric eye circles (256). Above all, Kwakiutl artists exploited the explosive visual force which was released by painting violently colourful designs on the surfaces of masks, paddles, and feast dishes. Complex masks sometimes opened to reveal inner beings (255), which returned the ceremonial frenzy to calmer human origins, at other times alternating monsters appeared that built up the tempo and excitement still further. Despite this expressionist bent, however, a certain quality of formal control was always present to accompany the mastery of the Northwest Coast carver. That control was based on the concept that beaks, ears, eyes, paws, fins, teeth and hair were schematic enough to make for easy recognition. For example, an animal with prominent front teeth is always a beaver; otherwise the same animal is a bear. A killer whale is easily recognized by the projecting dorsal fin. An eagle's beak does not recurve as fully as a hawk's. Mosquitoes were provided with long *probosci*, and bumblebees with stinger spines. Even by a fragment – a single abstracted motif – an animal could be recognized. Artists accepted traditional limitations of form and pattern and worked within the rules, even though amazing variations were evolved, according to ceremonial need. For example, at a time when the totem poles to the north were decaying and Haida villages no longer looked like totem pole palisades, the carving of the Kwakiutl, like that of Willie Seaweed and Charley James, was undergoing something of a 20th-century renaissance.

A regard for sculptural massing invested the totem poles and masks of the Haida, living on the Queen Charlotte Islands at a mid-point on the Coast, with monumentality. The Haida style holds the position of classic balance in the art. Haida masks are somewhat turgid; by comparison a Tsimshian mask is delicate and elegant (see numbers 281 and 282). The Haida architectonic predilection is perfectly underscored here by the large mask from the Kagani Haida now owned by the University of California at Los Angeles, with its reproduction of the framing members of a Haida plank house carried upon its head. The Haida territory held the largest, if not the tallest, timber. Trees were of notably wide circumference. The poles and houseposts attained a spatial depth and articulation in their carving that is extraordinary, and a formal resolution exceeding that in Kwakiutl art. Expressionism is partially subverted by formalism. The sense of power is not so obvious. This powerful restraint is apparent in small frontlets (293), or in the trance-like figure of a shaman (286), or in solid canoe prow crest figures (338). It invests a contemporary gold bracelet with

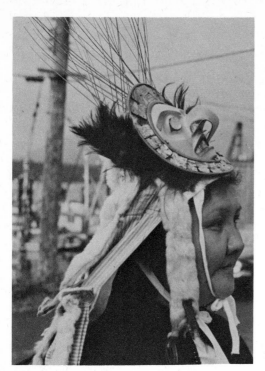

Woman wearing frontlet
Catalogue no 294

dignity (366). There is a healthy rotundity to the work, whether it is in partial relief or free-standing.

The traditional assimilation of motif, particularly as one progresses northwards, does lead to attribution problems. An obvious bulging Haida bear mask found in Tsimshian country may offer no problem. But where precisely were all those superbly carved and painted storage chests made, and which type belongs where? Which were Bella Bella? What about the stylistic exchange accompanying intermarriage and exchange of privileges? An outstanding and dramatic example of such integration is a Chilkat blanket (356) woven on Kwakiutl territory by the Tlingit weaver Mary Hunt, who, when she married, took her pattern board with her, and wove into her blanket garish 'expressionist' Kwakiutl colours entirely out of keeping with the original Tlingit colours. A recent book by Bill Reid intelligently discusses the blend of tribal characteristics which is fundamental to Northwest Coast art.[8] One wonders, for example, if the Tsimshian carver of 279, later absorbed Tlingit-Haida influences and was also the carver of 278 and other hybrid masks.

The most northerly of the tribes – the Tsimshian near Prince Rupert, British Columbia, and the Tlingit of southern Alaska – stress heraldic assertion and the inheritance and maintenance of crests through validation of social rank as much as the Haida do, but with a softer eloquence. Going above the central region of the coast positions us beyond the Haida sculptural centre. If the forms are not as pure, they are even more beautiful. The Tsimshain in particular had a great regard for elegance and a nicety of technique unparalleled on the entire coast. The unbridled expression of wildness and animal power is not to be found here, despite the fact that the customary animal repertoire is fully maintained. Tsimshian frontlets, for example, have a jewel-like delicacy, as if the carver would be happiest making miniature objects (297). Tsimshian masks are generally sharper in profile than those of the Haida. They are often imbued with sharp-edged sensitivity and look lighter, as if the wood were as smooth as paper. Noses tend to be thin and the mouth slim and flatly triangular, with a straight upper lip. The forehead will often taper back as well as upward from the exquisitely carved eyebrows. These are aristocratic presences unlike the Kwakiutl monsters or the self-contained broad-faced Haida masks. Their totem poles from the upper Skeena River are the tallest known but slim, contrasting again with Haida massiveness.

Tlingit art emphasized principles of decorative organization, so that the hypnotic effect of the best pieces was openly sumptuous. It was the most lavish of Northwest Coast styles, and sometimes the most pretentious. It took into account flat design as well as sculpture, especially in house partitions and carved panels (245, 244). Masks among the Tlingit are often consciously appealing; witness the use of irridescent abalone shell in the snout of the Swan mask (268) or in the highly worked patterns along the movable beak of the ingenious movable mask (269). Neither of these decorative additions have much to do with the spectral feeling of the masks in their dramatic context; they are lavish shell decorations, elaborated for the sake of it. The most sumptuously carved clan house in all the Northwest Coast was probably the Klukwan Whale House of the Northern Tlingit, part of the stage of which has been brought together here (244). The original effect, to judge by photographs, was positively baroque.

Tlingit concentration of decorative refinement and flat design came together beautifully in Chilkat blankets, long woven by the Chilkat branch of the Tlingit, though the idea is supposed to have originated among the Tsimshian (354). It can also be seen in Tlingit beadwork costumes (357), though the traditional Coastal sculptural emphasis is lacking. Household utensils – ladles made of mountain sheep horn, beautifully worked with a cow horn eagle poised on top of the handle (326), or combs of wood, or a unique form of slat armour – ranked so high as artistic products that Aurel Krause, in his 19th-century study of the Tlingit which is so invaluable as a field record, spent more time describing the decorative arts than the masks and ceremonial paraphernalia, although 'masks, rattles, drums, and dance wands used for ceremonial and shamanistic performances are found in extraordinarily large numbers.'[9]

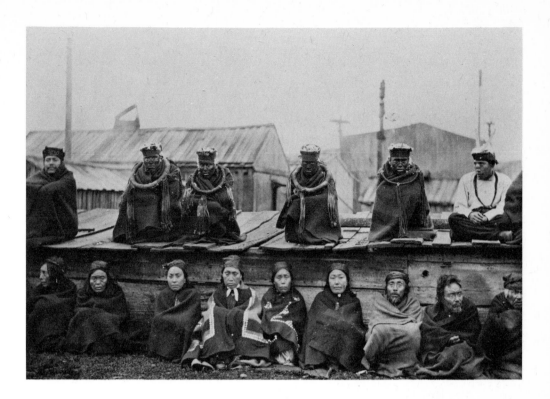

Kwakiutl feast 1894
Smithsonian Institution

Notes

1 'Bella Coola', *British Columbia Heritage Series I, Our Native Peoples*, Vol. 10, Provincial Archives, Provincial Museum, Victoria, B.C., 1953, page 28.

2 Franz Boas, 'The Decorative Art of the Indians of the North Pacific Coast of America', *Bulletin of the American Museum of Natural History*, 1897, Vol. IX, pages 123–176. Reprinted in Franz Boas, *Primitive Art*.

3 Gene Weltfish, *The Origins of Art*, New York – Indianapolis, Bobbs-Merril Co., 1953, page 31: 'when the mechanical demands of the craft are in the background, art begins'.

4 Wilson Duff, *Images, Stone, B.C.*, Toronto, Oxford University Press, 1975.

5 Philip Drucker, *Indians of the Northwest Coast*, Anthropological Handbook No. 10, American Museum of Natural History, New York, McGraw-Hill Book Co., Inc., 1955, page 15.

6 Alice Henson Ernst, *The Wolf Ritual of the Northwest Coast*, Eugene, University of Oregon, 1952, page 4.

7 Audrey Hawthorne, page 133.

8 Bill Holm and William Reid, *Form and freedom; a Dialogue on Northwest Coast Indian Art*. Houston, Texas, Institute for the Arts, Rice University, 1975, page 180.

9 Aurel Krause, *The Tlingit Indians* (translated by Erna Gunther), Seattle, University of Washington Press, 1956, page 141.

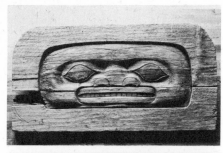

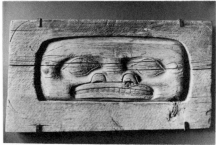

244 Carved panels from Whale House at Klukwan *c* 1875 AD
Alaska, Tlingit
Spruce wood

a 66 cm high, 1.29 m wide, 7.5 cm deep
Lent by Mr and Mrs Michael R. Johnson

b 69 cm high, 1.24 m wide, 7.5 cm deep
Lent by Mr and Mrs John A. Putnam

The interior of Whale House of the Chilkat Tlingit at Klukwan, Alaska, contained a painted wall screen and house posts of exceptional complexity. The front of the raised platform was faced with two of the carvings included here. While the original Whale House is no longer standing the screen and house posts are preserved at Klukwan (Juneau and Haines).

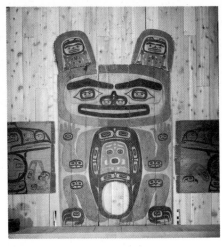

245 House screen *c* 1840 AD
Northwest Coast, Alaska, Tlingit
Wood, paint 4.57 m high, 2.74 m wide
Lent by the Denver Art Museum QT1–41

This extraordinary screen is one of the finest treasures of North American art. It was made in about 1840 as the centre partition for the house of Chief Shakes of Wrangell, Alaska; it is copied from an older screen and it is also related to another inferior bear wall board at Klukwan (see Marius Barbeau, *Totem poles*, volume 1). It is a representation of the brown bear, a Tlingit clan crest, and is a superb example of the hypnotic imagery, symbolic content and design system of the Northwest Coast. Two-dimensional design was the Tlingit forte and the monumentality, frontal symmetry and elaborate employment of images within images of the Shakes screen make it unsurpassed as an expression of two-dimensional Tlingit art. Nothing disturbs the rhythmic purity of the hollow silhouette and hocker inserts. 'Following the death of Chief Shakes in 1916, his widow, wishing to keep all the family heirlooms together, placed them on display as a tourist attraction. This screen, however, was removed from the display in 1933, when it was purchased by the art dealer Walter C. Walters. In 1939 the artist Wolfgang Paalen acquired the screen from Mr Walters. He placed it in his home as part of the decor (Mexico City). Finally in 1950 the Denver Art Museum acquired it from Mr Paalen.' (See Norman Feder and Edward Malin, page 30.)

246 Main brace *c* 1850 AD
Northwest Coast, Alaska, Tlingit
Wood 23 cm high, 1.83 m long, 7.5 cm deep
Lent by Mr and Mrs John A. Putnam

This main brace from a war canoe was carved of red cedar and shows how sculptural even the structural parts of a canoe became in Chilkat–Tlingit hands. Inscribed on the back: 'Chief Chathitch (Hard to Kill)'. At one time painted light green. Probably from Klukwan. Formerly in the Pullen Museum collection.

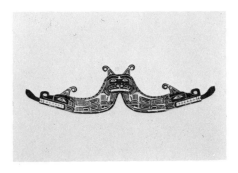

247 Sisiutl *c* 1927 AD
Northwest Coast, Kwakiutl
Red cedar, paint 1.48 m high, 5.94 m long
Lent by Detroit Institute of Arts, purchase City Appropriation

The double-headed serpent played an important role in the Kwakiutl winter ceremonies. It had the power to assume a fish shape, and to touch it was death. As a supernatural helper it brought power and was especially beneficial to warriors. According to Franz Boas, its eyes, when used as sling stones, could kill whales, and its body could become a canoe by the motion of its fins. Often depicted with a face at the centre, it appeared in the winter ceremonials, sometimes worn as a belt (see number 364) or used as a feast dish. This carving was sculpted in 1920 by Dick Price (Ya-hun-qua-lae), of the Vancouver Island Kwakiutl, and is one of the most monumental projections of the image known. Purchased for the Detroit Institute of Arts by Marius Barbeau, the Canadian folklorist and student of Northwest Coast culture.

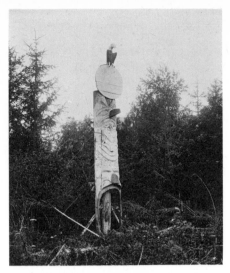

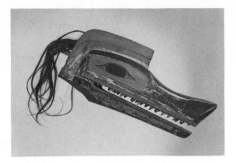

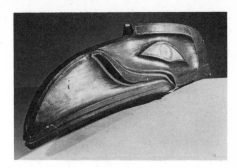

248 **Pole (house entrance pole)**
20th century
Northwest Coast, Bella Coola
Wood, paint 7.62 m high
(opening 1.82 m high, 81.5 cm wide)
Lent by the National Museum of Man,
National Museums of Canada,
Ottawa VII–D–400

This pole stood against a house, and the
hole served as an entry. An eagle
(thunderbird) perches on top of a large
circle made from boards. Below this sun
representation is seen the cannibal giant or
'sharpnose of the north', whose ashes
changed into mosquitoes when he was
burned to cinders. A small beaver is set in
the monster's chin. Below this is a large face
with upturned mouth, perhaps a bird. The
bottom face is again the cannibal spirit.
Harlan I. Smith collected this pole in 1923
on the south Bentinck arm at Thalhio. The
awkward breaking of its vertical lines by the
sun board is a concept that is not found
north of the Kwakiutl–Bella Coola area,
where totem pole carving was more
integrated in style. (See Marius Barbeau,
Totem poles, volume 1, page 151.)

249 **Wolf headdress** Late 18th century (?)
British Columbia, Vancouver Island,
Nootka
Wood, paint 18.5 cm high, 51.5 cm long
Lent by the Denver Art Museum NNu–7

The upper part of the superstructure of this
famous mask has been made by steaming
and bending the wood. Its form anticipates
the late 'baroque' Kwakiutl dance masks of
the 19th and 20th centuries (see number
256). It was used in the rites of the
Klukwala (Wolf Society), in a southern
ceremonial dance related to the more
complex Kwakiutl Hamatsa (cannibal)
Society functions. It seems to belong to the
Nootka tribe but to a later phase than the
Nootka figure carvings in the British
Museum. It has also been attributed to the
Kwakiutl.

251 **Mask** Pre 1900 AD
Northwest Coast, Kwakiutl
Wood, paint, graphite
94 cm long, 26 cm wide
Lent by John H. Hauberg

This mask was used in the Noohlum, a
Quatsino Sound–Hope Island equivalent of
the Luwulakha ritual, in which the dancers
wore masks of supernatural origins but were
not themselves possessed as in the Hamatsa
(cannibal) dances. This type of mask is
sometimes confused with Hamatsa masks.
Pictured by Edward S. Curtis in volume 10
of his famous study, *The North American
Indian*.

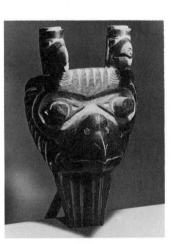

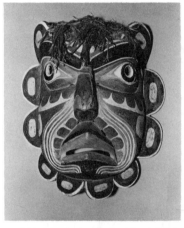

250 **Mask** c 1870 AD
Northwest Coast, British Columbia,
Cowichan
Wood, paint, cloth, beads, feathers
50 cm high, 30.5 cm wide
Lent by John H. Hauberg

Birds erupt from this mask which is also a
bird composite, with five tail feathers
painted on the forehead and wings to the
side of the projecting eyes. Associated
with the Swaikhwey ceremony, the
myth concerns a boy who plunged into the
lake and came to rest upon the housetop of
supernatural beings, who presented him
with their power. When he returned to the
mortal world he found the mask had
accompanied him. Collected in Nanaimo,
British Columbia, from the family of
Charley Jim, a medicine man of the area.

252 **Mask** c 1880–1890 AD
Northwest Coast, Kwakiutl
Wood, paint, red cedar bark 49 cm high,
44 cm wide
Lent by John H. Hauberg

Represents Komokwa, lord of the oceans,
who lived beneath the sea in a magnificent
house supported by live sea lions, and who
could command his killer whales to hunt
food for his feasts. If a mortal could journey
to Komokwa's dwelling, the right to use his
masks, dances and sacred songs was his and
was transmitted to his lineage. Collected at
Port Hardy, British Columbia, in 1970.

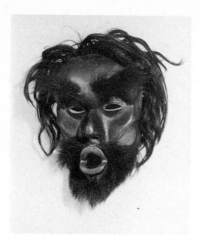

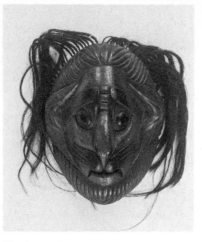

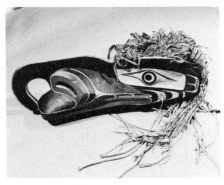

253 Mask *c* 1870 AD
Northwest Coast, Kwakiutl
Wood, hair, graphite
30 cm high, 23 cm wide
Lent by Mr and Mrs Morton I. Sosland

One of the finest and most expertly carved
Tsonoqua masks known. Human hair is
used on top of the mask and bear fur around
the chin, eyes and mouth. It has a black
graphite surface, accentuated by red. The
hollow cheeked severity and deep carving of
this mask give a convincing feeling of
supernatural demonism. Tsonoqua is a
woman forest ogre who devours children,
and whose presence is announced by a
whistling in the woods; she always has a
heavily puckered mouth. To this day little
children run behind their mothers when
Tsonoqua's presence is announced in
Kwakiutl territory. Such masks were used
by important members of the tribe to
confirm their family identity and hereditary
rights at a potlatch or copper breaking
ceremony. This exhibit was used once more
for this purpose by its owner, Chief George
Scowl in 1967, by being held up to his face
for a few moments, before its sale to
Norman Feder, who had had to wait several
seasons before Mr Scowl would part with it.
It was formerly the property of Johnny
Scowl of Kingcome Village.

254 Mask 19th century
Northwest Coast, Kwakiutl
Painted wood, hair 33 cm high
Lent by the Trustees of the British
Museum 1944.Am.2.145

This mask represents Noohlmahl, the fool
dancer, who was one of the two mythical
beings in the Hamatsa winter dances.
Dancers wearing these masks caused
trouble, unless placated in the dance. A
similar mask was collected by the Wilkes
expedition in 1842 (Smithsonian). Beasley
Collection.

256 Crooked beak mask *c* 1915 AD
Northwest Coast, British Columbia,
Kwakiutl
Wood, paint
28 cm high, 86.5 cm long, 21 cm wide
Lent by Mr and Mrs John A. Putnam

One of the masks accompanying the
cannibal dancer novice (see number 258).
By Willie Seaweed.

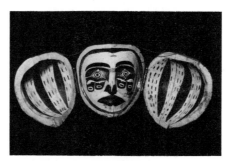

255 Mask *c* 1900 AD
Northwest Coast, Kwakiutl
Wood, paint, hinges circumference
closed: 1 m; open: 29 cm high, 79 cm wide
Lent by Mr and Mrs Morton I. Sosland

When closed this object represents a sea
urchin in ball form; when opened it
becomes a white-faced mask with painted
sea urchin spines on either side. It opens on
European-style door hinges.

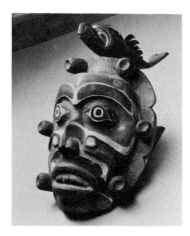

257 Mask *c* 1920 AD
Northwest Coast, Kwakiutl
Wood, paint, metal fins 69 cm long
Private Collection

Personifies Yagis, a sea monster who
delights in capsizing canoes and eating their
contents. Carved by George Walkus,
Blunden Harbour. (This information
corrects the attribution in *The Imagination of
Primitive Man*, Nelson Gallery, 1962.)
Edward Malin purchased the mask at Fort
Rupert, British Columbia in 1947 from
Johnny Hunt, the nephew of George Hunt
and a member of an important Kwakiutl
family.

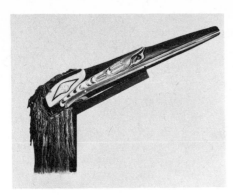

258 **Hamatsa mask** *c* 1920
Northwest Coast, Kwakiutl
Wood, cedar bark, paint 1.72 m long
Private Collection

A mask representing Hokhokw, one of three monster bird beings in the Hamatsa dance, one of the most important of the Kwakiutl winter ceremonial rituals. Hokhokw has a long beak and dances four times around the floor, crouching and loudly clacking his beak, manipulated by strings, at the initiation of a cannibal novice into the society. The Kwakiutl had a little-known cannibal rite involving the consumption of a ten-year-old mummy. Edward Curtis took several photographs of this act in a shed, but did not publish them; the originals are in a Boston private collection. Bill Holm, who has collected over two hundred photographs of Hamatsa masks, was recently sent a photograph of this one. He thinks it is by a Blunden Harbour carver, probably Charlie George Sr. Although the style is closer to the older carver Willie Seaweed it is heavier than his work, which George knew, as he was a younger contemporary and associate of Seaweed.

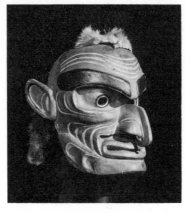

259 **Mask** Early 20th century
British Columbia, Kwakiutl
Wood, paint, fur
34 cm high, 20.5 cm wide
Lent by the Denver Art
Museum NKw–33

This red cedar mask embellished with commercial paint represents Bokwus (see Audrey Hawthorn, pages 291–296); he was a wild, non-human creature thought to live in the forests and attract the spirits of drowned people to his abode. Such masks were worn in dances dramatizing family legends. Once owned by Walter Walters.

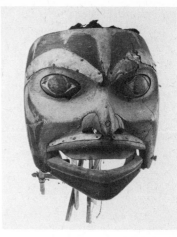

261 **Mask** *c* 1880 AD
Northwest Coast, Alaska, Kagani Haida
Wood, hide, canvas, paint
38 cm high, 38 cm wide
Lent by the University of California at Los Angeles Museum of Cultural History, Gift of the Wellcome Trust X65–4266

This mask with movable eyes has a hide and slat framework to cover the head and shoulders of the wearer. According to the Museum's notes, the spirit of sleep is portrayed. This mask took part in the initiation of novices into societies. The movable eyes and wide mouth are characteristic of Kagani Haida masks.

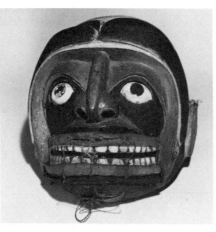

260 **Mask** 19th century
Northwest Coast, Kwakiutl
Painted wood, canvas
23.5 cm high, 25.5 cm wide
Lent by the Trustees of the British
Museum 7184

Wooden mask painted light blue, red, black and white. Lower lip of canvas movable by strings, eyes also movable by strings. It probably depicts an earthquake. (See A. Hawthorn, page 208.) Presented to the Christy Collection by Henry J. Gardiner, April 15 1871.

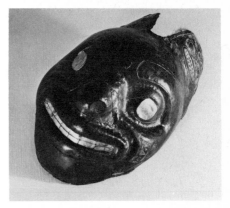

262 **Mask** 19th century
Alaska, Tlingit
Copper, abalone shell, skin, rawhide lashing, fur remnants
29.8 cm high, 20 cm wide
Lent by the Saint Joseph Museum 143 5364

This sea bear mask of hammered copper is probably a potlatch mask. The copper is treated like the wood of most Northwest Coast masks, except that facial characteristics are more generalized. It has a startlingly ferocious aspect despite its smile. The crest is Haida, although a similar mask, now in the Museum of Primitive Art, New York City, by the same artist but with better preserved fur above and between the ears, was found in the Tlingit area. (See *The Far North*, no. 316.)

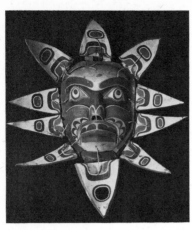

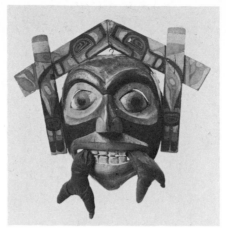

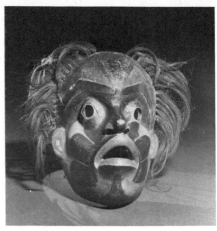

263 Mask 19th century
Northwest Coast, Haida
Painted wood, leather 77 cm high
Lent by the Trustees of the British
Museum 1944.Am.2.146

Articulated dance mask or 'transformation'
mask representing the sun or moon, with
triangular pieces hinged with leather to
close over face. At the moment in the dance
when the music stopped the outer carving
was pulled back by a system of strings to
reveal the human nature of the
mythological character. The spirit
dramatized here may be Komokwa, king of
the world beneath the sea. He comes to land
at the time of frighteningly high tides,
accompanied by sea animals.

Collected by George G. Heye at Alert Bay,
Vancouver Island. Presented to the Heye
Foundation by Harmon W. Hendricks.
Exchanged into the Beasley Collection,
1937.

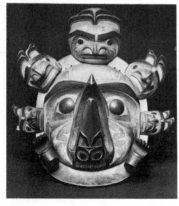

264 Mask 19th century
Northwest Coast, Haida (?)
Wood 27.5 cm high, 25 cm wide
Lent by the Trustees of the British
Museum 6437

Grotesque wooden mask of a face with an
eagle or raven's beak and five smaller
animal faced heads, of graduated size, fixed
around the rim. The style is a hybrid of
Bella Coola and Haida. Painted green,
black and red. Christy Collection.
Presented by J.L. Brenchley, March 24
1870.

265 Mask *c* 1875 AD
Northwest Coast, Alaska, Kagani Haida
Wood, paint, stuffed black cloth
60 cm high, 65 cm wide
Lent by the University of California at Los
Angeles Museum of Cultural History, Gift
of the Wellcome Trust X65–4280

This celebrated mask is one of the most
astonishing from the Northwest Coast and
was probably made by the carver of
number 261. It has movable eyes and an
openwork frame which denotes an old-style
housefront with gable. The whales' tails of
stuffed cloth hang from the mouth. It may
represent a sea monster who had a head like
a house, or symbolize the hero who killed it
and performed valorous deeds in its guise.
The original owner was Chief Skowl of the
northern-most branch of the Haida on
Prince of Wales Island at old Kasaan. At
the time of his death, during the winter
1882–83, the ethnologist Niblack took at
least two photographs of Chief Skowl lying
in his coffin surrounded by his ceremonial
possessions. This mask can be seen in both
of them. (See *Masterpieces from the Sir Henry
Wellcome Collection* page 23, and
Washington, *Boxes and Bowls* page 18.)

266 Mask Early 19th century
Northwest Coast, Bella Bella
Wood 26.5 cm high, 15.5 cm wide
Lent by the Trustees of the British
Museum N/N

Mask of a man, painted red, black and
green, with human hair attached. Collected
on HMS *Grappler*, 1864. Beasley
Collection.

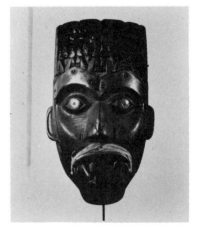

267 Mask *c* 1825–1865 AD
Northwest Coast, Tlingit
Wood, copper 26.8 cm high
Private Collection

One of two superb, similar masks from the
Tlingit at Hoonah. The other, painted and
in higher relief, but probably by the same
carver, is usually exhibited in the Museum
of the American Indian, New York (see F.J.
Dockstader, number 88). The pair formed
part of the same shaman's paraphernalia.
In both cases land spirits are on the crown,
otters are on either cheek, and a frog
emerges from the mouth. This mask,
however, represents a male spirit, since it
once had a fur moustache (skin remaining).
Since land otters were associated with
insanity this mask may have been used to
cure the mentally ill. This exhibit once
belonged to Wolfgang Paalen, the artist,
who collected Northwest Coast material in
the late 1930s. One of the other great
objects he owned was the Chief Shakes
screen.

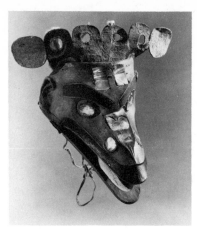

268 **Mask** *c* 1850 AD
Northwest Coast, Tlingit
Wood, shell, leather, ermine
30.5 cm long
Lent by Mr and Mrs Morton I. Sosland

This mask probably represents a trumpeter
swan. Some of the abalone is restored. Like
the Whale House panels, it comes from the
Klukwan Tlingit, north of Juneau, Alaska.
Masks from this area tend to be quite
baroque, heavily inlaid with abalone shell,
occasionally with a movable jaw or beak.
Collected by Norman Feder. Klukwan clan
material is generally jealously guarded and
held to this day.

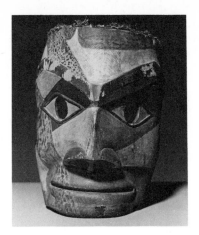

270 **Mask** *c* 1900 AD
Northwest Coast, Nootka
Wood, paint 29 cm high, 21 cm wide
Lent by John H. Hauberg

This Nootka face mask represents the wild
man.

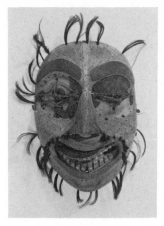

272 **Mask** 19th century
Northwest Coast, Kwakiutl (?)
Wood 28 cm high
Lent by the Trustees of the British
Museum 1914–65

Echo mask painted green, red and black
with movable eye and mouth covers, hair
attachments. Christy Collection.

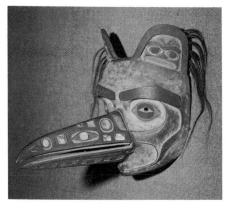

269 **Mask**
Northwest Coast, Tlingit
Wood
Lent by Dr and Mrs Oliver E. Cobb

This is one of the most perfect Tlingit
masks, notable not only for its exquisite
craftsmanship, but for its double-jointed
raven mandible. The beak moves as a unit,
but the upper and lower mandibles
articulate separately. A bear's ears
surmount the mask. From the Sitka Tlingit,
William Fitzhugh, an early San Francisco
collector; the Museum of the American
Indian; to A. E. Gallatin 1944; by descent
to the present owner.

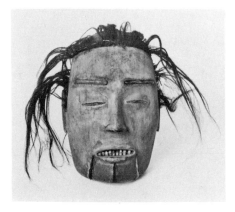

271 **Mask** 18th century
Northwest Coast, Nootka or Kwakiutl
Wood, hide 28 cm high
Lent by the Trustees of the British
Museum N.W.C.56

This mask may represent a dead warrior.
The eyebrows and the three grooves on the
chin are inlaid with hide. Human hair is
attached to the top and sides of the face.
The style relates to Kwakiutl masks used in
the Toxuit dance in which a woman is
killed by make-believe decapitation.
Collected on Captain James Cook's third
voyage (1776–1780) when it was left by
Indians on the deck.

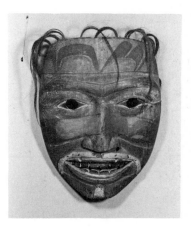

273 **Portrait mask** *c* 1850 AD
Northwest Coast, Haida
Wood, paint, skin, hair, copper
26 cm high, 19 cm wide
Lent by John H. Hauberg

A portrait mask, with the flat upper lip,
broader nose, narrower eye sockets, and less
subtle transitions in carving detail which
suggest the heavy and forceful style of the
Haida, rather than the more attenuated
Tsimshian portrait style so evident in
number 282.

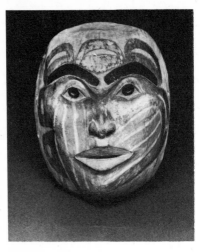

274 Mask Early 19th century
Northwest Coast, Haida
Wood 21 cm high
Lent by the Trustees of the British
Museum 42.12–10.84

This mask, representing a human face, is
decorated in green, red and black.
Presented by Captain Belcher December 10
1842.

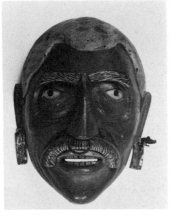

276 **Mask** Mid 19th century
Northwest Coast, Haida
Wood 25 cm high
Lent by the Trustees of the British
Museum 1947.Am.5.1

Portrait mask of a man wearing ear
pendants of abalone and a nose ornament.
Along with the mask of an old woman with
labret this mask is an example of the broad
style of Haida portrait masks. They relate
closely to the more sensitive Tsimshian
portrayals (see number 281). Purchased
from Sir Sydney Burney. Probably
presented to the Marquis of Lansdowne
while Governor General of Canada
1883–1888.

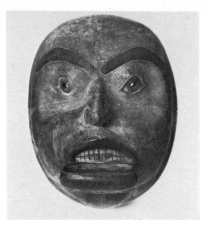

278 **Mask** Mid 19th century
Northwest Coast, Haida (?)
Wood 24 cm high
Lent by the Trustees of the British
Museum 55.12–20.195

Dance mask representing a woman's face,
with labret in lower lip. Given to the British
Museum by the Lords of the Admiralty,
December 20 1855. Collected by Surgeon J.
Neilson, R.N. from Haslar Hospital,
Portsmouth.

The designs are symbolic of clan or
shamanistic affiliation. Three similar masks
by the same artist, all collected between
1825 and 1834, are in the Peabody Museum
Salem, the Peabody, Harvard University
and the Smithsonian Institution. They were
first discussed in *The Far North*, page
236–237. Both Haida and Tlingit
attributions have been given to this group.

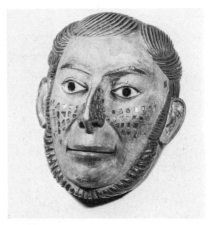

275 **Mask**
Northwest Coast, Haida
Wood, paint inlaid glass
26 cm high, 23 cm wide, 15 cm deep
Lent by the Joslyn Art Museum, Omaha,
Nebraska 1959.532

So sensitive were Haida carvers to the
European's presence that they could
convincingly render his rounded face – so
different from the flatter features of the
Indian. This mask is a masterpiece of the
genre. The ruddy faced trader or seaman
even has freckles of inlaid glass. This
feature would have been considered a
European characteristic by Indians.

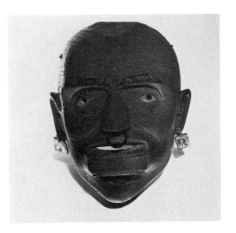

277 **Mask** Mid 19th century
Northwest Coast, Haida
Wood 25 cm high
Lent by the Trustees of the British
Museum 1947.Am.5.2

Portrait mask of a woman wearing labret,
earrings of abalone and nose ornament.
Painted maroon and red with black
eyebrows. See above entry.

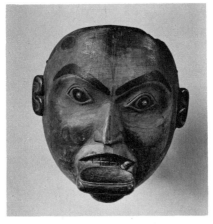

279 **Labret mask** *c* 1800 AD
British Columbia, Tsimshian
Wood, paint, beads
23 cm high, 20 cm wide
Lent by the University Museum,
Philadelphia 45–15–2

The eyebrows and the shape of the eye
sockets converge towards a sharp nose – a
Tsimshian characteristic. Two early
Russian trade beads form the pupils of the
eyes, a most unusual feature.

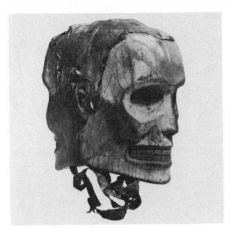

280 **Mask** *c* 1900 AD
British Columbia, Tsimshian
Wood, rawhide, paint
22 cm high, 22 cm long
Lent by the University of California at Los
Angeles Museum of Cultural History, Gift
of the Wellcome Trust X65–8554

This well carved Janus head mask is a
Tsimshian variant on the carved skulls used
by the Kwakiutl in their Hamatsa
(cannibal) ritual. It was used by a ghost
dancer.

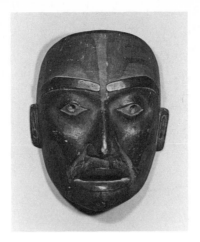

282 **Mask** Mid 19th century
Northwest Coast, Tsimshian
Wood, paint, pitch
24 cm high, 19 cm wide
Lent by John H. Hauberg

The narrow nose and the upward curve of
the upper lip, making a triangular pattern
out of the nose and upper lip, indicate that
this portrait mask is Tsimshian. Tsimshian
masks also have large eye orbs which bulge
pyramidally. Note the ear lines painted
above the eyebrows on the forehead.

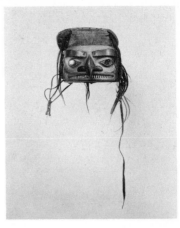

284 **Mask**
Northwest Coast, Tlingit
Wood, copper, walrus hide, human hair
16.5 cm high, 19.5 cm wide, 24 cm deep
Lent by the University Museum,
Philadelphia NA 10832

The age of the mask is indicated by its
strongly architectonic character and
schematic features, and particularly by the
exaggerated mouth full of teeth. It is quite
comparable with some of the late 18th- to
early 19th-century masks in the Leningrad
anthropological collections.

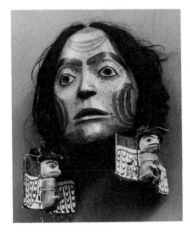

281 **Mask** *c* 1900 AD
British Columbia, Tsimshian
Wood, hair 30.8 cm high
Lent by the Portland Art Museum 46.14

A sensitive and realistic portrait mask; the
Niska Tsimshian were particularly good at
making these. The girl's face is painted red
and adorned with black human hair. There
are two hair pendants attached depicting
eagles with outstretched wings. The wings
are hinged and when opened reveal
miniature eagles.

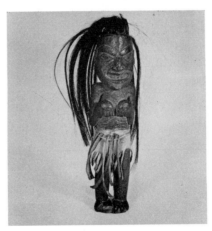

283 **Figure**
Northwest Coast, Tlingit
Wood, human hair, bone 10 cm high
Lent by the Taylor Museum of the
Colorado Springs Fine Arts Center 4910

A Shaman's spirit figure.

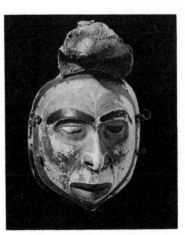

285 **Mask** *c* 1875 AD
Alaska, Tlingit
Wood, paint 34.5 cm high, 19.5 cm wide
Lent by the Museum of Primitive Art, New
York 56.330

This mask represents a dead man, the spirit
of death being conveyed by the inverted
eyes. It was part of a shaman's kit.
Collected by Wolfgang Paalen, on the
Alaskan coast, about 1939. A walrus ivory
charm from the same shaman's box is
illustrated in Robert Bruce Inverarity, *Art
of the Northwest Coast Indians*, plate 166.

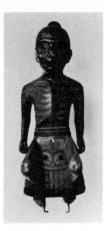

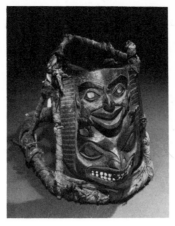

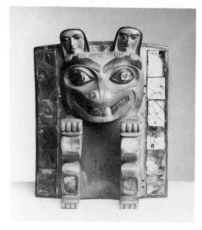

286 **Figure** 19th century
Northwest Coast, Haida
Wood
55 cm high, 19 cm wide, 14 cm deep
Lent by the Trustees of the British
Museum 1944.Am.2.131

Grave wood carving of an emaciated man
with label reading: 'Hydah medicine man.
This man was lost in the woods. He fell and
broke both legs and was found as
represented here. Starved to death.' This
exceptional figure represents a shaman
suspended in his grave box, his feet pointing
downward in the position they would
occupy if the figure reclined. Beasley
Collection.

288 **Headdress** 18th century
Northwest Coast, Nootka
Wood, abalone, fibre
18 cm high, 23 cm deep, 14 cm wide
Lent by the Trustees of the British
Museum 1678

Headdress carved with two faces, painted
red and green. Supported on a circular
framework of abalone shell and bone bound
in vegetable fibre. Previously owned by the
United Services Museum. Christy
Collection.

290 **Frontlet**
Northwest Coast, Haida
Wood, shell, paint 19.3 cm high
Lent by - Mr and Mrs Morton I. Sosland

This bear frontlet has been attributed to the
great Haida artist Charles Edenshaw
(1839–1924), who carved both for trading
purposes and for his own people, because of
the carved faces on the ears. The
extraordinary precision of the carved details
(claws, eyes, ears) is another Edenshaw
characteristic, as is the formal beauty of the
hollowed-out back. For more works by
Edenshaw see the catalogue *Arts of the
Raven*, text on gallery 6. This problem is
discussed by Bill Holm and Bill Reid in
Form and Freedom, Houston, Rice University,
1965, no. 70.

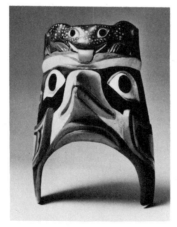

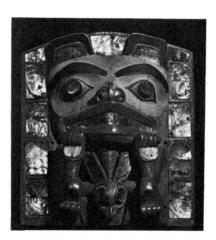

287 **Grave marker** *c* 1875 AD
Northwest Coast, Bella Coola
Wood, paint 1.45 m high, 62 cm wide
Lent by the Denver Art Museum QBC-1

The Kwakiutl and Bella Coola made a
number of such grave images. It represents
a proud, alert bald eagle, the crest (clan)
affiliation of the deceased. Red cedar and
native pigments. This one was collected in
the field about 1890 and exhibited at the
1893 Chicago Worlds Fair.

289 **Headdress** 19th century
British Columbia, Vancouver Island,
Cowichan
Wood, paint 22.5 cm high, 15 cm wide
Lent by Ulfert S. Wilke Collection

Represents a hawk. This is a more
elementary version of the chiefs' frontlets of
the Northwest Coast tribes above
Vancouver Island, although the display
function is the same. Purchased on the
Cowichan reservation. It once belonged to
Chief Toe-peed-mont who died in about
1910. Two similar masks, called Nootka,
are mentioned in Audrey Hawthorne.

291 **Frontlet** Late 19th century
Northwest Coast, Tlingit
Wood, pigment, shell inlay, fibre
15.5 cm high, 14 cm wide
Lent by the Brooklyn Museum. Gift of
Princess Gourielli 50.158

This frontlet represents a bear and another
animal.

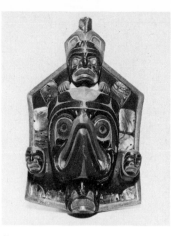

292 Frontlet
Northwest Coast, British Columbia, Bella
Coola
Wood, shell, paint, mirror
28 cm high, 18 cm wide
Lent by Mr and Mrs Morton I. Sosland

A raven is represented with small face
masks carved into the hand on either side.
Above there is another mask and below is a
cod. It is in a style commonly called 'Bella
Coola Bluebird' because of the typical blue
paint. Collected from a Kwakiutl, James
Puglas, at Village Island by Norman Feder.
Though not painted blue, another frontlet
with projecting style called Kwakiutl in the
Portland Art Museum is possibly by the
same hand (see Erna Gunther, *Art in the Life
of the Northwest Coast Indian*, page 98). Both
share the same prognathous style.

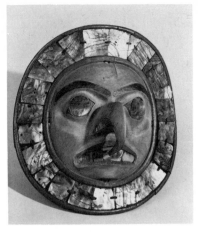

294 Frontlet *c* 1800 AD
Northwest Coast, British Columbia,
Tsimshian
Wood, paint, shell 22 cm high, 21 cm
wide
Lent by Mr and Mrs Morton I. Sosland

Hawk face, shown here with the cloth,
ermine and bristle foundation shown in the
accompanying photograph. In more
traditional days it would have been worn by
men only and not by a woman. The object
is certainly in the Tsimshian style, and was
traded to the Kwakiutl at Alert Bay, from
whom it was acquired by Norman Feder.
He took several photographs of it being
worn; he also removed the modern orange
paint and restored a small piece of abalone
shell. Collected from Henry George, Port
Hardy, British Columbia.

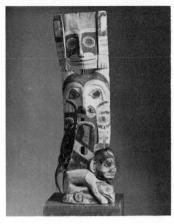

296 Frontlet *c* 1875 AD
Northwest Coast, Alaska, Tlingit
Wood, paint, hair 46.8 cm high
Lent by Mr and Mrs Morton I. Sosland

This atypical frontlet, possibly made for a
shaman, depicts on the bottom part a killer
whale, in an unusual quadruped form. It
closely parallels a pair of killer whale house
posts at Klukwan, carved, according to
Barbeau, in about 1875 by a Wrangell
craftsman. The upper face of the frontlet is
an owl, and the centre face is human.

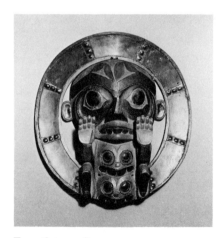

293 Frontlet *c* 1870 AD
Northwest Coast, Bella Bella
Wood, paint, copper
21 cm high, 19 cm wide
Lent by John H. Hauberg

The huge open eye sockets, depressed cheek
contours and short, heavy eyebrows are
typical of Bella Bella composition. The
round rim is a delicate variant of the round
Tsimshian plaques (number 294). The
separating of the figure from its field by
piercing is unusual in Northwest Coast
carving, and adds large scale drama to this
jewel-like piece.

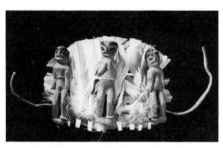

295 Band
Northwest Coast, Alaska, Tlingit
Wood, leather, feathers, paint
6.1 cm high, 7.3 cm wide
Lent by the Smithsonian Institution
68,009

Three miniature wooden human figures
painted red and mounted on a feathered
band. Found in a shaman's box, Sitka,
Alaska. Tlingit shamans used miniature
adornments like this band, tiny crowns and
maskettes in practicing their craft. Given by
J.J. McLean, December 2 1882

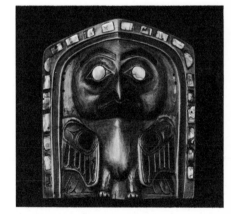

297 Frontlet
British Columbia, Tsimshian
Wood, paint, shell
18 cm high, 16.3 cm wide
Lent by Mr and Mrs Morton I. Sosland

A perching eagle, surrounded by a two-step
frame inlaid with abalone shell. Worn by a
chief and attached to his headdress.

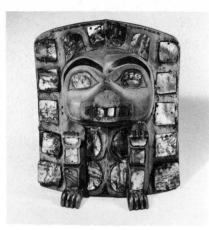

298 **Frontlet** 19th century
Northwest Coast, Haida Haganai
Wood, haliotis, paint 19 cm high
Lent by the University of East Anglia, the
Robert and Lisa Sainsbury Collection

This frontlet representing a bear belonged
to Chief Son-i-hat of the village of Kassan,
Prince of Wales Island. The subject and
treatment are similar to that of number 245,
the Chief Shakes screen.

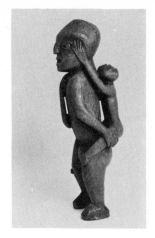

300 **Figure** 18th century (?)
Northwest Coast, Nootka (?)
Wood 34 cm high
Lent by the Trustees of the British
Museum N.W.C.66

Carved wooden figure representing a
woman carrying a child on her back.

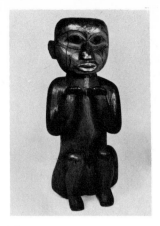

302 **Figure** Early 19th century
Northwest Coast, Haida
Wood 71.5 cm high
Lent by the Trustees of the British
Museum +202

Crouching figure in wood, painted red,
decorated with copper and black. Possibly a
war canoe bow ornament. The rounded
carving suggests Haida origin. Presented by
Fleetwood Sandeman May 18 1877.

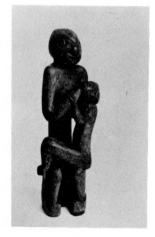

299 **Figure** 18th century (?)
Northwest Coast, Nootka
Wood 27 cm high
Lent by the Trustees of the British
Museum N.W.C.64

Carved wooden figure of a woman with a
child sitting on her knee. The domed
forehead, flattened artificially, shows a
Koskimo (Salish) practice. No provenance:
probably from Sir Ashton Lever's Museum.

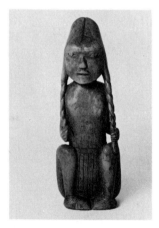

301 **Wooden figure** 19th century
Northwest Coast, Nootka (?)
Wood 29 cm high
Lent by the Trustees of the British
Museum 1679

Effigy figure of a woman in a squatting
position. Her hair is in plaits. Said to be a
Koskimo woman. Previously owned by the
United Services Museum. Christy
Collection.

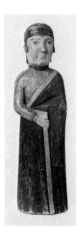

303 **Male figure** Early 19th century
Northwest Coast, Haida (?)
White maple 33 cm high
Lent by the Trustees of the British
Museum 2290

Portrait figure wearing a European shirt,
painted red, blue and brown. One of a
group of thirteen figures collected in 1832,
by Charles Wilkes. Three are now in the
Smithsonian Institution, see Hooper
Collection, Phelps, London, 1975, plate
182. Presented to Kew Gardens by Dr Lyall
of the North American Boundary
Commission; presented by Kew Gardens to
the Christy Collection. Originally
attributed to Lock-Qui-Lilla Indians.

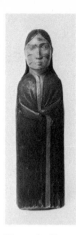

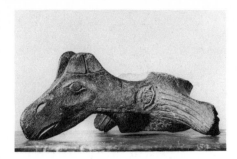

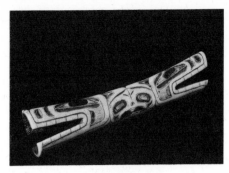

304 Female figure Early 19th century
Northwest Coast, Haida (?)
White maple 32 cm high
Lent by the Trustees of the British
Museum 2291

See previous entry.

306 Tobacco mortar 18th century
Northwest Coast, Alaska, Tlingit
Whale bone
30.5 cm long, 26 cm wide, 11 cm high
Lent by Mr and Mrs Robert Campbell

This object is made from whale neck
vertebrae; the image follows the natural
contours and depicts an eagle. The tobacco
mortar is peculiar to the Tlingit. 'We are
now more prone to think of the (coastal)
Tlingit as partially a people who moved
down the river valleys from the interior
Athabascan territory. The grinding of any
food product is an interior trait in the
Northwest.' (Erna Gunther, letter
concerning this piece.) Collected by
Klondike Kate, a well-known Yukon gold
rush dance hall queen in the 1890s.

308 Soul catcher 19th century
Northwest Coast, probably Tsimshian
Bone, haliotis shell 20 cm long
Lent by the Trustees of the British
Museum 1939.Am.11.1

'Sisiutl', the double-headed sea monster, is
depicted at each end. Soul catchers or soul
traps were used by shamen to capture a
person's soul in ceremonies. It was thought
that the implement actually swallowed the
soul helping the shaman to cure the afflicted
person. Soul catchers were traditionally
made from the femur of a bear, although
other bones were used. The carved
decorations show traces of red pigment.
Presented by P. Beeman. Collected by his
uncle Samuel Beeman of the Hudson's Bay
Company, before 1867.

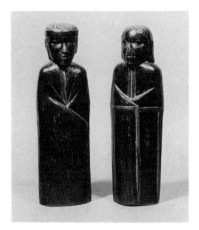

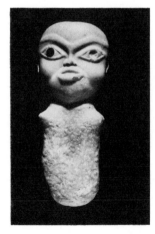

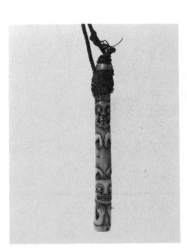

305 Pair of figures *c* 1830–1860 AD
Northwest Coast, Haida
Wood, paint 30 cm high
Lent by Mr and Mrs William D. Wixom

Representing a chief and his wife, this pair
relates to several similar figures which may
be by more than one carver. (See the pair
from the British Museum, above.)
Some are of white people and others are
carved with more detail. The hunched,
archaic feeling of the couple may place
them early in the series. The type relates to
Haida argillite figure carvings and was
perhaps suggested by them. A bone carving
of this type is in the Smithsonian.

307 Ceremonial head Date unknown
Northwest Coast (possibly Vancouver
Island)
White stone inlaid with haliotis
22 cm long
Lent by the Trustees of the British
Museum 1949.Am.5.12

One piece of inlay remains. Bequeathed by
Oscar Raphael.

309 Awl case
Northwest Coast, Tlingit
Ivory 15 cm high
Lent by the Fine Arts Museums of San
Francisco 6342

Even this miniature utilitarian object has
been treated like the animal crest designs on
totem poles.

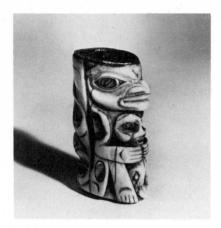

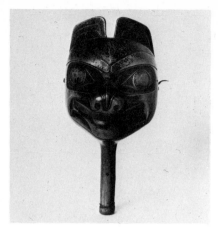

310 **Pipe bowl** 19th century
Northwest Coast, Tlingit (?)
Walrus ivory inlaid with haliotis shell
8 cm high
Lent by the Trustees of the British
Museum 8956

The carving represents a bear crest.
Presented to the Christy Collection by A.W.
Franks, September 15 1873.

312 **Ceremonial rattle** Late 19th century
Northwest Coast, Salish
Horn, wool 44 cm long
Lent by the Trustees of the British
Museum 1944.Am.2.153

This composite horn and wool rattle made
from a Haida horn ladle is from Duncan,
Vancouver Island. The design probably
represents a skate. Collected by Lieutenant
Emmons. Beasley Collection.

314 **Rattle** 19th century
Northwest Coast, Haida
Wood 17 cm high, 13 cm diameter
Lent by the Trustees of the British
Museum +5930

Uncoloured dance rattle carved to
represent 'Hoorts', the bear from Queen
Charlotte Island. Rattle: seven blue beads,
two stones, one nail. Purchased through the
Christy Fund from Montague Troup
December 13 1892.

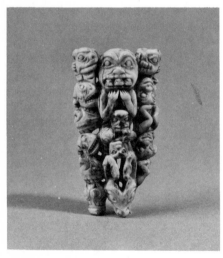

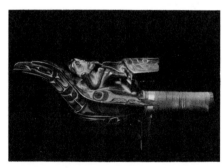

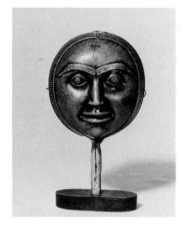

311 **Shaman's charm**
Northwest Coast, Tlingit
Ivory 10 cm high, 5.5 cm wide
Lent by the Museum of Primitive Art,
New York 57.82

This charm was found with number 285,
the shaman's mask (dead man).

313 **Rattle**
Northwest Coast, Kwakiutl
Wood, paint 28.5 cm long
Lent by Mr and Mrs Morton I. Sosland

Northwest Coast rattle, with carved relief
designs painted in Kwakiutl colours (red,
black, green). The type is most common in
the area north of the Kwakiutl.

315 **Rattle** 19th century
Northwest Coast, attributed to the
Tsimshian (?)
Wood 30 cm high
Lent by the Portland Art Museum
Collection 55.256

This rattle, made from two pieces of wood
joined with leather thongs, probably
represents the sun or moon. The smooth
facial features and precisely carved surfaces
suggest the Tsimshian style.

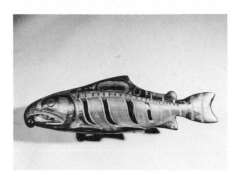

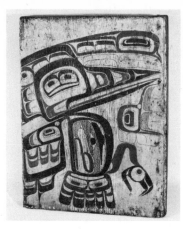

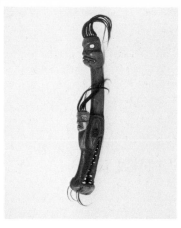

316 Rattle 1900 AD or earlier
Northwest Coast, Alaska, Tlingit
Wood, paint
19 cm high, 65 cm long, 9 cm wide
Lent by Mr and Mrs John A. Putnam

Represents a salmon with exposed ribs
containing an effigy of a shaman. A
marvellous example of the Northwest Coast
concept of transformation between man
and animal. Formerly in the Katherine
White Collection.

318 Box drum c 1830–1850 AD
Northwest Coast, Tlingit, Alaska
Wood, paint
94 cm high, 68.5 cm long, 38 cm wide
Lent by Mr and Mrs Morton I. Sosland

Box drums were sometimes suspended from
beams and beaten with the feet. This one
has a suspension rope which is not original.
The uptilted raven design on one side
indicates the drum can be attributed to the
Master of the Raven Screens in the Denver
Museum, but from later in his career. It was
collected by Axel Rasmussen, from
Yailthcock, a famous Klukwan chief, and
restored by Bill Holm.

320 Ceremonial club Late 18th century
Northwest Coast, Nootka
Wood, haliotis shell 53 cm long
Lent by the Trustees of the British
Museum N.W.C.100

One end is carved to represent a human
head; the other end is a wolf's head.
Decorated with hair and teeth. Collected on
Captain James Cook's third voyage
(1776–1780).

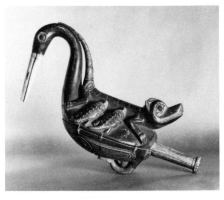

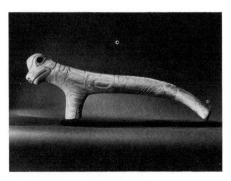

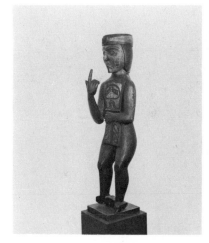

317 Rattle c 1870 AD
Alaska, Tlingit
Ivory 19.5 cm high, 28 cm long
Lent by the Denver Art Museum MT1–3

The bird is an oyster catcher, carrying on its
back a family of land otters. Since these
were thought to have the power to cause
insanity, this rattle was probably used by a
shaman to treat mental illness. For a frieze
of land otters on the top portion of a Tlingit
shaman's mask see number 267.

319 Slave-killer 18th century(?)
Alaska, Tlingit
Antler, shell 44.5 cm long
Lent by the University of East Anglia, (The
Robert and Lisa Sainsbury Collection)

A beautifully executed bone club from the
Northwest Coast. Its head is similar to
Northern style daggers. In form it is an
extraordinary survivor of the ancient
Columbia River slave-killers of the rare
one-bladed type (see E. Strong, figure 52).

321 Potlatch figure Mid 19th century
British Columbia, Kwakiutl
Wood, paint 1.27 m high
Lent by the Taylor Museum of the
Colorado Springs Fine Arts Center 3973

Potlatch figures were displayed sometimes
on the roof of the potlatch giver's dwelling,
as a welcome to guests. This magnificent
figure is presenting a copper, the gift of
which often marked the last part of a
potlatch feast. Sculpturally one of the finest
of known potlatch figures, this example has
the compactness of the best mediaeval
sculpture.

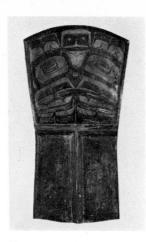

322 **Copper** 19th century
Northwest Coast, Tsimshian (?)
Copper
78 cm high, 43 cm wide (maximum)
Lent by the Trustees of the British
Museum 1900.7–24.1

The upper part of this copper is painted
black, with a bear design. Presented to the
British Museum by Mr R. Day on July 24
1900. Mr Day purchased it from A.W.
Vowell, of the Indian Commission for
British Columbia, in 1894. It had originally
been obtained by Hudson's Bay Company
Agents at Fort Simpson, where Negh-Hum-
Gee-Asc said that it had been found on an
island in Alaska by Sitka Indians.

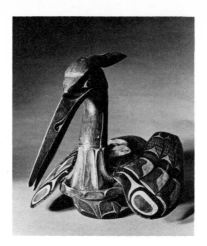

324 **Crest hat** *c* 1900 AD
Northwest Coast, Kwakiutl
Wood, paint 34 cm high, 61 cm wide
Lent by John H. Hauberg

This heron crest hat was still being used in
the 1960s. 'It was carved at Wakeman
Sound by Herbert Johnson for his father
about 80 years ago. . . . It was then given
to Herb Johnson in a potlatch given by his
father when his older brother was killed at
Kildall cannery about 50 years ago.'
(Personal correspondence to Michael
Johnson from Port Hardy, British
Columbia, 1969, by Dusty Cadwallader.)

The right to wear crest hats was reserved for
high ranking members of the tribe. See
number 325 for a Tlingit interpretation of
the crest hat.

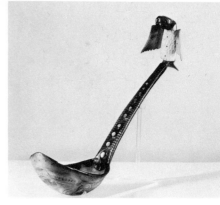

326 **Ladle** Late 19th century
Northwest Coast, Tlingit
Horn, bone, copper, abalone shell inlay
Handle 30.5 cm long,
Bowl 19 cm high, 12.5 cm long
Lent by the Cleveland Museum of Art
The Harold T. Clark Educational
Extension Fund
Extension Exhibitions Department

A very stylish piece with the surmounting
eagle in cowhorn. This ladle marks the
height of the Northwest Coast penchant for
conspicuous display – with the earlier
passionate expression replaced by
calculation. The best contemporary
Northwest Coast pieces carry forth this
sense of stylization (266).

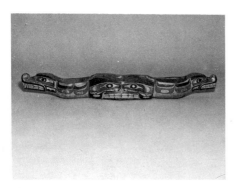

323 **Model feast dish** *c* 1906 AD
Northwest Coast, Kwakiutl
Wood, paint 10 cm high, 91.5 cm wide,
13 cm deep
Montana Private Collection

This cedarwood feast dish was made by the
Kwakiutl carver Charlie James as a study
for his 20 foot dish. As with other Kwakiutl
works commercial paint is used to delineate
the image, in this case a sisiutl.

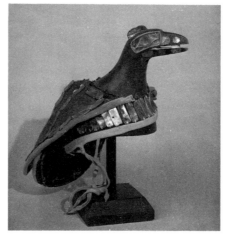

325 **Clan hat**
Northwest Coast, Alaska, Tlingit
Wood, felt, shell, skin, blanket cloth 48.5
cm long
Lent by Mr and Mrs Morton I. Sosland

This hat represents a raven. From Saxman
Village, adjacent to Ketchikan, Alaska.
Photographs exist of it being worn at a
Saxman burial. It is wrongly called
Tsimshian in Minneapolis, *American Indian
Art : Form and Tradition*, number 453.

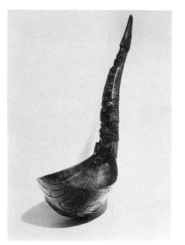

327 **Spoon** 19th century
Northwest Coast
Horn 53 cm long
Lent by the Trustees of the British
Museum 1949.Am.22.82

An unusually deep ceremonial spoon of
mountain goat horn carved with totemic
ornamentation. Each family had a supply of
spoons; the number within a family was
determined by the number and the
grandeur of the feasts they could afford to
give.

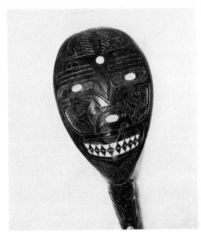

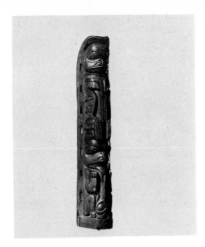

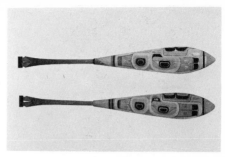

332 Two ceremonial paddles 19th century
Northwest Coast, Tlingit
Wood, painted black, blue, red
1.21 m long
Lent by the Trustees of the British
Museum +227

328 **Spoon**
Northwest Coast, Haida
Horn, ivory, abalone shell 31 cm high
Lent by the Joslyn Art Museum (Gift of Dr
and Mrs A.F. Jonas) 1952.53

Carved mountain goat horn spoon from the
northern part of the Northwest Coast. The
abalone and ivory inlay, and the beaver
design carved on the back, create an
elaborate effect compared to the average
small hand spoon.

330 **Model totem pole** *c* 1890 AD
Northwest Coast, Haida
Wood, mountain goat horn 67.5 cm high
Private Collection

The elegant carving depicts, from top to
bottom, a sea lion with front and back
flippers, a bear with sectioned hat, and a
raven looking upwards. The deep carving is
echoed by the inlaid flange which elegantly
frames the entire composition. The piece
was varnished, but when a small section was
cleaned, soot was revealed overlaying the
varnish, indicating that perhaps it had
remained in native hands longer than was
usual for model poles, which were generally
sold.

The Northwest Coast obsession with
symbolic animal design extended to the
surface decoration of canoe paddles. The
conventional eyes and animal parts on the
two paddles were drawn in opposing pairs,
so that when considered together they are a
bi-lateral unit. The same idea was applied
to Chilkat blankets, storage chests and
bracelets. These paddles were presented to
the Christy Collection by Fleetwood
Sandeman, May 18 1877.

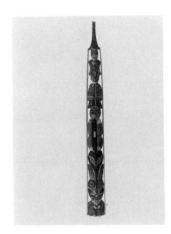

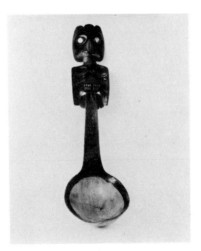

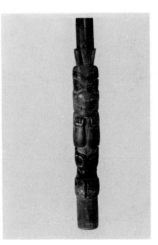

329 **Model totem pole** Late 19th century
Northwest Coast, Bella Coola
Wood 1.81 m long
Lent by the Trustees of the British
Museum 1905.7–21.2

Wooden painted open-work totem
pole/house pole model, probably used on
the front of a house or for a potlatch pole.
Since these models were specimen carvings
for sale, liberties could be taken with their
forms, not allowable in the originals.

331 **Spoon** 19th century
Northwest Coast, Tlingit (?)
Horn, copper, abalone 63 cm long
Lent by the Trustees of the British
Museum 1954.W.Am.5.987

Large mountain sheep horn spoon with a
beaten and engraved copper handle; eyes of
copper, figure inlaid with abalone.
Wellcome Collection.

333 **Wooden staff** 19th century
Northwest Coast, Haida
Wood 1.53 m long
Lent by the Trustees of the British
Museum 1920.4–73

Carving shows a whale and a bear, the
latter wearing a potlatch hat with 13
divisions. Originally there was another
carving joined to the top.

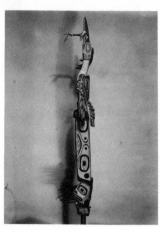

334 Staff
Northwest Coast, Tlingit
Wood, paint
3.04 m long, 30 cm wide, 14 cm deep
University Museum, Philadelphia NA
9498

A prestigeous object, used to display crests while speaking. Among the Tlingit in particular these staffs became monumental, tall, bladed sculptures, a stage which marked a climax in their development.

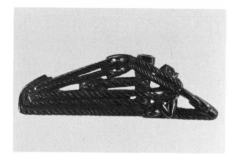

336 Pipe Mid 19th century
Northwest Coast, Haida
Argillite 22.5 cm long, 7 cm high
Lent by the Trustees of the British
Museum D.C.20

In the design a white man wearing a tail-coat is caught in the ship's rigging. Carving in argillite is indigenous to the Queen Charlotte Islands and was begun in the early 19th century, continuing until today. Bragge Collection, Christy Collection.

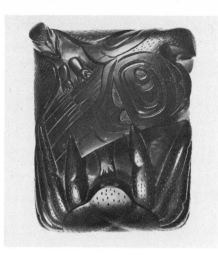

338 Plaque Late 19th or Early 20th century
Northwest Coast, Queen Charlotte Islands, Haida
Argillite 22 cm high, 16.5 cm wide
Lent by the University of California at Los Angeles Museum of Cultural History, Gift of the Wellcome Trust X65–4007

Shows a crab clutching a raven's wing and an eagle clutching the opposite side of the wing, with a fish beneath the raven. This forceful composition has a dynamic asymmetry rare in Haida argillite carving. Its form was apparently suggested by argillite box lids, but no function – except sale – was intended here.

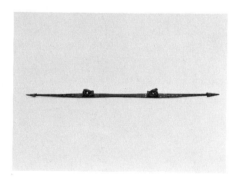

335 Ceremonial bow 19th century
Northwest Coast, Haida (?)
Wood, haliotis shell 1.62 m long
Lent by the Trustees of the British
Museum 1949.Am.22.81

Wooden ceremonial bow inlaid with haliotis shell and ornamented with two bear heads in full relief. These bows were usually used at potlatches in the copper-breaking ceremony. Oldman Collection.

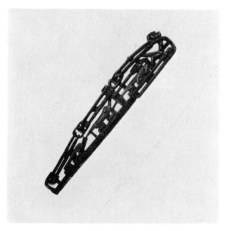

337 Pipe Mid 19th century
Northwest Coast, Haida or Tlingit
Argillite 44 cm long, 8 cm high
Lent by the Trustees of the British
Museum Q72.Am.63

The pipe shows a white man wearing a tail-coat caught in ship's rigging while chased by three monsters, probably grizzly bears. These pipes and other argillite carvings were made by the Haida exclusively for trade purposes.

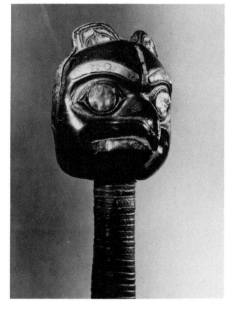

339 Fighting knife, surmounted by a bird's head 19th century
Northwest Coast, Haida
Copper, horn, haliotis shell inlay, hide
56 cm over-all length
Lent by the University of East Anglia
(Robert and Lisa Sainsbury collection)

The shape of this knife is possibly European in origin, however the motif and use are entirely native to America.

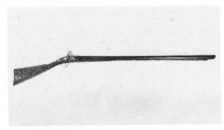

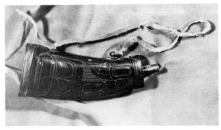

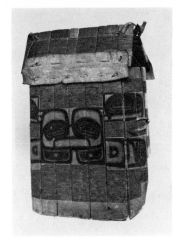

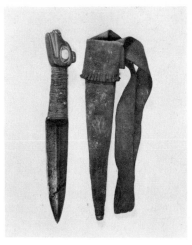

340 **Musket with powder horn**
Late 19th century
Northwest Coast, Queen Charlotte Islands,
Haida
Wood, brass, mountain goat horn
Gun 1.32 m long; powder horn 19.5 cm
long, 7 cm wide
Lent by Mr and Mrs Rex Arrowsmith

An English flint lock musket bearing the
name Joseph Golcher on the lock. Beaver
and sea bear designs proliferate on the butt
and stock; the powder horn has bear leg
motifs. An example of how the Haida urge
towards carved embellishment could
convert a trade item into a thoroughly
Indian object. For an illustration of another
carved Haida gun see *People of the Potlatch*,
Vancouver Art Gallery with the University
of British Columbia, number 40.

342 **Slat armour** Early 19th century
Northwest Coast, Tlingit
Wood, elkskin, rawhide 58.5 cm high
Lent by the Trustees of the British
Museum 1929.12–18.2

The wood is bound with elkskin and
rawhide; the lashing is of braided fibre.
Decorated with animal designs, possibly the
owner's crest. Originally Tlingit warriors
went into battle wearing full armour
including helmet, visor, collar and body
armour. But at a later period armour was
used as a costume for ceremonies. This
piece, and a small group of pieces collected
on Kotzebue's voyage, were purchased
from his family's house in Revel, Estonia,
in 1929.

344 **War knife and scabbard**
Alaska, Tlingit
Leather, metal scabbard 76 cm long (with
strap), knife 35 cm long
Lent by the Taylor Museum of the
Colorado Springs Fine Arts Center 5051,
5052

Weapons on the Northwest Coast reached
great decorative heights among the Tlingit
who made superbly carved and inlaid
knives such as this one as well as ferocious
looking war helmets and slat armour.

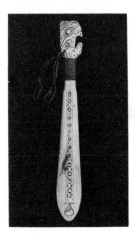

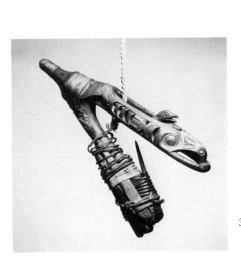

341 **Club** 18th century
Northwest Coast, Nootka
Bone 58.5 cm long
Lent by the Trustees of the British
Museum N.W.C. 41

Fishing club of whale bone, inlaid with
haliotis shell along the length of the blade;
grip bound with cord. The end carved with
grotesque bird's head. Previously owned by
Sir Joseph Banks. Collected on Captain
James Cook's third voyage (1776–1780).

343 **Fish hook**
Northwest Coast, Alaska, Tlingit
Wood 25.5 cm long
Private Collection

An exceptionally well sculpted halibut hook
in the form of a sculpin (a small American
sea fish) or a dogfish. The tiny raven moves
in its slot to attract attention in the water.
Collected at Sitka 1931, ex-Beasley
Collection.

345 **Spear thrower** *c* 1830 AD
Alaska, Tlingit
Wood 37 cm long
Lent by the Denver Art
Museum QTl–130

The Atlatl (spear thrower) is uncommon on
the Northwest Coast, suggesting that this
one is copied from those used by southern
Eskimo groups, near to the northern
Tlingit. The Tlingit carver has
incorporated decorative carving to indicate
the owners' crests. A later use of this kind of
owner identification can be seen in the
recarved stocks of trade muskets. (See
number 340.)

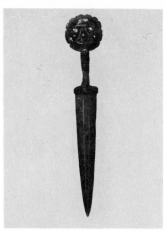

346 Dagger Late 19th century
Alaska, Tlingit
Copper, wood, rawhide, abalone
56 cm long
Lent by University of California at Los
Angeles Museum of Cultural History (gift
of the Wellcome Trust) X67–457

The handle represents the sun.

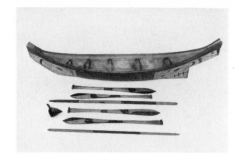

348 **Model whaling canoe** 19th century
Northwest Coast, Haida
Wood 1.67 m long
Lent by the Trustees of the British
Museum +228

Model of a whaling canoe painted in black,
red and green with four paddles. Presented
to the Christy Collection by Fleetwood
Sandeman, May 18 1877. The Haida made
the most magnificent Northwest Coast
canoes which reached 75 feet in length.

350 **Blanket** *c* 1870 AD
Northwest Coast, Salish
Dog wool 1.19 m wide, 1.35 m long
Lent by the Brooklyn Museum X763

These blankets, called 'nobility blankets',
were woven by the Salish of the Lower
Fraser River Valley. The designs were
traditionally owned by the weaver's family.

347 **Canoe model with bailer,
paddles and sail**
Northwest Coast, Haida
Wood, sailcloth
72 cm long, 14.5 cm wide, 17 cm deep
Lent by the Royal Scottish
Museum L.304.110

After the introduction of European masts
and sails the Indians were able to make
much longer voyages than they had before.

349 **Blanket** 18th century
Northwest Coast, Nootka
Bark, wool 1.52 m long
Lent by the Trustees of the British
Museum N.W.C.53

Blanket of cedar bark and mountain goat
wool, decorated with an oyster catcher
(with short legs, therefore not a raven) and
a pair of skates. The chevron and zig-zag
border is from the Salish weaving tradition,
and appears in two other undecorated
mantles in the British Museum and another
in Vienna at the Museum für Volkerkunde.
For an illustration of Nootka Indians
wearing similar mantles in a house interior
see the print after John Webber in Captain
Cook's *Atlas*, volume 4.

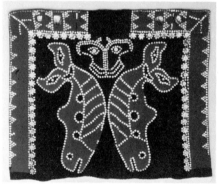

351 **Button blanket** 19th century (?)
Northwest Coast, Kwakiutl
Trade blanket, felt, buttons
1.83 m high, 1.83 m wide
Lent by Mr and Mrs Peter B. Thompson

Shows two plunging killer whales, with a
mask in between. The active design and
restless outlines are strongly Kwakiutl. (See
the Tsimshian button blanket number 352.)
Old Chinese buttons, which were coveted
trade goods, were customarily used on these
blankets as late as the early 1900s.

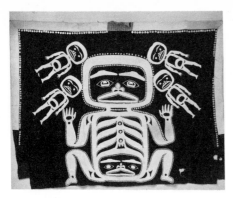

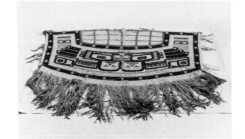

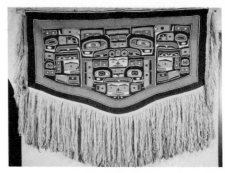

352 Button blanket Early 20th century
Northwest Coast, Tsimshian
Buttons, blanket, felt
Montana Private Collection

Perhaps the finest Northwest Coast button wearing blanket, with its dramatic and tasteful patterns. Its quality approaches that of the dynamic bear image on the famous Denver Chief Shakes Screen. It is very similar to the fine blanket collected by the Indian, Louis Slotridge, on the Nass River in 1918, for the University of Pennsylvania, except that this one has extraordinary angled felt appliqué figures instead of bears' ears. (See Norman Feder, *American Indian Art*, figure 162.)

354 Chilkat blanket *c* 1825–1850 AD
British Columbia, Tlingit
Wool, cedar bark
83 cm high (centre), 1.49 m wide
Lent by the Portland Art Museum
Collection 48.3.546

Found in Tsimshian territory in 1880, this exhibit has a panel with 18 geometric rectangles above the design, which only occurs on very old Chilkat blankets. The design represents Konakadet, according to notes made by its ex-owner Mrs H.C. Champlin. He is a mythical Tlingit strong man (known to the Haida as Wasco) not Tsimshian, so this blanket could not be Tsimshian as recorded in the Portland Art Museum catalogue. (See E. Gunther, *Art in the Life of the Northwest Coast Indian* number 125, page 204.) Konakadet is generally shown as an aquatic wolf with some killer whale features.

356 Chilkat blanket *c* 1900 AD
Northwest Coast, Tlingit–Kwakiutl
Wool, cedar bark warp
1.24 m high, 1.47 m wide
Lent by Mr and Mrs Morton I. Sosland

This hybrid blanket is in pure Chilkat style, but the colours are in louder Kwakiutl taste. It was woven by Mary Hunt, a Tongass Tlingit, who took her pattern boards with her to the south when she married into the Kwakiutl Hunt family. Some eight or nine blankets of this type were made and are mostly still owned by Kwakiutl. Collected by Norman Feder from Mary Waddums at Alert Bay, but formerly owned by Ed Whannock.

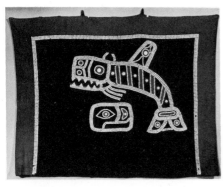

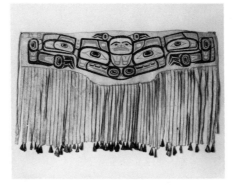

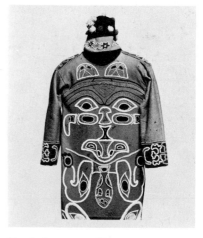

353 Button blanket 19th century
Northwest Coast, Tlingit, Alaska
Shell, buttons, cloth
1.32 m long, 1.72 m wide
Lent by the Portland Art Museum
Collection 48.3.553

Blue Hudson's Bay blanket with red broadcloth border. Killer whale design with rocks (in the form of a head) on which the whale was stranded while chasing a seal. The decorative character of Tlingit art is well brought out by the interchanging three rank, two rank and single rank button systems which seem to make the whale shimmer and glide. From Wrangell. 'Obtained from Mrs Blake, March 10 1934. The blanket was purportedly made for Mrs Blake's mother at a time before she (Mrs Blake) could remember.' (See E. Gunther *Art in the Life of the Northwest Coast Indian*, page 203.)

355 Dance apron
Northwest Coast, Alaska, Tlingit
Deer hide, deer hoofs, paint
66 cm high, 1.11 m wide
Lent by Mr and Mrs Morton I. Sosland

This apron represents a bear and was worn with a painted shirt now in the Riverside (California) Municipal Museum. (See *Yakutat South*, Art Institute of Chicago, 1964, page 75, where both are illustrated.) It was used by shamans. The design is typical, and is used by Bill Holm (see Bill Holm, page 36) to illustrate the principle of bi-lateral symmetry and linear emphasis systems in Northwest Coast design.

357 Beaded coat *c* 1890 AD
Northwest Coast, Tlingit, Alaska
Stroud cloth, beads
1.17 m long, 1.55 m across sleeves
Private Collection

A sea bear with four eyes is probably represented on the front of this exhibit. A photograph exists showing this coat being worn at a gathering in the 1890s. Rarely does Tlingit beadwork become so elaborate. This is probably an example of Athabascan influence upon Chilkat work.

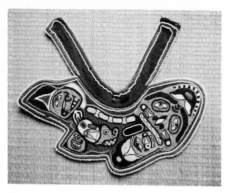

358 **Beaded collar** Early 20th century
Northwest Coast, Alaska, Tlingit
Bead work on red cloth with black backing
and green ribbon edging 40.5 cm long
Lent by the Portland Art Museum
Collection 48.3.709

The design represents a dog fish, with its
face on the right; various sea monsters float
in its body.

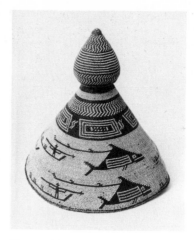

360 **Hat** 18th century
Northwest Coast, Nootka
Cedar bark, squaw grass 30 cm high
Lent by the Trustees of the British
Museum N.W.C.6

Conical hat with onion-shaped top and
woven ornamental design of whale hunt.
Captain Cook mentions the Nootka
wearing such hats. Lewis and Clark also
mention seeing them at Fort Clatsop in
1805. See Norman Feder and Edward
Malin, page 32, figure 32.

362 **Labret** Early 19th century
Northwest Coast, possibly Haida
Wood, haliotis shell 7.5 cm long
Lent by the Trustees of the British
Museum 1939.Am.11.2

Labrets were inserted in the lower lips of
women of rank in northern regions. One
piece of haliotis shell is restored.

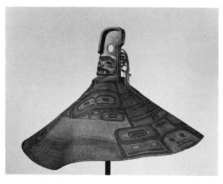

359 **Clan hat**
Northwest Coast, Alaska, Tlingit
Woven spruce root, paint
42 cm high, 60.5 cm diameter
Lent by the University Museum,
Philadelphia NA 11743

A whale crest crowns this spruce root hat.
Whale clan hats like this usually come from
the Sitka area.

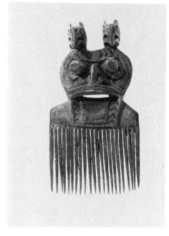

361 **Comb** 19th century
Northwest Coast, Vancouver Island,
Cowichan (Salish)
Wood 14 cm high
Lent by the Trustees of the British
Museum 2286

Combs were used for grooming the hair and
never worn. The upper part of this one
represents 'Swaixwe' who was a mythical
sky-being who descended to earth and lived
in the lakes. Cowichan from Duncan,
Vancouver Island. Collected on the
Columbia River. Christy Collection. See
number 250.

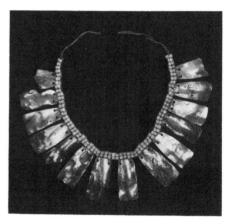

363 **Necklace** 19th century
Northwest Coast, tribe unknown
Beads, abalone 34 cm long
Lent by the Trustees of the British
Museum 2004

Necklace of two rows of white beads, from
which hang fourteen oblong pendants of
abalone/haliotis shell. The beads were
probably trade goods from European or
Russian traders. Christy Collection.

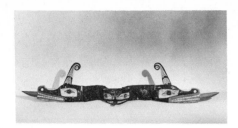

364 Sisiutl belt
Northwest Coast, Kwakiutl
Leather, painted wood with mica
92 cm long
Lent by Mr and Mrs Morton I. Sosland

The centre carving is attached.
Collected by Norman Feder at Alert Bay,
Vancouver Island in 1960.

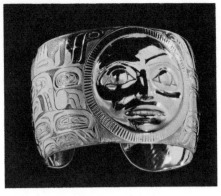

366 **Bracelet** 1971
Northwest Coast, Haida
Gold 4.5 cm wide
Lent by Mr and Mrs Michael R. Johnson

This gold bracelet by the contemporary
Haida artist Bill Reid is even more beautiful
and technically perfect than the nineteenth-
century ones of coin silver. The feeling of
scholarly preservation and love of tradition
is perfectly balanced by the dynamic
character of the central image.

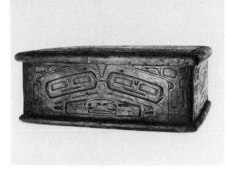

368 **Lidded box** c 1900 AD
Northwest Coast, Alaska, Kagani Haida
Wood, sinew
55.5 cm long, 38 cm wide, 22 cm high
Lent by the University of California at Los
Angeles Museum of Cultural History,
Gift of the Wellcome Trust X65–7482
a and b

The corners of this box are slit and the
bottom stitched to the sides with sinew. The
sides have beaver motifs with bird profiles
at each corner. It was collected at
Hydaburg, Prince of Wales Island before
1924.

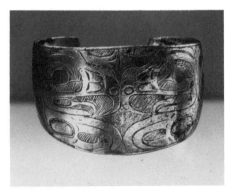

365 **Bracelet** Before 1900 AD
Northwest Coast, Alaska, Tlingit
Silver 5 cm diameter
Private Collection

Made from coins of nickel silver, the
bracelet shows two hawks in profile which
join frontally to show a bear.

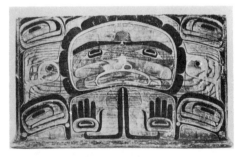

367 **Storage box** c 1860–1870 AD
Alaska, Tlingit
Wood, paint 40.5 cm high, 44 cm long
Lent by Mr and Mrs Robert Campbell

The hatchings in the eye sockets are a type
of shading seen on incised Haida argillite
carvings, but not usually in Tlingit work.
The central image, a beaver crest with
cross-hatched tail above the nose, recalls
mask designs of the Kwakiutl area with
their sun ray surrounds. Collected by
Captain Daniel O'Neil, an Oregon pioneer
who died in 1905.

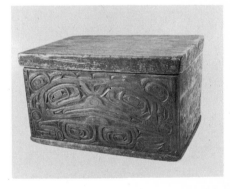

369 **Food box**
British Columbia, Tsimshian
Wood, sinew
26.5 cm high, 44 cm long, 33 cm deep
Lent by the Taylor Museum of the
Colorado Springs Fine Arts Center 4941

Frederick Douglas noted of this piece
'carving is good but not absolutely top'. The
frog designs carved into the two long sides
deserve better than this, partly because of
their age. 'Collected at Sitka in 1883 as an
antique, it is at least middle 1800s if not
earlier.'

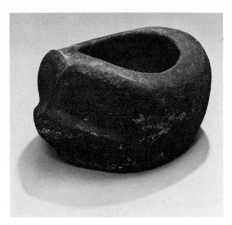

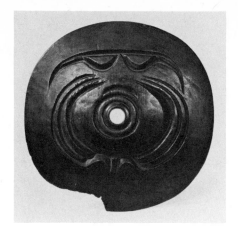

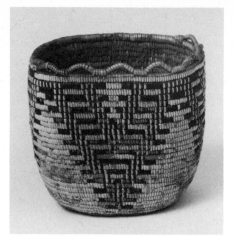

370 Mortar
Northwest Coast, Haida
Stone
27 cm high, 21.5 cm wide, 15 cm deep
Lent by the National Museum of Man,
National Museums of Canada,
Ottawa Vii–B–1064

The shape of the eyes of the frog, either
closed or unfinished, give this sculpture a
peculiarly tentative quality. Used to grind
tobacco for chewing. Perhaps several
hundred years old. Collected 1895–1901.

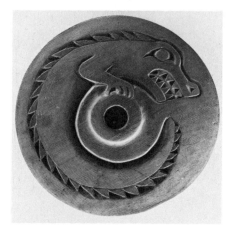

373 Basket Mid 19th century
Washington, Salish
Grass 7 cm high, 8 cm long, 6 cm wide
Lent by the Trustees of the British
Museum 8191

Small cup-like basket of stoutly woven
grass. Decorated with step pattern and
loops around the rim. Collected by Captain
Belcher before 1842. Presented to the
Christy Collection June 10 1872 by A.W.
Franks.

372 Spindle whorls 19th century
Vancouver Island, Cowichan
Wood

a 21.5 cm diameter
Lent by the Brooklyn Museum 05.416

b 18 cm diameter
Private Collection

Used to spin the fibres for Salish blankets
made from dog hair. In contrast to the bi-
lateral symmetry of the northern style of the
Northwest Coast the images on Salish
whorls are generally presented whole, as in
b, which was collected at Nanaimo by
Norman Feder in 1971.

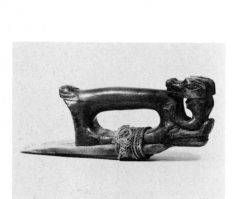

371 Adze Late 19th or early 20th century
Northwest Coast, Vancouver Island,
Nootka
Wood, bone 31 cm long, 9.5 cm wide
Lent by the Brooklyn Museum 05.246

374 Cradle 19th century
Northwest Coast, Salish
Wood 65 cm long
Lent by the Trustees of the British
Museum 1958.Am.2.3

Basket-work cradle made from sapwood or
young trees of *Thuja Plikata*, with a delicate
decorative pattern in yellow and dark
brown on natural. The fibres are wrapped
around heavy splints to allow for strenuous
use. Presented by Dr C.P. Newcomb in
1904 to the Royal Botanical Gardens, Kew,
and to the British Museum, 1958.

154

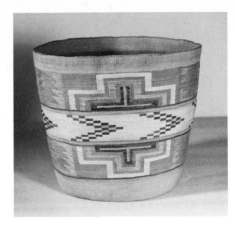

375 **Basket** *c* 1890 AD
Alaska, Tlingit
Spruce root 40.5 cm high
Lent by the Nelson Gallery of Art/Atkins
Museum (Nelson Fund) 33–1322

The Alaskan Tlingit made the most
imposing Northwest Coast baskets with
imbricated (overlaid in embroidery)
abstract patterns upon them, which were
totally different in style from the carvings
and paintings. Note how the centre band,
with its arrow-shaped pattern repeats,
prevents the large cross designs from being
static. This band seems superimposed over
the basket as a separate design layer.

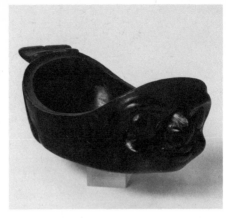

377 **Carved bowl** 18th century
Northwest Coast, Haida
Wood 26 cm long, 13 cm wide
Lent by the Trustees of the British
Museum N.W.C.25

The early collection date proves the
existence of a mature, recognizable Haida
style much earlier than it has generally been
thought to have developed. Presented to the
British Museum by Sir Joseph Banks, May
22 1789.

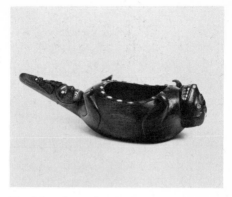

379 **Food bowl** 19th century
Northwest Coast, Haida
Wood, inlaid with haliotis 46 cm long
Lent by the Trustees of the British
Museum 1962.Am.4.1

The composite animal represented in this
bowl has some of the attributes of a beaver
but with a modified tail. On the handle is
carved an eagle and a human face. A.W.F.
Fuller Collection.

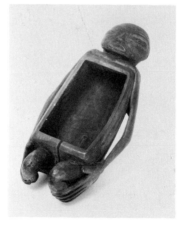

376 **Bowl** 18th century (?)
Northwest Coast, Salish (?)
Wood 8 cm high, 26 cm long, 13 cm wide
Lent by the Trustees of the British
Museum N.W.C.9

This bowl, carved for a potlatch ceremony,
represents a female figure reclining on her
back. Possibly owned by Sir Joseph Banks.

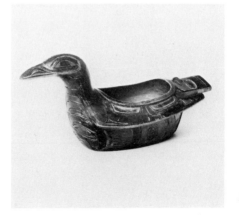

378 **Bowl** 19th century
Northwest Coast, Haida
Painted wood
11 cm high, 25 cm long, 12 cm wide
Lent by the Trustees of the British
Museum N.W.C. 10 & 7843

Represents a duck. Presented by A.W.
Franks May 17 1872 from the Purnell
Collection to the Christy Collection.

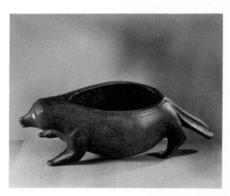

380 **Bowl** *c* 1800 AD
Northwest Coast, Queen Charlotte Island,
Haida
Wood, abalone shell 12.5 cm high, 17.8
cm wide, 48.5 cm deep
Lent by the University Museum,
Philadelphia 45-15-3

This beaver bowl was collected by William
Clark, though the date and location is
unknown. Clark was not only a partner in
the Lewis and Clark expedition which was
the first party to reach the Pacific Ocean
overland (1804–06), but he was also a
Governor of the Missouri Territory from
1813–21 and noted for his fair treatment of
the Indians.

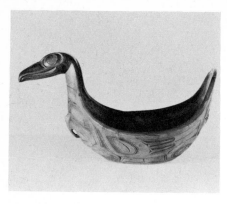

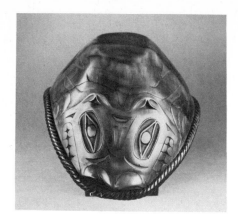

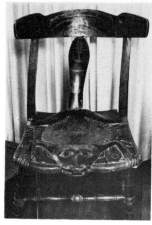

381 Grease dish
Northwest Coast, Queen Charlotte Islands
(Haida)
Mountain sheep horn
11 cm high, 15 cm wide
Lent by the Taylor Museum of the
Colorado Springs Fine Arts Center 4974

Collected at the same time as the food box
(number 368), carved in the form of a
merganser, with a hawk face on the breast
and a bear's image on the tail. Grease was
used as a luxurious condiment at feasts. The
horn was boiled to render it soft and pliable,
then trimmed with a knife and shaped
against a wooden form.

383 Bowl *c* 1880 AD
Alaska, Tlingit
Horn 11 cm high, 24 cm long
Lent by the Nelson Gallery of Art/Atkins
Museum 31-125/35

Made of steam-softened mountain sheep
horn, this elegantly formed and carved
translucent bowl is based on simpler
Athabascan horn prototypes. The rim
design is derived from sailors' rope. Many
such feast bowls were made by the Tlingit,
and some were Athabascan bowls recarved
with animal crests.

384 Chair *c* 1860–1870
Northwest Coast
Wood, paint
83.5 cm high, 42.5 cm wide, 44 cm deep
Private Collection

When auctioned in 1967 at Sotheby's this
chair was described as a recarved European
chair. Actually it was made entirely by an
Indian carver in the manner of a Canadian
chair of the period 1860–1870, with beaver
features conjoined in an extraordinary way
to the form source. The 'European' slat has
become a beaver tail, the seat his back and
head, the leading edge his jaws. The
English splat-backed chair was a product of
trade with China in the first place, and
Northwest Coast design is deeply if
remotely influenced by Asian concepts, so
this chair is the result of a fascinating cross-
cultural reversal, that nonetheless has
allowed the artist more, not less, freedom of
expression over the stereotyped native
backrest.

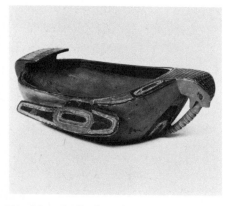

382 Food bowl Early 19th century
Northwest Coast, 'Tlingit-influenced Aleut'
Painted wood 29 cm long, 19 cm wide
Lent by the Trustees of the British
Museum 1680

Carved in the form of a beaver or bird,
painted black, green and red. It can be
directly compared with a skate image bowl
and a bird bowl belonging to the Natural
History Museum in Oldenburg, Germany,
which in turn relate to similar idiosyncratic
dishes at Leningrad, collected at Kodiak
Island after an Aleut population had been
introduced there. (See *The Far North*, page
177.) United Services Museum. Christy
Collection.

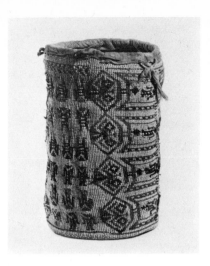

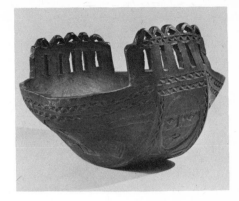

385 Bag Late 19th–early 20th century
Lower Columbia River, Wasco
Basketry 16 cm diameter at base
Lent by the Brooklyn Museum. Gift of Mrs
Frederic B. Pratt 36.499

This twined hemp bag shows the stylized
head designs typical of this tribe's basketry
from pre-contact times onwards. Large
Wasco bags are called sally bags and small
ones usually wallets.

387 Spoon *c* 1800 AD
Washington, Salish, Chinook
Bone 12.5 cm long, 5.5 cm wide
Lent by the Trustees of the British
Museum N.W.C.111

Small bone spoon with serrated edges on
the handle.

389 Two horn bowls *c* 1850 AD
Oregon and Washington, Wishram–Wasco
Sheep horn
a 10 cm high, 16.5 cm wide, 18 cm long (not
illustrated);
b 12.5 cm high, 20.5 cm wide, 18.5 cm long
Lent by Mr and Mrs Morton I. Sosland

The six incised faces in the smaller bowl
bring to mind the pre-historic petroglyph-
pictograph, Tsagaglalal, the huge facial
image painted in red ochre at Long
Narrows. The ribbed figures along the keel
of the larger bowl bear a striking
resemblance to the famous Salish spirit
guardian sculpture, one of the treasures of
the American Museum of Natural History
(see Miguel Covarrubias, page 122). Bowls
of this rare type were made in the
neighbourhood of the Dalles, the eastern
end of the Columbia River Gorge.
Collected by Judge Wickersham.

The Columbia River ribbed figures and
faces, with circled eyes and mouths, clearly
descend from the ancient carved bone
amulets found near Wishram, Washington,
and in the Columbia River Gorge area.
This is an area with a long stylistic history.

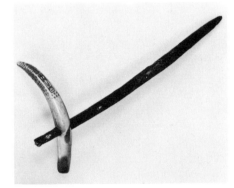

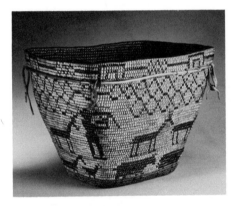

386 Digging stick
Oregon, Chinook (?)
Horn, wood
73.5 cm long (stick), 26 cm long (handle)
Lent by the Oregon Historical Society

The elk horn handle of this object is
beautifully engraved with dot and circle
designs, also found in horn feast dishes of the
Salish tribes of the Northwest. The panel
compares with the Wishram bowls in this
exhibition (number 389) and derives from
the same pre-contact tradition. The lack of
rib marks is a variant seen in Salishan spirit
guardian figures, and the famous spirit
board in the American Museum of Natural
History, New York.

388 Basket 19th century
British Columbia, Chilcooten
Wood, reed
31 cm long, 41 cm wide, 29 cm deep
Lent by the Nelson Gallery of Art/Atkins
Museum (Nelson Fund) 33–1261

Though the shape and appearance of this
container is Salishen it is actually from the
most southern Athabascan tribe. The way
the hunter's gun is bent downwards towards
the deer exhibits a remarkable imagination.

Plains

The Plains Indians:
An Aesthetic of Mobility

The Plains area of North America extends from west of the Mississippi River to the Rocky Mountains, and from the Saskatchewan River in Canada to central Texas. In its early history influences from the Ohio–Mississippi region to the east filtered out onto the Plains creating a modified Woodland culture with pottery, small burial mounds and some agriculture. Contrary to common belief, agriculture was practised on the Plains before horses were possessed, particularly in the region with adequate rainfall. Hopewellian villages have been excavated near Kansas City and as far west as Colorado. After 800 AD these village dwellers were replaced by more stable groups who had migrated from the Mississippian cultures, coming in three stages from the northeast (Sioux), the southeast (Caddoan) and the deep South (Caddoan). By the time of 16th-century European exploration of the Plains (Coronado reached southwestern Kansas in 1541), there were semi-agricultural tribes on the eastern plains and hunters to the west.

Around the upper basin of the Missouri River lived the Blackfoot, a loose confederacy of three tribes. To the east were the Gros Ventre, an Algonquin-speaking tribe with the Assiniboines to the south. The Crows separated from the Dakotas in the eighteenth century and moved west, while in South and North Dakota lived the western Sioux or Tetons, including the Oglala, Hunkpapa, Brule, Miniconjou, Sihasapa, Sans Arch and Two Kettle. To the east were the Santee Sioux, while the Algonquin Cheyennes who had migrated from Minnesota had two branches, with the Algonquin Arapahoes encamped between. Over the southern Plains were bands of Comanches, Kiowas and Apaches, the Kiowas having migrated from the Yellowstone River where they were friends with the Crow. These tribes were always nomadic although the shifting and spreading of their territories was greatly intensified after the introduction of the horse. Late in the seventeenth century the Plateau groups, the Yakimas, Nez Perces and other tribes of the middle Columbia River valley developed a horse culture.

To young people reading the books of the German novelist Karl May, the only Indians were those of the Great Plains and the Plateau region beyond. With their buffalo hunts, horse raids, scalp locks, flying shields and war dances, and above all their action-packed and dangerous way of life, the Plains tribes epitomised the wild Indian. To Europeans these tribes seemed untamed and therefore romantic, but they thought of themselves as hunters, practical men, well adjusted to living in an economy which required small and far flung groupings. 'The Sioux were a systematic people. They were organizers and classifiers. As the universe was intricately patterned into hierarchies and divisions, so was the nation.'[1]

Hunting groups undoubtedly encouraged independence, for no band was tied to a village or to a particular hunting ground. Their home was space, the earth was a total environmental unit. To cope with this freedom there had to be military discipline and leadership, and societies were formed with ceremonies designed to benefit all. The tension between freedom and responsibility led to a need to establish a highly regimented society, which was satisfied by a complicated system of honours and rewards. The beautiful pipes and pipe bags, the horse-hair and scalp-fringed war shirts, the society bundle wrappers and medicine hoops were all symbols of authority and supernatural power; they were embodiments of prestige and responsibility long before they were ever works of art. To the Indian they were evidence of fragile relationships with space, the creator, and with their disciplined world.

For this reason it is not quite fair to refer to Plains 'sculpture', for the whistles (466) and dance stick carvings have a fragmentary, detached, and rough and ready air, as if they could evaporate once their designated purpose was served. They are incomplete symbols. Even the hot file marks stippled on dance sticks are like feathers upon the wood. All animal renderings are flatly generalized as if caught on the move. Indeed, a feather bonnet (431) or dance collar (424) is an extremely fragile, almost evanescent, object. Such art is different from the solidity of Northwest Coast monumental wood sculpture.

Iron Tail, Sioux.
One of Fraser's models for 'buffalo nickel'
Courtesy Colin Taylor

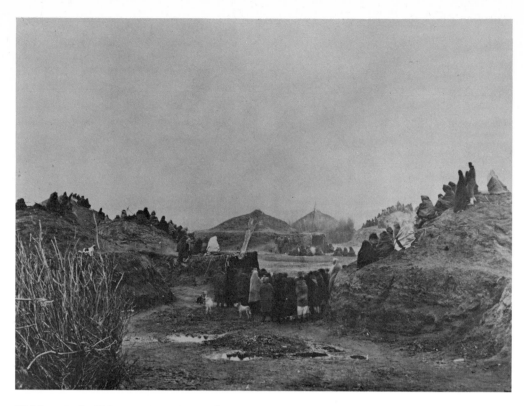

Earthlodge village, Nebraska 1871
Smithsonian Institution

Neither the buffalo nor the white eagle waited around in the living state to be studied. The idea of any object, animate or inanimate, posing is entirely alien to the Plains Indian concept of nature. Nothing was rendered from life but from memory or through mystic communication. Images were painted upon a shirt or dress as though they floated; visions on shields made visible the invisible (515). An entire teepee was a round medicine poem or song. Borders that exist for us with our concepts of artistic propriety were crossed and recrossed without concern, for the projection of ideas into space was paramount and all-encompassing.

The soft leathers and buckskins, the quills and beads, the emphasis upon animal skins in costumes in the 19th century and the elaborate clothing of later days all were agents of artistic dematerialisation. They blend into the landscape unless articulated by quillwork or beadwork. The embodiment of the vision quest so central to the sustenance of Plains spiritual life was steam from the water thrown against the heated rocks of a sweat lodge, not art. The elk horn spoon which flicked the water against the rocks was as transparent as the clouds of steam (451). The spoon was the smallest denominator in the purification rite, the merest intercessionary agent. The compelling grandeur of the concept was in inverse ratio to the modesty of the specific instrument. That is the exquisiteness of Plains art.

The brilliant and explosive presence of the Plains Indian helps create the illusion that he lived a long time on the American steppes, always proud, fierce and warlike. The timelessness exists only in retrospect. Actually their culture exploded, burned brightly like a flame, and then smothered, all in a little more than a century. The earliest Plains dwellers eked out a fragile existence by planting corn, beans, melons and some tobacco in that inhospitable land. The acquisition of the horse and the gun from European traders completely changed the life style of the Plains Indians, making them ultimately the strongest and most mobile group. Until about 1725 when the French began exchanging guns for furs the Sioux were considered by their Minnesota neighbours, especially their kinsmen the Winnebagos, by whom they were constantly molested, as a poor and depressed tribe with only the rudiments of Great Lakes culture. It was not until they were forced out onto the Plains, and certainly not until they adopted the horse culture that they found their own identity, about 1760–70. Likewise the Assiniboine did not move from the Lake of the Woods in Ontario until after 1640, migrating to Saskatchewan and then into upper Wyoming and Montana, while some remained in Canada as 'stony Indians'. The other great Plains tribe, the Blackfoot, were of Algonquin stock, though their speech shows long

acclimatization. Robert Lowie felt that 'the strongest claim for early Plains residence may be made for the eastern Shoshoneans, the Blackfoot, and the Arapaho-Gros Ventre, Kiowa-Apache, Pawnee and some other Caddoans.'[2] The rise of these and the other people who arrived on the Plains was as sudden as their hegemony was short. When the first American army post, Fort Laramie, was built in 1834 on the North Platte River, the Teton Sioux left their old hunting grounds to move closer to the traders.

The horse was brought first into New Spain and then into the Southwest, the original stock probably coming from Hapsburg, Holland.[3] By 1720–30 the horse had reached the Northwestern Plains and Plateau, on both sides of the Rocky Mountains. One of the first Plateau tribes to trade the horse into the area gave its name to the Indian horse, 'Cayuse'. By 1750 the horse was seen in South Dakota and by 1770 among the eastern Sioux. Twenty years later the horse had replaced the dog as the major goods carrier, though both were used in concert until modern times.

A drawing of Crow Indians by Catlin
British Museum

Possession of the horse expanded the domain of the Plains Indian. It fostered a fast new discipline for hunting the buffalo, and encouraged trade trips from far and wide to the fair maintained by the Mandan on the Missouri River, where all manner of goods, including porcupine quills, could be obtained. Encampments could be made further apart, and much greater distances could be covered. The new skill of horseback riding heightened Indian militancy and fostered the system of war honours; it led to new battle and raiding tactics, and was a new test of the physical prowess that was one of the measures of bravery in Plains society. It pitted the Plainsman squarely against his fellows as well as against the buffalo. Inter-tribal warfare began at this time and when threatened by the white man it was difficult for the tribes to overcome old emnities. The army exploited this situation by employing scouts to aid in the defeat of their rivals. With the advent of the horse there grew a welter of different attacking tactics. For example the Comanches of the Southern Plains, who developed the finest light cavalry in the world (with the Sioux in second place), spurned activity of any kind on foot, being 'the only people who staged mounted horse raids, whether after a single pony or an entire remuda.'[4]

The earliest datable Plains artifact is a pictographic robe collected in 1804 by Lewis and Clark, which is now at Harvard University. It describes an inter-tribal battle of 1797 and marks a beginning of our knowledge of Plains art. The early period was recorded by several early 19th-century explorers and their artists, the most famous of whom are Paul Wilhelm, Duke of Wurtemberg; George Catlin, the painter and ethnographer; Prince Maximilian Wied zu Neuwied and his artist Carl Bodmer, and Rudolf Friedrich Kurz, the Swiss diarist. They were there in the halycon days of the 1820s, 30s and 40s. Catlin's is the first description of that mobile art object, a highly decorated Sioux cradle: 'the child in its earliest infancy, has its back lashed to a straight board. . . . In this instance, as is often the case, the bandages that pass around the cradle, holding the child in, are all the way covered with a beautiful embroidery of porcupine quills, with ingenious figures of horses, men, etc. A broad hoop of elastic wood passes around in front of the child's face, to protect it in case of a fall, from the front of which is suspended a little toy of exquisite embroidery, for the child to handle and amuse itself with (actually the child's umbilical cord amulet). To this end other little trinkets hang in front of it, there are attached many little tinselled and tinkling things, of the brightest colours, to amuse both the eyes and ears of the child.'[5]

Francis Parkman, an historian who visited the Rocky Mountains in 1846, vividly recalled the Sioux Strong Heart Society: 'A warlike association . . . with dancers circling round and round the fire, each figure brightly illumined at one moment by the yellow light, and at the next drawn in blackest shadow as it passed between the flame and the spectator. They would imitate with the most ludicrous exactness the motions and voice of their sly patron the fox.'[6] But as an elderly man, Parkman, writing a new preface to his youthful adventures, looked back upon it all as history dead and gone, as if centuries rather than decades had elapsed. 'For Indian tepees, with their trophies of bow, lance, shield, and dangling scalp-locks, we have towns and cities, resorts of health and pleasure seekers, with an agreeable society, Paris fashions, the magazines, the latest poem, and the last novel, . . . The buffalo is gone, and of all his multitudes nothing is left but bones.'[7]

Eastern Sioux costume and wood carving (452) were quasi-Great Lakes in style. In fact floral patterns were transmitted across the Plains as far west as the Blackfeet (448) of Montana and Alberta and then on to the west coast region (196). Early 19th-century

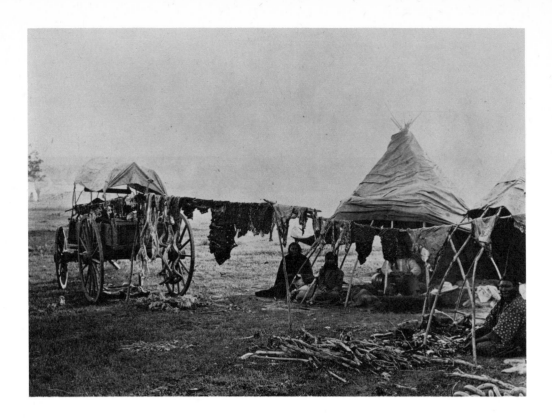

Cheyenne camp 1895
Smithsonian Institution

Plains quillwork (there is precious little of it left) correspondingly felt the influence of the closely spaced and refined Woodlands quill patterns, though the Plains versions were soon unrecognizable as they became more bold and visually oriented (403). Quillwork passed through the stage Catlin described in his passage on the Sioux cradle with harmony in cream, orange, brown and black, through wider spaced designs adding red, green and blue, and finally into the colour field efflorescence of the Reservation period at the close of the century.

Even the ceremonial objects had to be activated to convey their symbolic associations. A fragile birdskin or tiny deer toe rattle withdrawn from the concealment of a medicine bundle had the power to invoke the spirits and space and that which is beyond. The lighter the object the easier it was to handle. Roaches and hair ornaments were light enough to be borne by the wind when worn. Horse hair and thin elk horn plating were legitimate materials for heavy duty. Streamers of eagle feathers and dyed horse tails attached to feather bonnets were transformed by the dancers who wore them, and clothes with flaps and fringes became animated, even animal like, in processions or dances. Dance sticks awaited the articulation of the hands which held them, and even a riding quirt became a notched, modular design progression, stretched outward by the wielder to urge a horse to full speed. Seeing them in movement gave an incredible flamboyance to eagle feathers, crow feathers, trailing green and red felt. Saddle trappings, moccasins and tobacco pouches were made in praise of movement. They were as transportable as a modern wallet or purse, except that they were assigned exceptional significance as emblems of tribal responsibility or ceremonial dignity. Pipebowls with stems were like projectiles, often with feather fans attached. Meat cases (472) were extraordinarily light, considering the importance of what they carried. Sundance images, despite being at the very centre of the Plains ceremonial round, were fragile leather cut-outs (463). The buffalo himself – 'I whose tread makes the earth rumble' – ran across the Indian scene like so many silhouettes in a shooting gallery, waiting to be picked off by bullets or arrows (462). In fact the Great Spirit himself was not depicted. The most sacred objects of all were the elaborate medicine bundles. In Crow society an Indian who had received several dreams or visions, which entitled him to make bundles, would still purchase another bundle from some great medicine man. 'Sometimes, too, the power of a purchased bundle was overshadowed by a later vision, adding still another bundle to the owner's possessions. In such cases the original bundles were usually abandoned, but they were seldom destroyed. So some Indians came to possess a number of

bundles, each differing from the others in its content and, often, also in the purpose for which it was used. This is the principle reason why the number and variety of Crow medicine bundles probably exceeds that of the other Plains tribes.'[8] An example of the outcome of such use is the beautifully quilled bundle wrapper from the Teton Sioux Elk Dreamers' Society with its depiction of an exaggeratedly antlered elk head (469). It was an erotic symbol for the Indians who were guardians of sexual prowess within the society.

The destruction of Plains culture began between 1871 and 1872 when it was discovered simultaneously in Germany, England and the United States that American bison hides were good for tanning fine commercial leathers, while the bones made excellent fertilizer. The senseless slaughter immediately began. Dodge City and Fort Wallace, Kansas, swarmed with professional buffalo hunters, or slaughterers. From there they could reach anywhere in the Plains. In the next two years, railroads shipped over one million three hundred thousand hides east with most of the subsequent booty unrecorded.[9] By the turn of the 1880s buffalo ranks were dangerously thinned; by the middle of the decade they were gone. Chief Sitting Bull said: 'A cold wind blew across the prairie when the last buffalo fell . . . a death wind for my people.'

Crow reservation 1907
Catalogue no 692

After the close of the Civil War, land-hungry Americans wanted their West, and in three decades they swallowed it. It was wrested from the Indians with the utmost disregard for Indian traditions or feelings, and the treaties signed were so numerous that Indian rights today are a monstrous legal tangle. Land and space were bargained away. European-style security seemed bondage to the Plains people. A people who were used to hunting were to become farmers. Even the reserves, which in theory were to be held in perpetuity, were chipped away at for the benefit of the white man. 'When I went to see my grandfather (the U.S. President), he told me I should have my reserves; that I should have fifty miles up and down the Missouri River for fifty years, and that I might become rich and high up; but I am like one on a high snow bank; the sun shines continually and melts it away, and it keeps going down until there is nothing left.'[10] It was a bitter time. 'But there are many things you have said to me which I do not like,' said a Comanche chief to the Indian commissioner in 1867 'they were not sweet like sugar, but bitter like gourds. You said you wanted to put us on a reservation, to build our houses and make us medicine lodges. I do not want them. I was born upon the prairie where the free wind blew and there was nothing to break the light of the sun.'[11] The wily Oglala Sioux statesman, Red Cloud, even addressed his protests to New Yorkers at Cooper Union to a standing ovation. He knew how to keep the commissioners on tenterhooks and forced them to back down on the location of the Oglala agency. He won a battle but the war was lost.[12]

In spite of the general similarities between the tribes of the Plains, the decorative work of each group was distinctive, although the identifiable patterns and colours changed periodically with the assimilation of the traditional designs of other tribes and the impact of trade goods. On the Northern Plains it was the Western Sioux who developed the widely spaced designs of abstract triangles, boxes, and stepped lines against blue or white fields of beads. Further west the aggressive Blackfoot decorated their war shirts with bold checkerboard patterns during the 1860s and 1870s. Red felt was also used for the backgrounds of horse paraphernalia, the multicoloured martingales, pommel ornaments and cruppers. At this stage the designs are understated and all depends on the innate character of the natural materials, the horse hair and weasel fringes, the fine grained buckskin texture and the finely translucent sheen of naturally dyed quills. During the Reservation period, after 1875, some of the finest beadwork was done by the Crow and Blackfoot. The Blackfoot specialized in dresses and capes with strongly contrasted bands, carried from shoulder to shoulder, while the Crow embellished their horse trappings with white beaded lines against bright blue, yellow, red and green hour-glass and triangular figures.

Some of the late Sioux, Crow and Blackfoot costumes were applied to cloth rather than buckskin or cowhide, with the beadwork fields invading the entire garment, occasionally spreading symmetrically on four sides as in (429). Capes and small shirts were made to put over European clothing until eventually the entire space was invaded by elaborate decorations. In retrospect this Reservation period style appears as a valiant re-assertion of Indian taste, that refused to subside in the face of forced acculturation.

The culmination of Plains art might be painted buffalo robes which were produced by all of the tribes. They were the ultimate form of imagery upon which tribal aspirations, tribal lore, and personal aggrandizement could all be concentrated. In general, pictographic designs were the work of men boasting about their exploits, and there was a strong element of competition behind the urge to paint these robes. Quilled or painted abstract designs were generally by women. The Plains ethnologist John C. Ewers has postulated a late 18th-century–early 19th-century style, here called the 'stick' style because of its angularity, that was altered almost immediately upon European contact in the 1830s.[13] There is a vigour of style in stick style depictions that seems to derive from rock art pictographs. Notre Dame University has lent an unpublished robe painted in this early style (509), perhaps lightly softened; and from the Linden Museum, Stuttgart, come the earliest known geometric painted robes, collected by Prince Maximilian zu Wied Neuwied in 1832, with striking red and black box-in border devices that have been called earth symbols (508). A robe from Copenhagen shows the introduction of pony bead accents during the 1840s (511); and there is also a luxurious buffalo robe that once belonged to Chief Sitting Bull (512). How much more consciously artistic these robes became across the years is demonstrated by the Southwestern Plains (Ute?) robe which harmoniously combines a concentric design with pictographic horses and riders (488). When trade muslin came to be substituted for hide, the pictographic technique became more lively and anecdotal than ever, quite altered from the stiff and remote stick style. I would postulate a transitional phase for the mid part of the century and a 'loose' style for muslin days. The Kiowa artist Silverhorns, who began as a ledger book artist with a spontaneous, untaught style, drew honest and worthy images on paper in the 1880s and 90s. It is sad to record that he ended as a souvenir artist who squandered the old Plains pride in a dashing line.[14]

On the Southern Plains the Cheyenne in the middle of the century specialized in beadwork borders with feather patterns that predicted what would shortly spread to the whole area. From the Vonbank collection come a number of tobacco bags decorated with the characteristic Cheyenne harmonies of blue, black and white. The work of the Kiowa and Comanche, living in Oklahoma and Texas, stressed border beading, bands of green, yellow and red with the over-all colour a particular mustard yellow. The Kiowa hand drum depicting a brave raising his bow at a buffalo shows this colour preference (518) as well as suggesting the confidence the Indians had at this time in a plentiful supply of buffalo.

Plateau Indian art by Yakima, Nez Perce, and Bannock tribes in Idaho and Washington State was much influenced by Western Plains art, that of the Crow and Blackfoot in particular. Their designs, however, tend to be less strict, and the beadwork harmonies less coherent, though they are often appealing, with a bright and wild effect, sometimes not unlike a crazy quilt. The Nez Perce made woven hats that relate to the Californian style rather than to the Plains (487), and a Yakima trade blanket exhibited here with beaded roundel and strip, shows ladder-like patterns in the roundel, which are derived from neighbouring west coast Salishan basketry (373).

Twentieth century Plains art is not dead, even now, despite the abundance of work produced for the tourist trade. The elaborate pictorially beaded dress with its marvellous framed panels across the shoulders depicting birds (430), is a notable case in point. It dates from about the time of World War One. Only last year was shown a man's burial outfit mounted on commercial cowhide. It was from the Three Peoples Reservation at Fort Berthold, North Dakota, and was made for an errant husband to be buried in, with carefully executed and tightly stitched floral patterns on a sulphurous yellow ground with a crystalline optical effect, 'two years of work'. Though recently completed it would cost even more than an old ethnological object, and therein lies the problem of keeping this mobile art alive: when well done, and elaborate, the work takes so long to do that it becomes completely uneconomic.

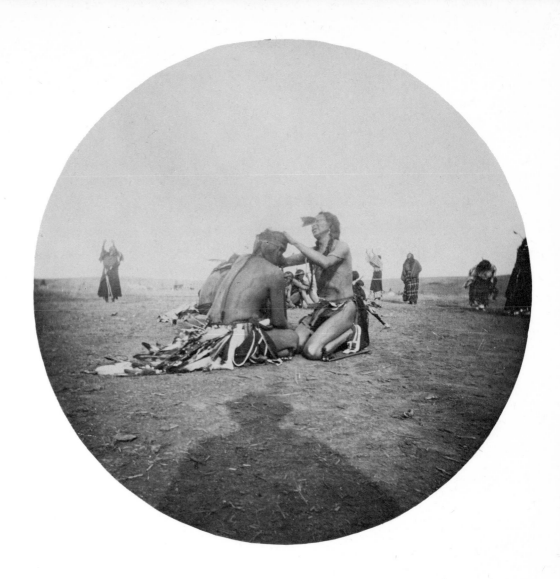

The ghost dance: Praying
Smithsonian Institution

Notes

1 Royal B. Hassrick. *The Sioux, Life and Customs of a Warrior Society*, Norman, University of Oklahoma Press, 1964, page 30.

2 Robert H. Lowie, *Indians of the Plains, Anthropological Handbook No. 1*, American Museum of Natural History, New York, McGraw-Hill Book Company, Inc., 1954, page 193.

3 Frank Gilbert Roe, page 154.

4 T. R. Fehrenbach. *Commanches, the Destruction of a People*, New York, Alfred Knopf, 1974, page 126.

5 George Catlin, Vol. II, 1841, page 132.

6 Francis Parkman. *The Oregon Trail*, New York, Rinehart & Co., 1931, pages 299–300.

7 Francis Parkman, page xiii.

8 William Wildschut (edited by John C. Ewers). *Crow Medicine Bundles*, Contributions from the Museum of the American Indian, Heye Foundation, New York, 1975 (manuscript written in 1927, published first 1960), Vol. XVII, page 13.

9 David A. Dary. *The Buffalo Book, the Full Saga of the American Animal*, Chicago, The Swallow Press, Inc., 1974, page 96.

10 Testimony of Palaneapope (Yankton Sioux), *Great Documents in American Indian History*, page 195.

11 Speech by Ten Bears (Comanche), *Great Documents in American Indian History*, page 195.

12 A classic account of Red Cloud's Cooper Union speech is written in James C. Olson. *Red Cloud and the Sioux Problem*, Lincoln, University of Nebraska Press, 1975 (published 1965), pages 110–113 and Chapter 8.

13 John C. Ewers. *Indian Life of the Upper Missouri*, Norman, University of Oklahoma Press, 1968, Part II, Chapter 8.

14 Oscar Brouse Jacobson. *Sioux Indian Painting*, Nice, C. Szwedzicki, 1929, Plate 24.

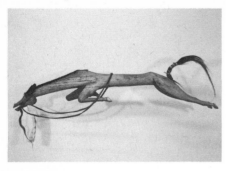

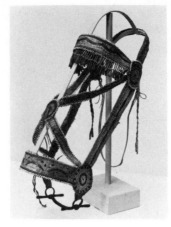

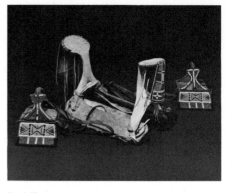

390 **Horse effigy**
North and South Dakota, Sioux
Wood, leather, horsehair, paint
95 cm long, 27 cm high, 14 cm wide
Lent by the Robinson Museum, Pierre,
South Dakota

This carved wounded horse is unique in
Plains art and is a masterpiece of Sioux
horse sculpture. No other complete
equestrian sculpture is known to exist. Its
leaping profile and narrow width lend a
supernatural quality; the tail of horsehair
and the sweep of the leather reins provide a
relief to the forward movement.

The style is a development of the horse
dance stick, here joined to a type of
contouring often encountered in painted
and drawn horses in ledger books and hide
paintings. Quite possibly this sculpture was
used in a Victory Dance, for it seems to
illustrate Chief Luther Standing Bear's
description in *My People the Sioux* (Boston
and New York, Houghton Mifflin Co.,
1928, page 57): 'If a horse had been
wounded, the animal was brought into the
dance and painted where it had been struck
by a bullet. Even the horses received praise
for the part they had taken in battle.'

It was collected by Mary C. Collins
(1846–1920), a missionary at Little Eagle
Station, Grand River, Standing Rock
Reservation, between 1884 and 1910.
Although it is not known how she came into
possession of this horse, she was a friend to
the Indian and counselled Sitting Bull to go
to Fort Yates to stop the Ghost Dancing
before many Indians were killed. Her
homaeopathic remedies gave her some
standing as a medicine woman.

391 **Headstall** Before 1854 AD
Northern Plains, Blackfoot
Hide
Lent by the National Museum of Denmark,
Department of Ethnography Hb 124

There is a simplicity in the design of this
headstall, with its broad, undulating quilled
strips, which is missing in the more
elaborate horse trappings produced in the
Reservation period.

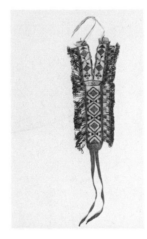

392 **Horse crupper** *c* 1830 AD
Plains, probably Cree
Buckskin, quillwork 46 cm long
Lent by C.F. Taylor Collection, Hastings

Cruppers were attached to the back of the
saddle and looped under the horse's tail.
The design, as in most early Cree quillwork,
is geometric.

393 **Saddle**
Wyoming, Crow
Buckskin, beads, wood frame
40 cm high, 29 cm wide, 66 cm long
Lent by the American Museum of Natural
History 50/2422a–c

This is a woman's saddle. The beaded flaps
on the front and rear pommels and on the
stirrups are typically Crow. They were
made near the Wind River in Shoshone
territory. Crow Reservation period horse
trappings were the most elaborate on the
Plains. Collected 1901.

394 **Headstall (bridle)** Early 19th century
Northern Plains, possibly Cree
Buckskin, quillwork 40 cm long
Lent by C. F. Taylor Collection, Hastings

This headstall with quill wrapped rosettes
and looped fringe was attached to the front
of the bridle. Some of the best Cree
quillwork was done during the period
1820–1860 by Cree women married to
white trappers and fur traders.

395 **Horse collar** *c* 1885 AD
Montana, Crow
Leather, cloth, beads
96.5 cm high, 53 cm wide
Lent by the Denver Art Museum BCr–8

Used as part of festival horse trappings on
womens' horses. Crow horse equipment was
the most elaborately beaded on the Plains,
reaching its most showy stage between 1880
and 1910. The leather is native tanned
buffalo; the cloth is strouding.

397 **Riding quirt** *c* 1865–1875
Wyoming, Arapaho
Elk horn 50 cm long (excluding thong
handle), 6 cm wide
Lent by Mr and Mrs Rex Arrowsmith

Incised designs on this elkhorn quirt show
two warriors and a maiden with braids. The
thongs for whipping the horse are missing.

399 **Riding quirt** *c* 1885 AD
Montana, Crow
Wood, tacks, leather 1.16 m long
(including lash)
Lent by the Chandler–Pohrt Collection

A similar Crow quirt is illustrated in the
book by Benjamin Capps, page 58, with the
leather handle missing in this example.

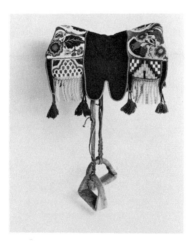

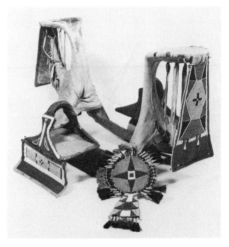

396 **Woman's ceremonial saddle** *c* 1900 AD
Northern Plains, Blackfoot
Hide, beads, wool 43 cm long
Lent by the Trustees of the British Museum
1949.Am.23.1

The design motifs formed with pony beads
and wool tassels show the influence of the
Woodlands style. The checkerboard
hassock patterns are bolder and more
typical of Blackfoot designs.
A. W. F. Fuller Collection.

398 **Woman's saddle with stirrups
and horse head ornament**
Late 19th century
Northern Plains, Crow
Wood, rawhide, buckskin, hair, beads
Saddle 41 cm high, stirrups 24 cm long,
head ornament 25 cm long
Lent by C.F. Taylor Collection, Hastings

Typical Crow white-outlined beaded stitch
and design. The saddle is constructed of
wood, covered with rawhide. The pommel
and cantle are decorated with deerhide
drops. The stirrups are of the same
construction. The head ornament is
rawhide decorated in multicoloured
beadwork and fringed in black horse hair.
These saddles were used by wives of wealthy
Crow warriors. Such regalia is still used in
ceremonies by Crow women. Collected by
Charles Schreyvogel in 1882 (not the horse
head ornament).

400 **Coup stick** 19th century
Northern Plains, Blackfoot
Buckskin, feathers, wood 54 cm long
Lent by the Trustees of the British
Museum 1903–81

The weight is in the shape of a compressed
sphere, covered with red buckskin;
ornamented with red, blue and yellow
beads in cruciform pattern, fringed with
feathers, connected by blue buckskin with
wooden handle covered with red buckskin.
The woven flap which fastens around the
wrist is covered with a lozenge pattern in
blue and white. Formerly the property of
Standing Alone. Purchased by the Christy
Fund from The Freeman Collection, May
14 1903.

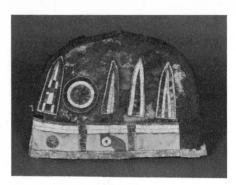

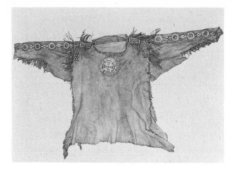

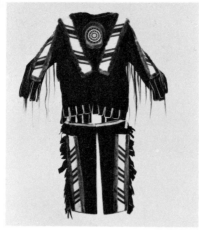

401 Hat Early 19th century
Canada, Cree or Blackfoot
Skin, calico, felt, quills
19 cm diameter, 56 cm at bottom
Lent by the Manitoba Museum of Man and
Nature H4.4.8

Caps like this are not described in the
anthropological literature, according to the
Manitoba Museum of Man; it derives
perhaps from the hoods worn by the Plains
Cree. It was collected between 1846 and
1848 by the artist Paul Kane, who gave it to
his benefactor, G.W. Allan, of Toronto, and
in turn to his grand-daughter, Mrs Ralph
D. Baker, who presented it to the Manitoba
Museum of Man.

403 Shirt *c* 1860–1870 AD
Northern Plains, Crow or Blackfoot
Hide
91.5 cm long, 53.5 cm across shoulders
Lent by the Royal Scottish
Museum UC 315

The repetition of the circle or target motif
across the shoulder line does not detract
from the centre roundel which has
directional cross symbols; however this
complexity marks the beginning of a more
'baroque' tendency in shirt decoration.

405 Coat and leggings 19th century
Woodlands
Cloth, beads, fur
Coat: 88 cm long, 1.56 m wide;
leggings: 72 cm long
Lent by the Trustees of the British
Museum Q72.Am.17

Decorated with panels of white beadwork
with stripes and kites in yellow, blue and
green; beadwork enclosed in rodent fur
strips. Though recorded as Woodlands,
probably from the Canadian Blackfoot with
Plains target and beaded stripe designs.

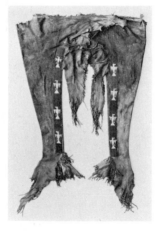

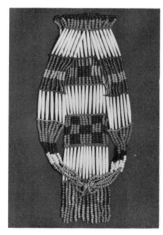

402 Shirt and leggings *c* 1860–1870 AD
Northern Plains, Blackfoot
Elk skin 1.07 m long
Lent by the National Museum of Denmark,
Department of Ethnography H 3458 A-B,
Hc 323

The beaded strips on this pre-Reservation
piece show eight thunderbirds.

404 Neck ornament Late 19th century
Northern Plains, Blackfoot
Bone, beads, leather 1.27 m long
Lent by the Trustees of the British
Museum 1903–48

This ornament was made from small pieces
of hand-drilled polished bone, circular in
section, arranged in groups of seven,
parallel, with large glass beads. The beads
are separated from the bones by transverse
strips of leather. While men's hair pipe
ornaments extended laterally across the
chest (see number 426), the womens' Plains
regalia hung from the shoulders, joining
beneath the bustline. Formerly the property
of Weasel Moccasin. Freeman Collection,
purchased through the Christy Fund.

406 Woman's garters Late 19th century
Northern Plains, Blackfoot
Beads, hide, cloth
35 cm long, 23.5 cm wide
Lent by the Trustees of the British
Museum 1903–47

Formerly belonging to Berry Child these
garters are decorated with pony beads.
Freeman Collection purchased through
Christy Fund.

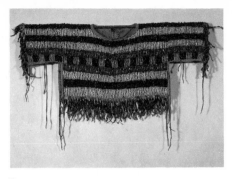

407 Dance cape *c* 1900 AD
Northern Plains, Blackfoot
Cloth, beads 30.5 cm high, 59 cm wide
Private Collection

The strong horizontal multiple beaded
design is typically Blackfoot. These tubular
beads came from Czechoslovakia.

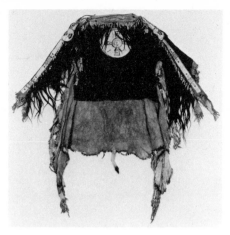

409 Shirt and leggings *c* 1840 AD
Northern Plains, Hidatsa or Mandan
Hide 1.42 m high, 56 cm wide
Leggings 1.50 m long
Lent by the Royal Scottish
Museum 402/1 & A

The horizontal marks on the leggings
indicate raids, while the hair-fringes denote
honour. Such an outfit demonstrated the
owner's bravery.

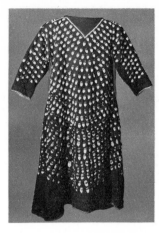

411 Dress Late 19th century
Northern Plains, Crow (?)
Cloth 1.26 m long, 1.28 m wide at sleeves
Lent by the Trustees of the British
Museum 1930–20

Dress of blue cloth trimmed with red cloth.
Decorated with lines of white pony beads
between the two colours at the neck and
shoulders. Sewn with cotton. Decorated
with elk teeth, some real, some of bone.
Previously owned by Mr L.C. Clarke
F.S.A.

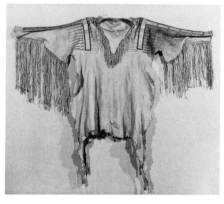

408 Shirt *c* 1835 AD
Middle Missouri River, Mandan (?)
Deer skin, beads, paint, quills
85 cm high, 1.56 m wide
Lent by the Chandler–Pohrt Collection

This handsome shirt is decorated with blue
and white pony beads and has painted on it
36 tobacco pipes and 28 human figures in
the shape of a medicine coup stick (see
number 467). The yellow quilled panels are
little faded, despite the shirt's age. Collected
by Stephen Gale, a prominent early
Chicagoan.

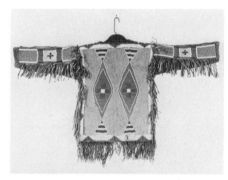

410 Shirt *c* 1885–1890 AD
Montana, Crow
Beads, buckskin, cotton
42 cm high, 77 cm wide (across sleeves)
Lent by the Nelson Gallery of Art/Atkins
Museum (Gift of Mr Daniel R. Anthony
III, and Mrs Eleanor Anthony Tenney)
50–73/46

This shirt for a child has the strong colour
typical of Crow beadwork design as it
became formalized during the Reservation
period. It is distinguished by a bright blue
field with green, red, blue and yellow sub
areas, edged in white. Design concerns
engulf the textile.

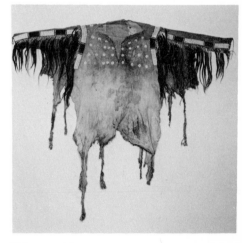

412 Shirt *c* 1860 AD
Wyoming, Cheyenne
Buckskin, buffalo, leather, beads, scalp
locks, quills 1.37 m wide across shoulders
Lent by Hermann Vonbank 67/47

Made of soft antelope skin, the upper field
was originally black but has been bleached.
Shoulder and sleeve panels are of white and
black lazy-stitched seed beads from which
dark brown scalp locks and orange coloured
bunches of horse hair are suspended. These
are sinew wrapped and decorated with
white quills.

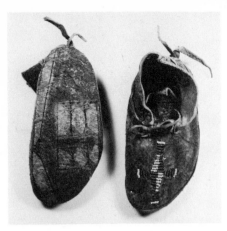

413 Child's moccasins *c* 1870 AD
Wyoming, Cheyenne
Buckskin, beads 11 cm long
Lent by Hermann Vonbank 65/25

Uppers of smoked buckskin with soles
fashioned from an old parfleche. Soles
usually have the tough hair side turned
outward, but this has been reversed here to
display the parfleche pattern.

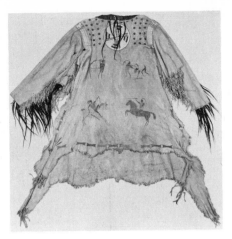

415 Shirt Before 1838 AD
Northern Plains, Yankton Sioux
Buckskin
1.34 m long, 51 cm across shoulders
Lent by the Royal Scottish
Museum 1942.1

This shirt depicts the exploits of its owner,
Wanata, on the front and back. The
painting is in the stick style: for the last
stage of this type of narrative picture
decoration see the drawing on number 422.

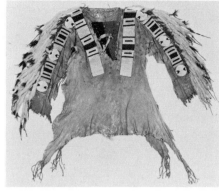

417 Shirt and leggings Late 1870s AD
Northern Plains, Sioux
Buckskin
Shirt: 1.19 m long, 45 cm wide;
leggings: 1.19 m long, 28 cm wide
Lent by the Royal Scottish
Museum 1895–337 & A

The roundel patterns, which were dominant
in early Sioux costumes with quillwork
decoration, are here partially absorbed by
the over-all geometric rhythm of the beaded
bars and boxes. In later work the geometry
became more complex and linear and the
roundels disappeared, except on blanket
strips.

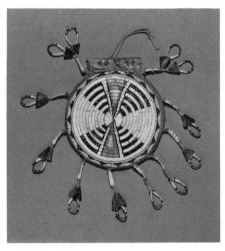

414 Pouch *c* 1870–1875 AD
Wyoming, Arapaho
Buckskin, quills, claws 14.5 cm diameter
Lent by the American Museum of Natural
History 50.1/1327

A refined adaptation of the target design
found on shirts in the Central and Western
Plains (see numbers 403, 419). Collected
before 1910.

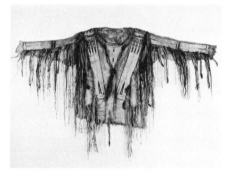

416 Shirt *c* 1870 AD
North and South Dakota, Sioux
Buckskin, ermine tails
62 cm high, 1.41 m wide
Lent by the Linden Museum 113.245

This shirt once belonged to the famous
'Western' artist Charles Schreyvogel
(1861–1912).

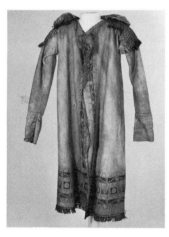

418 Woman's dress Late 19th century
Northern Plains
Skin 1.33 m long, 1.88 m wide
Lent by the Trustees of the British
Museum 1949.Am.22.175

Woman's dress ornamented with a painted
design in red and grey and with quillwork
ornament in black, blue, green, white and
yellow. Oldman Collection.

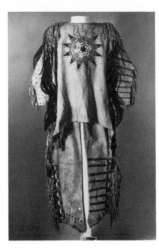

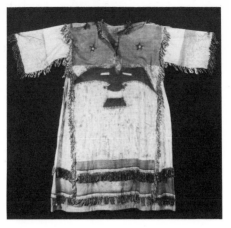

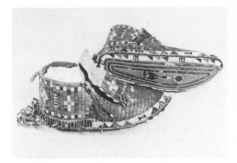

419 Warrior's costume 19th century
Northern Plains, Sioux
Hide, quill, horsehair
1.60 m across shoulders, 2.60 m long
Lent by the Trustees of the British Museum

The leggings and shirt are decorated with red and blue quillwork, the shoulders fringed with horsehair. Such shirts are thought to have protected the warrior in battle. Christy Collection, acquired from Mr Jeffs, 1893.

421 Ghost dance dress *c* 1890 AD
North and South Dakota, Sioux
Muslin, paint 1.39 m high, 1.46 m wide
Lent by the Linden Museum 56.091

The adherents of the Ghost religion, started by the Nevada Paiute seer Wovoka, predicted the extermination of the white man and the resurgence of the disappearing buffalo. It spread like wildfire to the Plains and reached its height in 1890. The massacre of 127 members of a Teton Sioux band by the United States military was the result of one militant Ghost dance. Wounded Knee marked the end of Ghost dance risings, except for occasional incidents. The Sioux in particular developed a Ghost shirt that was believed impervious to bullets, and Ghost dresses of a new type with eagle and star visionary symbols. This dress belonged to E.W. Lenders, then Carl Graf von Linden and has been in the Linden Museum since April 26 1905, about 15 years after it was made for an Oglala Sioux woman.

423 Moccasins Early 1890s AD
North and South Dakota, Sioux
Buckskin, quills, beads, metal
11 cm high, 26 cm long
Lent by the Saint Joseph
Museum 143/3137

Very elaborately worked moccasins, with feathered circle bead designs on the soles, metal cones around the lower heels, and syncopated cross patterns on the red field. It is quillwork of a quality rarely seen in Reservation period work. It is closely allied in feeling to the pipe bag (number 506) which may be by the same artist. 'Burial' moccasins were beaded on the soles and used in the womens' adoption ceremony. Many surviving pairs were never buried, but were evidence of wealth and prestige. Harry L. George Collection, collected about 1900.

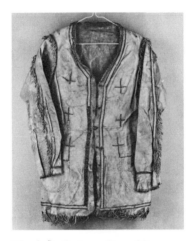

420 Man's jacket *c* 1875–1880 AD
Northern Plains, Sioux
Buckskin
Lent by Conception Abbey (Benedictine), Missouri

From the eastern Sioux, tailored in European style. The cross designs may indicate Christian conversion, but this is not clear as they could also have been included as medicine (a power), or simply made for presentation to a Catholic Father, who sent the piece on to Conception Abbey, the headquarters for the Fort Yates Indian Mission.

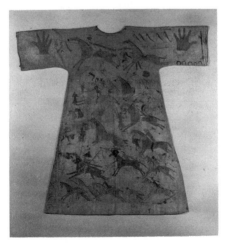

422 Woman's dress *c* 1890 AD
North and South Dakota, Sioux
Muslin
Lent by Conception Abbey (Benedictine), Missouri

The characteristic pictorial style of the Early Reservation Period has been applied to a dress made of trade muslin.

424 Dance collar *c* 1875–1880 AD
North and South Dakota, Sioux
Horse hide, quills, mirrors, tin, feathers
88 cm long, 28.5 cm wide (not including feather fringe)
Private Collection

Used in the grass dance which the Sioux obtained from the Omaha tribe. Modern versions of this type of collar can be seen today at social dances. The sharp colour differentiation indicates horse hide was used for the field; later on cow hide was used. The earliest dance collars were made of otter fur.

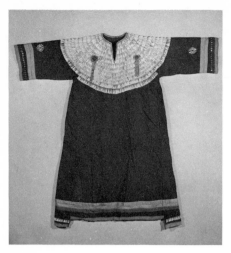

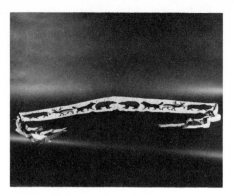

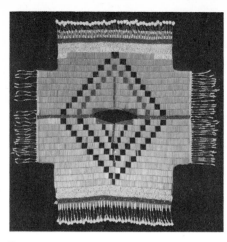

425 Dress
North and South Dakota, Sioux
Trade cloth, dentalium shells, ribbon, trade
mirrors 1.37 m high, 1.42 m wide (across
shoulders)
Lent by Conception Abbey (Benedictine),
Missouri

An elaborate, showy dress of a type worn by
the Sioux women in the 1880s and 1890s.
The twelve rows of collar shells were traded
from the west coast. The ribbon appliqué
borders show Great Lakes influence (see
number 131). Possibly collected at Fort
Yates, North Dakota, where Conception
Abbey had its mission.

427 Belt or sash *c* 1880–1885 AD
Western Plains, tribe uncertain
Beads, buckskin 10.5 cm high, 1.90 m
long (including ribbons)
Lent by Mr and Mrs Rex Arrowsmith

Two bears, two wolves, two elk and two
buffalo advance and retreat across the
striking white field of this sash.

429 Dance cape *c* 1900 AD
Manitoba, Plains Cree (?)
Beads, canvas 20.5 cm high, 40.5 cm wide
Lent by the Hudson's Bay Company
Historical Collection, Lower Fort Garry
National Historic Park

This cape was worn over a shirt on festive
occasions. The silver tubular beads, with the
white, red and black, form an all-over
pattern when spread out flat, so the design
was not frontal as it was in many Plains
dance capes of this period.

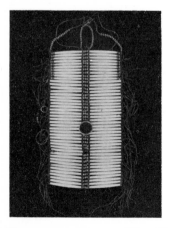

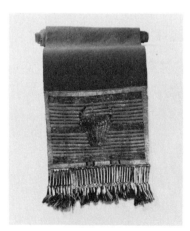

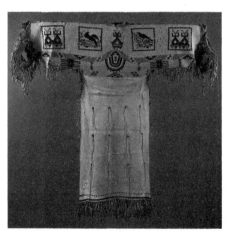

426 Breast ornament *c* 1880–1885 AD
Northern Plains, Sioux
Bone, glass, brass 43.5 cm long
Lent by the Trustees of the British
Museum 1938.3–11.1

Between each pair of 'hair-pipe' beads are
three brass beads. A European pocket
mirror is attached to the centre of the breast
plate and at one side is a brass ring with the
gem removed.

428 Breech cloth Late 19th–early 20th
century
Northern Plains, probably Sioux
Flannel 1.45 m long, 31 cm wide
Lent by the Brooklyn Museum. Henry L.
Batterman Fund 46.78.2

The breech cloth decoration depicts a
bison.

430 Dress *c* 1914 AD
North and South Dakota, Sioux
Deerskin, glass beads, metal beads, sequins
1.32 m high, 1.55 m wide (across sleeves)
Montana Private Collection

This dress shows how complex and
elaborate Sioux beadwork became just
before the modern period. The images on
the shoulder panels are sub-divided into six
shades of blue, five shades of green, four
shades of red, yellow, brown, pink, madder,
orange, purple, black and variegated white
beads.

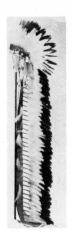
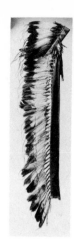
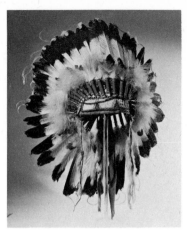
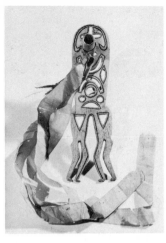

431 Warbonnet *c* 1880 AD
Northern Plains, Oglala Sioux
Buckskin, feathers, tradecloth
2.18 m total length
Lent by C.F. Taylor Collection, Hastings

Warbonnets had a highly symbolic
meaning. Traditionally, each feather
represented a brave exploit, not necessarily
of the wearer, but of the tribe itself. A
warbonnet may also represent the council
fire, each feather signifying a member of the
council with the horsehair tips being the
scalplocks of each warrior. The central
plume represents the owner of the bonnet.
The feathers are from the Golden Eagle, the
sidedrops are ermine, the front band is of
seed beads on hide. This bonnet belonged to
Cinte Mazza (Iron Tail, 1847–1916). He
worked for Buffalo Bill's Rodeo for many
years.

432 Headdress Late 19th century
Montana, Cheyenne
Feathers, cloth, ribbon, beads
1.78 m long
Lent by the Nelson Gallery of Art/Atkins
Museum (Nelson Fund) 31–125/38

The beaded brow band has green, diamond
shaped patterns with red and blue edging
on a yellow ground. A gathering of cut
feathers distinguishes the interior of the
crown. The trailer has forty eagle feathers.
From Lamedeor, Montana.

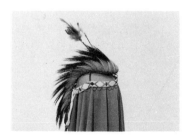

433 Roach
Plains, Ojibway (Saulteaux)
Cotton string base, deer hair, porcupine
hair 32 cm high, 9 cm wide, 33 cm deep
Lent by the National Museum of Man,
National Museums of Canada, Ottawa
V–F–71

434 Warbonnet 20th century
Northwestern Plains, Arapaho
Feathers 76 cm long
Lent by the Trustees of the British
Museum 1939.Am.22.1

This warbonnet was collected in 1927 from
Yellow Calf, the last chief of the Arapaho,
who died in 1938. Presented by G.M.
Mathews.

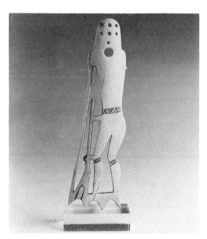

435 Roach spreader *c* 1850–1860 AD
Upper Missouri River
Elk horn 20.5 cm long, 5.5 cm wide
Lent by Mr James Economos

There is no specific data on this
unpublished piece. It has been turned into a
two-dimensional figure with great
ingenuity, marking a high point in this form
of sculpture. The figure appears to be
holding a Kentucky rifle.

436 Roach spreader Early 19th century
Minnesota, Santee Sioux
Elkhorn 15.5 cm long
Lent by the Brooklyn Museum 50.67.163

Roach spreaders are worn to splay outward
roach headdresses. Norman Feder has
demonstrated that old spreaders were made
of thin plates of elkhorn which took a high
polish, and has isolated an Osage type
(downward sloping front) and a Missouri
type (Mandan, Hidatsa, etc.) with the
upright feather socket cut off at an angle,
not straight as here. The feather socket was
used to mount a feather plume which
pivoted. Socket cylinders of bone were
usually canine femora. The round hole
behind the scalp lock is for attachment of
the roach and spreader to the wearer's
head. It was only after the Osage removal
to Oklahoma in 1872 that elkhorn was
abandoned in favour of materials such as
leather (or even plastic) and head ties
became fashionable. Feder found 37
elkhorn spreaders in American museums:
'undoubtedly many more hidden
away . . . will eventually come to light'.
(See Norman Feder, *Elk Antler Roach
Spreaders*.) It was collected by Dr Nathan
Sturgis Jarvis, who was stationed at Fort
Snellings as an army surgeon from 1833 to
1836 and is the best documented object of
its type. An even more elegantly carved
figure spreader, probably also eastern Sioux
and also early has come to light (see
number 435) bearing out Feder's
contention. When worn, spreaders were
mostly concealed by the headdress and
plume; art that concealed art, for as
adornment they ranked high.

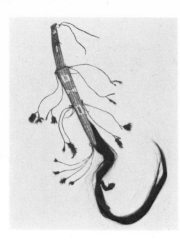

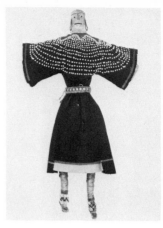

437 Head ornament 19th century
Northern Plains, Cree (?)
Quilled horsehair 1.25 m long, 6 cm wide
Lent by the Royal Scottish
Museum 1890.485

Quills, hair and attachments made this
ornament feather light.

439 Two mirrors *c* 1900 AD
Montana, Assiniboine
Wood, paint, mirror, clock gears
a 37.5 cm high, 24 cm wide
b 46 cm high, 21 cm wide
Lent by the American Museum of Natural
History 50/1970, 50/1967

Both of these brightly coloured mirror cases
were collected from the Assiniboine in 1901.
a is anthropomorphic, and *b* is decorated
with clock gears, an example of adaptation
of alien materials to Indian taste. These
mirrors were used in dances, but no
information exists as to particular use. They
are by the same artist.

441 Doll *c* 1870
Montana, Crow
Sacking, buckskin, beads, cloth, leather
57 cm high
Lent by Hermann Vonbank 56/2

The body of this large doll is of stuffed flour
sacking. The head is buckskin, and the face
is stitched with white and dark blue seed
beads. The belt is commercial leather, inset
with brass tacks. Moccasins of buckskin
with seed beads. Sinew and cotton fibre
sewn.

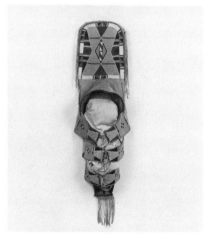

438 Ornament Early 19th century
Northern Plains, Blackfoot or Cree
Hide, quill, moosehair, beads 8 cm long
Lent by the Trustees of the British
Museum 2598

The ornament is decorated with moosehair,
dyed crimson and yellow, and a few tassels
of hair hung with copper cones and pony
beads.

440 Teepee model *c* 1875 AD
Montana, Blackfoot
Hide, beads, quills
61 cm high, 1.09 m long
(displayed opened and flattened)
Private Collection

The Blackfoot believed deeply in celestial
deities, the sun and his wife, the moon. The
moon is repeatedly represented by yellow
circles in blue triangles along the bottom of
this model. Above a three-striped rainbow,
sun symbols create a yellow light, the beam
of which bisects the centre field. To the left
is the owner's personal dream vision.
Models were made both for children and for
sale.

442 Cradle board *c* 1900 AD
Montana, Crow
Wood, canvas, leather, beads
1.02 m high, 29.5 cm wide
Lent by the Denver Art Museum BCr–40

One of the finest Crow beaded cradles. It
represents the height of interlocking X-
diagonal, triangular cross and geometric
design as interpreted by the Crow of the
Reservation period. The multiple, cross-over
beaded flaps are typical of the Crow as is
the white bead outlining, here exceptionally
controlled and thin, as if drawn by a pen.
See the discussion of Crow cradles, William
Wildschut and John C. Ewers, *Crow Indian
Beadwork*, pages 33–35. Formerly L.D. Bax
Collection

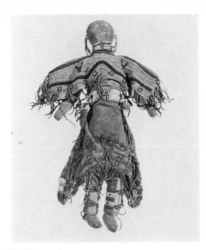

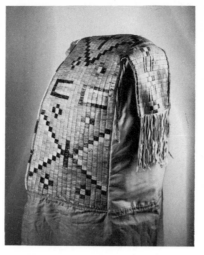

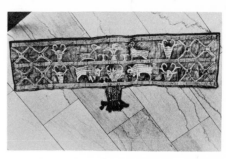

447 Quill work panel *c* 1840–1860 AD
North and South Dakota, Sioux
Quill, leather, cotton
26.8 cm high, 1.10 m long
Lent by the Joslyn Art Museum, Omaha
Public Library Collection, 567.1949

This is probably a cradle panel. The upper
part shows mountain sheep with an eagle
between them; the lower panel shows two
buffalo with a buffalo head in the centre. At
the sides, above and below, are four
antelope heads. The quills, which were
originally yellow, are much faded.

443 Doll 19th century
South Dakota, Sioux
Cow hide, beads, cotton, shells 50 cm high
Lent by the Chandler–Pohrt Collection

This large doll is a miniature representation
of a Sioux woman in classic fancy costume
with earrings and lace choker. The stuffing
is cotton, and the dress is of cow hide. The
belt has a knife case and strike-a-light
attached. Collected at Pine Ridge
Reservation in 1890.

445 Cradle cover *c* 1890 AD
North and South Dakota, Sioux
Dyed quills and cotton 1.08 m high
Lent by Conception Abbey (Benedictine),
Missouri

The loud pink field and loosely conceived
patterns in the quilled panel are typical of
the Reservation period's interest in brilliance
rather than refinement.

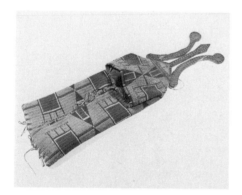

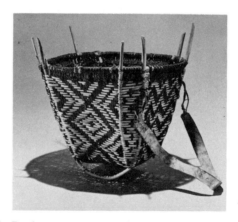

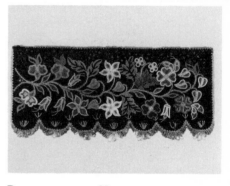

444 Beaded cradle Late 19th century
Northern Plains, Sioux
Seed beads, hide, canvas, brass,
rawhide, wood 1.05 m long, 30 cm wide
Lent by the Kansas City Museum of
History and Science 40.399 Dyer
Collection 32

Made for the granddaughter of Old-man-
afraid-of-his-horses. Collected by Mrs D. B.
Dyer, Fort Reno.

446 Basket
North Dakota, Hidatsa
Willow 43 cm high, 42 cm diameter
Lent by the American Museum of Natural
History 50/7174

The resemblance between Arikara and
Hidatsa twilled basketry from North
Dakota and that of the Cherokee and Gulf
tribes (see 63) is due perhaps to the fact
that the Arikara are of Caddoan stock and
originally migrated from the south, settling
near the Siouian Mandan and Hidatsa. The
triangular patterns of this burden basket
(used with a rawhide tump) are narrow
bark strips. Four bent poles constitute the
framework. For a similar Arikara basket see
Otis Mason, *Indian Basketry*, New York,
Doubleday, Page and Company, 1904,
volume II, page 293.

448 Drum cover *c* 1885 AD
Northern Plains, probably Santee–Sioux
Buckskin, velvet, beadwork 60 cm long
Lent by C.F. Taylor Collection, Hastings

This drum cover is decorated with seed
beads. Such covers were used around the
front of drums, traditionally supported by
four forked sticks set in the ground. This
piece was collected at Battleford, on the
northern Saskatchewan and Alberta
borders. A number of Eastern Sioux moved
to Canada after the so-called 'Minnesota
Massacre' of 1862, bringing their style
tradition northwest with them.

449 Bowl *c* 1835 AD
Minnesota, Sioux
Wood, tacks 40 cm diameter
Lent by the Chandler–Pohrt Collection

A feast dish, made of maple burl,
representing the glutton of Sioux
mythology. The Sioux consumed enormous
quantities of food at feast times. Used in the
days before enamel and tin ware.

451 Ladle 19th century
Montana, Sioux
Horn, paint 22.3 cm long, 10.9 cm wide
Lent by the Smithsonian Institution L–52

Horn ladles were a speciality of the Western
Sioux. Given by Major James Bell,
December 11 1894.

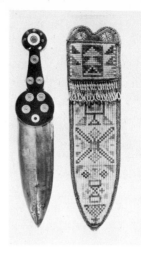

453 Knife Early 19th century
Northern Plains, Chippewa (?) or Cree
Knife: iron blade, inlaid horn handle
Sheath: hide, quill 36 cm long
Lent by the Trustees of the British
Museum 1949.Am.22.134

Knife with sheath decorated in black, red,
blue and white quillwork. Oldman
Collection.

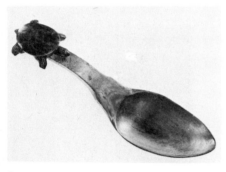

450 Spoon Mid 19th century
North and South Dakota, Sioux
Wood, stain 72 cm long, 20 cm wide
Lent by the Smithsonian Institution
76,832

The turtle effigy, carved with a distinct flat
carapace, appeared over and over again in
Sioux pipe stems, indicating a single carver
with a long and productive life. This spoon
is by him; it was captured by the Second
Nebraska Cavalry from the Sioux,
September 3 1863, and given by Governor
R.W. Furnas on January 4 1886.

452 Bowl
Minnesota, Sioux
Wood, paint
20.5 cm high, 42 cm diameter
Montana Private Collection

Sculpted from maple wood, this bowl is
probably from the Eastern Sioux, who
shared to some extent in the Great Lakes
wood carving tradition. The confronted
heads resemble those on Ojibway pipe
bowls and also early pictographic profiles
on Plains hide paintings. Its quality is
denoted by the thin painted rim line and by
the subtle way the heads are stepped upon
the rim. Collected in 1768, this bowl was
auctioned at Sotheby's, April 29 1974,
number 128.

454 Gun-stock club *c* 1865–70 AD
Northern Plains, probably Sioux
Metal, wood, mirror 72.5 long
Lent by the McCord Museum,
Montreal M15894

This well-balanced club is ornamented with
incised lines and pierced designs as well as
two small mirrors.

455 Quiver, bow and arrow *c* 1860 AD
Wyoming, Cheyenne
Puma, cloth, wood, horsehair, rawhide
Quiver 1.60 m long, bow 1.15 m long,
arrow 68 cm long
Lent by Hermann Vonbank 67/43

The quiver has a macabre and shifting
leonine grace. The carrying band and bow
cover display puma forepaws and claws.
The pelt is rubbed with yellow ochre with
bead-stitched cuffs. At the opening of the
arrow holder is a long pointed sewn-on loop
of puma tail decorated with yellow beads,
and the lower end is decorated with red
strouding cut in forked-tongue-like
patterns. The arrow holder is held stiff by a
stick, on the end of which is tied white
horsehair. The laminated bow is made of
hickory (?) with red painted rawhide along
the back side. The arrow is of finely worked
hard wood tree shoot with reddened
grooves along its length. A stabilizing three-
sided feather is fixed to the shaft with sinew.
This warrior's equipage is the very
incarnation of hunting magic.

457 War club *c* 1880 AD
North and South Dakota, Sioux
Stone, wood, rawhide
24.5 cm long (club head)
Lent by the Joslyn Art Museum, Omaha
Public Library Collection 698.1949

Depicts a mountain sheep with turtle on the
back. One of the finest examples of this type
of club known.

459 Shield with cover and trailer
North and South Dakota, Sioux
Rawhide, buckskin cover, paint, feathers,
blanket 1.75 m long including trailer;
shield 43 cm diameter
Lent by the Saint Joseph Museum 143–3441

Called a flying shield, owing to the green
blanket cloth trailer, which extended when
used on horseback. On the shield cover two
mounted warriors are depicted, with drawn
bows and arrows, in the act of meeting on
the warpath.

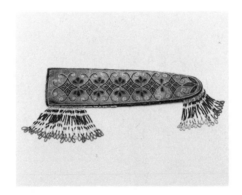

456 Club *c* 1860 AD
Western Plains, Soshone (?)
Wood, metal, tacks, hide
84.5 cm long, 19 cm wide (across blade)
Lent by Mr and Mrs Rex Arrowsmith

An old parfleche or meat case wrapper has
been used to wrap this iron bladed club
with trade tack patterns.

458 Knife sheath Late 19th century
Northeastern Plains, Cree
Buckskin, ribbon, beads 33 cm long
Lent by Peter Adler Collection.

In buckskin, edged in blue ribbon, with
multi-coloured floral bead appliqué and
beaded fringe. It has an inland version of a
C-curve.

460 Amulet
Montana, Crow
Wood 27.5 cm high, 7 cm wide
Lent by The Fine Arts Museums of San
Francisco 23435

Used in a medicine bundle. The Crow had
the most varied collection of medicine
bundles, due to copying and exchanging
personal contents.

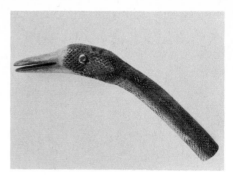

461 Charm Mid 19th century
Montana, Gros Ventre
Brass, muslin, rawhide
Lent by the Chandler–Pohrt Collection

This brass war medicine charm was worn
into battle, encased in its rawhide envelope
and muslin inner bag. The bag also
contains fragrant balsam needles. The
amulet was fashioned from the butt plate of
a trade musket; the seven brass locks
represent the Big Dipper. Originally
belonged to Sits-as-a-Woman, who signed
the treaty of 1855. Collected by Richard
Pohrt at Hays, Montana, 1937.

463 Rawhide cut-outs
Northern Plains, Sioux

a **Man** 33 cm high
82-45-10 27498

b **Buffalo**
34.3 cm long, 21.6 cm wide
82-45-10 27497

Lent by the Peabody Museum of
Archaeology and Ethnology, Harvard
University

These cut-outs were suspended from a Sun
Dance pole; the buffalo figure was a prayer
for meat, and the man was a similar prayer
for victory in war. They are another
example of the strong Plains feeling for
silhouette and essential form, also seen in
the pictorial drawing. Collected by Alice C.
Fletcher from the Oglala Sioux in 1882.

465 Dance stick *c* 1850–1860 AD
North Dakota, Mandan or Arikara
Wood, tacks 39 cm long
Private Collection

Both the Mandan and the Arikara
maintained a Womens' Goose Dance
Society in which this long necked goose
image was used. Note the hot file marks.

466 Dance whistles Late 19th century

a **Whistle** *c* 1890 AD
Northern Plains, Oglala Sioux
Ash 71 cm long, 5 cm wide, 4.3 cm deep
Lent by the University Museum,
Philadelphia 45-15-1207

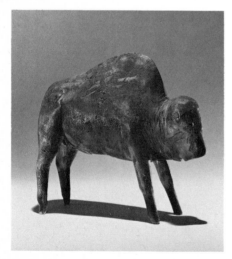

462 Buffalo Late 19th century
Montana, Crow
Wood 15.5 cm high, 18 cm long
Lent by the American Museum of Natural
History 50.1/974

This votive sculpture with horns and tail
missing was once part of a medicine bundle,
collected before 1910.

464 Ceremonial club *c* 1860 AD
Wyoming, Arapaho
Wood, tacks, quilled wrapped thongs, deer
toes, buffalo hair 1.01 m long
Lent by the Denver Art Museum QAr–2

Carried by an officer of the Tomahawk
Lodge (or Club Man's Society), an
Arapaho military society. Officers had to
ride out ahead in an attack and strike the
enemy with these clubs (see J. Mooney,
pages 987–988). Collected in 1884.

b **Flute** Early 19th century
Northern Plains, Chippewa
Wood 92.8 cm long
Lent by the Brooklyn Museum
Formerly in the Nathan S. Jarvis
Collection, Frank S. Benson, Henry L.
Batterman Fund 50.67.91

c **Flute** Early 19th century
Northern Plains, Sioux (?)
Wood, feathers, metal 64 cm long
Private Collection

The whistle was used in the grass dance and
the flutes in courtship. *c* represents a crane,
an erotic symbol on the Plains.

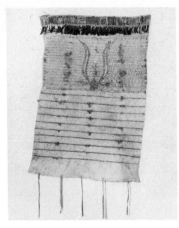

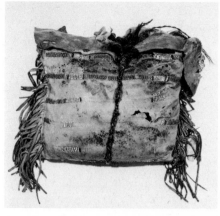

467 **Medicine coup stick** *c* 1875 AD
Montana, Assiniboine
Wood, paint 84 cm long
Lent by the Chandler-Pohrt Collection

This coup stick, a tapered human effigy,
was used in battle. Black Elk tells us that
sticks as well as lances were carried into
mounted battle, the warrior depending on
equestrian skill rather than a lethal blade or
arrows. It is decorated with burnt-in hair
and hot file marks. In battle it probably had
a red stroud wrapper. Collected at Fort
Peck, Montana.

469 **Medicine bundle wrapper** *c* 1870 AD
Northern Plains, Sioux
Buckskin (elk?), quills, horsehair
1.09 m high, 76 cm wide
Lent by E. Michael Haskell

The Elk Dreamers society of the Sioux used
this beautifully figured (Wicaska) outer
wrapper. A bull elk is depicted with greatly
exaggerated horns. The cult reflected the
Sioux concept of sexual passion:
'Supernatural power lay behind
manifestations of sex desire; consequently
numerous mythical creatures were thought
to control such power, and of these the bull
elk was the most important'. (See Helen H.
Blish, *A Pictographic History of the Oglala
Sioux*, Lincoln, University of Nebraska
Press, 1967, page 199.) The last Elk
Dreamers' official meeting was held in
1885.

471 **Medicine bundle** Before 1840 AD
Upper Missouri
Buffalo hide, beads, various materials
28 cm high, 33 cm wide
Lent by Hermann Vonbank 66/29

A large amount of ritual material, packaged
in a pouch of small dimensions. The objects
emanate a magical sense of power.
Medicine bundles, owned by societies,
villages and doctors were at the very core of
Indian religious mystique; they only found
their way outside the Indian world when
the last bundle keeper disposed of it. This
case is of smoked heavy buffalo hide
stitched with horizontal bands; under the
cords is a piece of pressed tobacco.
Contained in the case are the following:

Long bird tail (prairie chicken?), three
short sweet grass braids tied into colourful
printed cotton wrapper, tied with knotted
wool.

Eagle feather, the under-half of which has
been cut off (war honours) with a leather
band, fastened with sinew as well as red
strouding and horsehair knotted into a
leather band. Eight hawk feathers wrapped
in pairs with sinew bands; two sweet grass
braids.

Matted buffalo wool in a buffalo bladder.
Black bird skin stuffed with buffalo hair and
stroud strip and long white horse tail hairs
pulled together with sinew fastening.
Coloured lump of pulverized catlinite.
Three sweet grass braids, beaver pelt strips.

468 **Digging stick** *c* 1875 AD
Montana, Crow
Wood, paint, skin 89.5 cm long
Lent by the Chandler–Pohrt Collection

This stick was used in the rites of the Crow
tobacco society, probably by a medicine
bearer, since it has an otter medicine skin
attached, as well as a tobacco (seed?) skin
pouch and three eagle feathers. It is
decorated with painted and incised bear
paws and a running zig-zag line which may
be lightning. The small stick may be a
tamper. For an account of tobacco society
adaptation and planting rites see Edward
Curtis, volume 4, pages 14–17.

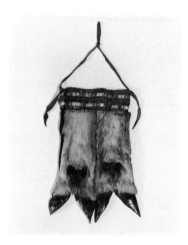

470 **Pouch** Late 19th century
Canada, Alberta, Blackfoot
Elk skin with hooves, quills
18.8 cm high, 28 cm wide
Lent by the McCord Museum, Montreal
M5893

The Indian identification with nature is
underscored by such pouches.

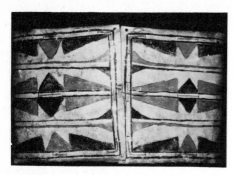

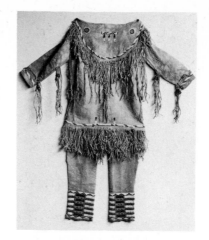

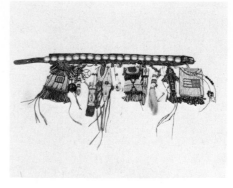

472 Parfleche *c* 1880 AD
Northern Plains, Arapaho
Rawhide, paint 43 cm high, 69 cm long
Lent by Hermann Vonbank 64/22

Both outside flaps painted in strident
geometric arrow and diamond motifs on
shafts, with double lined frames around
each flap.

475 Child's belt Late 19th century
Oklahoma, Cheyenne
Leather, beads, metal, various objects
56.3 cm long, 30 cm overall width
Lent by the Kansas City Museum of
Science and History

This is a rather baroque example of
ornamentation for a child. Possibly the belt
was meant as protection against danger, or
for wearing at a particular festival. For the
complete history see Mrs D.B. Dyer, *Fort
Reno.*

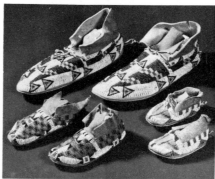

474 Child's costume *c* 1891 AD
Oklahoma, Southern Cheyenne
Buckskin, beads, antelope dew claws
Shirt: 45.5 cm long, 81 cm across sleeves;
leggings: 37 cm long; 3 pairs moccasins:
25.5 cm long, 19.6 cm long, 15 cm long
Lent by the Nelson Gallery of Art/Atkins
Museum (Gift of Mr J. Stanley
Levitt) 74–22/1,2 74–22/3,4,5

This child's costume was a gift from the
Southern Cheyenne to Jacob Schweizer's
granddaughter, Renatta Levitt in 1891. It
is a typical example of the feather design of
the early Reservation period in Oklahoma.
The two small pairs of moccasins allowed
for the baby's growth; the adult pair was for
the mother.

473 Parfleche Before 1870 AD
Wyoming, Cheyenne
Rawhide, paint 37 cm high, 65 cm long
Lent by Hermann Vonbank 74/133

The Cheyenne excelled at making
parfleches with articulate and refined
designs, in which the colours have an almost
translucent sharpness.

476 Case 19th century
Wyoming, Cheyenne
Rawhide, paints 48.5 cm long
Lent by the Denver Art Museum PChy–6

Made for carrying personal objects.
Collected around Fort Laramie in the
1860s.

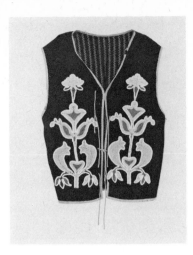

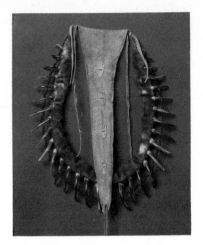

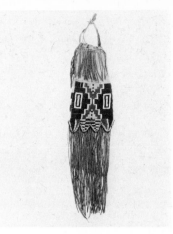

477 Vest *c* 1890 AD
Southern Plains, Oklahoma, Ponca
Cloth, beads 43 cm high, 51 cm wide
Lent by E. Michael Haskell

This Great Lakes style vest combines
dynamic flower, leaf and curvilinear
abstract forms in a way which conveys a
feeling of ascendant growth.

479 Bearclaw necklace *c* 1860 AD
Oklahoma, Pawnee
Bear claws, otter fur, blue trade beads,
rawhide, parfleche, dye
59 cm high, 34.5 cm wide
Montana Private Collection

Since prehistoric times the grizzly bear
claw necklace has shown the distinction and
prowess of its warrior wearer. While the
claws on this example are shorter than those
on the famous Sauk and Fox necklace in the
Chandler–Pohrt Collection (see cover, Flint
Institute, *Art of the Great Lakes Indians*), and
although the symmetry is less perfect, it is a
purer object in that the claws have not been
refined by later substitution, though this
was also Indian custom.

481 Pouch *c* 1870 AD
Southern Plains, probably Kiowa
Buckskin, beadwork 48 cm long
Lent by C.F. Taylor Collection, Hastings

The step motif design on one side of this
pouch is in the red glass beads highly
favoured by the Kiowa. The other side
demonstrates the Southern Plains broad
band lazy-stitch technique. The fringe is
covered with red earth.

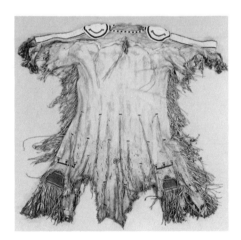

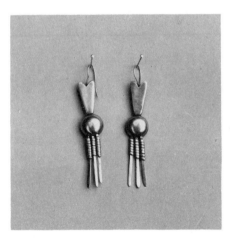

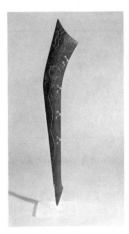

478 Dress Before 1859 AD
Oklahoma, Black Pawnee
Buckskin
1.52 m long, 50 cm across shoulders
Lent by the Royal Scottish Museum 390

The Southern Plains propensity for border
designs is shown in the strong lines on the
shoulder band and the refined use of the
feather motif on this fine Southeastern
Plains costume. From the T. Constable
Collection.

480 Pair of earrings *c* 1875–1900 AD
Southern Plains, tribe uncertain (Kiowa?)
Silver 7 cm long
Private Collection

Pendant earrings with three hanging
dangles, made of 'German' trade silver.

482 Club *c* 1800 AD
Southern Plains, Oklahoma, Pawnee (?)
Wood 69 cm long, 11.5 cm wide
Montana Private Collection

This club is in the form of a gunstock; it is
incised with stars on one side and a comet-
like design on the other. Made from cherry
wood, with ochre stain. Originally scalp
locks hung from the indentations.

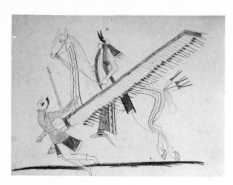

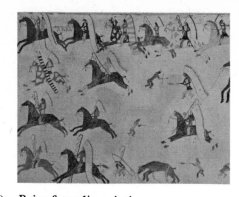

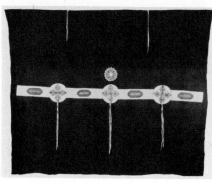

483 Album of ledger book drawings
Oklahoma, Kiowa
Paper, pencil, crayon (in cloth
binder) 27.5 cm high, 40 cm wide
Lent by the Nelson Gallery of Art/Atkins
Museum 64-9
(Gift of Mr and Mrs Dudley C. Brown)

This lively and important drawing book
contains 75 works by the Kiowa artist
Silverhorns, who was the most prolific of the
many Plains artists working in this medium,
inspired by traders. Subjects include the
killing of Pawnees by Kiowas, a clandestine
romance, the making of buffalo hunt
medicine, the stealing of women, the
encounter and killing of a Navajo, various
dances, courtship scenes, a Kiowa being
killed by a Cheyenne, the receiving of food
after a night's debauch and the messiah
(ghost) dances. Silverhorn's early crayon
and pencil style, seen here, is more Indian –
his later drawings with water colour and
heavy ground lines were more
European in style. Over 600 of his drawings
have been located by John C. Ewers, and
an incomplete bound sketchbook by him is
at the Marion Koogler McNay Art
Institute, San Antonio, Texas.

484 Pair of muslin paintings
c 1875–1885 AD
Oklahoma, Kiowa
Muslin, paint
a and *b* 90 cm high, 2 m wide
Lent by the Nelson Gallery of Art/Atkins
Museum (Nelson Fund) R70–20/1,2

These are fine examples of the crowded
narrative style of later Plains painting, as it
developed after trader's muslin became
available. An animal device is depicted on
the upper right of *a*. Traders sometimes
hung these works in their cabins, others
were retained by the Indians as personal
records.

486 Blanket with beaded strip
c 1880–1890 AD
Washington–Idaho, Nez Percé
Blanket, beads
1.27 m high, 1.52 m wide (edges slightly
trimmed)
Lent by Mr and Mrs Morton I. Sosland

Made from a US army blanket. A Plateau
variant on the Plains wearing blanket. Note
the colour variation between the centre
roundel and the two side ones. The separate
roundel above the beaded strip has a
triangular stepped motif drawn from
Salishan and Californian baskets. These
also appear on Nez Perce woven caps and
sustain an attribution to the Plateau area.

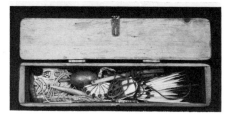

485 Peyote box *c* 1920–1940 AD
Texas, Kiowa–Comanche
Wood, various materials
44 cm high, 9 cm wide, 9 cm deep
Lent by Anthony Berlant

The ritual of the Native American Church
involved the consumption of Peyote, the
buds of which are absent from this kit.
Included in the box is a peyote fan made of
feathers, a beaded pin representing an open
peyote fan, a beaded gourd rattle with an
inscribed image of Jesus on one side and an
angel on the other. There is also an eagle
bone whistle, a purse, a miniature bible, a
garnet, a drum stick, a decorated tip of a
deer antler and sage which is buried during
the ceremony. The box shape recalls the
traditional boxes used to keep prayer
feathers and ceremonial paraphernalia in
the Southwest.

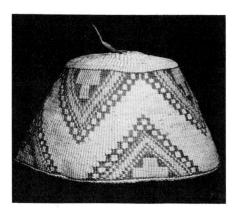

487 Cap *c* 1850 AD
Washington, Nez Perce
Indian hemp, bear grass, maiden hair fern
12 cm high, 18 cm diameter
Lent by Hermann Vonbank 73/120

Woman's cap stitched in false embroidery
technique.

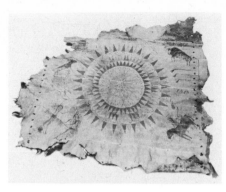

488 Robe *c* 1875–1880 AD
Southern Plains, Utah, Ute (?)
Buffalo hide, quills, paint, strouding
1.84 m long, 1.97 m wide
Lent by the Kansas City Museum of
History and Science

This Indian tanned buffalo robe is aberrant
in its combination of an abstract centre
field with pictorial motifs at the edges. The
design is almost as schematic as that of a
quilt and lacks Plains improvisation. Horse
raiding honours, like horseshoe prints, are
part of the radial centre field, the innermost
motif of which indicates the connection of
such designs to the sun symbol. The yellow,
peach and green colours are neither
Southwestern nor Plains, but at the
juncture of both, hence the attribution to
the Ute.

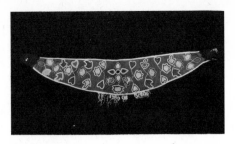

490 Martingale
Plateau area, Yakima(?)
Cloth, beads, leather 1.37 m wide, 24 cm
high
Lent by the Cleveland Museum of Natural
History 3137

Made with trade materials and decorated
with floral appliqué beadwork, under
Blackfoot influence.

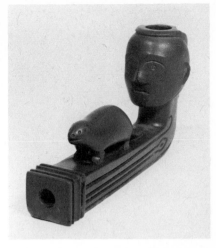

492 Pipe bowl Early 19th century
Plains (Eastern), possibly Pawnee (?)
Catlinite 16 cm long
Lent by C.F. Taylor Collection, Hastings

Catlinite pipe, in the form of a man's head;
the square grooved shaft is topped by a
beaver. The hairstyle is associated with
Pawnee warriors rather than Eastern Sioux
or Chippewas.

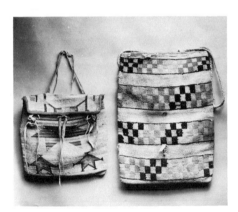

489 Two bags
Idaho Washington, Nez Perce
Hemp, wool
a 50 cm high, 35.5 cm wide *c* 1875 AD
b 33 cm high, 33 cm wide *c* 1890 AD
Private Collection

So-called Nez Perce 'cornhusk' bags were
actually woven with native hemp and
embroidered with wool abstract ZX or zig-
zag designs. The checker board pattern (*a*)
and the tree design (*b*) are uncommon, as is
the flap edged with strouding on *b*. The Nez
Perce developed a flourishing business,
making these bags for surrounding tribes.
While unique to the Nez Perce the bags
bear relationship to Wasco 'Sally bags' (see
number 385) and to Salish work.

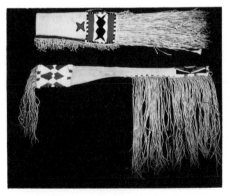

491 Gun case and saddle bag *c* 1850 AD
Washington, Nez Perce
Elk hide, beads, buffalo leather, cloth
Guncase 1.27 m long less fringe ; saddle
bag 31 cm high, 1.27 m long
Lent by Hermann Vonbank 73/121,
73/122

Two impressive examples of Plateau
beadwork. Both are early enough to be
expansive and powerful in form as well as
colourfully beaded. The case has pony
beads in both lazy and overlay stitch
backed by red material at the open end.
There is a star superimposed out of red
clothbound pony beads on the bag. (For a
Nez Perce cornhusk bag with star design see
number 489.) Both of these objects are
sinew sewn. Acquired from Larry Tyler,
Seattle.

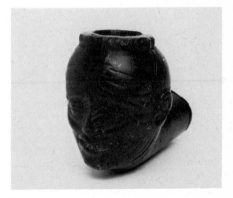

493 Pipebowl
Northern Plains, Sioux
Slate 6 cm high, 4 cm wide, 7.5 cm long
Lent by the Royal Scottish
Museum 1956.678

The depiction of a wrinkled human head is
part of a sculpture tradition shared by the
Eastern Sioux and Ojibway; but this bowl,
with its rougher carving and cruder stem
would best be classified as Sioux (see
number 492).

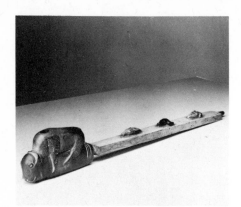

494 Pipe *c* 1860 AD
Northern Plains, Sioux
Pipestone, wood
Private Collection

Notice how the buffalo's head is
incorporated into the lower part of the
pipestone bowl, to increase the feeling of a
running charge.

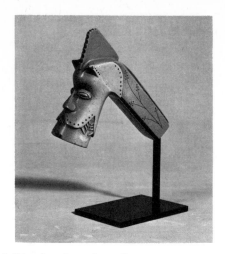

496 Pipe bowl *c* 1850–1875 AD
Northern Plains, Sioux
Red catlinite 12.5 cm high, 15 cm long
Private Collection

This bowl represents a stylized horse. It is
by the same master as the similar pipe bowl
in the Saint Paul Historical Society
Collection. (See N. Feder, *Two Hundred Years
of North American Indian Art*, number 73,
illustrated.)

498 Pipe bowl *c* 1860 AD
North and South Dakota, Sioux
Catlinite 12.5 cm high, 19.5 cm long
Lent by Mr David T. Beals III

The massive size of this bowl is unusual,
otherwise it is typical in form. Catlinite was
quarried at Pipestone, Minnesota, and
traded throughout the Plains. The bowl was
collected by Seth E. Ward, great-
grandfather of the lender, at Fort Laramie,
Wyoming, where he was stationed during
the Civil War. He had been married to a
Sioux woman and undoubtedly obtained it
either through his wife's family or in trade.

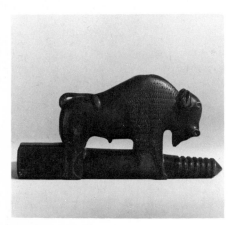

495 Pipe bowl *c* 1850–1860 AD
Wyoming, Cheyenne
Stone 12.5 cm high, 12.5 cm wide
Lent by the Denver Art Museum PiChy–3

A black stone carving of a standing buffalo.
A number of pipes like this exist by the same
Cheyenne sculptor, almost exactly similar
to each other; some are at the Maryhill
Museum and the Philbrook Art Centre,
Tulsa.

497 Pipe bowl Mid 19th century
Northern Plains, Sioux
Catlinite 8 cm high, 6 cm wide
Lent by the Denver Art Museum
PiS-24

499 Tobacco tamper *c* 1880–1890 AD
Northern Plains, Sioux
Wood, paint (traces) 65.5 cm high
Montana Private Collection

Reportedly found on the battlefield at
Wounded Knee, 1890. The Sioux, along
with the Crow, maintained an important
tobacco society. Note the balls that rattle in
their open-work compartment.

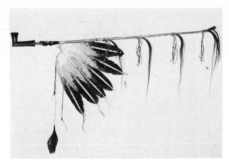

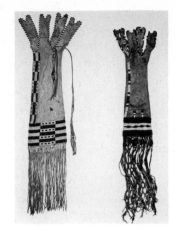

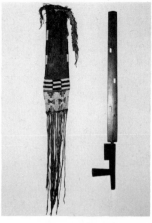

500 **Pipe** *c* 1830 AD
North Dakota, Mandan
Catlinite, wood, feathers, horse hair, ermine
pipe bowl 12 cm long; pipe stem 97 cm long
Lent by Hermann Vonbank 68/68

Pipes in the broad area that stretches from
the upper Missouri to the Osage in southern
Missouri and eastern Kansas, skirting the
Plains, often look thin and springy like this
one. The feather fan increases the
projectile-like quality. A better known
example of this type of pipe from the Osage
is in the Denver Art Museum.

502 **Two pipe bags**
Wyoming Cheyenne
Buckskin, beads, tin
a 37.5 cm long (without fringe)
Before 1850 AD
b 47 cm long (without fringe) *c* 1850 AD
Lent by Hermann Vonbank

Both of these bags show the bar type designs
that were used before 1870 running along
the length (edge) and the width (bottom,
above fringe). *a* is slightly earlier as it does
not have the feather pattern beadwork
spikes or the top flaps which open in four
directions, both Cheyenne characteristics
which feature on later bags.

504 **Pipe** *c* 1855 AD
North Dakota, Teton Sioux
Catlinite, wood
Pipe bowl 20.7 cm long, pipe stem 64
cm long
Lent by Hermann Vonbank 67/34

The three cut-out rectangular sections in
the ash stem cause a striking play of light
when the pipe is held up. The insides of the
cuts are painted red and green.

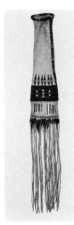

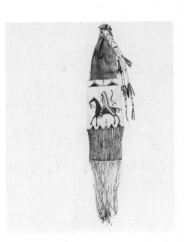

501 **Tobacco pouch** Before 1850 AD
Northwest Plains, probably Crow or
Blackfoot
Buckskin, beads, quills, tin
47.5 cm long with fringe
Lent by Hermann Vonbank 68/60

'Pony beads' are in a lazy stitch
configuration. Each fringe pair is wrapped
with yellow, red and blue porcupine quills.
There is a horizontal sinew thread across
the base of the quills. There are two beads
on each fringe, with tin cones into which are
set animal hairs, perhaps white mountain
goat. Back and front decoration are the
same. Sinew sewn.

503 **Pipe bag** *c* 1835 AD
Plains, probably Sioux
Buckskin, beads, quillwork 1.02 m long
Lent by C.F. Taylor Collection, Hastings

Decorated with pony beads.

505 **Pipe bag and attached sash** *c* 1875 AD
Plains, Sioux
Buckskin, beads, quillwork
1.15 m long (total)
Lent by C. F. Taylor Collection, Hastings

This bag is decorated with a realistic figure,
who may be the owner riding into battle,
worked in beads on a hide base, with fringes
of wrapped quill and hide. The attached
sash is unusual and may be a 'no retreat'
sash, such as were sometimes worn by
distinguished warriors.

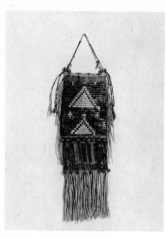

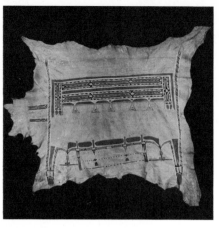

506 Pouch Early 1890s
North and South Dakota, Sioux
Buckskin, quills, beads, bells
48.5 cm high, 16 cm wide
Lent by Mr and Mrs Robert H. Mann Jr

A Sioux tobacco bag with fully quilled red
field and beaded upper edge. It is decorated
with coins and bells; the earliest of the 17
United States penny dangles is dated 1864
and the latest 1889.

508 Painted hide *c* 1830 AD
North and South Dakota, Sioux
Buffalo hide, paint
1.35 m high, 1.85 m long
Lent by the Linden Museum,
Stuttgart 36.103

On his famous exploration trip up the
Missouri River in the company of the artist
Carl Bodmer, Prince Maximilian Zü Wied
Neuwied of Wurttenberg collected two
superb Mandan and Hidatsa pictorial hide
robes and a pair of near duplicate 'box and
border' painted hides. One of the hides is
exhibited here. There are no finer robes of
this type extant. Note the succinctness of
design and brilliant features like the earth
red 'sausage' (Ewers) or lozenge spots,
contrasting with the highly controlled black
box and pendant enclosures. This type of
abstract design was painted by women, who
wore the robes in girls' puberty rites.
Maximilian's artist Bodmer depicted a
similar robe worn by a Sioux woman in his
celebrated 'Atlas', plate 42. Subsequent box
and border robes tended to be looser in
configuration and used more colours. (See
A. Schulze–Thulin, page 50.) Collected
1832.

509 Hide painting Early 19th century
Eastern Plains, Sioux(?)
Bison skin
Lent by Notre Dame University, Fort
Wayne, Indiana

The drawing on this bison robe records the
war exploits of its owner during the 1830s
(note the arrows and lances and continuous
design of the horses and warriors). There is
no documentation for the painting.

507 Robe *c* 1830 AD
Upper Missouri area
Buffalo hide, paints
1.98 m long, 1.49 m wide
Lent by Hermann Vonbank 71/102

Decorated with negative engraving,
strengthened with red. Four hourglass
designs alternating red on black and vice
versa on each band. Upper half has three
stripes running diagonally across length,
which the hourglass motifs interrupt. The
ears of the young buffalo are pulled inward.

510 Bison robe *c* 1840 AD
Northern Plains, tribe unknown
Hide 2.10 m high, 1.67 m wide
Lent by the National Museum of Denmark,
Department of Ethnography Hd 60

The drawings record the owner's bravery
record, including his horse stealing, and are
separated by five pony-beaded medallions.
Although it was collected by the museum in
1870 the style of drawing indicates it must
date from the 1840s.

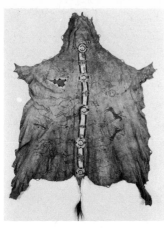

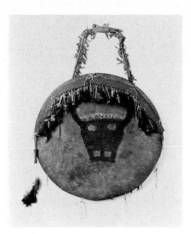

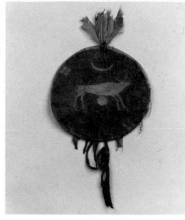

511 **Bison robe** *c* 1830 AD
Northern Plains, tribe uncertain
Hide 2.05 m high, 1.60 m wide
Lent by the National Museum of Denmark,
Department of Ethnography Hc 478

The elementary character of the drawing
suggests this robe was made about 1830.
Deposited in the National Museum of
Denmark in 1861.

513 **Shield** *c* 1860–1865 AD
Northern Plains, tribe uncertain
Buffalo skin, tradecloth, feathers
53.5 cm diameter
Lent by Mr Paul Stolper

A series of cut eagle feathers across the top
surrounds the buffalo image, painted on a
turquoise green background.

515 **Shield** *c* 1870 AD
Oklahoma, Cheyenne
Rawhide, leather, cloth, feathers, paint
47 cm diameter
Lent by the Denver Art Museum PChy–19

This appears to be an early representation
of a steer with celestial symbols. Collected
by George M. Moffet in Oklahoma in the
early 1880s.

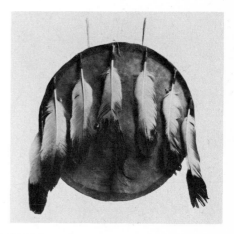

512 **Robe** 19th century
Northern Plains, Sioux
Bison hide, paint, beads
Private Collection.

This box-and-border painted robe, which
belonged to Sitting Bull, was meant for
winter use since the bison fur was not
scraped off. Dr Keedler, who attended
Sitting Bull at Fort Yates after his surrender
to the Government, was given this robe by
the Sioux chief.

514 **Shield** Before 1870 AD
Eastern Plains
Buffalo hide, feathers, cloth, scalps, bells
46 cm diameter
Lent by Hermann Vonbank 72/114

The front of the shield shows the partly
scraped hair side of a buffalo pelt; in the
bare spots are painted figures and symbols.
Horses and a flintlock musket can be
recognized. On the upper part of the shield
hangs red strouding with ornaments
stitched on, intertwined with scalp locks,
grass bells, and feathers of eagle, bluejay,
yellow and red shafted flickers, and an
unidentified white bird. The feathers are
cut to indicate successful coups.

516 **Shield**
Southern Plains, tribe uncertain
Buffalo hide, eagle feathers, hair
53.2 cm diameter
Lent by Mr and Mrs Peter B. Thompson

This shield has a sophisticated simplicity of
concept, with the seven feathers hanging
like an ascending and descending musical
scale. The concentric outer border and
beige colour indicate a Pueblo influence.
The Southern Plains Comanche and Kiowa
raided in New Mexico and the buffalo
sometimes ranged below Albuquerque. It is
old enough to be fashioned from a buffalo
hump and to be decorated by a scalp lock in
the middle.

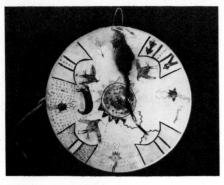

517 **Shield** *c* 1880–1890 AD
Southwestern Plains, Kiowa (?)
Buffalo hide, buckskin, hair, paint
57 cm high, 57 cm wide
Lent by the Maxwell Museum of
Anthropology 43.8.16

The way the design elements combine and
break into zig-zag components gives this
medicine shield and cover an electric
quality. There is a sun and a star in the
centre, and there are three thunderbirds,
lightning, rain, and animal symbols. A
scalp lock is attached. Given to the Museum
by former governor M.A. Otero in 1943.

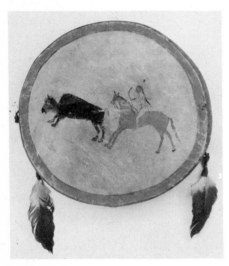

518 **Drum**
Southern Plains, Kiowa
Deer hide 45·5 cm diameter
Lent by the Nelson Gallery of Art/Atkins
Museum (Nelson Fund) 31-125/12

This Kiowa hand drum or tambourine
depicts a lively encounter between an
Indian hunter and a buffalo; the yellow,
green and red colours produce a typical
southern Plains harmony.

Pastoral Designs for the Arid Lands:
The Art of the Southwest
and the Far West

In the Southwestern States of New Mexico and Arizona Indians live communally in adobe villages, much as they have lived since early times (800 to 1000 AD) when they were spread over New Mexico, Arizona, Utah, California, Nevada and Mexico. They still plant corn and squash, as their ancestors did in the early years of the Christian era; their dances are similar to those of the ancients and they invoke the same Gods. Their traditions were venerable by the time the Spanish conquistadors pushed into the Gran Chichimeca in the 16th century at which time the word pueblo, Spanish for town, was used to describe their communal settlement. While many of the pueblos that Coronado and other Spaniards plundered from 1540 onwards have disappeared, others have sprung into life, and the original patterns of life have remained. Today there are nineteen pueblos in New Mexico and a handful of Hopi towns on three mesas in northern Arizona; they have populations ranging from one in Pojoaque, to more than two thousand in Santo Domingo. Although basically a sedentary people, during their history when their material existence has been threatened by outside incursion they have defended themselves. One example of this is the Pueblo Revolt of 1680–92 when the Spanish were driven, temporarily, out of the Southwest. There was an uneasy relationship with the non-native tribes like the Apache, which sometimes flared into warfare.

An inner resistance to alien cultural pressure and a determined adherence to the old customs explain how the Indian has maintained his ancient culture and even enlarged its outlook in the modern age. Religious belief is still strong, particularly in the less permissive pueblos. The continuity of Pueblo and Navajo Indians is assured as long as the system of belief remains intact. Some of the Indians have accepted jobs off the reservations, so that the pueblos along the Rio Grande River have become to some extent dormitory towns. Since the Spanish conquest Catholicism and the old ways have co-existed quite successfully at the pueblos; when Mass is over the dances on the plaza begin.

The most documented of the cultures of the Southwest is called the Anasazi, from a Navajo word meaning 'the old ones'. These early plateau people inhabited the drainages of the San Juan, Rio Grande, Upper Gila and Salt Rivers, a sizeable portion of Utah and a corner of eastern Nevada. Their earliest sequence is called Basketmaker, due to the profusion of tightly woven baskets found in their burial places. During the Basketmaker I (100–400 AD) and particularly Basketmaker II (400–700 AD) periods they produced basketry (519c) and sandals (519a), and also the beginnings of pottery (519d) and pit houses, precursors of the kivas or underground ceremonial chambers. To this day these are the secret centres of pueblo ritual, prayer and purification. The succeeding Pueblo period is also divided into horizons. During the Pueblo I period (700–900 AD) the villages were made up of rectangular living chambers in true masonry, these developed into joined multi-roomed houses with kivas during the Pueblo II period (900–1100 AD); communal dwellings of several storeys and several hundred rooms were constructed in Chaco Canyon, New Mexico shortly after 1000 AD. Pottery was made of finer paste, with black designs on a white background or slip. This painted pottery became more inspired during Pueblo III times (1100–1300 AD), and was accompanied by the development of cliff houses and towns in large caves, which were dwelling complexes for richer and larger communities such as Canyon de Chelly and Mesa Verde. These pueblos were abandoned for unknown reasons about 1270 (this occurred earlier in the Mesa Verde area than in the Kayenta area to the west) taking us into period IV (1300–1700 AD), famous for its kiva murals and Sikyatki pottery. This pottery was distinguished for its free-hand design and spatter technique (553), and had a freshness of approach which I think is still not accorded sufficient recognition. Houses of the period were built into cliffs and then on top of mesas, which led to the pueblos constructed around courts or plazas which are lived in today. The Historic period or Pueblo V extends from about 1700 to the present. Ironically enough, since the Spanish Catholic priests discouraged burial of pottery with the dead, early historic pueblo ware is more sought after than the archaeological pots, and even the late 18th-century Kiua polychrome pot lent

The potter mixing clay – Hopi
by Edward Curtis

Pueblo, San Ildefonso 1879
Smithsonian Institution

here is uncommon (599). Its bold motifs have great power in comparison with the later, more self-conscious, ware with which we are more familiar.

The parallel ancient Hohokam culture (300 AD to present) was located in the desert valleys of the Salt and Gila Rivers below modern Pheonix, Arizona; they were the ancestors of the Pima and Papagos. After several centuries of development (Pioneer and Colonial phases 300–900 AD) their accomplishments included, in the Sedentary period (900–1200 AD), the development of irrigation farming and the decorative etching of shells with fermented cactus juice. The Hohokam were the first people to use a true etching process. Most of the works by them exhibited here are from the Sedentary period, or Classic period (1100–1300 AD), notably a massive deep-shouldered pot painted red on buff (535) and an engaging stone lizard effigy palette (534). This was the classic phase of the Hohokam, the later Salado horizon lost the earlier coherence in design (546). Mosaic jewellery (which has survived into the present) was already flourishing in classic Hohokam times, influenced by the Mixtec Indians of Mexico (532). The historic and modern Pima and Papago basket weavers and agriculturalists are descendants of the Hohokam and live in the same general area, or to the south.

While the Mogollon peoples of southeastern Arizona (700–1300 AD) produced a fine and sometimes monumental corrugated pottery, their archaeology is not as well known. Tularosa pottery is a meeting of Anazasi and Mogollon influences. New discoveries in the Mimbres valley area of southwestern New Mexico are adding to our knowledge of their history. Included here is a crane-and-head design pot only recently unearthed (520), that suggests a reliable earlier than supposed date for such ware, 1030 AD. Mimbres painted pots of the 11th and 12th centuries AD are among the most lively and complex pictorial records of a way of life left by an ancient Amerindian culture, although the pots themselves were made of poor quality clay and were often indifferently formed.

In the Southwest, we confront an arc of artistic development from the archaeological evidence of 400 AD to the present.[1] Here the most exacting excavation work has been done over the past 75 years and the conditions of preservation in the river basin and deserts have provided excellent data. The evidence presented here documents continuity within change. An ancient Basketmaker II twined bag and a modern Hopi striped poncho clearly show a common heritage of linear design (631). A tablita or dance headdress from the Mimbres area and a traditional Hopi one share the same flatness of design, although

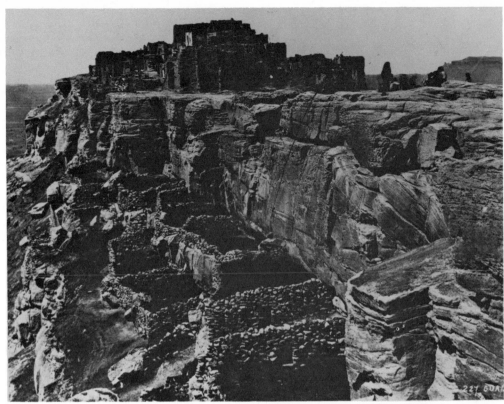

Pueblo, Hopi, Arizona 1875
Smithsonian Institution

their dates are a thousand years apart (530, 666). Mohave pottery dishes, flat and
roughly triangular in shape, at first glance look like Hohokam pot shards. The action and
reaction of cultural cross currents across the centuries can hardly even be indicated here.
The Navajo, an Athabascan people originally from Canada, settled in the Southwest about
1400 AD, learning their weaving techniques from the Pueblo Indians.[2]

From the time when the Europeans first came in contact with the Indians of the Southwest
they have remained outsiders. Frank Hamilton Cushing, one of the few Americans ever to
live with the Zuni, and the first to do so, overcame their defenses only after great difficulty.
Though he eventually became a priest of the bow, Cushing was told in no uncertain terms
at the outset that if he adopted Zuni dress, food and customs totally he would find the
pueblo a place of riches, 'but if you do not do as we tell you, you will be very, very, very,
poor indeed'.[3] Cushing's description of a Zuni pueblo in 1879 (he came across it after days
astride a government mule) evokes the vision of the conquistadors who first saw the town,
though at a slightly different site, in 1541. 'A banner of smoke, as though fed from a
thousand crater-fires, balanced over this seeming volcano, floating off, in many a circle and
surge, on the evening breeze. But I did not realise that this hill, so strange and picturesque
was a city of the habitation of man, until I saw, on the topmost terrace, little specks of black
and red moving about against the sky . . . Imagine numberless long, box-like shapes, adobe
ranches, connected with one another in extended rows and squares, with others, less and
less numerous, piled upon them lengthwise and crosswise, in two, three, even six stories,
each receding from the one below it like the steps of a broken stair-flight – as if it were a
gigantic pyramidal mud honeycomb with far outstretching base – and you can imagine a
fair conception of the architecture of Zuni.'[4]

Why did these Southwestern Indians survive when acculturation in other parts of the
United States and Canada did so much damage? One reason is the strong centrality of
pueblo government and social organization; this enabled the people to present a solid flank
to the outside world, so that they could not be thrown off balance as the nearby nomadic
Apache were. Although they are referred to as villages, towns or even cities – there is no
end of confusion on this score – the pueblos were really miniature nations, with their own
government, which was not imposed by Washington but asserted by land grants from the
Spanish King. During Abraham Lincoln's administration in the 1860s almost every pueblo
received a walking cane which symbolically confirmed their territorial rights and are still
proudly preserved under the Pueblo Governor's protection.

The self-contained social life and the fixed environmental focus are heightened by the Pueblo religion which is based on an intimacy of outlook difficult for the outsider to grasp, and which has passed down intact from generation to generation. The Pueblo Indian's relationship to his myths and deities arises out of his closeness to them in nature. The home of his gods is nearby; the Hopi gods live in San Francisco peaks, those of the Zuni in Corn Mountain, those of the Acoma in Taylor Mountain and those of the San Ildefonso in the Black Mesa. The place of the peoples' first emergence from the earth can always be pointed out. Likewise the Pueblo conception of death is typically intimate. In Hamilton A. Tyler's study of their religion he says: 'That local underworld is not only the place from which the race emerged and the place to which its individuals return, but it is as well the storehouse of all life-giving crops which are in season drawn up to nourish the living'.[5]

This humanism was given full rein in a ceremonial calendar of dance and prayer. The kachina season lasted half the year (autumn and winter), dances went on all year. Some were held for expounding mythological history, for corn and for rain, to honour the deer and buffalo, on saints days, festivals and of course during the kachina season – the time of the arrival, occupation and departure of those intermediaries who were messengers between the human world and the sacred one. During the last fifty years new kachinas have been devised, have been danced for a number of seasons and have then disappeared. A good kachina carver is not judged by how he changes the style, but by how he interprets the given elements. A mudhead or a squash kachina always look the same. There is always the same demure, quixotic disposition, the same spirit personification. 'Not only men and animals, but plants, stones, mountains and storms, astral bodies, clouds, sky and underground have spirits which may be evil or beneficent to human beings . . . personified as kachinas, who come into our modern world trailing the tatters of everything historical or legendary in the Hopi past. Their pictures are found carved on stones in various parts of Arizona; their prototypes are found in Zuni and the Rio Grande pueblos; they carry implements like the most ancient ones found in ruins; they chant in languages older than anyone knows; and their customs, though they are prescribed by ancient ritual, still show the effects of the modern store, for a felt hat may be the basis of the god's head-dress, and the priest who serves the underground altar often appears in overalls.'[6] Supplications were enacted in disguise; all the cloud terraces, rain lines, flowers, lightning and water symbols painted on the masks and tablitas were symbols behind which the Indian hid.

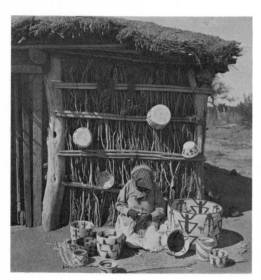

Papago woman making basket
Smithsonian Institution

While Ruth Benedict perhaps overemphasized the passive side of pueblo life when she called the Southwestern Indians Apollonian, her term does generally apply, most of all to the art.[7] The most dynamic designs on the pottery tell of the unhurried approach of the decorator. Each curve is carefully measured as a unit, and each motif is as light as a feather. There is always a sense of enclosure about the cutout forms and silhouettes. The bars and lines that form eyes and the emblems that spell out cloud terraces or feathers are self contained units. The art was associated with the orderly and the rational and the symbolism of corn flowers, sun, rain-filled clouds and prophetic winds tends to the positive, avoiding dark and gloomy subjects on the whole. Mischa Titiev's diary, kept at Oraibi in the 1930s tells us, however, that pueblo peoples were beset with taboos and personal difficulties and tensions; all was not always harmonious in the Apollonian paradise, and there were unpleasant incidents such as the partial exodus from Old Oraibi early in this century and the schism later at San Ildefonso.[8] There is a severity and discipline in the designs understood by the Indians.

What is beautiful dictates the artistic decisions. Even the most ogre-like kachina has some appeal – a sweetness of texture, colour, gesture. Even the grotesque glutton priest in his pot (601) is tame. The ten foot high Zuni Shalako (both the mask of Shalako (659) and a kachina doll instructionary figure are exhibited here (656)) trundles like a gigantic flower-float in a procession. If ritual observance was the man's prerogative then the representation of pastoral imagery was mainly the womens' concern. The rosettes, rainbows, birds, flowers, insects and dragonflies painted so lovingly on Pueblo pots are evidence of this. A Sikyatki bowl with a free-hand rush or reed design seems to glisten with dew or rain drops (555). On another Sikyatki bowl (551) two parrots are back to back on a centre line, in an ingenious reversal of design that suggests the movement they make scrabbling around on a perch.

It is easy to forget the complex preparations needed for the ceremonies and dances, and a significant part of the life of a Pueblo or Navajo dignitary is expended on correctly

conducting every element of the preparation. The philosophy is summarized in the gently persuasive cadence of the long Navajo Night Chant:

> *In beauty (happily) I walk*
> *With beauty before me I walk*
> *With beauty behind me I walk*
> *With beauty below me I walk*
> *With beauty above me I walk*
> *It is finished (again) in beauty*
> *It is finished in beauty*[9]

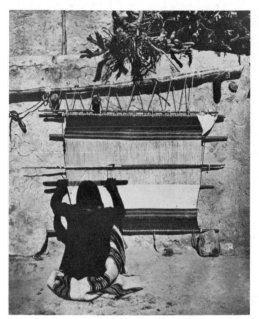

Hopi weaver
Smithsonian Institution

The Southwestern regard for environment can be seen in the terrace patterns, stripes, bars, diamonds and triangle-like elements in Navajo wearing blankets. These are like a poetic recall of the actual landscape with its buttes, mesas in parallel lines, canyons and plateaux, that often stand against each other in ascending configuration, just as they do in the blankets. A mid-19th-century blanket from the museum in Omaha, Nebraska, illustrates this, it parallels the many-layered contours of the northern Arizona landscape (618). In about 1890 the wool warp threads in Navajo textiles were replaced by cotton yarns and at times the motifs were suggested by traders who also supplied analine dyes. In recent years the best Navajo weavers have used vegetable dyes.

The border designs of the Acoma embroidered mantas widened and narrowed according to a fixed formula. The stripes in Navajo chiefs' blankets were laid out with exactitude, so that the progression from the centre is equal in either direction. Occult balance in early Pueblo art takes many forms, a good example is the subtle play of negative-positive apposition in a Mimbres pot (521) with a single animal biting its tail; half the space is left entirely unoccupied, but balance is not lost. Conversely another Mimbres bowl has a design of four turkeys with four exactly equal images balanced in total symmetry (525), as if the design had been drawn on a piece of paper which was then folded and folded again. An Anasazi pot from the Maxwell Museum has a fine-line design of amazing complexity and over-riding constancy, as tightly drawn as the over-lapping lines in a rendering of a ball of twine (540). Even asymmetrical running patterns wander until they somehow consciously balance each other (549). Each carefully decorated pot was in effect a sketch for the next, and each textile was put away to compare against the next. Perfection was an accumulative effort, with little left to chance. A beautifully fashioned necklace of shell beads (hishi) or one of beautifully matched turquoise stones was only made possible by systematic application (640). The same drawn out procedures are essential to their laboriously polished pottery with its rigorously controlled designs.

The war-like Apache evolved an art of consequence that looked both ways. That was only natural as they were distributed in almost pinwheel fashion around the Pueblo and Navajo lands, with the Paiute and Grand Canyon tribes bordering them on the west and the Pima and Papago bordering them to the south. The Apache Gans masks, with open work, tablita-like superstructures attached to soft skin or sacking head covers (674), are obviously loose re-interpretations of Pueblo masks. They are extraordinarily dramatic as worn at a girl's puberty rite by five dancers descending from a mountain cave to enact the creation myth. The burden baskets used at this rite were painted with black and red wave-like designs around the mid-body and decorated with Plains-like buckskin fringes and flaps, painted a musty yellow (565), and the costume was elaborate, strongly influenced by the Southern Plains tribes (627). On the other hand western Apache tray baskets with spacious pinwheel or lily-like designs mark the influence of the western edge of California (567). Other Apache baskets mark contact with Havasupai basketmakers who live in an isolated tributary of the Grand Canyon. The melting-pot character of Apache art is further demonstrated by the parfleche case from the Lipan Apache (626), the most northern Apache group, who were closely influenced in such work by the horse nations further to their north.

In general the lives of the Californian Indians were sparse. The people were not farmers but acorn gatherers and fishermen who from 1300 AD onwards made steatite images to ensure hunting and fishing magic (559). There was small-game hunting among tribes like the Modoc of the Oregon-California border area, and some horse culture among the Nevada Paiute. Although the material conditions of life were simple, a rich dance tradition

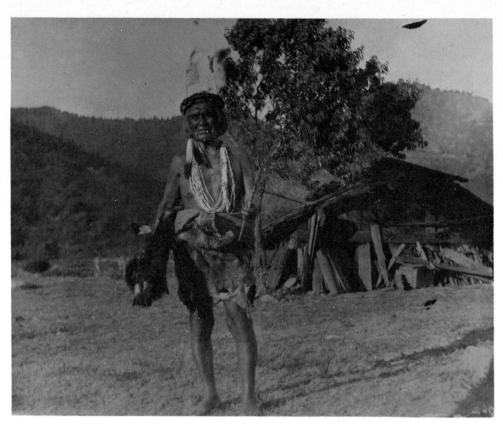

Hupa man, California 1901
Lowie Museum, University of California

existed among the Hupa, Yurok and Karok tribes of the northern part of California. Obsidian blades were used in the deer dance (560), and elkhorn purses were used to hold shell money (561). In fact the Indians of central and northern California were conscious enough of money to make currency part of artistic expression. 'Kaia' shell money was attached to baskets as a decorative refinement and as a symbol of wealth. 'Many thousands of pieces (of finely graded shell money) are coined yearly, and the Indian money-maker is a familiar sight in every rancheria.'[10]

Until settlement began in earnest, as a result of gold in California in 1848, Indian California was like an untouched oasis. The influence of the Hudson's Bay Company was too far north to reach here, while Mexican control of the area was nominal, so that many of the Indians had been left alone, except for those unfortunate Mission Indians that came to depend almost wholly on the early Franciscan fathers (562). But within a short time, little more than half a century, their spirit was broken. Extensive collecting of their artifacts did not begin until shortly before 1890. Only scattered remnants of the old culture remain today. There was so little time to collect that the 1862 deposit date on the Tulare basket from Copenhagen is very early (583).

The Pomo and Hupa made elaborate crowns of carefully matched flicker feather shafts, or plaited cloth ones with irridescent red woodpecker scalps. To their ears and head they attached plugs and delicate mobile-like structures of gossamer lightness (596). Cradles were fashioned from row upon row of open work splints, like a Japanese lantern. The Yokuts of the central California valley, not far from present day Fresno, made large round gambling trays with a design of humans joining hands across the field; some of them were very rich and complex in design, others were more elementary but had great clarity and carefully worked out proportions as in the example shown here (581). Into these trays the women threw dice made of split acorns filled with pitch and ornamented with a shell insert. The same lightness that invested costume also applied to the baskets. These Indians had a simple culture which went hand in hand with gambling and a regard for wealth and conspicuous display – eloquently expressed in outfits and baskets that were notably complex. The people of this area were technicians. The Pomo, for example, had both 'soft' and 'hard' weaves, intricate terms to break down weaving sub-techniques, and clear terms for each type of basket. There was nothing casual about the approach, and nothing simple

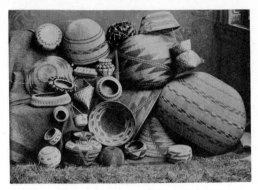

about the highly calculated result. Great baskets can possess a warmth that contrasts with the cold uniformity of pottery. To the Indians these were living things, entities of mind and imagination, and not lightly displayed. The famous Pomo feather-embroidered gift baskets were presented to friends, or given at weddings (593). They were feather-light invocations to rites of passage. Many of these gift baskets, called 'e-pi-ca', were equipped with suspension strings so that they could twist and turn in the sunlight, their abalone shell dangles glinting against the bright colours in the light. The sought after baskets by Datsolalee are the most perfectly executed of all (585). The lidded Mono basket (590) has designs that offer the illusion of expanding and contracting before our eyes. The arrow patterns on Pomo baskets transform into trees (597), and the diamond pattern common to central California baskets suggests the coiled reptilian grace of the snake itself (581).

Photograph of Pomo and Apache baskets
by Carpenter
Catalogue no 686

Notes

1 An invaluable survey of prehistoric Southwestern artifacts is: Franklin Barnett, *Dictionary of Prehistoric Indian Artifacts of the American Southwest*, Flagstaff, Northland Press, 1973.

2 Another theory is that the Athabascan peoples may have taken a Dene weaving tradition with them which made them susceptible to Pueblo weaving techniques. This tradition would have survived in Salish nineteenth century weaving, the Nobility blanket in this exhibition being an illustration in kind.

3 Frank Hamilton Cushing, *My Adventures in Zuni* (originally published in *The Century Magazine*, Vols. XXV and XXVI, 1882–83), Palmer Lake, Colorado, Filter Press, 1967, page 14.

4 Frank Hamilton Cushing, page 2.

5 Hamilton A. Tyler, *Pueblo Gods and Myths*, Norman, University of Oklahoma Press, 1964, page 3.

6 Erna Fergusson, *Dancing Gods, Indian Ceremonials of New Mexico and Arizona*, Albuquerque, University of New Mexico Press, 1931, pages 12–121.

7 Ruth Benedict, *Patterns of Culture*, New York and Boston, Houghton Mifflin Company, 1934.

8 Mischa Titiev, *The Hopi Indians of Old Oraibi, Change and Continuity*, Ann Arbor, University of Michigan Press, 1972. A typical combination of Hopi kindness with exorcism quoted from this book, page 87: 'Joe described the proper treatment of a witch. He said that one must disarm her with kindness and courtesy, otherwise she might inflict even greater injuries on a sufferer. Constant watchfulness was also necessary.'

9 Washington Mathews, *The Night Chant*, New York, American Museum of Natural History Memoir, No. 6, 1902, page 145.

10 Carl Purdy, 'Pomo Indian Baskets and their Makers,' (originally published by C. M. Davis Co., Los Angeles, 1902), Mendocino County Historical Society, Ukiah, California, no date, page 15.

519 Basketmaker objects 100–700 AD
New Mexico and Arizona

a **Sandal**
Arizona, Seyihatsosi Canyon
Fibre 24 cm long
15-11-10/A3554

b **Woven bag**
Arizona, Burial Cave, Marsh Pass
Fibre 12.7 cm long
15-11-10/A2208

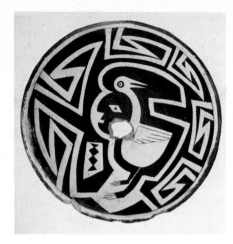

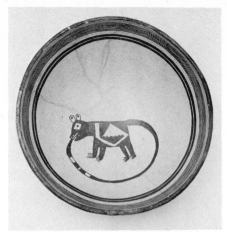

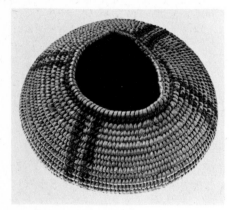

c **Basket**
Arizona, Burial Cave, Marsh Pass
Fibre 44.5 cm high
12-11-10/A2382

d **Bowl**
Colorado, La Plata Penier
Clay 20.3 cm wide
29-38-10/A6293
Lent by the Peabody Museum of
Archaeology and Ethnology, Harvard
University

Basketmaker material has been found in
caves and rock shelters, dried by the sun,
which preserved the fibres and mummified
the bodies. These pre-pueblo examples
demonstrate the early use of the geometric
designs and textile techniques which form
the basis of Southwestern art. Yucca and
milkweed were used for fibres, and string,
shell beads, feathers and bone for jewellery.
Clay was not used until Basketmaker II
times. It is thought that the unworn sandals
found next to bodies were offerings for the
afterlife. Collected between 1915–24.

520 Bowl 1080–1130 AD
New Mexico, Mimbres
Clay 24.5 cm diameter, 11.3 cm deep
Lent by the Janss Foundation

In Mimbres pottery one recurrent symbol is
a long-necked crane associated with a
detached or floating human head. The bowl
exhibited here gives an abstract rendering
of this iconographic idea. The Mimbres
culture has been neglected by
archaeologists for several decades, and the
ruins have been severely pillaged by pot-
hunters, but recent work by the Mimbres
Foundation attempts to save what
information still exists about this unique
culture, and in 1975 on the Mattocks Ruin
this vessel was recovered. It came from a
sub-floor burial in room 431, which was
built in the 1080s AD. The accurate
temporal placement of the bowl is made
possible through the recovery of the first
tree-ring dates for the Mimbres culture.
The vessel was buried with a young woman
who may have died in childbirth.

521 Pot
New Mexico, Mimbres
Painted clay 10.5 cm high, 21 cm wide
Lent by the Taylor Museum of the
Colorado Springs Fine Arts Center 4482

The tail of this animal is sympathetically
adjusted to the curvature of the rim.

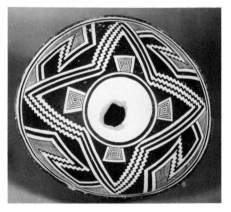

522 Bowl *c* 1100 AD
New Mexico, Mimbres culture
Painted clay
11.5 cm high, 28 cm maximum diameter
Lent by Mr and Mrs Julian W. Rymar

A geometric Mimbres design with a killing
hole for the spirit's release. The stepped fret
recalls contemporary San Juan drainage
pottery designs to the north, in Arizona.

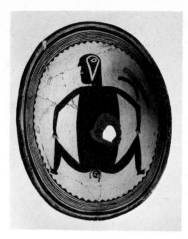

523 Pot *c* 1000–1130 AD
New Mexico, Mimbres
Clay, paint 17 cm wide, 6 cm deep
Lent by the Peabody Museum of
Archaeology and Ethnology, Harvard
University 94632

A birth scene is depicted on this pot. Found
over body in burial on the Swarts ranch,
Grant County, New Mexico (H.S. and C.B.
Cosgrove, *The Swarts Ruin: a Typical
Mimbres Site in Southwestern New Mexico*,
papers of the Peabody Museum, volume
XV, number 1, 1932). Collected by Mr and
Mrs C.B. Cosgrove, 1924.

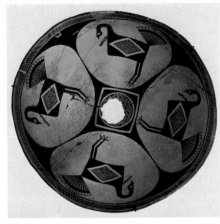

525 Pot
New Mexico, Mimbres
Painted clay 13 cm high, 30 cm wide
Lent by the Peabody Museum of
Archaeology and Ethnology, Harvard
University 94916

A four turkey design pot with beautiful tail
fan patterns and diamonds on the body.
Found over the skull on a burial site at the
Swarts Ranch, in the Mimbres Valley, New
Mexico, collected by Mr and Mrs C.B.
Cosgrove in 1925.

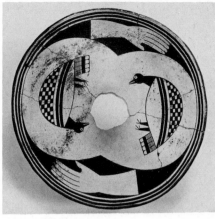

527 Bowl with killing hole
11th–12th century
New Mexico, Mimbres
Painted clay
Lent by the Maxwell Museum of
Anthropology B10/174

The bird and hand motifs are combined
with an extraordinarily vital handling of
the negative 'white' and positive 'black'
base, creating a rhythm that shifts from
clockwise to counter-clockwise. Pots were
often killed ceremonially. This Mimbres pot
was collected before 1930.

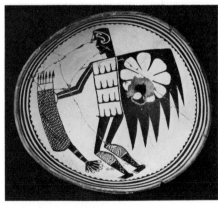

524 Pot 1000–1200 AD
New Mexico, Mimbres
Clay 23 cm wide
Lent by the Peabody Museum of
Archaeology and Ethnology, Harvard
University 24-15-10/94584

This exceptionally fine piece of Mimbres
pottery depicts a warrior with shield, quiver
and arrows. Collected by Mr and Mrs C. B.
Cosgrove in 1924.

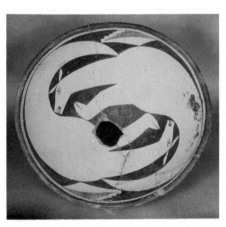

526 Bowl
New Mexico, Mimbres
Clay, painted
11 cm high, 28.5 cm diameter
Lent by the Nelson Gallery of Art/Atkins
Museum (Nelson Fund) 62–21/10

A classic phase pictorial pot with composite
animal forms; deer-like head, lizard-like
tail. The 'killing hole' has been filled.

528 Ornaments *c* 1000–1130 AD
New Mexico, Mimbres
Shell, turquoise 2.5 cm high, 3.5 cm wide
Lent by the Peabody Museum of
Archaeology and Ethnology, Harvard
University 95762

These bird ornaments are from Nan Ranch
Ruin, three miles below the Swarts Ruin on
the east side of the Mimbres River; they
were found at the right side of a child's skull
in grave number 34, below the floor of a
house. Collected by the Cosgroves, 1926.

529 **Bird fetish** *c* 1000–1130 AD
New Mexico, Mimbres
Wood, paint 10.5 cm high, 35 cm wide
Lent by the Peabody Museum of
Archaeology and Ethnology, Harvard
University 95458

This sculpture and the tablita hint at a rich
Mimbres wood carving tradition, co-
existing with the pottery. The discovery of a
multiple-image owl painted effigy board,
with other wooden artifacts miraculously
preserved in a dry cave in the Mimbres
Valley area in 1975, gives further support
to this idea, and helps explain the fragments
at Harvard, of which this piece is one of the
most legible. Collected by the Cosgroves in
1926 from a cave on the Doolittle ranch,
Grant County, New Mexico, in a tributary
canyon of the Mimbres River.

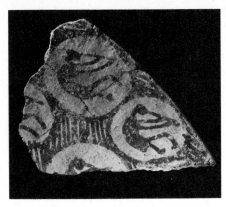

531 **Potsherd** *c* 800–900 AD
Arizona, Hohokam
Clay, paint 12 cm high, 9 cm wide
Lent by the Peabody Museum of
Archaeology and Ethnology, Harvard
University 4980

This object has a hump-backed flute player
painted on it, 'Kokopelli'. He is today a
Hopi kachina whose main concerns are
rain, harvests and human fertility, but his
origins in the Southwest may be very
ancient; he appears on Anasazi pictographs
and petroglyphs, and on San Juan Pueblo
II pottery. He figures also in Hohokam art,
on his way north from mezzo-American
origins. It has recently been questioned
whether the Hohokam flute player is in fact
ancestor of the Hopi Kokopelli, or whether
he is related to the flute player who
symbolizes part of Tezcatlipoca, God of the
Smoking Mirror, in ancient Mexico valley
ceremonies. A link might still be made, even
though the modern Kokopelli has different
attributes. (See Charles di Peso, volume 2,
page 305.) Collected at Snaketown,
Arizona. Gilla Butte phase.

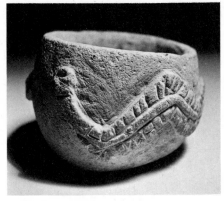

533 **Effigy vessel** 10th–11th century AD
Arizona, Hohokam
Clay 10 cm diameter
Lent by the Heard Museum
NA–SW–Hh–A1–113

This 'colonial' period vessel's sides represent
a coiled rattlesnake; crossed lines show
scales. It is mica and sand tempered. A
similar bowl is illustrated in Wolfgang
Haberland's *The Art of North America*, New
York, Crown Publishers, 1964, page 99.

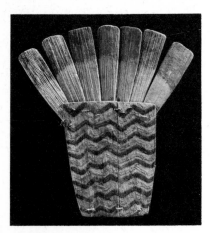

530 **Tablita** *c* 1000–1130 AD
New Mexico, Mimbres
Wood 42 cm high, 43 cm wide
Lent by the Peabody Museum of
Archaeology and Ethnology, Harvard
University 97378

Found in a cave on Mule Creek, a tributary
of the San Francisco River, Grant County,
New Mexico. Collected by the Cosgroves in
1929.

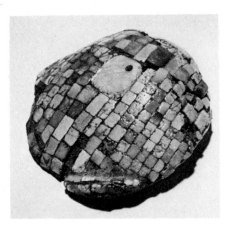

532 **Pendant** *c* 900–1100 AD
Arizona, Hohokam
Shell, turquoise, coral
5 cm long, 3.5 cm wide
Lent by the Heard Museum
NA–SW–Hh–J–29

There is a long tradition of mosaic pendants
in the Southwest; work similar to this is still
being done today. Collected by Frank
Mitalsky at La Ciudad Ruin, Phoenix.

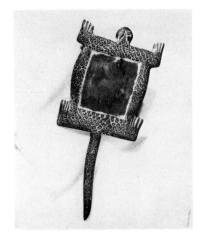

534 **Palette** *c* 900–1100 A D
Arizona, Hohokam
Slate
25.5 cm long, 12 cm wide, 1.3 cm deep
Lent by Mr and Mrs Rex Arrowsmith

These palettes were used by the Hohokam
peoples to prepare paint. This is an
elaborate incorporation of the lizard image.
Snaketown phase.

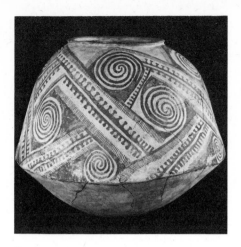

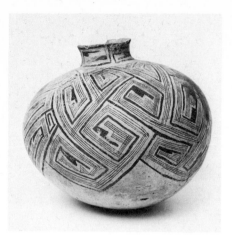

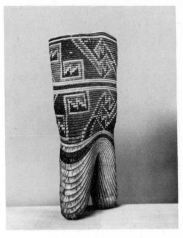

535 **Jar** 900–1100 AD
Arizona, Hohokam
Clay, paint
Lent by Anthony Berlant

Red and buff designs on a voluminous
Hohokam pot. The linear motifs may have
been suggested by the geometric lines of
irrigation channels and ditches.

537 **Pot** 1000–1100 AD
Arizona, Anasazi
Clay, paint 25.5 cm high, 30 cm diameter
Lent by the Heard Museum
NA SW Mg A2 1

Olla or high-shouldered water storage
vessel painted with opposing and
continuous diagonal lines with solid and
hatched patterns. The star-shaped bottom is
close to Tularosa ware, but sloppy
execution is reserve black and white type.
From Citadel Ruin, northeast of Flagstaff,
Arizona.

539 **Baby carrier** 1050–1300 AD
Arizona, Anasazi
Coiled basketry
56 cm high, 22 cm wide, 15 cm deep
Lent by the University Museum,
Philadelphia NA 4925

There is some discussion about the use of
this uniquely preserved Pueblo III period
basketry construction, which reflects the
influence of the earlier Basketmaker culture
c 500–600 AD upon the succeeding pueblo
peoples. The zig-zag and key designs are
sharply defined in two reverse zones,
separated by parallel bands, so that the
design is equally beautiful upside-down.
The transition from the cylindrical body to
the overlapping coiled foot is
extraordinarily skilful. The original
location of this piece is unknown.

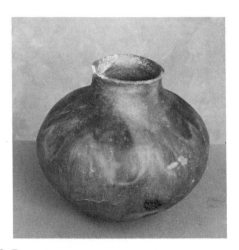

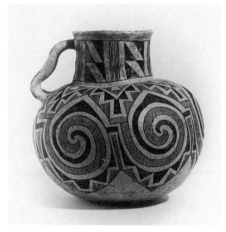

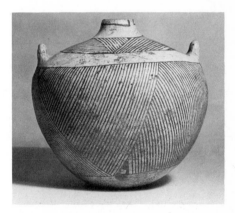

536 **Pot** c 1150–1300 AD
Arizona, Hohokam
Clay 21 cm high, 25 cm diameter
Lent by Darrell L. Bolt

Seed storage type pot, of Gila red. The
Hohokam peoples lived in the Salt and Gila
River valleys to the south and near present-
day Phoenix. The fire clouding decoration
is intentional. 'The presence of each cloud
represents the spot where a stick rested
against the vessel; as the stick burned, a
yellowish corona was formed around the
black spot, and this then changed into the
normal red background of the pot.' (Emil
W. Haury, in a letter concerning this pot.)

538 **Jar with handle**
New Mexico, Anasazi
Clay, paint
17.5 cm high, 45 cm circumference
Lent by the Maxwell Museum of
Anthropology B10/447

A Tularosa black and white jar decorated
by a system of six swirls and geometric filler
designs. For other Tularosa style pottery see
numbers 544, 537.

540 **Pot** c 1250–1300 AD
New Mexico, Anasazi
Clay, paint 20 cm high, 20 cm wide
Lent by the Maxwell Museum of
Anthropology 9208.5.10

This Taos black and white decorated
canteen, with handles and covered
shoulders, has fine line work in overlay
design. Found on the D.H. Lawrence
ranch, near Taos, where the author lived.

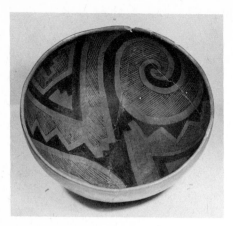

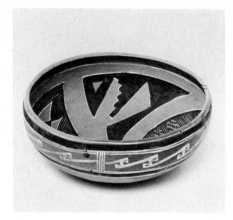

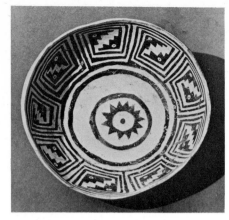

541 **Bowl** *c* 1250 AD
Arizona, Anasazi
Clay, paint
12.5 cm high, 27.5 cm diameter
Lent by the Maxwell Museum of
Anthropology B10/344

A typical Saint John's polychrome red ware
pot, originating from the Wingate area of
northeastern Arizona. This type of ware
was heavily traded in its period, and is
found in many sites in the Southwest.

543 **Bowl** 1300–1400 AD
Arizona, Anasazi
Clay, paint 11 cm high, 25.5 cm diameter
Lent by the Heard Museum
NA SW Mg A7-4

Red slipped composite black and white
scroll and abstract design; typical of painted
work made about 1300–1400 AD in an area
four miles north of Holbrook, Arizona,
hence the term four-mile polychrome.
Collected by Raymond Lucas.

545 **Five bowls** 1000–1200 AD
Arizona, near Snowflake
Pottery
a Snowflake black on white, no. 126
25.6 cm diameter
b No. 102
11.3 cm high, 22.5 cm diameter
c Sun design, no. 128
19 cm diameter
d No. 125
21.2 cm diameter
e Holbrook black on white, no. 112
11.2 cm high, 22.5 cm diameter
Lent by Leland and Crystal Payton

All of these black on white bowls were
excavated not many miles from Snowflake,
Arizona. These are San Juan pieces from
the late Pueblo II to Pueblo III periods.

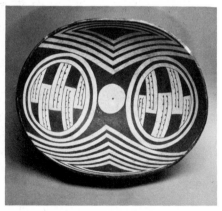

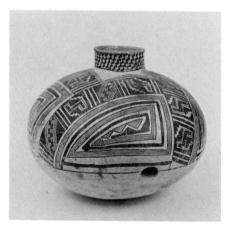

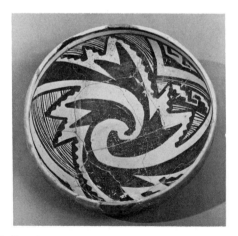

542 **Pot** *c* 1200–1350 AD
Arizona, Wingate
Clay 25.5 cm high, 30.5 cm wide
Private Collection

This exceptional Wingate pot with its bold,
graphic circles and chevron design looks
forward to the 'reed' and 'rush' designs on
the Sikyatki pot from the Berlant
Collection.

544 **Pot** *c* 1100 AD
New Mexico, Tularosa
Clay 33 cm high, 40 cm diameter
Lent by the Taylor Museum of the
Colorado Fine Arts Center 4601

This pot has carrying holes. The controlled
black (positive) and white (negative) zones
of Tularosa vessels point toward the
complicated Pueblo III and IV pots.

546 **Bowl** *c* 1300–1350 AD
Arizona, Gila River
Pottery 11 cm high, 24 cm diameter
Lent by Leland and Crystal Payton
No. 131

The nervous free-hand decoration is typical
of late Gila pottery. It was made by the
Salado people who were successors to the
Hohokam on the Gila River, coming from
the Little Colorado. These two unrelated
tribes seem to have come together in a
friendly manner and lived in the same
communities.

204

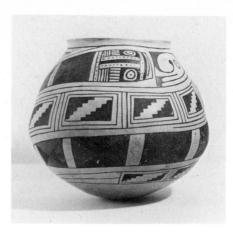

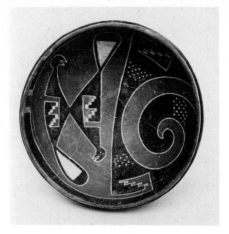

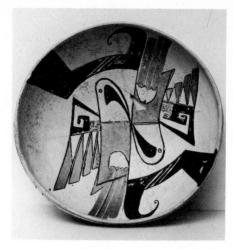

547 Pot 1160–1260 AD
Mexico, Casas Grandes, Chihuahua
Clay, paint 23.5 cm high, 28 cm diameter
Lent by the Maxwell Museum of
Anthropology 65.24.76

This pot has three serpents painted around
its circumference with raised head designs,
and two macaws. Casas Grandes was in
mediaeval times a dissemination point
between Mezzo–America and the
Southwest. Macaws were raised there and
traded to the north, influencing the
pueblos, who still use macaw feathers in
ceremonies today and carve parrot fetishes
(see number 665). Charles de Peso (volume
2, page 468) pictures macaw nesting boxes
and turkey pens at Casas Grandes.

549 Bowl 16th century
Arizona, Holbrook vacinity
Clay, paint 31 cm diameter, 13 cm high
Lent by Anthony Berlant

This is a four-mile polychrome with a
circular field, equally divided into a scroll
and a striking double parrot design.

551 Bowl 16th century
Arizona, Sikyati
Clay, paint 26 cm diameter, 8 cm high
Lent by Anthony Berlant

This polychromed bowl has an even more
complex, convoluted and sweeping double
parrot design than the earlier four-mile
polychrome (number 549).

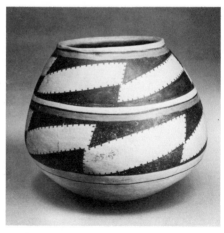

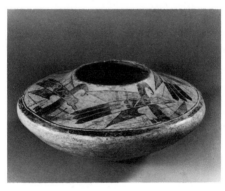

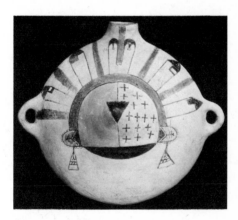

548 Pot 1160–1260 AD
Mexico, Casas Grandes, Chihuahua
Clay, paint 18 cm high, 20.5 cm diameter
Private Collection

While some features of Casas Grandes
culture are middle American, others point
further north, among them the
parallelogram motif (as used here in a two-
tiered design) which reappears in Historic
period pueblo Rio Grande pottery. (See
Larry Frank and Francis Harlow, numbers
18, 20, 59, 107, 127, 128.) Later on the
design was used on the neck or shoulder of a
pot, rather than on the body.

550 Jar 15th century
Arizona, Sikyatki
Clay, paint 17.5 cm high, 40 cm wide
Lent by the Peabody Museum of
Archaeology and Ethnology, Harvard
University 25093

This large storage jar was collected by
Thomas V. Keam in 1890; received by the
Museum in 1943.

552 Canteen 16th century
Arizona, Sikyatki
Clay, paint
44 cm high, 41 cm wide, 21 cm deep
Lent by Anthony Berlant

This pot is proof that the canteen shape is
pre-European, and not borrowed from US
army issue. The design is a variation on the
Ahül kachina, and the mask form and
feathers have been adapted to the circular
ceramic shape. A similar canteen is in the
Field Museum, Chicago.

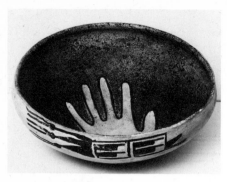

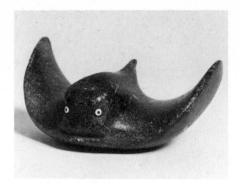

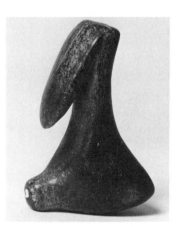

553 **Bowl** 16th century
Arizona, Sikyatki
Clay, paint 28 cm diameter, 11 cm high
Lent by Anthony Berlant

The spatter-painted hand design on this
fine pot is an example of the free effect
achieved by the northern Arizona potters.
The outside border is gracefully juxtaposed
to the interior image.

555 **Bowl** 16th century
Arizona, Sikyatki
Clay, paint 24 cm diameter, 11 cm high
Lent by Anthony Berlant

A reed design is perhaps intended; see
number 542 for a Wingate interpretation of
the motif. This Sikyatki version is drawn in
a looser free-hand technique, rather like
Japanese ceramic designs. (It too is Shibui.)

557 **Stingray** c 1600 AD
California, Chumash
Steatite, shell, pitch
4.5 cm high, 9.5 cm wide, 6.5 cm long
Lent by the Southwest Museum, Los
Angeles 149–G–100

These steatite images from the Channel
Islands of southern California constitute the
only naturalistic sculptural manifestation
between the Columbia River and the west
coast of Mexico.

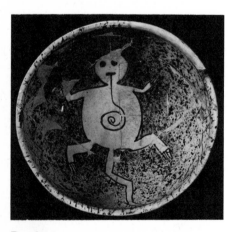

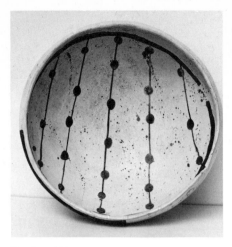

554 **Bowl** c 1400–1500 AD
Arizona, Awatovi
Clay, paint 11 cm high, 23 cm wide
Lent by the Peabody Museum of
Archaeology and Ethnology, Harvard
University 5360A

This restored pottery bowl with zoomorphic
figure was excavated by J. O. Brew at
Antelope Mesa, Hopi reservation at
Awatovi.

556 **Petroglyph fragment**
California, Inyo County, King's Canyon
Stone 46 cm long, 26 cm wide
Lent by the Southwest Museum, Los
Angeles 823-G-7

This fragment stands for the most
widespread Amerindian art: rock carving
and painting. Examples have been found
from Vermont to California, and
throughout Canada. This fragment comes
from Pre-Hispanic southern California,
King's Canyon, west of Darwin, Inyo
County. A mountain sheep has been etched
into the charcoal grey stone.

558 **Pelican** c 1600 AD
California, Chumash
Steatite, shell, pitch
8 cm high, 4 cm wide, 5.5 cm long
Lent by the Southwest Museum, Los
Angeles 149–G–108A

Like the whale and stingray in this
exhibition this pelican stone was used in
fishing-magic rites held by the Chumash
Indians, who inhabited the channel islands
and coast area above present day Los
Angeles before the establishment of the
white man. Shell eyes and breast points
were attached by pitch taken from the La
Brea tar pits on the grounds of the Los
Angeles County Museum of Art.

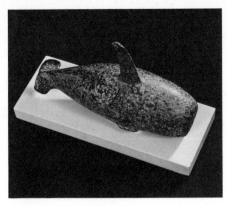

559 Whale *c* 1600 AD
California, Chumash
Steatite 13 cm high, 21 cm wide
Lent by Karen Bunting

The killer whale (actually a type of shark) sought the warmer waters of southern California in the winter where it was seen by the Chumash. In summer it appeared off the Northwest Coast and became part of the mythology of the Haida and Tlingit.

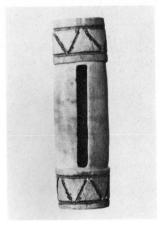

561 Purse
Northern California
Elk antler 14 cm high, 4 cm wide
Lent by the National Museum of Denmark, Department of Ethnography H 1938

This is an unusually large and impressive elk horn purse.

563 Basket 18th century
Southwest, California
Grass 30.5 cm diameter
Lent by the Trustees of the British Museum VAN 188

Shallow golden-brown basket, made by Mission Indians from Santa Barbara, collected by Hewitt on Vancouver's voyage. Ornamented outside and inside with narrow circumference bands of black and white chequers between which are spaced woven spread eagle designs. Presented by A. W. Franks, March 16 1891.

560 Blade
California, Klamath River
Obsidian 29 cm long, 13 cm wide
Lent by the Peabody Museum of Archaeology and Ethnology, Harvard University R464

Used in the deer dance of the Hupa, Yurok and Karok Indians of extreme northern California. Deposited in the museum by Frederick H. Rindge of Santa Monica, California, between 1894 and 1896.

562 Dish
California, Mission Indians
Spruce root 45.5 cm diameter
Lent by the Trustees of the British Museum N.W.C.46

The catherine-wheel design is in black on a rusty-coloured field. This basket was made by the Mission Indians, near present-day San Diego.

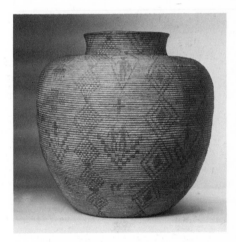

564 Storage vessel *c* 1890–1900 AD
Arizona, Apache
Basketry
Lent by the Nelson Gallery of Art/Atkins Museum (Nelson Fund) 33–1312

The Apache excelled at the making of large storage baskets for holding grain (even taller ones were made for trade). The designs – figures, diamonds, crosses and chevrons – are similar to those on Mescalero trays but have been more widely spaced.

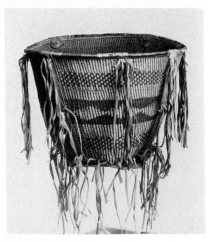

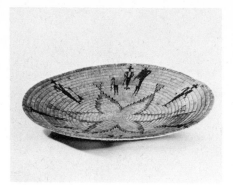

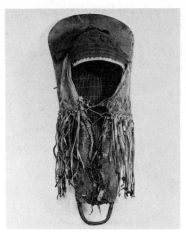

565 **Burden basket** Before 1900 AD
Arizona, Western Apache
Willow, buckskin
38 cm high, 40.5 cm diameter
Lent by the Nelson Gallery of Art/Atkins
Museum (Gift of Daniel R. Anthony III
and Mrs Eleanor A. Tenney) 50–73/28

A superbly executed version of a twined
burden basket that was used as a gift or food
basket as well as for its usual carrying
function. While the latter use has largely
disappeared today see Thomas Mails, page
81, for photographs of a basket of this type
used at the 1969 San Carlos Apache
puberty girl's rite. Rarely do the colours
survive so well as on this example.

567 **Tray basket** c 1900 AD
New Mexico, Apache
Willow 8 cm high, 57 cm diameter
Lent by Mr and Mrs Rex Arrowsmith

A star design in the centre of this round
Jicarilla basket is embellished by strongly
vertical designs in all the spandrels, showing
a man on horseback with spurs, three men
holding guns, and two deer. The designs
radiate across the coils in wave-like
reflections.

569 **Cradle**
Nevada, Paiute
Buckskin, wickerwork
91.5 cm long, 36 cm wide
Lent by the Southwest Museum, Los
Angeles 1393-G-2

Paiute cradles combine the Apache concern
with textiles with the Californian basketry
forms. This example is decorated with
flower motifs along the flaps and beads
along the fringed edges.

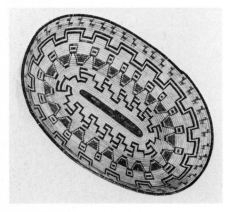

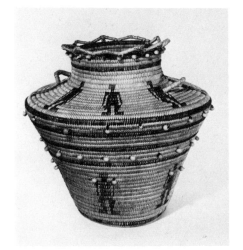

566 **Tray basket** c 1900 AD
New Mexico, Apache
Willow, myrtia, yucca root
57 cm diameter
Lent by Mr and Mrs Rex Arrowsmith

This is probably of Jicarilla Apache origin.
It has 43 animals around the inner rim and
a complex geometric field, exploiting
dynamically the large elongated oval
format.

568 **Basket** c 1900–1910 AD
Nevada, Paiute
Willow, beads 9 cm high, 16 cm diameter
Lent by Mr and Mrs George Lewis

This all-over beaded trinket basket, a
Paiute trade speciality, is interesting
because of its subtle colour harmony and
size, and for the refinement of its pinwheel
design, best seen from the underside.

570 **Olla** c 1910 AD
Arizona, Pima
Willow root, myrtia 35 cm high, 35 cm
wide
Lent by Mr and Mrs Rex Arrowsmith

This basket bears comparison with pottery.
The weaver relieved the monotony of
repeated figures by using opaque blue
padre beads.

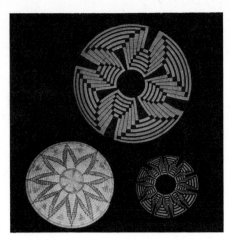

571 **Tray baskets** *c* 1910–1930 AD
Arizona, Pima
Willow, myrtia
a 6 cm high, 38 cm diameter
b 68.5 cm diameter
Lent by the Maxwell Museum of
Anthropology 68.68.81, 68.68.78

These Piman trays were used for food
gathering, principally mesquite beans.
Squash blossom designs. From the Gila
River Reservation. *b* was made by Mrs
Johns.

c **Tray basket** 20th century
New Mexico, Apache
Willow 9 cm high, 51 cm wide
Lent by the Maxwell Museum of
Anthropology 65.42.54

This Mescalero Apache basket is a more
modern example of number 567.

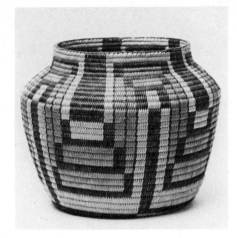

573 **Basket** Early 1930s
Arizona, Pima
Grass, martynia and willow, utoi root
28 cm high, 34 cm diameter (at shoulder)
Lent by the Heard
Museum NA–SW–Pi–B–331

This coiled basket has stepped 'turtle'
patterns in black and red and white utoi
root dye. It was made at the Gila River
reservation by Anastasia Zachory.

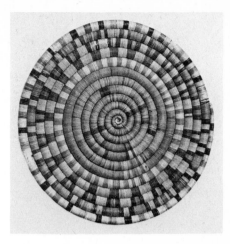

575 **Plaque** Early 20th century
Arizona, Hopi
Grass, yucca 44 cm diameter
Lent by the Heard
Museum NA–SW–HO–B–120

On the Second Mesa Hopi basketry plaques
are coiled around a grass foundation.
Modified cloud pattern; the centre motif is
an unidentified kachina. Given by Byron
Harvey.

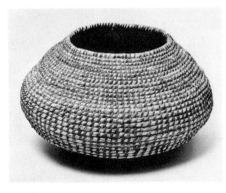

572 **Basket** 20th century
Arizona, Pima
Wheat straw
27.5 cm diameter (at opening)
Lent by the Heard
Museum NA–SW–Pi–B–301

Bundles of wheat straw are lazy-stitched
with either unpeeled willow or mesquite
bark for this simple, strong granary storage
basket. Made by Gloria Manuel of the Gila
River reservation. Collected by Byron
Harvey in 1971, before it was ever used.

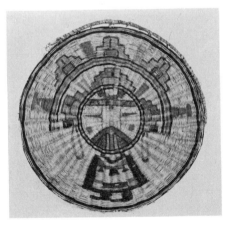

574 **Plaque** Early 1900s
Arizona, Hopi
Wicker, grass
Private Collection

Wickerwork is a speciality of the Hopi 3rd
Mesa. This plaque depicts Polik Mana or
the Butterfly Kachina.

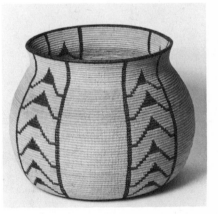

576 **Basket**
California, Chemehuevi
Willow, martynia
25.5 cm high, 31 cm diameter
Lent by the Southwest Museum, Los
Angeles 1499–G–151

The very small tribe of Chemehuevi, from
the lower Colorado River basin area of
Colorado, have an almost oriental
sensibility, demonstrated here in the
placement of the designs against the field.

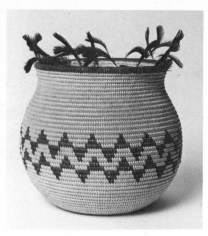

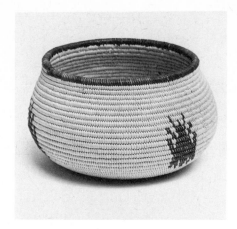

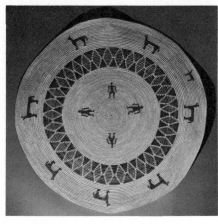

577 **Basket**
California, Chemehuevi
Willow, martynia with quail feather
trim 12.5 cm high, 13 cm diameter
Lent by the Southwest Museum, Los
Angeles 742–G–63

579 **Basket** 20th century
Arizona, Chemehuevi
Willow, martynia (devil's claw)
8 cm high, 13.5 cm wide
Lent by the Heard
Museum NA–SW–CM–B–3

This small basket is relieved only by three
tiny insect (stink bug) designs in martynia,
and a dark rim in the same vegetal
material. The Chemehuevi are unsurpassed
in the lower Colorado River area for giving
their baskets a tight, crisp elegance. From
Parker, Arizona.

581 **Gambling tray** *c* 1900 AD
California, Yokut
Swamp grass, redbud, bracken fern
66 cm diameter
Lent by the Fine Arts Museums of San
Francisco 51962A

The Yokuts gambling tray or 'table' was
woven for a woman's dice throwing game,
the discs made of walnut or acorn half shells
filled with pitch and imbedded with
abalone shell. This type of weaving stopped
shortly after 1900. This example is fairly
simple in design; the band is a rattle snake
image. For more complex Yokuts trays see
illustrations to Jerald Collings, 'The Yokuts
Gambling Tray', *American Indian Art
Magazine*, volume I, number 1, 1975, pages
10–15.

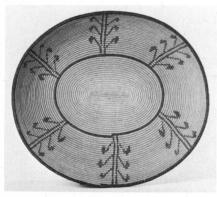

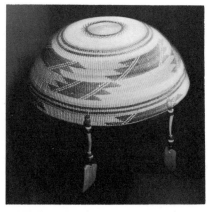

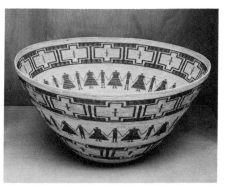

578 **Basket**
California, Chemehuevi
Willow, martynia, juncus
8 cm high, 40 cm diameter
Lent by the Southwest Museum, Los
Angeles 1499–G–159

580 **Cap**
California, Yoruk
Fibre with beads and shell decoration
35.5 cm high, 71 cm diameter
Lent by the Fine Arts Museums of San
Francisco 57983

Worn to protect the forehead against
carrying-straps. The baskets of the
Californian Indians are more finely woven
and have more imaginatively spaced
designs than do the baskets of the Nez Percé
(see number 487).

582 **Storage basket**
California, Yokut
Fibre 35.5 cm high, 71 cm diameter
Lent by the Fine Arts Museums of San
Francisco 51961N

The precision of Yokut design approaches
mechanical perfection. Note the unvarying
and expertly controlled progression of large
and small figures, and wide and narrow
bands.

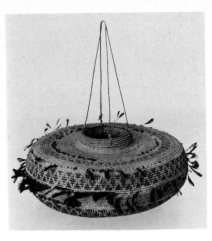

583 Basket Before 1862 AD
California, Tulare
Basketry 20.5 cm wide
Lent by the National Museum of Denmark,
Department of Ethnography Hc 481

As it was deposited in the museum in 1862
this must be an extraordinarily old Tulare
basket, far more subdued than more recent
examples (see number 584). The
rattlesnake design relates to Yokuts work
(581) while the shape recalls the Pomo.

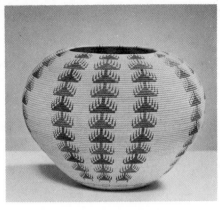

585 Basket Begun March 26 1917
and finished February 16 1918
Nevada, Washo
Mountain willow, bracken fern, redbud
bark 15.5 cm diameter, 31 cm high
Lent by the Clark Field Collection, the
Philbrook Art Center

Woven by Datsolalee (1831–1926), the best-
known American Indian basket maker, this
is perhaps her most perfect work. The
designs emerge from the rim like a waterfall
or bird migration, and the rhythm of the
pattern is matched by technical skill and
taughtness of weave. Appropriately enough
Datsolalee (Wide Hips) was named as a
child Young Willow. She completed 46
baskets on this scale, as well as smaller
baskets and rougher traditional conical
burden baskets. This is one of the last she
completed before going blind and is the
summation of her work; it took just short of
a year to complete. Datsolalee's work was
publicized in her lifetime and was much
sought after.

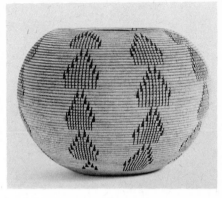

587 Basket 1900 AD
Nevada, Washo
Fibre 26.6 cm diameter
Lent by the Brooklyn Museum 72.5.2

Woven by Datsolalee. Note the alternations
of thickness in the arrowshaft groupings
between the various rows.

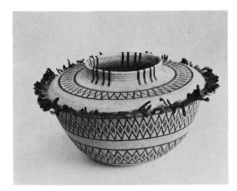

584 Basket Early 20th century
California, Tulare
Basketry with fringe of yarn and
feathers 26 cm high, 15.5 cm wide
Lent by the Nelson Gallery of Art/Atkins
Museum (Nelson Fund) 33–1272

This basket shows the change in Tulare
baskets from the 19th to the 20th century.

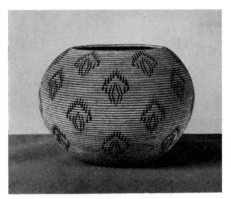

586 Basket c 1905 AD
Nevada, Washo
Willow, fern root
18 cm high, 25 cm diameter
Lent by the University Museum,
Philadelphia 38–26–1

By Datsolalee.

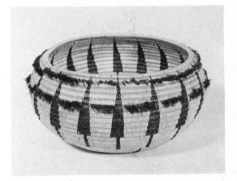

588 Basket Early 20th century
Nevada, Washo
Willow splint 8 cm high, 20 cm diameter
Lent by the Taylor Museum of the
Colorado Springs Fine Arts Center 1800

The design shows six arrowhead patterns
in a star form on the base, and tree patterns
around the shoulder, with two rows of
feathers woven in below the rim. Note the
alternations in thickness of the tree designs
between the rows. Made by Datsolalee.
Collected by Seligman.

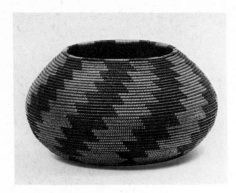

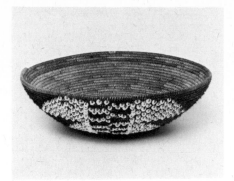

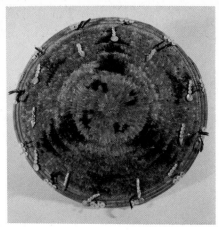

589 Basket *c* 1900 AD
Nevada, Washo
Willow, bracken fern root, redbud bark
19 cm diameter, 10 cm high
Lent by Donald D. Jones

Washo basket makers saved tri-colour effects for their best work. Twenty-nine stitches to the inch.

591 Basket Mid 19th century
California, Pomo
Grass, feathers, shell 24 cm diameter
Lent by the Trustees of the British
Museum 6222

Saucer-shaped gift basket, decorated with red woodpecker feathers and small perforated discs of white shell. Presented to the Christy Collection by W.J. Bernhard-Smith, March 4 1870.

593 Feather basket
California, Pomo
Feathers, shell, willow
5 cm high, 31 cm diameter
Private Collection

These baskets were given as gifts, often to mark rites of passage. The yellow feathers are breast of meadowlark, the orange ones are from woodpecker scalps, the dark ones are from Mallard duck. The shells were money; hence these were precious treasure objects. Quail feathers accent the rim. Collected at Clear Lake, California.

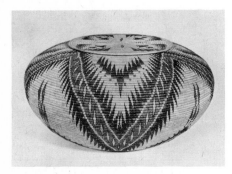

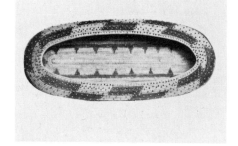

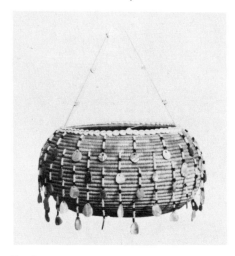

590 Lidded basket 1930 AD
California, Mono
Squawgrass, maidenhair fern
25.5 cm high, 51 cm diameter
Lent by the Taylor Museum of the
Colorado Springs Fine Arts Center 5641

The diameter of the mouth equals the height of this basket, and the four corner design elements of the lid are carried visually by the four tips of the chevron designs that meet the lid. Compared to the Washo bowl form (which this basket approaches) the swell at mid-body is noticeably more eliptical and the design components correspondingly stacatto and complex to emphasize and dramatize this sharp transition. One of the finest and most classic of Californian coiled baskets, it accomplishes through design variety and effulgence what the Datsolalee baskets accomplish by repetitive restraint: they are opposite sides in the California–Nevada basket complex. Made by Lucy Telles, another well-known basket maker, collected by P.B. Stewart.

592 Basket *c* 1900 AD or earlier
California, Pomo
Basketry, beads, shell
4.5 cm high, 39 cm long
Lent by the Nelson Gallery of Art/Atkins
Museum (Gift of Dr and Mrs W. David
Francisco) 72–15/2

An excellent example of a canoe-shaped basket with patterned weave. The shape of the body is more tightly executed than that of the typical Pomo feather basket, which was usually made using a simpler and rougher coiling technique. This basket was made using the Bambishu (three rod foundation) ribbed technique. The bead accents are subtly spaced wider and wider apart as they get further from the rim. Note how the dark areas are set with blue beads and light areas with red to mark pattern changes.

594 Basket *c* 1910 AD
California, Pomo
Basketry, shell, beads, root suspension
cord 7.5 cm high, 16.5 cm diameter
Lent by the Nelson Gallery of Art/Atkins
Museum (Gift of Dr and Mrs W. David
Francisco) 72–15/1

A non-feathered variant of the Pomo 'jewel' basket. Note the perfection of the globular shape. Two and three tiered hanging rows of shell pendants float from the shoulder and body of the basket in eye-catching profusion. Seventy-five of these pendants were tied by the maker, to make a crystalline relationship between static body and ephemeral embellishment. Bead pendant stalks add a quiet note of colour.

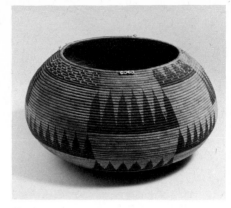

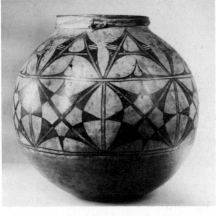

595 Pair of miniature baskets 20th century
California, Pomo
Willow, feathers
a Meadowlark feathers, quail
4 cm diameter
b Mallard feathers, quail 3 cm diameter
Private Collection

Made traditionally as miniature works to
show the maker's skill, today they are sold
as trinkets.

597 Basket
California, Pomo
Fibre, beads
Lent by the Fine Arts Museums of San
Francisco 2680L

This basket represents lines of arrowheads,
in a pictorial fashion.

599 Jar 1770–1780 AD
New Mexico, Kiua type, Cochiti (?)
Clay, paint 50 cm high, 53.5 cm diameter
Lent by the Nelson Gallery of Art/Atkins
Museum (Nelson Fund) 33–1146

The red rim on this strong-bodied
important jar denotes a date of about
1770–1780. After 1800 Kiua type pottery
has a black rim. The articulated feather
patterns are in shades of red, an unusual
feature not recorded elsewhere. It is
impossible to determine exactly whether it
was made at Cochiti or Santo Domingo;
after about 1850 the pueblos who made
these pots always made a distinct variation
on the bold patterns, those from Santo
Domingo having a more severe geometric
style and those from Cochiti being more
crowded and varied in design. Early
Historic pueblo pottery is rare, because
Spanish church authorities did not allow it
to be buried with the dead, and much was
destroyed in use. This piece has an old
binding to prevent cracking around the
neck. Purchased from Fred Harvey as
Cochiti ware.

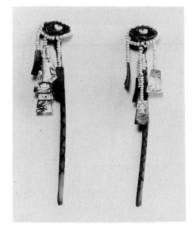

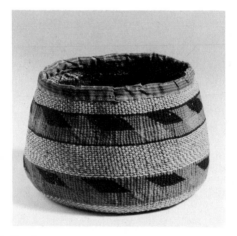

596 Pair of earplugs
California, Pomo
Bone, feathers, beads, shell 20.3 cm long
Lent by the Brooklyn Museum X765

The complete Pomo costume made the
wearer shimmer in the light with dangles
composed of feather shafts, feathers, beads
and fur. Similar costumes were worn by the
Karok and other northern California tribes,
but the Pomo ones were more delicately
conceived.

598 Basket
Northern California, Modoc
Fibre, wool 8.5 cm high, 7 cm wide
Lent by the Fine Arts Museums of San
Francisco 5134

The Modoc excelled at red wool
embroidery, which brightened their
baskets. They also painted bold red and
black designs on their bows.

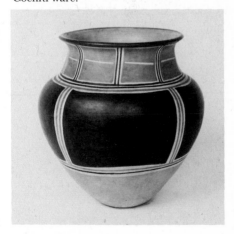

600 Olla *c* 1910–1915 AD
New Mexico, Santo Domingo
Clay, paint 28.5 cm high, 28 cm diameter
Lent by the Denver Art
Museum XSD–33

The 'negative' decoration on this water
storage jar was devised by three women of
the Aguilar family.

601 Kachina in jar
Arizona, Hopi
Wood, clay 16 cm high, 13 cm wide
Lent by the Peabody Museum of
Archaeology and Ethnology, Harvard
University 10/28886

This work shows the Tcüchkuti kachina
(glutton priest) in a jar-like 'Jack in the
box'. The cover of the jar is decorated with
the head of the Shalako Mana.

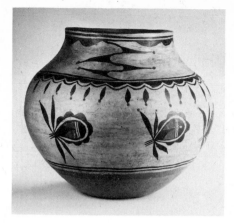

603 **Water jar** *c* 1880–1890 AD
New Mexico, Tesuque Pueblo
Clay, paint 25.5 cm high, 28 cm diameter
Lent by the Nelson Gallery of Art/Atkins
Museum (Gift of Daniel R. Anthony III
and Mrs Eleanor A. Tenney) 50/7310

An example of Tesuque Tatunge
polychrome, showing the dimpled surface
common at this pueblo, caused by the
slipping of the polishing stone. Six insects
are depicted around the middle of the body.

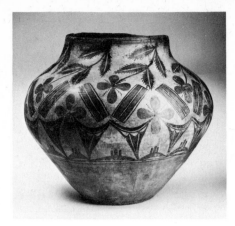

605 **Water jar** *c* 1890 AD
New Mexico, Zia Pueblo
Clay, paint 29 cm high, 27 cm wide
Lent by the Nelson Gallery of Art/Atkins
Museum (Nelson Fund) 3311/64

Decorated with feathers, flowers and native
mint leaves. Purchased from Fred Harvey.

602 **Jar** 1850–1860 AD
New Mexico, Isleta
Clay 33 cm high, 48.5 cm wide
Lent by the Maxwell Museum of
Anthropology 75.47.22

The original collector of this pot, Ruby
Johnson, was told that this storage jar,
excavated from an abandoned house in the
pueblo of Isleta, had holes put in it to keep
the bread (grain) from becoming stale.
Bought about 1968; from the worn
character of the rim this jar saw much use.

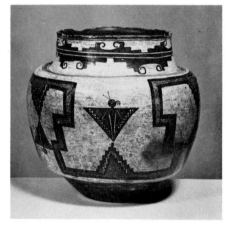

604 **Water jar** Early 19th century
New Mexico, Zuni
Terracotta 31.5 cm high, 33.6 cm
diameter
Lent by the Brooklyn Museum 03.132

This boldly decorated jar is distinguished
by its high shoulder, indented base and the
butterfly designs painted against the cream
slip. Collected by Stewart Culin on the
Museum Expedition in 1904.

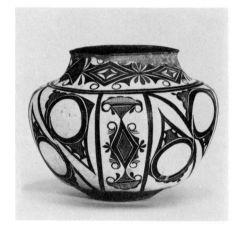

606 **Water jar** Late 19th–early 20th century
New Mexico, Zuni
Terracotta 71.7 cm high, 22.2 cm
diameter
Lent by the Brooklyn Museum X764

According to H.P. Mera ('The "Rain
Bird", a study in Pueblo Design'. *Memoirs of
the Laboratory of Anthropology*, Santa Fe, New
Mexico, vol. II, 1937) the circular designs
are 'rain bird' motifs.

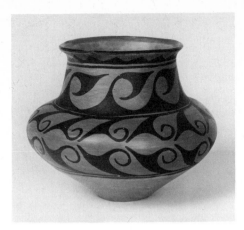

607 **Olla** 1909 AD
New Mexico, San Ildefonso
Clay, paint 23 cm high, 29.5 cm diameter
Lent by the Denver Art Museum XI–116

Made by Tonita Roybal. An example of the
painted pottery that preceded the better
known 'black on black' ware developed by
Julian and Maria Martinez. Maria's early
work was similar but in polychrome, not
black on red, and some of it is still
undifferentiated from the 'railroad' trade
pottery of this period.

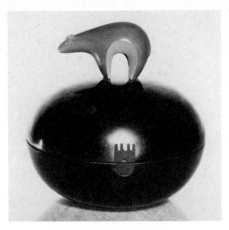

609 **Bear effigy pot** 1969 AD
New Mexico, San Ildefonso
Clay, turquoise 18 cm high, 18 cm wide
Lent by Mr and Mrs Peter I. Hirsch

This was made by one of the younger
generation of Hopi potters, Tony Da, a
grandson of Maria Martinez. The bear at
the top derives from Pueblo fetishes, but its
springy arch-like form is original, as is the
rendering of the bear paw imprint in
intaglio. There is only one paw imprint to
show where the two halves of the pot join:
this symbol now has a purely aesthetic
function. The pot was made by the
coil method; with gun metal finish.

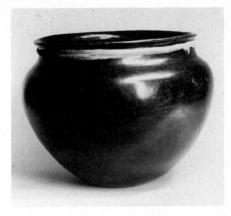

611 **Storage bowl** Mid to late 19th century
New Mexico, Santa Clara Pueblo
Clay 33 cm high, 41.5 cm wide
Lent by the Nelson Gallery of Art/Atkins
Museum (Nelson Fund) 33/1144

A superb example of voluminous Santa
Clara polished blackware, made by
reduction firing (oxygen exclusion) which
carbonizes the clay body. The hide strips
around the neck are applied wet and fit
tightly when dry to prevent further
cracking from use.

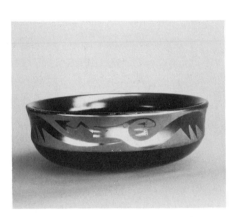

608 **Bowl** c 1925–1930 AD
New Mexico, San Ildefonso
Clay 8 cm high, 24 cm diameter
Lent by the Nelson Gallery of Art/Atkins
Museum. Gift of Dorothy Owsley
Ballard 75.33

This is a beautiful example of the polished
black on black pottery developed by Maria
Martinez, the most famous of the 20th-
century potters at the San Ildefonso pueblo.
The water serpent design was executed by
her husband, Julian. Signed on bottom
'Marie + Julian'.

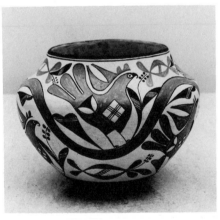

610 **Pot** 1969 AD
New Mexico, Acoma
Clay, paint
15.5 cm high, 20.5 cm diameter
Lent by Mr and Mrs Peter I. Hirsch

Lucy M. Lewis, one of the most famous
contemporary Indian potters, is well known
for carrying on traditional Acoma
polychrome ware methods. She is now 79
and has made few pots since 1970. On this
pot there are seven bird designs of
traditional Zia-Acoma type. Lucy Lewis
also used Zuni and Mimbres black and
white designs.

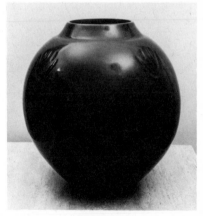

612 **Storage jar** 1968–1969 AD
New Mexico, Santa Clara
Clay
Lent by Mr and Mrs Peter I. Hirsch

This grain storage jar is distinguished
by four well-placed bear paw imprint
designs. It is a monumental bear paw work
by Margaret Tofoya, and was pebble
polished before firing. For details of her life
and technique see Albuquerque, *Seven
Families in Pueblo Pottery*.

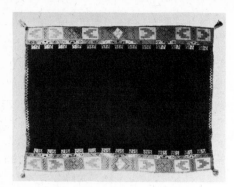

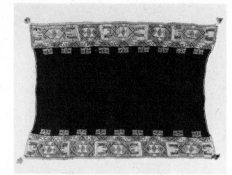

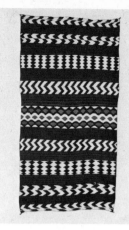

613 Manta *c* 1880 AD
New Mexico, Acoma
Wool 1.46 m high, 1.14 m wide
Lent by the Maxwell Museum of
Anthropology 71.26.1

This red and green manta has the black
field associated with the Acoma. Like the
others of its type, some dozen or so
examples, it exploits in a less complex but
nevertheless intense way, the types of
negative pattern border motifs that recall
those on far more ancient Paracas-
embroidered mantles from Peru. Worn as a
shawl and a wrap-around dress.

Wool embroidery was a speciality of the
Pueblos Acoma, Zuni, Laguna and Jemez,
as well as the Hopi. Writing in 1943, H.P.
Mera, Plate III, stated that 'less than a
hundred examples have been located which
can be considered as representing the type
of work produced previous to the 1880s'.
The earliest Pueblo embroidery dates from
the 12th century (fragments), although no
intact weavings from the 17th or 18th
centuries survive.

614 Manta *c* 1860–1880 AD
New Mexico, Acoma
Wool, dyes 1.01 m high, 1.42 m wide
Lent by the Denver Art Museum RAc–21

These are hand-spun wool yarns with
cochineal and green dye. Formerly Arthur
Seligman Collection.

615 Blanket *c* 1830 AD
Arizona, Navajo
Wool 1.27 m high, 2.46 m long
Lent by Anthony Berlant

This very early Serape-style blanket shows
the introduction of complex Mexican
Saltillo design elements into the Navajo
striped format (see number 616). The long
rectangular shape and extensive use of blue
recall New Mexico colonial style weaving.

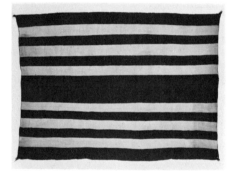

616 Chief's blanket *c* 1840–1850 AD
Arizona, Navajo
Wool 1.22 m long, 2.08 m wide
Lent by the Southwest Museum, Los
Angeles 535-G-627

The natural and indigo wool stripes of the
First Phase 'Chiefs' blankets were the basis
for subsequent styles that were ultimately
more adventurous (*c* 1850–55). They are
now among the most prized examples of
American Indian art.

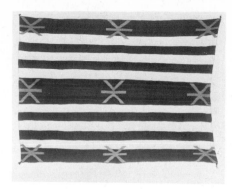

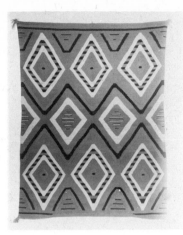

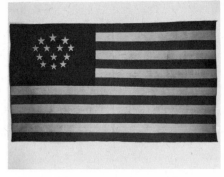

617 Chief's wearing blanket
Arizona, Navajo
Wool 1.83 m high, 1.37 m wide
Lent by the Nelson Gallery of Art/Atkins
Museum (Nelson Fund) 33–1432

619 Blanket *c* 1865–1870 AD
Navajo, Arizona
Wool 1.78 m high, 1.28 m wide
Lent by the Nelson Gallery of Art/Atkins
Museum (Nelson Fund) 33–1431

This Serape-style wearing blanket is
probably woven of saxony wool, which has
the soft sheen and restrained colours to
make possible a more delicate blanket style
with very close weaving. Saxony wool was
chiefly used after the Navajo return from
their incarceration at Bosque Redondo
(1868) but was in use earlier although it was
an expensive yarn.

621 Blanket *c* 1890 AD
Arizona, Navajo
Wool, chemical dyes
1.24 m high, 2.04 m long
Lent by the Southwest Museum, Los
Angeles 47-G-2

This early example of a Navajo blanket
with flag designs adheres to the original
thirteen stars. The Iroquois asked for an
American flag at a very early date, see
Richard Pohrt, *The American Indian/The
American Flag*, Flint Institute of Arts, Flint,
Michigan, 1975, page 5.

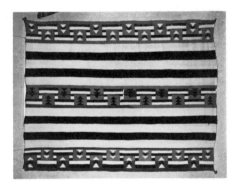

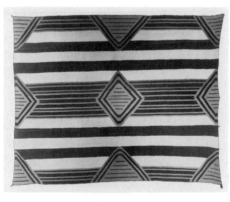

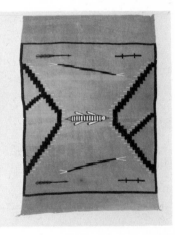

618 Wearing blanket Late 1860s
Arizona, Navajo
Wool 1.48 m high, 1.78 m wide
Lent by the Joslyn Art Museum, Omaha
Public Library Collection 219.1949

The design on this blanket expresses an
affinity with the mesas and mountains of the
Navajo country. It belongs to none of the
assigned phases of Navajo weaving, but
retains the horizontal bars of the 1st phase,
with the 'landscape' motifs inserted flush
against the borders and centre bar.

620 Chief's wearing blanket *c* 1870 AD
New Mexico, Navajo
Wool 1.88 m high, 1.54 m wide
Lent by the Nelson Gallery of Art/Atkins
Museum (Nelson Fund) 33–1421

A wine-coloured example of a Third Phase
chief's blanket. The diamond patterns
overlaid across the horizontal bars mark the
change from First Phase to Third Phase
chiefs' blankets.

622 Blanket *c* 1890 AD
Arizona, Navajo
Wool 1.20 m high, 1.83 m wide
Lent by the Nelson Gallery of Art/Atkins
Museum (Gift of Mrs Richard R.
Nelson) 74–58/1

This Navajo pictorial wearing blanket is
made of three-ply commercial aniline, dyed
red and black and in some places left the
natural yarn colour, with a bee depicted in
the centre. It is an early example of the
pictorial blankets which later went on to
depict trains, houses and trees; an art form
which still flourishes. No symbolism is
contained in these blankets, and the choice
of subject and design is quite personal to the
weaver.

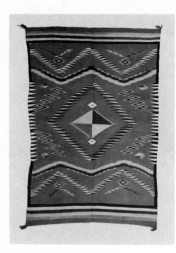

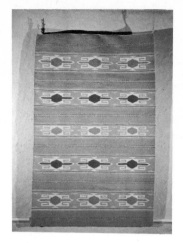

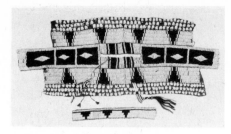

627 Dress yoke with tweezer case
New Mexico, Jicarilla Apache
Cloth, beads 1.14 m wide, 44 cm deep
Lent by the Royal Scottish
Museum 1888.818

The lazy-stitch technique, typical of
Southern beadwork, leads to a loose and
simple design. Along the lower borders are
imitation elk horn teeth.

623 **Blanket** c 1890–1895 AD
Arizona, Navajo
Cotton, wool 2.11 m high, 1.39 m wide
Private Collection

This is a particularly vivid example of an
eye-dazzler blanket. The introduction of
German-town yarns led to colourful
patterns with jagged terrace designs and
zig-zags on Navajo blankets during the
1890s.

625 **Textile** by Mary Lee c 1971 AD
Arizona, Navajo, Wide Ruins
Wool 1.43 m high, 89 cm wide
Lent by Mr and Mrs Morton I. Sosland

Made of wool, which has been hand-dyed
using vegetable colouring in an innovative
manner. The soft colours are typical of
Wide Ruins, situated below Ganado, and
the southeastern part of the reservation,
with fifteen cartouche-like designs which
are an indigenous contemporary feature.

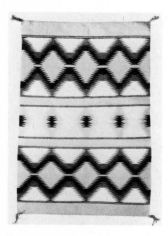

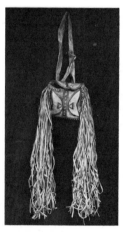

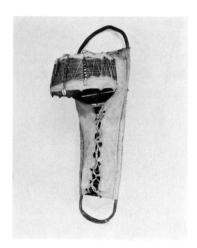

624 **Rug** 1944 AD
Arizona, Navajo
Wool, dyes 1.57 m high, 1.04 m wide
Lent by the Maxwell Museum of
Anthropology 63.34.86

This rug was made with chrome dyes, used
in the 1930s and early 1940s. The dyes were
then abandoned in favour of vegetable
dying (see number 625), which gave softer
and more modulated colours than those
seen here: shell pink and slate blue. Made
at the Fort Wingate School.

626 **Parfleche** 19th century
Southern Plains, Lipan Apache
Rawhide 27 cm high, 25 cm wide
Lent by the Trustees of the British
Museum 1954.W.Am.5.951

Parfleche with long lateral fringes, front
painted black, white, red, green, yellow.
Taken at Rey Moliena by Captain J.A.
Wilcox of the Fourth Cavalry during
General McKenzie's raid in May 1873.
Wellcome Collection.

628 **Cradle** 1885–1895 AD
Arizona, Apache
Wood, buckskin, beads, shells
97 cm high, 35 cm wide
Lent by the Saint Joseph Museum
143 3006

The outer frame is of bent willow, the back
slats of yucca bows. The amulets hanging
from the projecting sunshade were to
protect the child. Harry L. George
Collection.

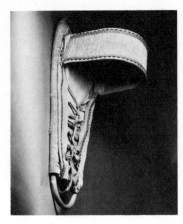

629 Cradle 1920s AD
Arizona, Apache
Wood, trade cloth 88 cm long
Private Collection

This cradle is from the San Carlos Apache.
Although it retains the form of the 19th
century type, the hide has been replaced by
cotton duck and rick-rack trimming added.

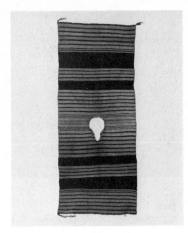

631 Poncho
Arizona, Hopi
Wool 91.5 cm high, 61 cm wide
Lent by the Denver Art Museum RHc-37

Woven in diagonal twill of hand-spun dark
blue and loose red wool yarns. Collected by
Thomas V. Keam in Arizona in 1895.
Formerly in the Field Museum, Chicago.

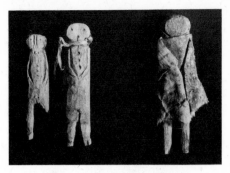

633 Three dolls
Arizona and New Mexico, Navajo
Wool, cloth, various materials

a 8 cm high
66.29.1

b 8 cm high
66.292

c 10 cm high
63.34.9

Lent by the Maxwell Museum of
Anthropology

a and *b* were found north of Gallup, New
Mexico, near Tohachi, at a camp site on the
surface with pottery fragments. Deposited
in the museum in 1966.

c was found by the archaeologist Earl
Morris in a cache of Navajo material in
Canyon del Muerto (Canyon de Chelly). It
was acquired by the museum in 1963.

These are curing dolls.

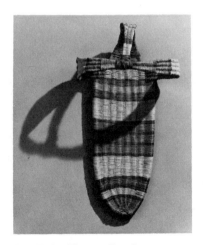

630 Cradle by Verona Dewhongva 1949 AD
Arizona, Hopi
Sumac shoots, dyes
53 cm high, 17 cm wide
Lent by the Denver Art Museum YH3–61

Cradle in the wicker-work technique of the
Third Mesa (see number 574). The dyes are
modern aniline. It was made for the Hopi
craftsman exhibition at the Museum of
Northern Arizona in 1949.

632 Figurine 19th century
Arizona, Hopi
Clay, paint 12 cm high
Private Collection

The clay images or statuettes made on
Shinumo Hopi pueblos were not objects of
worship but were used to adorn dwellings
and are depicted as wearing ordinary
clothing. The hairstyle of two wheel-shaped
knots at the side was typical of unmarried
Hopi girls. This image, formerly owned by
the University of Colorado Museum, was
collected by James Stevenson, see *Illustrated
Catalogue of the Collections obtained from the
Indians, New Mexico and Arizona in 1879*,
Smithsonian Institution, 2nd Annual
Report 1883.

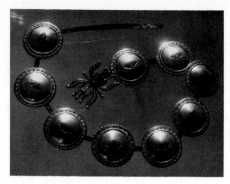

636 **Ring** *c* 1915 AD
Arizona, Navajo
Silver, turquoise 3 cm diameter
Lent by Proctor Stafford

The turquoise has turned partly green from use and the stone with a hole was once a man's ear bob.

638 **Belt** *c* 1885–1890 AD
Arizona, Navajo
Silver, leather 1.22 m long
Lent by Proctor Stafford

The round conchos denote the first phase or style, derived from Southern Plains silver discs (see number 475) and from Mexican silver roundels. The original buckle was a simple cinch belt and has been replaced by a cast silver buckle with turquoise decorations dating from about 1910.

634 **Necklace** *c* 1915 AD
Arizona, Navajo
Coral 36 cm long
Private Collection

Mediterranean coral was incorporated by the Navajo into prestige jewellery. An unusual feature is the coral inlaid clasp.

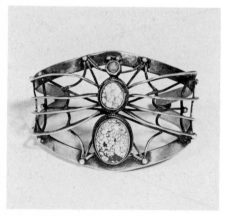

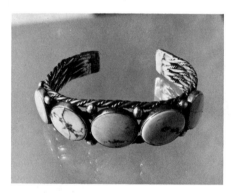

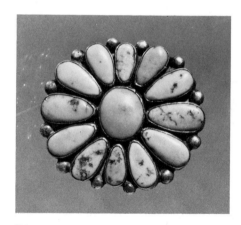

635 **Bracelet** *c* 1930 AD
Arizona, Navajo
Silver, turquoise 7 cm high, 6.3 cm wide
Lent by the Taylor Museum of the
Colorado Springs Fine Art
Center 3121

This bracelet is unusual both because of the pictorial character and the over-all complexity of the openwork. Perhaps the image was suggested by the spider gem turquoise. According to the Navajo myth Spider Woman taught the tribe to weave.

637 **Bracelet** *c* 1920 AD
Arizona, Navajo
Turquoise, silver 7.5 cm long, 2.5 cm wide
Lent by Proctor Stafford

By the 1920s silverwork had become more complicated than previously.

639 **Ring** *c* 1930 AD
New Mexico, Zuni
Silver, turquoise 3 cm diameter
Lent by Proctor Stafford

The elaborate use of turquoise contrasts with the simpler style of the Navajo.

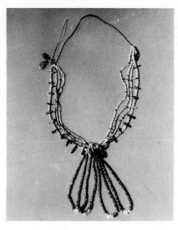

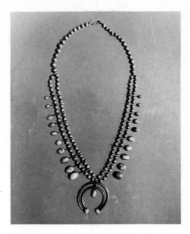

644 **Bridle** *c* 1895–1900 AD
Arizona, Navajo
Silver, iron, leather
59 cm long, 16 cm wide
Lent by the Nelson Gallery of Art/Atkins
Museum (Nelson Fund) 33–893

The decoration of this bridle consists of two silver conchos with spur-like pendants and a stamped forehead medallion. Navajo bridles, with Mexican-style bits, were powerful pieces of equestrian adornment which went out of fashion as the horse population diminished. The earliest bridles had simple silver plate ornaments.

640 **Necklace** *c* 1900 AD
New Mexico, Santo Domingo
Shell, turquoise 56 cm long
Lent by Proctor Stafford

Made from white shell beads (hishi). There are men's ear bobs at the top of the necklace, and there are joclaws at the bottom that have become green with use. The Indian preference for bright blue turquoise may have led to this heirloom piece leaving the pueblo.

642 **Necklace** *c* 1910 AD
Arizona, Navajo
Silver, turquoise 31 cm long
Lent by Proctor Stafford

While there are traditional features on this woman's necklace, including the naja, the individual style and the twenty graduated turquoises are unusually delicate.

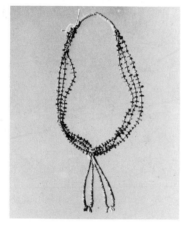

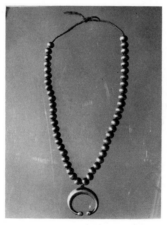

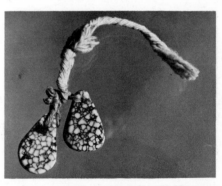

641 **Necklace** *c* 1900 AD
New Mexico, Santo Domingo
Shell, turquoise, coral 49 cm long
Lent by Proctor Stafford

The Santo Domingo Indians have always been expert in the making of shell and turquoise beads. The tassels are called joclaws and were originally used by women for earrings (see number 647). The joclaws were hung from the necklace for safe keeping and finally became integrated into the design. Only on the most remote parts of the Navajo reservation do women still wear joclaw earrings.

643 **Necklace** *c* 1865–1868 AD (?)
Arizona, Navajo
Silver, leather 43 cm long
Lent by Proctor Stafford

This necklace could date from the Basque Redondo period when the Navajos were forced into camps after their surrender to the US army. The leather thong is typical of this period, as are the rolled pieces of calico.

645 **Pair of ear bobs** *c* 1920 AD
Arizona, Navajo
Silver, turquoise 3 cm long
Lent by Proctor Stafford

This pair of ear bobs lack the usual hole, because they were attached to the ear by the silver loop on top. Silver is very rarely used to mount ear bobs.

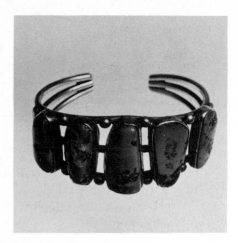

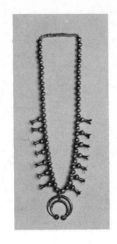

646 **Bracelet** *c* 1940 AD
Arizona, Navajo
Silver, turquoise 5.5 cm diameter
Lent by Mrs LaRue C. Jones

Note the simplicity and restraint of this late
1930s 'pawn' bracelet. Pawn bracelets were
put in pawn at the trading post for cash;
unredeemed jewellery enters the trade.

648 **Necklace** *c* 1905–1910 AD
Arizona, Navajo
Silver 82 cm long
Lent by the Nelson Gallery of Art/Atkins
Museum (Nelson Fund) 33–892

This squash-blossom necklace was
purchased from Fred Harvey & Co. by the
Nelson Gallery to use in a diarama. Note
the original string wrapping which fits
around the wearer's neck.

650 **Belt** 19th century
Southwest, Navajo
Leather, silver 98 cm long
Lent by the Trustees of the British
Museum 1923.12–14.44

Leather belt on which eight silver conchas,
made from Spanish dollars, are strung. The
conchas were adapted from Plains Indian
silver discs. The earliest Navajo belts had a
simple cinch buckle and plain discs but
were otherwise identical to this belt.
Collected by T.A. Joyce, 1923 and
presented by A.W.F. Fuller.

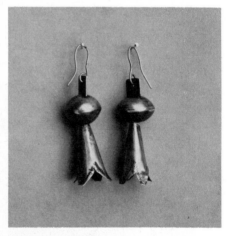

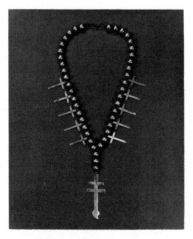

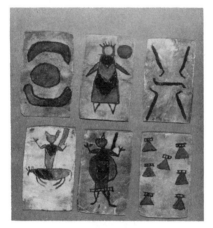

647 **Pair of earrings** *c* 1900–1920 AD
Arizona, Navajo
Silver 7.4 cm high
Private Collection

This type of earring was worn by Navajo
women and was also traded as far north as
the Rosebud Sioux. (See John A. Anderson
and H.J. Hamilton, plate 145, for an 1889
photograph of a Sioux woman wearing
similar 'squash blossom' earrings of an
earlier date than these.)

649 **Necklace** Probably late 19th century
New Mexico, Isleta
Silver 53.5 cm long
Lent by the Denver Art Museum JIs–3

A typical necklace showing Spanish
influence with its Christian cross and
Sacred Heart. In many ways European and
Indian motifs were interchangeable: the
Isleta cross and old Southwest dragonfly
double cross symbols, for example.

651 **Playing cards**
Arizona, Apache
Buckskin, paint 9 cm long, 7 cm wide
(39 cards with slightly varying dimensions)
Lent by Mr and Mrs Robert Witten

Sixty-six Apache playing card decks have
survived, of which this is one of the finest. A
more sophisticated deck is at Princeton
University, but its execution depended
more on Spanish precedent, while these
cards are clearly drawn in the spikey
free-hand manner seen on Apache shields
and medicine shirts. The red, yellow and
black pigments are non-commercial
vegetable colours. The deck is complete
with one exception, the seven of swords.
There are four Spanish Tarot suits, cups,
clubs, and coins. The sota (jack) and
caballero (knight) figures have ears while
the rey (king) has a crown. Acquired about
1885 by W. O. Kellner of Globe, Arizona.
'Apache' playing cards with American-style
decks are sometimes forgeries.

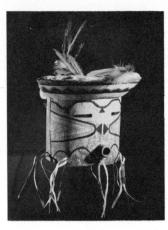

652 Mask Late 19th–early 20th century
New Mexico, Zuni
Leather 23.5 cm high, 20 cm diameter
Lent by the Brooklyn
Museum 04.297.5382

This kachina mask represents Chilchi.
Collected by Stewart Culin in 1904.

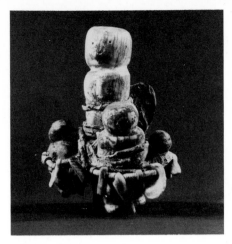

654 Fetish Date uncertain
New Mexico, Zuni
Bone, obsidian, shells, coral, hishi stone,
rawhide 11 cm high, 7.5 cm wide
Private Collection.

This powerful fetish image has a central
bone tied with concretions, shells, and other
substances.

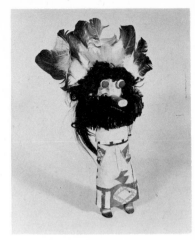

656 Kachina 20th century
New Mexico, Zuni
Wood, cloth, feathers, hair
48 cm high, 7 cm wide
Lent by the Taylor Museum of the
Colorado Springs Fine Art Center 1541

The doll represents Shalako in the
ceremonial dance. The Shalako opened the
Zuni ceremonial season; the kachina
dancer wore a wicker framework, so that in
life the image was a giant ten feet tall.

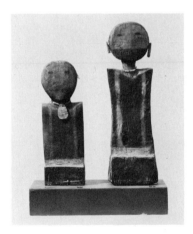

653 Figurines *c* 1900 AD
New Mexico, Zuni
Wood
a 33.6 cm high, 10.5 cm wide
b 43.2 cm high, 12 cm wide
Lent by the Brooklyn
Museum 04.297.5317, .18

These wooden figurines represent Zuni gods
of music, flowers and butterflies
(Payatamu). Collected by Stewart Culin in
1904.

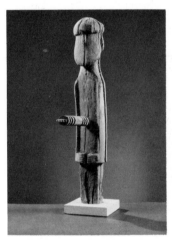

655 War god *c* 1900 AD
New Mexico, Zuni
Wood 64 cm long, 13.5 cm wide
Lent by the Brooklyn
Museum 03.325.4716

The figure was originally brightly painted
with a bundle of prayer sticks around the
middle. The projection represents Sipapu,
the hole from which the first Zunis
emerged. After ceremonial use the war gods
were left to decay. Collected by Stewart
Culin in 1903.

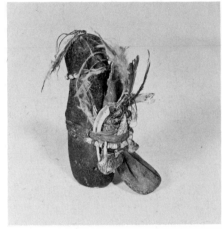

657 Fetish
New Mexico, Zuni
Basalt, shell, feather, beads
15 cm high, 5 cm wide
Lent by the Taylor Museum of the
Colorado Springs Fine Arts Center 2087

An anthropomorphic figure with a bundle
on the back containing two prayer sticks, a
sack of pollen, bone tusk and beads.

658 Fetish
New Mexico, Zuni
Basalt, turquoise 13.5 cm high, 7 cm wide
Lent by the Taylor Museum of the
Colorado Springs Fine Arts Center 3162

This bird fetish complete with wings and
necklace of turquoise is a particularly
decorative example of Southwestern
fetishes.

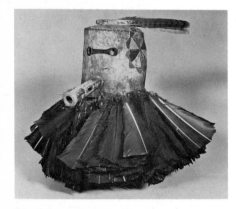

659 Mask
New Mexico, Zuni
Leather, feathers 18 cm high, 16 cm wide
Lent by the Taylor Museum of the
Colorado Springs Fine Arts Center 5144

At the winter solstice the Shalako kachinas
come to Zuni to perform the first dances of
the kachina symbol. A doll representing
Shalako in full regalia is shown in number
656.

660 Kachinas
Arizona, Hopi
Wood, paint
Collected by Senator Barry Goldwater.
Lent by the Heard Museum

a Nahoilo Chaktaka (runner kachina)
1960 AD
30 cm high
NA-SW-HO-F-113

Made by White Bear.

b Mastos kachina *c* 1970 AD
27 cm high
HOS-175

This contemporary kachina was made from
a corn husk.

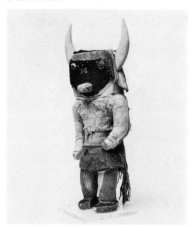

c Big Head Kachina Pre 1900 AD
25.5 cm high
NA-SW-HO-F-347

Originally a kachina called Wuuka
Quto or Mosaieu kachina. Horns
have been added at some time during its
history.

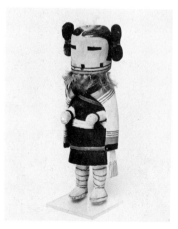

d Kachina Mana 1961 AD
32 cm high
NA-SW-HO-F-456

This image has maiden hair whorls and
wears a wedding sash.

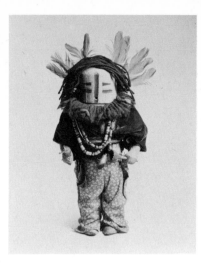

661 Kachina 20th century
New Mexico, Laguna Pueblo
Wood, coral, beads
Private Collection

Kachinas from this pueblo are rare, as they
are not sold. This one shows evidence that
the dress has been revised. The arms move
as with Zuni kachinas.

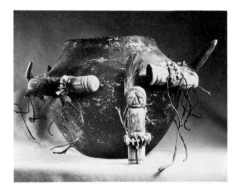

662 Fetish pot 20th century
New Mexico, Zuni
Clay, bone, pitch, shells, turquoise, hide
22 cm high, 25 cm diameter (at shoulders)
figure fetish 12.5 cm high
Lent by Dr and Mrs David Francisco

This is not an old pot, but it has been
authentically used. The figure fetish fits into
the pot, and was fed ceremonially through
the hole. Secured by Richard Vanderkamp,
successor to C.G. Wallace of the Zuni
Mercantile Company and in turn sold by Al
Packard and acquired by the lenders a
decade ago.

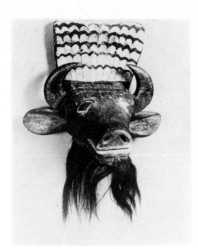

663 Buffalo head
New Mexico, Zuni
Wood, paint
27.5 cm high, 28.5 cm wide (maximum)
Lent by the Taylor Museum of the
Colorado Springs Fine Arts Center 1549

This head would have been part of the
ritual paraphernalia used in an
underground ceremonial kiva, probably
placed on an altar, possibly of the Buffalo
Clan. It is one of the few remaining
examples of these potent effigies extant.

665 Three bird fetishes

a **Finch** *c* 1900–1910 AD
San Juan
Wood, paint 22 cm high, 12.5 cm wide

b **Parrot** 1890–1900 AD
Zuni
Wood, paint 60 cm long, 9 cm high

c **Dove** 1920s AD
Hopi
Wood, paint 28 cm long
Lent by Mr and Mrs Rex Arrowsmith

The use of parrot or macaw fetishes in the
Pueblo religion has a Mezzo–American
origin. See note to number 547.

667 Stone image Early 20th century
New Mexico, Cochiti, Koshare clan
Stone, paint 26 cm high, 20.5 cm wide
Lent by the Taylor Museum of the
Colorado Springs Fine Arts Center 1799

This stone image from a Pueblo kiva has an
outline of a human figure. On the head are
three turquoise stones and eagle down.

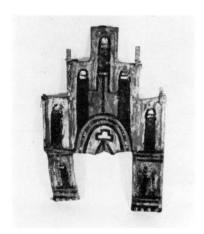

664 Tablita Early 1900 AD
Arizona, Hopi
Wood, buckskin, paint
55 cm high, 35.3 cm wide
Lent by Mr and Mrs Rex Arrowsmith

The headpiece with phallic design
represents a Sio Hemis kachina and was
worn in the dance. This is a modern
survival of the ancient Mimbres tablita.

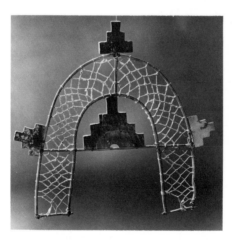

666 Tablita 19th century
Arizona, Hopi
Wood, string 42 cm high, 43 cm wide
Lent by the Peabody Museum of
Archaeology and Ethnology, Harvard
University 28728

An unusual airy dance head tablet collected
by Thomas V. Keam.

668 Shield *c* 1805 AD
Southwestern, Cochiti
Buffalo skin, paint 52 cm diameter
Lent by the Stolper Galleries, Munich

Painted on the shield is a horned kachina
dance mask. Formerly owned by the
Museum of the American Indian, Heye
Foundation.

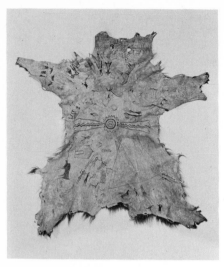

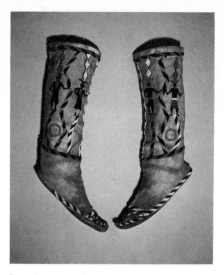

669 Shaman's robe Before 1910 AD
New Mexico, Taos Pueblo
Buffalo skin 2.13 m high, 2.59 m wide
Lent by the Stolper Galleries, Munich

The northern Rio Grande pueblo of Taos
was influenced by Southwestern Plains art.
Shamen made hide paintings as a source of
personal medicine. Collected by M.R.
Harrington in 1910.

671 Leggings *c* 1800 AD
Southern Plains, New Mexico and Arizona,
Apache
Deerskin, beads 38 cm high, 11.5 cm wide
Montana Private Collection

The beaded image of a Gans dancer on
these leggings indicates that they were used
by a mountain spirit dancer (number 674).

672 Fetishes
New Mexico, Taos
Clay, paint, leather, rawhide

a Buffalo or bear, pink earth paint with
concentric markings around the dark nose
and rawhide strap
7.5 cm long

b Buffalo made from dark grey clay with ears
of yellow, stippled to indicate hair
15 cm long, 8 cm high

c Deer (head only), ears and antlers of leather
4.5 cm long, 4 cm high

d Unidentified animal, yellow clay, leather
ears and tail
13 cm long, 5.3 cm high

Private Collection.

670 Hide painting
Arizona, Apache
Bear hide, paint 1.37 m long, 1.45 m wide
(maximum)
Lent by the Taylor Museum of the
Colorado Springs Fine Arts Center 1550

This Mescalero Apache hide painting, with
its abrupt changes in scale of
representations and with its swirling
drawings, shows how the Plains tradition of
pictorial hide painting was adapted by the
Apache. The effect, while not as grand as
was obtained on the northern Plains,
nevertheless has rhythmic vitality.

673 **Dress outfit** *c* 1900 AD
New Mexico, Apache
Buckskin, beads, tin, shell, paint
Lent by the Maxwell Museum of
Anthropology 70.70.1–6

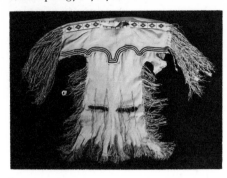

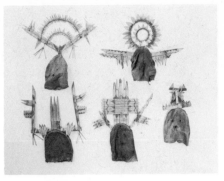

a Buckskin woman's dress, beaded trim, tin
 dangles, fringe

b Buckskin cape, yellow field, bordered with
 three white and three black beaded rows,
 with loomed rectangular breast panel

c Pair of high buckskin moccasins with
 folded-over tops and loomed bead trim

d Plain high buckskin moccasins

e Buckskin leggings with loomed beadwork

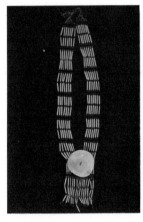

674 **Gans masks** 20th century
New Mexico, Apache
Sacking, wood, paint, metal
87 cm high (maximum)
Lent by the Maxwell Museum of
Anthropology 61.3.70–74

Complete sets of Apache Gans, or mountain
spirit masks are rarely seen outside the
Apache world. Unfortunately this set has no
accompanying information, though it is
probably of Mescalero Apache origin.
Originally the Gans were sent as delegates
of the Supreme Being (Giver of Life). They
were tutelary spirits who revealed to the
Apache the good ways of life, *i.e.* to govern,
cure, plant and harvest, to hunt and to be
disciplined. They returned to their
mountain caves when disappointed by the
Apache corruption of their teachings. Four
dancers and a clown impersonate the Gans
in order to keep the faith of the ancient
Gans teachings. The Gans dance mask
designs (the upper structure is called the
horns) were copied and developed from
rock paintings the Gans left as they entered
their sacred caves. Collected by Joseph
Imhoff.

f Plains-style glass bead necklace with shell
 runtee

 This Jicarilla Apache puberty rite costume
 was last used at a puberty dance in 1955 at
 Dulce, New Mexico, before being acquired
 by the Museum. The plain moccasins were
 extra 'for wearing in heaven'. Both a girl
 and a boy participated in the Jicarilla
 Apache five-day adolescence rite, though
 the rite was held by the girl's family. See
 Morris Opler, pages 103–115, for an
 account of this rite.

Photographs by Edward Curtis
and Historical material

Edward Sheriff Curtis (1868–1952)

M. Gidley

Edward Curtis was born near Whitewater, Wisconsin, but his father joined the great westward migration in search of a better life and Curtis grew to manhood in Seattle, Washington. Seattle, though becoming increasingly citified, was then still a frontier town and still frequented by a few dispossessed Indians who seemed to Curtis, as he photographed them at the beginning of his career, decadent and lost. By 1892 he was a partner in a studio and his pictures of local Indians were starting to win prizes. He carried his camera to cover the hardships of the Klondike gold rush in 1897 and he was fond of climbing and photographing on Mount Ranier. One weekend he rescued some travellers who were stranded on the mountain. These included George Bird Grinnell, an authority on Indians. Grinnell befriended Curtis, secured his appointment as Official Photographer to the Harriman Alaska Expedition of 1899, and encouraged him to accompany him also on his annual visit to the Piegan Sun Dance Ceremonies the following year.

In watching these rituals of pain suffered to secure visions, Curtis appears to have experienced a sense of communion with the Indians. Out of it came his conception of a comprehensive written and photographic record of the most important peoples west of the Mississippi and Missouri Rivers who still retained 'to a considerable degree their primitive customs and traditions'. Although it came to anger him that the U.S. and Canadian governments were unnecessarily *instrumental* in promoting the demise of the Indians, he saw their passing largely as a kind of historical necessity, regrettable but inevitable. His writings and pictures are an elegy to a receding civilization and he said he chose 'The Vanishing Race' as the first of his comprehensive series because it 'expresses so much of the thought that inspired the whole work'. Perhaps Curtis was too pessimistic in feeling that the Indians had no definable future as Indians, but it is true that he lived at a time which was the last possible one for many images to be caught by his camera: faces of great patriot chiefs like Red Cloud, Little Wolf and Joseph; dying forms of dress, such as the Hopi 'squash blossom' hairstyle or Wishham nasal shells; the vital celebration of ceremonies like the Buffalo Dance; or everyday things – painted teepees, fishing practices, headdresses. And, indeed, Curtis did often ask his subjects to re-enact past events or to stage practices which had died out, and this has led some critics to accuse him of romanticisation or, even, fabrication.

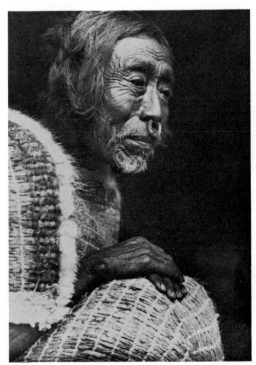

II*i* Yakotlus – Quatsino

At the start Curtis probably had little idea of how much the realization of his dream of a comprehensive record would cost him. In the end he had produced *The North American Indian* (Cambridge and Norwood, Massachusetts, 1907–1930), a monumental work of twenty volumes of illustrated text and twenty portfolios of large-sized photographs, two popular books, a number of magazine articles, and a film, all on Indian themes. But to do this – while also maintaining his wife and children and bearing responsibility for his studio – for thirty years he had frequently to work over seventeen hours a day, travel a continent, and manage a team of assistants. Also, before he secured the patronage of the financier J. Pierpont Morgan, the encouragement of Theodore Roosevelt (who wrote a Foreword to *The North American Indian*) and the editorial services of Frederick Webb Hodge, Curtis had to raise funds by magic lantern lecture tours, and in the twenties he had to encourage people to take out subscriptions to the limited edition of his huge work. It is not surprising that by the time the work was completed, his health was broken; he moved his studio to Los Angeles and in his final years became interested in mining and dreamed of an expedition to the interior gold mines of South America.

The North American Indian contains millions of words – anthropology, oral histories, biographical sketches, history, folklore, mythology, and so on – together with transcriptions of music, examples of native designs, and thousands of photogravures. But it is not only *breadth* of coverage which makes the work so distinctive; Curtis wanted it to present, in essence, nothing less than the very spirit of the Indian peoples. To this end the pictures were not what he called 'mere embellishment' but 'an illustration of an Indian character or of some vital phase in his existence'. Thus the portrait of Two Whistles attempts to render a man Curtis describes in words as follows: 'Born 1856. Never achieved a recognized coup', though he participated successfully in numerous battles. 'First fasted at the age of thirty-five [and received a graphic vision. In an outbreak at the Crow Agency in 1887 he] was

shot in the arm and breast, necessitating the amputation of the arm above the elbow. In the portrait Two Whistles' rugged courage, sustained by his 'medicine', penetrates to us, even through the paint which could so easily obscure any individuality.

Curtis often achieved dramatic portraits by allowing the head to break the frame and by using strong shadow, sometimes accentuated at the printing or engraving stage, techniques illustrated here in the profile of Vash Gon. Sometimes he could not resist a touch of humour, as in the view of 'A Nakoaktok Chief's Daughter' which, though it graphically presents the fact of her elevated status in her society, also mildly mocks her pretensions by having her posture and the set of her lips echo the shapes of the wooden effigies below.

The very composition of a picture like 'The Cañon de Chelly' has much to tell: without reducing the Cañon's scale or harsh grandeur, the photograph stresses the fact that it is *home* to these Navaho who traverse its floor. Similarly, the Crow war party depicted in 'In Black Cañon' is dappled in light and shade of similar textural feel to the trees, shrubs and grass of the valley through which its members pick their way with such assurance. In 'The Fire Drill' the movement of lines and the play of textures in the swirling bark at the foot of the tree, in the man's apparel, in the twigs in his hair, in the very lines of his feet and his face, all betoken that he is as rooted in that land as the tree by which he squats, and has been so since the origin of fire itself. In other words, Curtis used all the artistic resources of photography – as well as its technical resources (such as the gold tone process and sepia) – in the presentation of what is not just another ethnological study but a vision of Indian life.

Each of the forty photogravures in the present exhibition was selected partly because it illustrates such a vision. The original negatives were first made between 1898 and 1928. They appear here as titled by Curtis when included in *The North American Indian* (and all words in quotation marks in the following captions are Curtis' own). The pictures in this exhibition belong to the set belonging to Exeter University Library (no. 4 in an edition of 500). Further information on Curtis' work may be found in R. Andrews, *Curtis' Western Indians* (Seattle and New York, 1962); T. C. McLuhan and A. D. Coleman, *Portraits from North American Indian Life* (New York, 1972 and London, 1973); and M. Gidley, *The Vanishing Race: Selections from Edward S. Curtis' 'The North American Indian'* (Newton Abbot and London, 1976).

III*b* Cañon de Chelly – Navaho

I Plains

a **Red Cloud – Ogalala Teton Sioux**

'Born 1822. [Died 1909.] At fifteen he accompanied a war party which killed eighty Pawnee. He took two scalps and shot one man. At seventeen he led a party that killed eight of the same tribe. During his career he killed two Shoshoni and ten Apsaroke.' Many tales of his individual exploits have been recorded. To whites he first gained prominence in 1866 when he took Fort Phil Kearny by defeating Captain Fetterman. He became head-chief of the Ogalala, advocated moderation to his own people while speaking for Indian rights to the whites, but – as this portrait conveys – died with but poor prospects for his people in view.

b **Two Whistles – Apsaroke (or Crow)**

He is depicted here in his hawk 'medicine', which was purchased with a horse from the Sioux.

c **For A Winter Campaign – Apsaroke**

'It was not uncommon for Apsaroke war-parties . . . to move against the enemy in depth of winter. The warrior at the left wears the hooded overcoat of heavy blanket material that was generally adopted by the Apsaroke after the arrival of traders. The picture was made in . . . the Pryor mountains, Montana.'

d **In Black Cañon**

'The picture illustrates the Apsaroke custom of attaching at the back of the head a band from which fall numerous strands of false hair ornamented at regular intervals with pellets of bright-colored gum. Black Cañon is in the Bighorn Mountains, Montana.'

e **Little Wolf – Cheyenne**

Little Wolf is the chief who, with Dull Knife, led the last armed resistance of the Northern Cheyenne against the U.S. government. In 1878 a party of them broke out of their reservation in the southern plains, where they had been starving, to return to their own homelands in the Dakotas. Chased by thousands of troops, decimated by fighting, disease, and winter storms, they were recaptured but allowed to remain in the north.

f **Porcupine – Cheyenne**

Porcupine's head is protected from the fierce sun which bakes the Plains in summer by a thatch of cottonwood leaves.

g **The Lone Chief – Cheyenne**

h **In a Piegan Lodge**

Little Plume and his son, Yellow Kidney, the medicine pipe between them, surrounded by the appurtenances of Plains life.

i **Old Person – Piegan**

'The young men eagerly seize every occasion of public festivity to don the habiliments of their warrior fathers.'

j **Bear Bull – Blackfoot**

'The plate illustrates an ancient Blackfoot method of arranging the hair.'

k **The Painted Tipi – Assiniboin**

'A tipi painted with figures commemorative of a dream experienced by its owner is a venerated object. Its occupants enjoy good fortune, and there is no difficulty in finding a purchaser when after a few years the owner, according to custom, decides to dispose of it.'

l **A Stormy Day – Flathead**

A break in the storm over the Flathead camp on the Jocko River in western Montana.

II Northwest

a **The Fisherman – Wishham**

He is fishing for salmon with a dip net in an eddy of the Columbia River and will 'in a few hours, secure several hundred salmon – as many as the matrons and girls of his household can care for in a day'.

b **Wishham Girl**

This girl wears ornamentation of beads of a Plains variety and shell beads inherited from when her people inhabited the Pacific slope before migrating inland over the Rockies. The dentalium shells through the nasal septum were indispensable for well-born persons. The headdress consists of shells, shell beads, commercial beads, and Chinese coins of a type that appeared comparatively early in the Columbia River region.

c **Holiday Trappings – Cayuse**

These fine deer skin garments are evidence of wealth in this Oregon tribe.

d **Chief Joseph – Nez Percé**

The famous chief who is credited with conducting the Nez Percé retreat in 1877 after their defeat in the struggle to retain their lands and freedom.

e **Nez Percé Babe**

f **Princess Angeline**

Daughter of Chief Seattle, from whom Seattle took both its name and title, she was a familiar figure in the city during Curtis' youth.

g **Cowichan Girl**

'A maiden of noble birth clad in a goat-hair robe.'

h **Puget Sound Baskets**

'Basketry continues to be an important industry of many Puget Sound tribes. Women of the Skokomish band of Twana are especially skilful in weaving soft, flexible baskets.'

i **Yakotlus – Quatsino**

A member of one of the Kwakiutl bands of British Columbia.

j **A Nakoaktok Chief's Daughter**

'When the head chief of the Nakoaktok Kwakiutl holds a potlatch (a ceremonial distribution of property to all the people), his eldest daughter is thus enthroned, symbolically supported on the heads of her slaves.'

k **The Fire Drill – Koskimo**

This Koskimo Kwakiutl lights a fire in the traditional manner.

III Southwest

a **The Vanishing Race – Navaho**

'The thought which this picture is meant to convey is that the Indians as a race, already shorn of their tribal strength and stripped of their primitive dress, are passing into the darkness of an unknown future.'

b **Cañon de Chelly – Navaho**

'In northeastern Arizona, in the heart of the Navaho country – one of their strongholds, in fact. Cañon de Chelly exhibits evidences of having been occupied by a considerable number of people in former times, as in every niche at every side are seen the cliff-perched ruins of former villages.'

c **A Point of Interest – Navaho**

d **Vash Gon – Jicarilla**

e **Judith – Mohave**

'A young Mohave woman of about eighteen years of age.' It is said that it was through viewing Curtis' portraits of Mohave girls – with their eyes like 'those of the fawn of the forest, questioning the strange things of civilization' – that J. Pierpont Morgan, the financier, agreed to act as patron to *The North American Indian* enterprise.

f **At the Trysting Place**

These Hopi girls, wearing the 'squash blossom' hairstyle traditional for unmarried women, wait for their suitors.

g **Snake Dancer in Costume – Hopi**

The snake dance is an exciting and seemingly dangerous ceremony in which captured snakes are handled, propitiated and released in acts symbolic of man's need for right relationships with nature, thus ensuring rain and fertility.

The Potter Mixing Clay – Hopi

'This woman, so aged that her shrivelled skin hangs in folds, still finds pleasure in creating artistic and utilitarian pieces of pottery.'

i **Girl and Jar – San Ildefonso**

'Pueblo women are adept at balancing burdens on the head. The design on the jar here illustrated recalls the importance of the serpent cult in Tewa life.'

j **Tesuque Buffalo Dancers**

This dance was originally performed in supplication for an abundant supply of buffalo. 'The two male dancers are accompanied by the Buffalo Girl, who is fully clothed in native costume and has a pair of small horns on the head. The three give a very striking and dramatic performance under the watchful eye of the head of the hunters' society.'

k **Washo Baskets**

Curtis considered these baskets, made by Datsolalee, a woman of this Plateau Shoshonean people, to have 'not been equalled by any Indian [then] living'.

l **Fishing with a Gaff Hook – Paviotso**

From Walker Lake, a salt lake in western Nevada, the Paviotso take trout and other fish by a variety of fishing methods.

m **A Wappo**

'The Wappo were a Yukian group occupying a detached area in the northeastern corner of Sonoma County', California.

IV Eskimo

a **Kenowun – Nunivak**

'The nose-ring and labret of beads are typical' of this Alaskan Eskimo people.

b **The Drummer – Nunivak**

The skin of this enormous drum (3′ 6″ in diameter) is made from walrus bladder.

c **The Village – Hooper Bay**

This Alaskan Eskimo settlement, seen here in summer, 'consists of dwellings dug and built into a hill with such little regard for order that the entrance of one may open on the roof of a house below.'

d **A Family Group – Noatak**

Ola, a Noatak Alaskan Eskimo, with her husband and son.

Historical material

Prints, drawings and paintings

675 JOHN WHITE
Five watercolours *1587*

Indian Man of Florida *112*
26.8 cm high, 13.7 cm wide

Eskimo Man *114a*
22.7 cm high, 16.4 cm wide

Indian Village of Pomeiooc *34a*
22.2 cm high, 21.5 cm wide

**Map of Eastern North America –
Florida to Chesapeake Bay** *110*
37 cm high, 47.2 cm wide

Indian Woman and Young Girl *35*
26.3 cm high, 14.9 cm wide

Lent by the Trustees of the British
Museum

676 FABER
**Page illustrating 'The Four Indian
Kings Speech' after the engravings
by John Simon**
Paper 30 cm high
Lent by the Trustees of the British
Museum

677 JOHN WEBBER
Three engravings
Woman of Nootka Sound *39*
A Woman of Prince William Sound *47*
A Man of Nootka Sound *38*
Private Collection

John Webber (aged 23) was the artist on
the ship *Discovery* which visited the
Northwest Coast (1776–80). The volume
of his engravings was published in 1892.

678 **Plains Chief and his wife** *c 1850 AD*
Watercolour on paper
12 cm diameter
Lent by Sven Gahlin, London

679 CHIEF FRANCIS
Self-portrait
Watercolour 20.5 cm high, 28 cm wide
Lent by the Trustees of the British
Museum

Caption: 'A drawing of the Muscogie
Chief Frances of himself; being his first
attempt; and never having seen a pencil
or colour in his life before'.

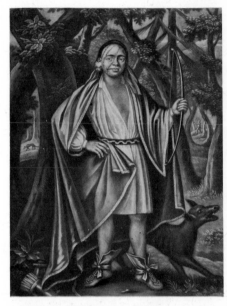

680 JOHN SIMON (1675–1755)
Four mezzotints of Indian Chiefs
Mounted on card 53 cm high, 38 cm
wide
Lent by the Trustees of the British
Museum

Four mezzotints of Indian Chiefs who
visited England and met Queen Anne in
1710. By W. Verelst, died *c* 1756.
Engraved by John Simon. The Chief
Tee-Yee-Neen-Ho-Ga-Row, of the
Canajoharie clan of Mohawks of Ohio
was Grandfather of Joseph Brant.

681 GILBERT STUART
Portrait of Joseph Brant *1786*
Oil on canvas 72 cm high
Lent by the Trustees of the British
Museum

This is one of three portraits executed by
Gilbert Stuart in 1786 on Brant's second
visit to London. There is one at Syon
House, London and another (a copy?) in
the New York State Historical
Association, Coopers Town, New York.
See J. R. Fawcett Thompson,
'Thayendanega the Mohawk and his
several portraits', *Connoisseur*, Vol. 170,
January 1969, pages 49–53. Joseph Brant,
or Thayendanega, was a well-educated
Mohawk chief and spokesman for his
people. He assisted the English in the
Revolution and eventually settled in
Ontario.

682 Birchbark map of the River System from the Ottawa River to Lake Huron *c* 1841 AD
Woodlands, Great Lakes
Impression scratched on birchbark
23 cm high, 39 cm wide
Lent by the British Library Map Library
R.U.S.I. (Misc.)

This map was found in 1841 by Captain Bainbridge of the Royal Engineers on 'the ridge' somewhere between the River Ottawa and Lake Huron and the St Lawrence River.

Maps drawn on bark, chiefly on birchbark were common among the North American Indians, who are known to have taken whole rolls of maps with them on their wanderings. A tracing of the map and the probable area of its locations indicated on an English map of the period are also included. The note which accompanies the Indian map offers it as an example to young engineers in their early efforts at surveying.

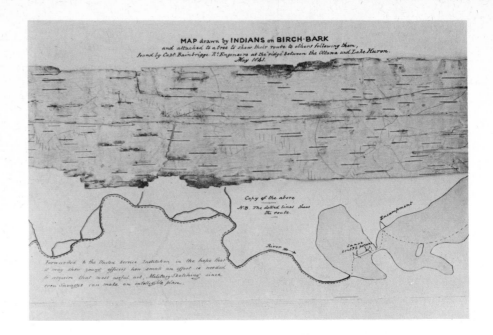

Photographs

683 ZENO SHINDLER
Sobita Chief of the Copote Utes
c 1868 AD
34 cm high, 25 cm wide
Lent by the Trustees of the British Museum
A 41/2035

'Sobita, Head Chief of the Capote Utas, and Brother of Carrisa, Head Chief of the Utas, Colorado Territory'. No 82 of a series by Shindler, Washington, 1868.

684 FIZGIBBON
Pawnee Chiefs
20 cm high, 25 cm wide
Lent by the Trustees of the British Museum
40/1995

685 EDWARD DE GROFFS
No 50 of the series 'Picturesque views of Alaska entitled: Basket Makers, Sitka, Alaska'
13 cm high, 21 cm wide
Lent by the Trustees of the British Museum
2111/271

686 CARPENTER (?)
Two photographs of Pomo and Pomo/Apache baskets from the Hudson Collection, Ukiah, California
a 21 cm high, 24.5 cm wide
b 17.5 cm high, 25 cm wide
Lent by the Trustees of the British Museum 2111/325; 2111/326

687 Eight photographs from Prince Roland Bonaparte's trip to America
Numbers 2, 3, 5, 6, 8, 9, 10, 11
Private Collection, London

688 FLY OF TOMBSTONE
Portrait of Geronimo
Private Collection, London

689 Stereoscopic prints 19th century
Private Collection, London

690 FREDERICK DALLY
Album: Photographic views of British Columbia 1867–70
Lent by Sven Gahlin, London

691 E. A. BONINE, Lamand Park, Los Angeles
Photograph of Yuma boy *c* 1870 AD
22.5 cm high, 11 cm wide
Lent by Sven Gahlin, London

692 Photographs from the collection of Sir Benjamin Stone
a **Ma-Lee in buckskin costume** 1907
20 cm high, 20 cm wide
b **Crow Indian Reserve group** 1907
22 cm high, 16 cm wide
Lent by M. G. Johnson Collection

693 MARGARET DUCHESS OF ARGYLL
Album of Photographs of the Athabascan Indians 1970
25 cm high, 25 cm wide
Lent by Margaret Duchess of Argyll